The Life and Art of

FLORINE STETTHEIMER

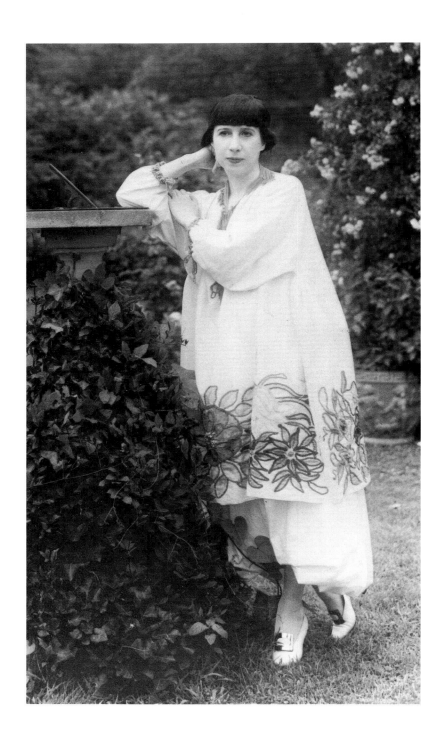

The Life and Art of

FLORINE STETTHEIMER

Barbara J. Bloemink

Yale University Press
New Haven and London

Dedicated to the memory of Robert F. Heins, and to Doris Heins
and Ada Werber, at ninety-five my very own Florine

Designed by Lisa C. Tremaine
Set in Bodoni Book type by The Composing Room of Michigan, Inc.
Printed in the United States of America by
Quebecor-Eusey Press

Library of Congress Cataloging-in-Publication Data
Bloemink, Barbara J.
The life and art of Florine Stettheimer / Barbara J. Bloemink
p. cm.
Includes bibliographical references and index.
ISBN 0–300–06340–7 (cloth)
1. Stettheimer, Florine, 1871–1944. 2. Painters—United States—
Biography. I. Stettheimer, Florine, 1871–1944. II. Title.
ND237.S75B66 1995
759.13—dc20 95–30528
[B] CIP

A catalogue record for this book is available from the British Library.

The paper in this book meets the guidelines for permanence and durability of the Committee on Production Guidelines for Book Longevity of the Council on Library Resources.

10 9 8 7 6 5 4 3 2 1

Frontispiece: Florine Stettheimer, ca. 1917–1920 (see fig. 38).

CONTENTS

ACKNOWLEDGMENTS

This book is a reflection of decades of fine writing and art scholarship by the many art historians and colleagues who have influenced my thinking. As they cannot all be mentioned by name I want to emphasize my appreciation for all that they have taught me. My mentor and primary influence has been Jules David Prown of the Department of History of Art at Yale University. The book would never have been possible without his good humor and continuing, unstinting support. Jules serves as my standard for careful reading of works of art, consummate scholarship, professional integrity, and good writing.

I would like to thank the following people who greatly assisted me. At Yale University: Bob Herbert, Alan Shestack, Celeste Brusati, Marie Kuntz, Patricia Willis, Donald Gallup, Steve Jones, and the staff at the Beinecke Rare Book and Manuscript Library for their indulgence over the years. At Stanford University: Al Elsen, Lorenz Eitner, Michael Sullivan, and Dwight Miller. At the Institute of Fine Arts, New York City: Colin Eisler, Richard Ettinghausen, Robert Rosenblum, and Gert Schiff. At Columbia University: Sally Weiner and Larry Soucy of the Art Properties Department and the staff of the Butler Rare Book and Manuscript Library. I would also like to express my gratitude to the readers of my dissertation: Linda Nochlin of the Institute of Fine Arts, Wanda Corn of Stanford University, and Romy Golan of Yale University. Their insight greatly assisted me in fine-tuning and improving the work.

Special appreciation is extended to Stettheimer collectors and family members, including Barbara Katzander, Jean Steinhardt, Mrs. John D. Gordan, John D. Gordan, Marjorie Gordan Bowden, Sherrey Wanger, Cynthia and Jan Nadelman, Joseph Solomon, Richard Kempe, Virgil Thomson, Francis Naumann, Fred Baker, and all the institutions that own Stettheimer paintings.

Countless professional colleagues and friends deserve thanks, including Barbara Haskell, Barbara Wollanin, Joann Moser, Stephen Weil, Philip Nowlan, Odile Duff, Bruce Kellner, Keith Davis, Elizabeth Sussman, and James Oles; the women of Art Table, including Mimi Poser, Carolyn Goldsmith, Karen McCready, Janice Oresman, Nancy Kauffman,

and Wendy Feuer; Katherine Moore, Athena Kimball, George King, and many others at the Katonah Museum of Art; Arlette Klaric, for her fine dissertation on the work of Arthur Dove and for our many discussions over the years on ideas and issues current in Stettheimer's lifetime; Lena Marley, for her careful reading of the manuscript and her encouragement; Joy Moser, for her insight, wide-ranging intelligence, friendship, and unwavering support throughout the process of conceiving and writing the dissertation; Jane Holcomb, for her editorial suggestions; Kevin Fewster, for nagging from twenty-four thousand kilometers away; Jimm Prest, for his undaunting support, curiosity, encouragement, and affection throughout the final stages; Heinz and Ann Hellin, Linda Seigneur, Charles Lovell, Mark Leach, Harry Bloemink, John Jacobs, Michele Oka Doner, Micky Wolfson, Iran Issa-Kahn, Henry Harper, Virgilio Sierra, Joe McCauley, Sally Heins, Christopher, Peter, and Geoffrey Lane, Debbie and Mike Luster, and in Australia Terry Smith and Virginia Spate. My thinking is regularly stimulated by the fine writing and insight of Carolyn Heilbrun, Linda Nochlin, Griselda Pollack, Briony Fer, Toni Morrison, and Carol Duncan.

In Kansas City, I extend my thanks to those who make up what I believe is the best museum staff in the country: Pauline McCreary, Barbara Guthrie, Michelle Bolton, Debroah Eve Lombard, Joe Chesla, Trish Finn, Marty Kniffen, Rodney Bishop, and Duane Twenge of the Kemper Museum of Contemporary Art and Design. Without their support and humor over the last year I would never have survived. Michelle Bolton's persistent and exacting care in organizing the illustrations and ephemera for this book made its publication possible. For their unwavering support and friendship, I extend special thanks to Crosby and Bebe Kemper, Margaret Silva, Byron and Eileen Cohen, Sharon and John Hoffman, Lewis Nerman, Jerome and Margaret Nerman, Lennie and Jerry Berkowitz, Sean Kelly, Pinky and Arthur Kase, Jonathan and Nancy Lee Kemper, James Kemper, Mimi and Dick Ahsmushs, Suzie Aron, Alice Thorson, Heidi Billardo, Marcie Cecil and Gardner Rapelye, Joanie and Roger Cohen, Melissa Rountree, Eric Anson, Patrick Clancy, Jim and Sherry Leedy, Jansen Pollen, John Uhlmann, Ken Ferguson, Sybil and Norman Kahn, Sheila Kemper Dietrich, Crosby Kemper III, Mark Wilson, Daniel and Mary Wyndam, and the William T. Kemper Foundation.

The people at Yale University Press, particularly Judy Metro, Mary Mayer, and Richard Miller, were unstinting in their generosity and assistance, and I thank them all. Finally, I remain grateful to Jules Prown, Helen Cooper, and Patricia Kane of the American Art Office of the Yale University Art Gallery, who supported my work through National Museum Act and Rose Herrick Jackson Fellowships during my time at Yale, and to the J. P. Mellon Foundation for the Yale Dissertation Fellowship, without which completion of this project would not have been possible.

PROLOGUE

It is difficult for a woman to define her feelings in language which is chiefly made by men to express theirs.—Thomas Hardy, Far from the Madding Crowd

On a sunny day in 1948, a New York lawyer, Joe Solomon, found himself seated in a rental boat in the middle of the Hudson River. On his lap he held a shoe box containing the ashes of the artist Florine Stettheimer. A few weeks earlier Solomon had received a call from one of his elderly clients, Stettheimer's sister Ettie, requesting that he hire a motor launch to travel up the Hudson River.[1] Ettie also asked Solomon to call the Universal Funeral Chapel and arrange to have her sister's ashes taken from the urn in which they had been confined for the past four years and placed in a cardboard box for retrieval.

On Saturday, September 25, Joe collected the ashes and picked up Ettie Stettheimer and her paid companion at Manhattan's Dorset Hotel. The three then continued by car to Nyack, where their launch waited. The weather was ideal for sailing. Solomon assumed that they were headed for West Point, where thirty years earlier Florine Stettheimer had painted one of the first paintings in her "new" style. Instead, as they passed Hook Mountain, Ettie asked that he turn the boat around and head back. Suddenly Ettie offered Joe the cardboard box with her sister's remains. "Now Joe," she said, "open the box and scatter the ashes." Shocked, the lawyer protested that Florine was, after all, not *his* sister, and handed the container back. Ettie poured most of the ashes into the silver and green water, then urged the lawyer to scatter the last little bit. As Joe threw the shoe box with its contents into the river, Ettie tossed in a bunch of brightly colored zinnias. Then, to Solomon's astonishment, she opened a large picnic hamper and handed him a chicken sandwich. After eating, they returned to shore and stopped for tea at the Bear Mountain Inn before returning to Manhattan.

If part of Ettie Stettheimer's intention was to create a mystery around her sister, she succeeded all too well. Four and a half decades after her death, Florine Stettheimer's work is virtually unknown, except to a small, select group of "special friends." Yet during her lifetime, numerous art critics hailed her as one of the "few important woman painters in the history of art," and her work was included in most of the significant exhibitions of her time. Stettheimer created more than one hundred and fifty paintings that are bold, ironic, inven-

tive, and among the most interesting produced in the early decades of this century. As a uniquely knowledgeable and sophisticated cultural observer, Stettheimer provides critical visual contexts for social concerns of her era, and her paintings offer an intimate perspective on the private and public interrelations among many influential figures of the art world between the wars. In addition to painting, Stettheimer wrote bitingly ironic poetry, designed furniture and picture frames, and was responsible for the stage design and costumes of *Four Saints in Three Acts,* one of the most important avant-garde theatrical productions of the 1930s. During the 1970s and 1980s, several feminist artists and art historians "rediscovered" Stettheimer's work. As a result, her paintings are occasionally placed in selected group exhibitions and catalogues tracing the work of women artists. Moreover, a number of contemporary artists list Stettheimer as among the major influences on their work.

Yet Stettheimer's work, despite its strength and its influence, remains little known to the general public, and most traces of her early life have been eradicated. The artist's whimsically designed furniture was given to Columbia University's theatrical department for its use in student productions and has long since disappeared. Driven by her desire for privacy (and prompted by sibling rivalry), Stettheimer's sister Ettie systematically edited all "personal" entries from Stettheimer's sketchbooks and diaries before donating them to the Yale and Columbia University archives. Various other factors contribute to Stettheimer's lack of widespread recognition, and they reveal a great deal about the modern art world that, then as now, is largely a commercial venture.

Florine Stettheimer lived during a time when women were not considered capable of creating significant art. The rigorous training and opportunities open to men were not easily available to women. Caught by familial duties and her nineteenth-century upbringing, with no husband or father to offer alternate outlets or opportunities, Stettheimer had to inventively piece together her formal art training. For women like Stettheimer, whose life choices express "a female impulse to power as opposed to the erotic impulse which alone is supposed to impel women," there was no script to follow, no recognizable career stages, as there would be for a man.[2] Throughout her life, the artist maintained a running battle to find the time to work on her art and be taken seriously as an artist.

Although never mentioned by reviewers and biographers as relevant, most of Stettheimer's significant work was created when she was between fifty and seventy years old. The notion of a middle-aged, avant-garde woman artist who retains her sense of humor, playful fantasy, and a highly independent style of working remains disconcerting even today and continues to contribute to her elusive reputation. Stettheimer was aware of the dilemma of the intelligent, mature woman, as she mordantly acknowledged in her poem "Civilizers of the World":

They like a woman
to have a mind.
They are of
Greater
interest they
find.
They are not
very young
women of that
kind.[3]

Stettheimer had enough money to make art for her own pleasure; she painted to suit herself, not the vagaries of the art market. Because she had no economic incentive to join any codified circle of artists and gain visibility "in the pursuit of a more orthodox artistic career,"[4] she remains outside the history of modern art. Ironically, financial security severely *inhibited* the dissemination and knowledge of her work, since works of art often must be seen and circulated to gain a widespread reputation. Stettheimer never actively marketed her work or associated with a single gallery, even when urged to do so by respected art dealers and friends. She turned down a number of one-person exhibitions and often priced her paintings steeply to discourage interested purchasers. After her death, the artist's virtual anonymity was ensured when her paintings were relegated to museum basements, thereby keeping them permanently off the market.

The works themselves contribute to their obscurity. The mature paintings combine the styles of Old Masters such as Brueghel and Velázquez, contemporary artists including Manet and Matisse, with theatrical design, children's art, and Persian miniatures, all seen through a decidedly feminine sensibility. Stettheimer's paintings lack the dominating iconic imagery, simplified unity, and transcendent subject matter of much so-called American modernist painting by artists such as Arthur Dove, Georgia O'Keeffe, or Charles Sheeler. Instead, her works are characterized by scattered figural groups of identifiable individuals engaged in separate, often mundane activities; or are portraits in which the sitter is repeated and surrounded by myriad seemingly unrelated objects. Horizon lines are often eliminated, and pictorial information is spread across and up the two-dimensional plane of the canvas. Instead of mechanized objects or abstracted forms, Stettheimer filled the empty spaces of her compositions with flowers, curtains, lace, trees, putti, tinsel, and hearts. Her subject matter consistently revolved around aspects of her daily life, and her works primarily portrayed friends, family, and intimate events. Because, historically, male critics and art historians have generated the criteria for identifying and judging "significant" art, Stettheimer's work is often dis-

missed as overly feminine, yet it is difficult to imagine anyone criticizing a work of art as being too masculine.

Part of the reevaluation necessary to appreciate Stettheimer's work lies in resisting the notion of a singular, linear cultural and stylistic evolution. Stettheimer's paintings do not fit neatly within any existing art-historical "isms" traditionally used to categorize modern art created between the two world wars. They are too satiric to be called romantic, too specific to fall under the heading of surreal or fantastic, and too obviously generated from a thorough knowledge of Western art history to be termed primitive. Although most modern artists in Europe and America worked within "the same broad cultural and economic space," few theoreticians and art historians have been willing to admit that "this space sustained a considerable diversity of work," and that even within recognized groups of artists "the structure of differentiation was itself a matter of argument and dispute."[5] As a result, Stettheimer's work has been largely forgotten, except as an example of American naïf or eccentric style. This categorization of the work—as artless and unsophisticated—could not be further from the truth. As the art critic Henry McBride noted, after shaking off the "conventional premier-coup of the pseudo-Sargents of her early career, Stettheimer 'evolved' a manner of painting that may appear willful, unconcerned with precedent and as unpredictable as the flight of a butterfly in a garden of flowers; and yet nothing could be false than to attribute its effects to lucky accidents. *Miss Stettheimer knew what she was doing.*"[6]

McBride began his catalogue essay for the Museum of Modern Art's 1946 retrospective exhibition of Stettheimer's work with these lines by Gerard Manley Hopkins:

All things counter, original, spare, strange:
Whatever is fickle, freckled (who knows how)
With swift, slow; sweet, sour; a dazzle, dim;
He fathers-forth whose beauty is past change:
 Praise Him.

As McBride so astutely recognized, in the eyes of subsequent critics and art historians, Stettheimer remains an oddity: her work and life run counter to "accepted" definitions of modernist art-making. The purpose of this book is to remedy this neglect by carefully tracing the development and context of Stettheimer's oeuvre in a manner normally reserved for work by significant male artists. The intent is not to position Stettheimer as a "heroic" or solitary genius. Nor is it to establish her as the ultimate feminist artist, thereby moving her from one generalized stereotype to another. Stettheimer did not consciously model her personal or professional life on any specific ideology, and to view her work through any single lens is to miss much of its meaning.

This book examines a life that was consciously dedicated to art-making and the work

that resulted. To date, there is no readable biography of Stettheimer, nor has there been any concerted effort to document her work or place it within a larger context. Primary information on Stettheimer is severely limited: a number of her paintings have been lost or destroyed over the years, and members of her family chose exactly what information would be passed down and recorded.[7]

Added to the difficulties in interpreting the work is the fact that Stettheimer consciously controlled viewer's perceptions. In a willfully modernist way, she toyed with time, space, and representation in her paintings, and manipulated viewers' apprehension of her imagery by codifying a symbolic vocabulary fully intelligible only to the initiates of her circle. Relatively late in life, the artist wrote a poem that has proven prescient and can serve as a warning when examining her life and work:

Occasionally
A human being
Saw my light
Rushed in
Got singed
Got scared
Rushed out
Called fire
Or it happened
That he tried
To subdue it
Or it happened
He tried to extinguish it
Never did a friend
Enjoy it
The way it was.
So I learned to
Turn it low
Turn it out

When I meet a
stranger—
Out of courtesy
I turn on a soft
Pink light
Which is found
modest
Even charming.
it is protection
Against wear
And tears . . .
And when
I am rid of
The Always-to-be-
Stranger
I turn on my light
And become
myself.[8]

Knowing this veiling of her true self to be a conscious decision, we might also assume it to operate in her work. Stettheimer's story and her development cannot be accurately told by examining only the facts, but require a close parallel study of her writings and visual output. Just as Marcel Proust's narratives are constructed through detail and nonsequential time, Stettheimer's paintings represent a continuously unfolding autobiography wherein themes of personal memory and family intimacy are interwoven around occasional chronological

anchors. To do it justice, the artist's life and work must be viewed in terms of context and con-fluence rather than through the restrictive lens of linear cause,[9] and must be reframed by examining the conditions of the artist's creativity. As Rosemary Betterton observes, "What a work represents can be changed from a traditional frame of reference in which it signified marginal, secondary or unspoken values to a new critical context in which those values can become central, productive and meaningful."[10]

Stettheimer's diaries and letters are quoted extensively to reveal as much as possible of the artist's personality. Unfortunately, the diaries cover only a limited segment of her life.[11] The rest must be inferred from the visual reading of Stettheimer's creative output. The initial chapters of this book are largely biographical, tracing the artist's early development and the sociopolitical and cultural context in which she matured. Stettheimer was not a "naturally gifted" artist, and a great deal of her painting before 1915 is mediocre in terms of aesthetic quality, originality, and skill. The early work does, however, contain crucial intimations of what was to come, and so receives careful attention here.

One of the most significant characteristics of art created during the period between the world wars is the ambiguous and often contradictory way that artists and the public inter-preted such ideologically charged words as *realism, decorative, modernism,* and *cubism.*[12] Modernism itself was, as Shari Benstock has written, "highly individualistic, often anarchic and incorporating contradictory impulses under a single *ism.*"[13] Among the interesting aspects of Stettheimer's mature work are the many parallels between it and other contempo-rary disciplines such as psychology, literature, science, and the cross-cultural integration of art forms including the decorative arts and interior design. Stettheimer's paintings are non-narrative according to traditional post-Renaissance definitions of storytelling and contain myriad layers of meaning encoded in all aspects of their subject matter, handling, design, and intention. As a result, her paintings, poetry, and theatrical designs require close reading to be understood.

Stettheimer's mature aesthetic style was grounded in the European decorative and fine-arts traditions. From this foundation, after 1915 she consciously invented a new, mod-ernist style, yet her influence on other artists was not apparent until three decades after her death in 1944. It is time that her work be accorded the place in the history of modernism that it deserves. As a woman who was unfettered by the usual financial or domestic responsi-bilities and was also an astute social historian, Florine Stettheimer provides us with a unique, alternative perspective from which to examine our often too rigidly held definitions of modernism, its progenitors, its derivations, and its traditionally accepted forms.

Ultimately, Stettheimer's life was that of a hardworking, diligent, driven artist fighting to create her own visual voice. The complexity, richness, and irony of her creative output is testimony to her success. The artist's work is also marked, however, by ambivalence. She

was brought up under the cloak of gentility in a decidedly matriarchal family, yet her work existed within a closed, paternalistic system. Her self-image as a professional artist sanctioned her efforts, but the ways in which she reacted to the pressures of the contemporary art world contributed to her subsequent lack of recognition. Half a century after her death, we have only a veiled image of the artist and no apparent niche in which to place her work. Because so many clues offering nuances of Stettheimer's life were destroyed, what remains is a caricature that obscures and inhibits serious investigation. The image traditionally handed down is hard to resist: an eccentric, upper-middle-class Jewish spinster who lived until her seventies with her two sisters and mother; a disappointed, reclusive, virginal artist who draped her bedroom in lace and her studio in cellophane and worried that her paintings would end up in the bedroom of some unknown man. Over the years this stereotyped image has become so pervasive that Stettheimer's work is rarely given serious consideration. Yet to a degree that transcends the work of all but a few of her contemporaries, Stettheimer's singular paintings and poetry unerringly reflect the times and culture in which she lived.

Although in a sense self-created, neither Florine nor her painting style appeared suddenly, out of nowhere, as is often implied. Her familial relations, upbringing, and character were decisive and powerful influences on her work; and it is only by understanding where she came from and how she viewed her work that we can judge it and her with any degree of accuracy.

1

Origins

Florine Stettheimer was born during the final quarter of the nineteenth century and grew up within the hermetic, financially comfortable world of New York's German-Jewish society. Her early life was the site of "quietly ticking clocks . . . private elevators . . . slippered servants' feet . . . fires laid behind paper fans." Through intricate intermarriages characterizing the "One Hundred Families of the *Other* Society," Stettheimer was related to numerous prominent families, including the Seligmans, Goodharts, Bernheimers, Beers, Neustadters, Walters, and Guggenheims:

> It was a world of heavily encrusted calling cards and invitations—to teas, coming-out parties, weddings—but all within the group. . . . It was a world of curious contradictions. It held its share of decidedly middle-class notions . . . yet it was also a world of imposing wealth. . . . It was a world that moved seasonally—to the vast "camps" in the Adirondacks (not the Catskills), to the Jersey Shore (not Newport), and to Palm Beach (not Miami). . . . Chefs, stewards, butlers, valets, and maids traveled with their masters and mistresses. . . . Every two years there was a ritual steamer-crossing to Europe and a ritual tour of spas.[1]

Little is known about Stettheimer's paternal ancestors. Her father's father, Max Stettheimer, described as a "stolid but colorless man, moody and uncommunicative," came from Bavarian German-Jewish descent. The few references to Max in family correspondence state, merely, "Max sat there." Around 1846 Max married Babette Seligman, thereby enhancing his social standing, as the Seligmans were a highly influential and wealthy family.[2]

Their son, Joseph Stettheimer, was a vague and enigmatic figure. He settled in Rochester, New York, sometime in the mid-nineteenth century and apparently spent enough time with Florine's mother for her to conceive five times. While his children were still young, however, he disappeared from the immediate life of his family. According to family mythology, Joseph eventually emigrated to Australia and was never heard from again.[3] Half a century later, the Stettheimer's lawyer noted that the women never mentioned their father: "It was a closed book . . . they always talked about their mother, their mother, their mother, their mother, you see, but never about their father and that left, I think, quite a mark on Florine Stettheimer."[4]

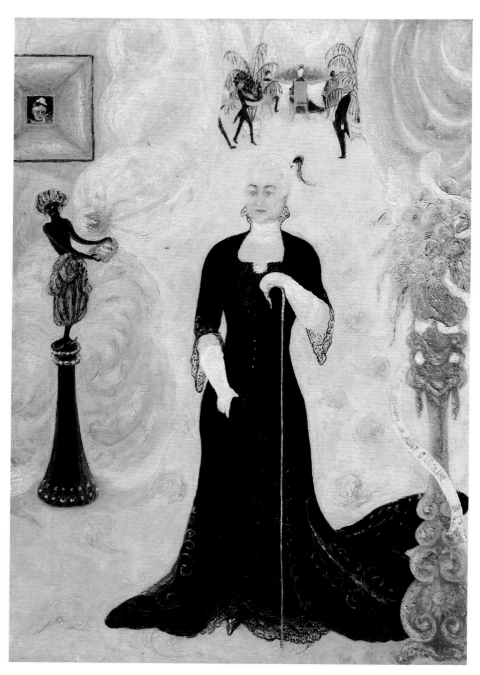

1. *Portrait of My Aunt, Caroline Walter Neustadter* (1928), 38 x 26 in. The Nelson-Atkins Museum of Art, Kansas City, Missouri (Gift of Miss Ettie Stettheimer) 51-13.

Stettheimer's main familial influence came through her mother. Stettheimer's maternal ancestors were a combination of old American ancestry and new immigrant money. Given to independent thinking and possessed of relative wealth and forceful personalities, Florine's maternal relations formed a large, extended clan. Members intermarried, provided training and employment, and closely monitored each others' activities. Her maternal great-great-grandparents, the Pikes, are the artist's earliest known relatives. The couple left Amsterdam after the Napoleonic conquest and arrived in New York City around 1809. The Pikes' daughter, Angelina, married Simon Content, the son of an auspicious colonial family.[5] In 1833 the couple were living in lower Manhattan when they commissioned the Staten Island artist I. Bradley to paint their portraits.[6] In the paired paintings, the Contents are portrayed as self-assured and successful. Angelina wears dangling gold earrings and other jewelry, giving an impression of financial stability. Simon holds up a manuscript inscribed with Hebrew writing, while Angelina sits with a copy of the *Book of Common Prayer,* indicating that the sitters were literate and that they considered their differing religious interests meaningful enough to note. The portraits' mix of religion, intellect, vanity, and wealth encompasses issues Florine Stettheimer struggled with throughout her life.

The Contents' daughter, Henrietta, married Israel Walter, a young, ambitious German immigrant. Walter was born in Germany on May 27, 1818. He served as an enlisted man in the American Seventh Regiment Mounted Cavalry during the Mexican War and afterward successfully established and ran a wholesale dry-goods business at 40 Beaver Street in Manhattan.[7] It is no accident that all of Stettheimer's later painted images of her childhood portray women: Henrietta bore nine girls, including Florine's mother, Rosetta, and one son. The matriarchal Walter family had a significant influence on the artist's self-image: two of Stettheimer's Walter aunts—Caroline, the eldest, and Josephine, the youngest—were among the most important figures in the artist's childhood development.

Caroline Walter, nicknamed "LaLa," married twice, first Louis Neustadter and, after Louis's death, his brother Henry, both of whom worked in the San Francisco cotton business. She traveled widely throughout Europe and kept apartments in Germany and Paris, where she would meet her Stettheimer nieces and take them on trips in her Packard at a time when automobiles were still relatively rare. To the Stettheimer sisters, Caroline Neustadter embodied formidable and majestic female authority. In 1928, after Caroline's death, Florine painted a memorial portrait of her aunt in elegant nineteenth-century surroundings (fig. 1). The painting shows Caroline wearing a black lace dress and train. She stands in the foreground surrounded by an elaborately carved torchère with flowers on the right, and a statue of a black-amoor holding a visiting card with the artist's name on the left. Stettheimer emphasizes Caroline's erect and corseted carriage by placing her behind a long, straight walking stick. Caroline's head, with its carefully marcelled hair, is decorated with a black egret feather. Her

rounded cheeks, pointed chin, and steady gaze caused Stettheimer's early biographer, Parker Tyler, to draw parallels between Caroline's demeanor and the famous Gilbert Stuart portrait of George Washington, Stettheimer's favorite politician.[8] In the background, Caroline is shown again, now pictured from behind, as she converses with a dinner partner while servants in full livery carry in an elaborately prepared game bird.

Rosetta, Stettheimer's mother, was the second oldest Walter child. Other than that she married Joseph Stettheimer and had five children, little is known about her personality or early life.[9] Scant information exists about the rest of the Walter children except for the seventh child, Josephine.[10] Josephine Walter was a remarkable woman, and she served as a role model for her Stettheimer nieces. Born on December 3, 1849, she attended Madame Mear's private school. After graduation, the family physician encouraged Josephine to study medicine. She matriculated at the College of the New York Infirmary for Women, receiving special permission to attend the lectures of Ogden N. Rood, professor of physics at Columbia College, and thereby becoming the first woman to attend Columbia. Following her graduation, she won a position on the house staff of Mount Sinai Hospital in New York. In 1886 the hospital granted Josephine its diploma, and she went on to become the first woman intern in America.

After three years in hospital service, Dr. Walter continued her studies in Europe, working with Professor Ohlshausen in Vienna, Professor Rudolf Virchow in Berlin, Dr. Jean Martin Charcot in Paris, and Professor Thomas Wells in London, each highly distinguished in their respective fields of medicine. She returned to New York in 1888 and entered active practice, specializing in the diseases and ailments of women.[11] Josephine Walter never married. Her life, with its assumption of a traditional male role and its concentration on women's issues, was highly unconventional. Undoubtedly, the proximity of such a life had a seminal affect on her nieces' growth and development.

The influence of the remaining Walter children on their Stettheimer nieces was mainly social.[12] Only Caroline and Josephine Walter, the best educated and most independent of her relatives, are mentioned with regularity in Stettheimer's diaries. With the others she was always polite, but slightly guarded, as revealed in one of the artist's poems:

> *Tame little kisses*
> *one must give*
> *to Uncles, Nephews*
> *and Nieces.*
> *And to friends*
> *who say you are charming*
> *one does likewise*
> *nothing alarming.*[13]

Rosetta and Joseph Stettheimer had five children: Stella, Caroline, Walter, Florine, and Henrietta.[14] Stella, the eldest, had blonde hair and light eyes. Walter was handsome, with light-brown hair and even features. The three youngest girls were slender, not very tall, and had reddish-brown hair. They actively contributed to a certain vagueness surrounding their origins by refusing to acknowledge chronological age.[15] Family records indicate that Carrie was born in 1869, Florine on August 19, 1871, and Ettie on July 31, 1875. Carrie was blue-eyed with a round face and a square jaw. She was the sister most firmly entrenched in nineteenth-century behavior and appearance. Her clothing tended toward the romantic, with bustle skirts and feathered hats, and she engaged in numerous charitable, social, and domestic activities befitting a proper nineteenth-century lady. Unlike Ettie and Florine, Carrie did not leave behind diaries or substantial correspondence. Ettie, the youngest, was the family "intellectual." Her features were finer than Carrie's and distinguished by prominent eyebrows that almost met over her nose. Ettie was known for her piercing dark gaze, sharp tongue, intelligence, and inability to suffer fools. She was the most flirtatious, dramatic, and outspoken of the sisters.

The few existing photographs of Florine show her with attractive, even features and brown eyes. Two years after her death, friends recalled her as being "small, dark, exceedingly slender, exceedingly modest, fanciful, and . . . of singular charm."[16] Continually caught between her gracious, duty-bound elder sister Carrie and Ettie, her temperamental, outspoken younger one, Florine acted like many middle children, keeping her own counsel and observing rather than interacting at social occasions. Florine's personal style was more tailored than her sisters', and she was the most likely to buy ready-made rather than designer dresses. Although often characterized as shy (by biographers writing after her death), her diaries and letters from friends indicate that she was quick, ironic, caustic, and highly judgmental in her opinions and observations.

Florine Stettheimer's early childhood encompassed a medley of people, places, textures, and visual imagery, and she used the materials of her existence to fuel her creative energies. The unusual timing of the artist's life, caught on the cusp between two centuries and cultures, gives it a complexity and richness of contrasts drawn together into a visual crazy quilt of memories. The quilt's underlying structure of the culture and mores of the nineteenth century is balanced by the social changes brought about by the new century, whose influences are woven throughout her early work and personal life:

And things I loved—
Mother in a low-cut dress
Her neck like alabaster
A laced up bodice of Veronese green
A shirt all puffs of deeper shades
With flounces of point lace

2. Fortune telling cards. Florine Stettheimer Papers, Rare Book and Manuscript Library, Columbia University.

Shawls of Blonde and Chantilly
Fishues of Honeton and Point d'Esprit
A silk jewel box painted with morning
* glories*
Filled with ropes of Roman pearls
Mother playing the Beautiful Blue
* Danube*
We children dancing to her tunes
Embroidered dresses of white Marseilles
An adored sash of pale watered silk
ribbons with gay Roman stripes
A carpet strewn with flower bouquets
Sèvres vases and gilt console tables
Mother reading to us Grimm's fairy tales
When sick in bed with childhood ills
All loved and unforgettable thrills.[17]

When Joseph Stettheimer deserted the family, possibly because of strained relations and a falling out with his wife's Seligman relatives, Rosetta stayed in Europe with her young children. This decision enabled her to avoid any social or financial embarrassment, as Europe was a more economical place for the family to live, and there were Walter family relations with whom they could socialize. A grandniece further surmised, "They may have lived in Europe because they had less money than the rest of the family but also because they seemed to like it."[18]

Germany, much as Stettheimer later resisted it, provided the main context for her early life. Her childhood memories, described in later poems and images, are of a happy time filled with creative activities and humor:

Early schooldays in a pretty town
where lived a King and Queen
And Papageno and Oberon
Goetz and Lohengrin
There was a military band
To which we "Little Ones" paraded
With Maggie every day at noon
And a cakestore which we raided

Every day at four
And life was full of parties
In woods where wildflowers grew
In parks where Greek gods postured
In our parlor of tufted Nattier blue.[19]

Among the few extant items from her youth is a set of awkwardly drawn fortune-telling cards painted by the artist in pen and ink with some areas highlighted in watercolor (fig. 2).

In a similar manner, "Florrie" filled a childhood scrapbook with a series of watercolors correlating individual figures with animals, birds, and insects, relating them through the use of design, color, and physiognomy. A nurse with furrowed brow, for example, is identified with an owl, a dapper gentleman with a butterfly, a bespectacled tutor with a grasshopper, a professorial man with a sly fox, and an elderly knitting nanny with both a crab and a ladybug. The childish style and handling of the sketches suggests they were executed before 1884.

Another sketchbook, later labeled "F's schoolgirl productions," contains more advanced drawings. On one page, a man and a woman sit at a breakfast table, visually separated by the large newspapers they hold up. On another, Florine drew and then partially erased a heart next to a sketch of a handsome lieutenant. The book contains numerous drawings of young men, including one titled "Fred," who is gazing with admiration at a young girl with blond hair (Florine's sister Stella?),

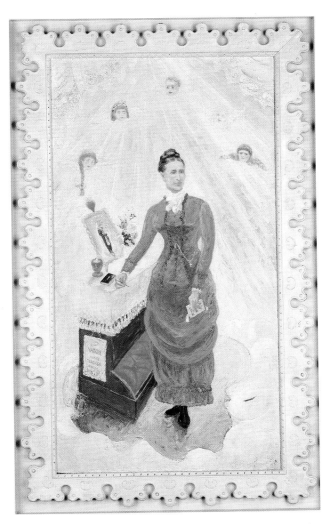

3. *Portrait of Our Nurse, Margaret Burgess* (1929), 38 x 26 in. The Minneapolis Institute of Art.

and a beautiful pencil sketch of Florine's brother Walter sleeping. The majority of drawings show Germans on holiday, women with parasols, boys with boats, men with cigarettes, and families with young girls visiting the baths at Warenmünde. Unfortunately, Ettie edited the scrapbook after the artist's death, eliminating its final pages.[20]

One of the most significant figures in Florine's childhood was the family's Irish nurse, Margaret Burgess, whom they called Maggie. Years later, when Stettheimer painted a portrait of her mother, she included a background scene showing the beloved nurse in her daily role. In the vignette, Maggie, holding baby Ettie, stands in an elegant garden with potted trees and a white picket fence. Meanwhile, the four other Stettheimer children dance and play on an adjacent makeshift stage, reenacting another of Florine's childhood memories:

> *My ring fell from the nursery window*
> *Into a flower bed below*
> *A fairy hopped out of a waterlily*
> *In a Xmas Pantomime show.*
> *Maggie carried me into a circus*
> *To give the little rider a kiss*
> *In our oleander treed yard on a stage*
> *I sang "Little Maggie May" with bliss.*
> *I dressed up in paper muslin*
> *With fringes and gold stars*
> *In that golden era when to*
> *Adventures there were no bars.*[21]

In 1929 Stettheimer painted a portrait of Maggie with her five little Stettheimer "angels" floating above her head (fig. 3). She is displayed in an authoritative pose: one hand resting on her prie-dieu holds a stylus, the other holds a book. Her expression is kind but rather sad. The black prie-dieu, with its bright-red tufted pillow, bears a sign proclaiming her "Maggie, Nurse, Teacher, Guide." The painting is intended as a memorial depicting Maggie in heaven, her little charges affirming her good works on earth. The five winged Stettheimer children form a pyramid around Maggie's head, with Walter, the only boy, at the top. Stella is differentiated from the younger girls by blonde hair and mature facial features. Carrie's characteristically round features are topped by a hair ribbon, and baby Ettie gazes quizzically from beneath her thick eyebrows. Young Florine, her reddish-brown hair worn at the side in a long braid, occupies the space nearest to Maggie's head. When the retired nurse died in 1913, Florine noted in her diary, "Our Maggie is dead. . . . I hope she found the heaven she always strove to attain."

Throughout her life, Florine maintained an ambivalent attitude not only toward organized religion but also toward any kind of imposed ethics or restraints, particularly when issued by a masculine authority figure. Other than Florine's grandfather, Israel Walter, most

members of her family did not actively practice religion. Instead, as with many assimilated German Jews in their social class, Judaism provided more of a social identity than a faith. By Florine's generation, little religious feeling remained. During their childhood in Europe, Stettheimer and her sisters often attended Catholic ceremonies and religious services in the company of their Irish nurse.[22] In a poem she titled "First Plastic Art—Herr Gott," the artist recalled that Maggie's religious faith resulted in her own introduction to sculpture:

Sh-Sh-shushed Maggie
Sprinkling holy water in my face
on entering the little chapel
from the sunny village street
In the light of the tall window.
An enormous statue stood
A man in a purple gown
with a high golden crown.
He had very pink cheeks
and a long white beard
and his hand was raised in blessing.
Maggie knelt and pulled me down
crossing herself she loudly whispered
That is the Lord God
With the golden crown.[23]

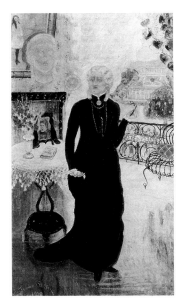

4. *Portrait of My Teacher, Fraulein von Prieser, Stuttgart* (1929), 38 x 26 in. Collection, Portland Art Museum, Portland, Oregon.

Art making was significant early in Stettheimer's life. When interviewed decades later she remarked, "I began painting as a little child." She noted that she had had a great deal of regular art training, "oh, lots and lots of it," but it didn't exactly "take," and she was "rather glad it didn't." [24] There is no indication whether the other sisters received art lessons. Early on, the Stettheimers spent a number of years living in Stuttgart, Germany, where Florine took lessons from Fraulein Sophie von Prieser, an elderly woman whose terrace overlooked the Royal Palace. Almost half a century later, the same year she painted Maggie Burgess's portrait, Stettheimer painted a portrait of her Stuttgart teacher (fig. 4). She inscribed von Prieser's name into the design of a wrought-iron railing through which a circle of children can be seen holding hands. Von Prieser is dressed in a dark nineteenth-century dress with high collar and lace cuffs. On a shelf behind the teacher in the portrait is a large classical bust later identified by Ettie as Juno, the Greek goddess whom Fraulein von Prieser believed she resembled. Florine readily reinforced that belief in her

painting. A portrait on the far wall depicts Florine as a young schoolgirl with long hair, hands clasped and mouth open as though reciting a lesson.[25]

By the time she reached her teens, Florine, her siblings, and her mother lived for at least part of the year in Berlin. In contrast to the more historic and traditional Stuttgart, Berlin was fast-paced and modern. Its central geographic location attracted both Germans and foreigners, giving it an air of transience.[26] While in Berlin, Florine continued both her art training and her lifelong aesthetic appreciation of young men, particularly those in uniform:

> *In Berlin*
> *I went to school*
> *I painted*
> *I skated*
> *I adored gay uniforms*
> *I thought they contained super forms*
> *Though they did not quite conform*
> *To my beauty norm*
> *The Apollo Belvedere.*[27]

During these years in Berlin, Florine made a number of drawings copied from repro-ductions of works of art. The eclectic subject matter and disparate approaches of the works indicate different art teachers and a precocious interest in working through various drawing techniques. The Berlin works are all academic in style, providing further evidence that her artistic production by age fifteen was the result of tutelage as to what was "correct" and "in-correct" draftsmanship. During these years, her subjects ranged from fairy queens with thick peasant legs to finely modeled classical heads. While not demonstrating innate "talent," the drawings show that at an early age the artist was a capable draftsman (figs. 5–7).

At the beginning of the 1890s, Rosetta and her children returned temporarily to New York. When Florine was nineteen, her eldest sister Stella married a Mr. Feuchwanger and left with him to settle in northern California.[28] Deprived of a father and eldest sister, the three youngest sisters might have looked to their brother Walter as a substitute, but as soon as he finished high school Walter also moved west, perhaps to escape the family's dominant female character. Walter eventually settled in California, where he married, raised Scottish terriers, and grew distant from the "eastern, non-marrying" Stettheimers.[29] The father's desertion and the subsequent departure of the two eldest children caused the three remaining sisters to form an unusually close bond and resolve that they would never abandon their mother. This decision eventually adversely restricted the lives of all three women, taking time away from other pursuits and binding them to an increasingly hermetic existence. At the same time, their difficult early experiences with their father freed them from believing that matrimony

5–7. Early drawings, mid-1880s. Florine Stettheimer Papers, Rare Book and Manuscript Library, Columbia University.

and romantic love would or could represent the sine qua non of their lives and enabled the women to have alternative goals. Carrie, as the eldest of the three remaining daughters, managed the family's activities. Over the next four decades Carrie remained the social organizer of the Stettheimer household, freeing her younger sisters to pursue chosen vocations.

Although Rosetta lacked the intellectual skills, training, and professional experience of several of her siblings, she compensated by instilling an unusually strong sense of individuality and independence in her remaining daughters. She encouraged her two youngest daughters to acquire intellectual and professional training far beyond what was considered

necessary for women at the time. In 1895, Ettie Stettheimer, following in the footsteps of her aunt Jo and her uncle William Walter, enrolled in Barnard College of Columbia University (fig. 8).[30] Ettie was one of the first women to attain a bachelor's degree from the university. In addition, she earned a lighthearted "degree" in "flirtation" from various male admirers and friends, along with a formal master's degree in psychology in 1898.[31] After graduation, Ettie went on to earn a Ph.D. at the Albert-Ludwig University in Freiburg im Breisgau, Germany, where she worked with the philosopher and teacher Heinrich Rickert. Her dissertation examined the philosophy of William James. Several years later she described this period of her life in her first published novel, *Philosophy*.[32]

Meanwhile, in 1892, Florine Stettheimer enrolled in a four-year drawing and painting program at the Art Students League. The artist later recorded her memories of these years in a poem that indicates that during her twenties she lived the life of a typical young, upper-middle-class woman, attending various social functions and having literate conversations with men whom she found attractive:

8. Ettie in graduation robes. Yale Collection of American Literature, Beinecke Rare Book and Manuscript Library, Yale University.

Art Student days in New York
Streets of stoop houses all alike
People dressed sedately
Bright colors considered loud
Jewels shoddy—
I affected empire gowns
Had an afternoon at home
Attended balls and parties
At Sherry's and Delmonico's
Sat through operas and the
Philharmonic.
I had a friend who looked Byronic
With whom I discussed books
Emerson and Ruskin
Mills and Henry James
When we felt mild
When we felt ironic
It was Whistler and Wilde.[33]

All too often the fact that neither Florine nor her two sisters ever married is interpreted as intimating that their single status was a result of eccentricity, lesbian inclinations, or physical appearance, rather than personal choice. Such assumptions indicate confusion between the social niche the women occupied and conjecture about their libidinous tendencies.[34]

While not classically beautiful, all three Stettheimer sisters were certainly attractive to men, as proven by their numerous flirtations and proposals. They were not unaware of sexual matters. Decades later, Ettie, annoyed at the obvious attempts of two male guests to censor some provocative statement, chided the speakers, "We may be virgins, but we know the facts of life!"[35]

Although she and her sisters befriended and associated socially with heterosexuals, bisexuals, and homosexuals of both sexes, there is no indication in any of Florine Stettheimer's correspondence, poems, or paintings of a sexual preference for women. To the contrary, everything suggests that from early in her life, the artist preferred the company of men. Her diaries demonstrate her overt admiration for the aesthetics of male bodies, particularly when unclothed or in uniform. Given her hermetic lifestyle, however, Stettheimer probably never acted on that appreciation. Her diaries and correspondence indicate that she was rather disinterested in sex, and her mature paintings, like her life history, suggest an arrested sexuality and a preference for flirtation and high-stylish affect over physical relations.[36] Throughout her life, Stettheimer's attachments tended to be romantic fantasies, the realities of which she rarely faced. Instead, as with certain male artists, most of Stettheimer's energy went into formulating and executing creative work. It is not clear to what extent this was the result of an overwrought nineteenth-century modesty, a desire to remain perpetually a young maiden (not married, childless), or anger against men and fear of marriage because of her father's desertion.

That none of the youngest Stettheimer sisters chose to marry was probably a response to their matriarchal upbringing and the changing role of women during the last decades of the nineteenth century. The 1890s, during which Florine was in her impressionable twenties, marked the first decade of significant transformation in the legal and professional possibilities for middle-class Western women.[37] While not yet ready to claim equality with men, women in large numbers grew increasingly sensitized to the debates on "the Woman Question," and they began actively fighting for better educational and professional opportunities. In Europe in 1884, following new laws in France which gave women the right to initiate divorce proceedings, vociferous demands for greater women's liberation generated a powerful new symbol, the "Femme Nouvelle." The image of this "New Woman" pervaded mass media on both sides of the Atlantic between 1889 and 1898. The French art critic Marius Ary-Leblond, commenting on the arrival of this new phenomenon, observed, "We find her in the salons, this *New Woman*. . . . She lives a full life, a complete and powerful one, equal in intensity and output to that of a man. . . . She has an individuality that contemporary painting . . . is beginning to translate into the frank and self-confident gestures, a quick suppleness, and firm, electric expressions. . . . These modern amazons are fiercely independent. . . . The New Woman is the woman of a century of inventions, independent, nomadic."[38]

The symbol of the New Woman offered an alternative to late-nineteenth-century notions

of unmarried women as easily pitied or patronized celibates.[39] In describing the Femme Nouvelle, Ary-Leblond inadvertently provided a very fitting physical description of Stettheimer: "The New Woman is not beautiful. She looks rather like a boy, and illustrates more than anything the expression of a firm character, a serene soul . . . with her elegant but weary body, her simple but courageous gestures completely devoid of the useless illusions that can be found in the falseness of high luxury."[40]

Marriage, traditionally regarded as women's ultimate goal and highest reward, suddenly came in for criticism. Some women openly derided the ideal of maternal instinct and scorned the notion that child care was the highest duty to which they should aspire. In the media, the New Woman justified her decision not to marry by pointing out that marriage as conventionally defined was little better than slavery.[41] This opinion was echoed by Stettheimer in a diary notation from the 1890s following a meeting with an old friend, Marie Glanz, now Frau Professor Drier: "Her husband is very unattractive, but most husbands are!" The artist's reaction toward the marriage of another friend, Alice Bamberger, who married a Frenchman, was no less cynical: "It seems strange that she lost her nationality on account of a proceeding that took five minutes."

Beginning in the 1890s, spinsterhood became not only a highly viable but occasionally even a preferable option as unmarried women assumed visible roles in the professions and in education. The American feminist Mary Livermore advised parents to train their daughters to support themselves because opportunities for good marriages were diminishing: men who were not killed by drink, vice, or overwork were not necessarily going to be good or competent husbands, as they could be unambitious or be deserters or dissolutes—attributes with which the Stettheimer women were already familiar.[42] The decision not to marry reflected women's rising expectations of "enlightened" men and, consequently, falling opportunities to find them. Women who, like the Stettheimer sisters, had the highest social status, standard of living, and level of education were left with the smallest pool of marriageable men. Among Florine's poems is one with overtly ironic overtones regarding contractual affiliations with men:

Sweet little Miss Mouse
Wanted her own house
So she married Mr. Mole
And only got a hole.[43]

Ettie Stettheimer was an outspoken, active feminist. She attended woman suffrage meetings in 1908 and 1909 and was aware of the proceedings of the First International Feminist Congress, held in Paris in 1896.[44] Susanna Moore, the protagonist of the novel Ettie wrote in 1923, was later described by a reviewer as "what emerged at the end of Victorianism

when the curtain of male supremacy was finally lifted. She is without mate, for by the time she was formed, her mate, who was her Victorian father, was dead . . . here she is in her youth—dedicated, wrong-headed, self-intoxicated and powerful."[45]

Florine was less outspoken in her affiliation with feminism, yet various entries in her diaries and poems reveal her allegiance to women's causes and her awareness of a developing "Female Aesthetic." After attending a 1909 performance of *Lysistrata* in Munich, Florine complained that it was a horrible evening: "The play was written by a man who was completely anti-feminist. . . . I concluded that they should have all the roles taken by men and the performance only for men—the way it was written, no woman could enjoy it." Florine's pro-women attitude, and her awareness of the stereotypes too often pinned on women, subtly worked its way into her viewing of paintings by other artists. She found the women in paintings by Ferdinand Hodler "pathetically patient looking"; visiting the Alte Pinakothek Museum in Munich, she was impressed by the image of a "delicate, nervous-looking little female copying Rubens' *Rape of the Two Nude Females*, I believe the Sabines, copying it in life size and with tremendous dash and strength."

One of the common threads throughout Stettheimer's life and work is that she saw herself not in the traditional role of woman as wife, helpmate, and mother, but as an earnest, professional artist. Despite her lack of interest in selling her work, Stettheimer took the making of art seriously, treating it as a career rather than a pastime. In almost all of her painted self-portraits, for example, she represents herself wearing a pantsuit and holding the implements of an art professional, rather than in the fashionable clothes worn by her sisters. Years later, her friend the artist Marcel Duchamp perceptively referred to Stettheimer as a "bachelor," drawing attention to her unmarried status in a men's career and clothing and playing on the French *bachelier*, which had come to connote a "New Woman."[46]

In the 1890s, Stettheimer's choice of the Art Students' League for further training was probably based, in part, on the liberalism of its policies toward women. When she joined, the institution had only been incorporated for thirteen years.[47] The League's methods, in terms of student involvement and practices, were considered radical for the time. One third of the institution's founders and a large percentage of the students who dominated the Board of Control were women. According to the League's constitution, half the board's twelve members were elected and half were appointed (by the six elected members). Stettheimer must have been well respected, as among the few extant records is a listing showing that in 1895 she was elected (not appointed) "corresponding secretary" to the Governing Board of the Art Student's League.

When announcing the founding of its new art school, the Art Student's League declared that it would offer the first life-drawing class for women in New York. (It was the second such class given in the United States.)[48] Although women in Europe and America regularly attended art classes, they were unable to attend the major European academies such as the

Ecole des Beaux-Arts until late in the nineteenth century, when it was no longer a highly prized achievement.[49] In addition, it was very difficult, if not impossible, for women to attend classes in drawing from nude models. This undoubtedly contributed to the failure of women artists to be granted equal professional status as men since careful and prolonged study of the nude model was considered essential for the production of "significant" work. While male artists drew from nude male and female models, women wishing to do figure studies generally had to work from plaster replicas of antique statuary.

In October of 1892, the year when the twenty-one-year-old Stettheimer enrolled, the Art Student's League had just moved from East Twenty-third Street to its present location at 215 West Fifty-seventh Street. The school prided itself on being independent of any college, museum, or art society, and tried to reflect all contemporary trends without associating exclusively with any one. Courses were treated as a combination of idealized nineteenth-century Parisian ateliers and medieval apprenticeships where students learned from professionals through demonstration or criticism. From the outset, the League promoted two somewhat contradictory styles and perspectives by hiring as professors artists who studied in Munich as well as artists who studied in Paris. To balance her youthful training in German art techniques and philosophies, Stettheimer chose to take instruction primarily from teachers well versed in the alternative, French academic tradition, with its emphasis on order, reason, discipline, synthesis, and clarity. It was this tradition which she later denounced in forming her own idiosyncratically modernist style.[50]

Stettheimer began her tenure at the League with Carroll Beckwith in a class in drawing from the antique, a requirement before she could work directly from the nude. Like his friend John Singer Sargent, Beckwith had worked in the Paris atelier of Charles Carolus-Duran and developed a reputation for portraiture. Stettheimer's large standing portrait of her older sister Carrie, with its muted color and bravura brushstrokes, dates from her early years with Beckwith (fig. 9). She painted the almost life-size painting in sedate tones with only the straw hat and diaphanous white dress giving light to the palette. Shown in three-quarter view, Carrie stands with her shadowed face set off against the lush green of potted ornamental trees.

In 1893 Stettheimer took a life-drawing and painting class (later called painting, drawing, and composition) with H. Siddons Mowbray. Mowbray, like Eakins before him, studied in Paris in the atelier of Léon Bonnat. Mowbray's interest in exotic subjects was furthered by his appreciation of Japanese woodblock prints, which may have sparked Stettheimer's appreciation of Ukiyo-e prints, which she began to collect.[51] Later, she incorporated many of the formal design and compositional motifs of Japanese prints into her paintings and furniture designs.

In 1893–94 Stettheimer also attended a life class with Kenyon Cox, and she continued taking classes with both Cox and Mowbray through 1895. Cox was an outspoken advocate of all students' learning Western art traditions: "Each new work [should] connect itself in the mind of him who sees it with all the noble and lovely works of the past." While not denying in-

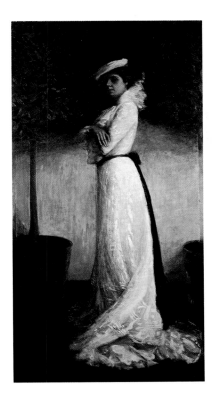

10 Mural studies, awaiting restoration. Columbia University of the City of New York, Gift of the Estate of Ettie Stettheimer, 1967.

9. *Portrait of My Sister Carrie in a White Dress*, 90½ x 47 in. Columbia University of the City of New York, Gift of the Estate of Ettie Stettheimer, 1967.

dividuality and originality, he believed that modern art should steep itself in historicism and tradition: "It wishes to add link by link to the chain of tradition, but it does not wish to break the chain."[52] In his teaching, Cox placed great emphasis on technique. Maintaining that modern art had lost a feeling for beautiful workmanship, he made his students examine the techniques of artists as diverse as Velázquez, Titian and Tintoretto, Rembrandt, Rubens, Frans Hals, and Millet. Along with Botticelli and Manet, these artists significantly influenced Stettheimer's later work. Cox also admired Italian Renaissance murals for their rich color and complex accessories. He thought that mural painting would further the renaissance of American art, and in the mid-1890s he was commissioned to paint two large mural lunettes for the Southwest Gallery of the new Library of Congress building in Washington. Mural painting was one of many experiments Stettheimer tried during the next two decades, working through past techniques, forms, and motifs to develop a personal style. Two early mural studies by Stettheimer exist that were probably painted while she was working with Cox. One is a ceiling with an octagonal central panel and the other a lunette (fig. 10).

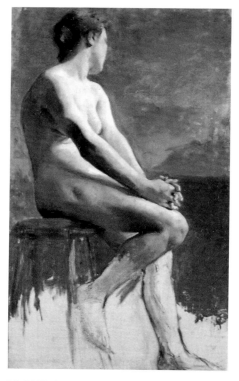
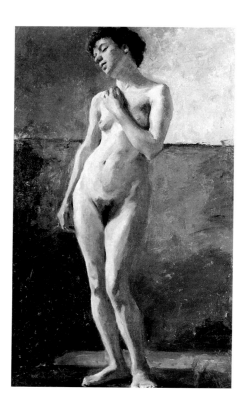

11-12.Nude studies, 1890s, 30 x 18 in. each.
Columbia University of the City of New York,
Gift of the Estate of Ettie Stettheimer, 1967.

Stettheimer's painted sketches of nudes from the 1890s recapitulate many of Cox's pre-
cepts that she later rejected. They also reveal proficiency in the handling of paint, form, and
composition. She began with careful, anatomically correct preliminary drawings, over which
she laid broad, flat strokes of pigment. The paintings demonstrate mastery of perspective and
foreshortening and the ability to portray difficult areas of the body, such as the hands and
feet. The poses are standard for art school. In one work, a fellow woman student is visible in
the background, behind the standing model. Stettheimer's early nude oil sketches present de-
personalized bodies, props on which to study the effects of light and shadow. The artist did
not idealize the nudes but noted every dimpled thigh and reddened hand. In one painting, she
captured the broad, individualized features of a standing model but depicted her with eyes
shut, as if bored and removed in thought from her present circumstance. (fig. 11-12) Twenty
years later, Stettheimer would also find the academic tradition she had learned boring and
would reject it to create her own idiosyncratic style.

2

Influence Gathering

Critics and biographers often mistakenly attribute Stettheimer's later painting style to personal eccentricity, rather than to numerous factors coalescing across Europe during the years before World War I. The changing role of women, the rococo revival and its "feminine" affiliations, a new psychology centering around associative memory and the redefinition of "interior space," and a zeal to integrate all the arts played a significant role in forming her mature aesthetic.

During the last decade of the nineteenth century, France enjoyed a temporary revival of the rococo style. Originating in the eighteenth century, the rococo in art and architecture was marked by lightness, delicacy, and artifice. The rococo revival recalled an era when French taste represented the apogee of Western culture. Toward the end of the nineteenth century, as the French nation felt itself economically slipping in relation to neighboring Germany, the government officially revived the rococo style, laying particular stress on the decorative arts. In 1890 France founded a new Salon, in which, for the first time, decorative arts were granted equal status with painting and sculpture. For many, this action represented a potential "renaissance of national taste."[1]

The French government's cultural arm concurrently promoted the idea that French crafts would not flourish again until women reestablished themselves within the home. Aesthetic styles such as the rococo were openly supported because they emphasized the organic side of the female gender and positioned femininity within the cycles and fecundity of nature. Supported by the government, the French media disseminated images of objects and furnishings in rococo style as a reaction against the growing popularity of the Femme Nouvelle phenomenon that it feared would turn women's interests away from domestic matters.[2] The rococo revival was not merely a historicizing act. Influential French taste-makers such as the Goncourt brothers infused the eighteenth-century style with new, nineteenth-century meaning. Through their efforts, the decorative arts were detached from their separate status as a craft. In the process, the primacy of technical skill was surpassed by notions of individual creativity—the way objects expressed the exceptional vision and genius of their creators. This adjustment of appreciation from surface execution to the creative process was a dis-

13. Scrapbook 1, Florine Stettheimer Papers, Rare Book and Manuscript Library, Columbia University.

tinctly nineteenth-century idea. The influential journal *La Grande Dame revue de l'élégance et des arts* in turn revitalized the rococo as the ultimate female-defined "contemporary" style. The journal included articles and illustrations suggesting to the modern woman that, in her increasing devotion to "imprinting her distinctive aesthetic on the objects around her," the rococo could serve as the perfect vehicle through which all elements of an interior space could be integrated to reflect a single personality: "Woman of today is wholly different from woman of thirty years ago. She has become more intelligent, more personal. Today's woman is also more artistic, more refined. . . . She is intuitive and refined . . . one who enjoys the quest for originality, new forms, rare harmonies. She . . . seeks to enchant even the smallest element of the interior with the mark of her personality."[3]

This concept increasingly appealed to Stettheimer's own idiosyncratic sensibility, and as she traveled through Europe the artist filled sketchbooks with drawings of rococo interiors and furniture designs (fig. 13).[4] In 1895, the catalogue cover for the Second French Exhibition of the Arts of Women reinforced the feminine qualities of the decorative arts by depicting two women, one sewing, the other holding an open book and pointing at the word *femme*. At the upper right corner, an attenuated butterfly hovers near a flower blossom.[5] A similar insect motif was picked up and repeated by Stettheimer in paintings executed throughout her later work. The same year, still at the Art Students' League, she made a similar drawing in aid of the Educational Alliance and Hebrew Technical Institute in New York.[6] Stettheimers's secular drawing of a long sinuous woman is highly uncharacteristic of her other work; and while she later abandoned specific references to rococo ornamentation, she retained the underlying philosophy that all objects should be stylistically integrated.

The concept of interior space as the visual correlative for individual persona was pivotal to Stettheimer's maturing aesthetic development. At the turn of the century, she was already designing furniture and decorative objects, an activity that she continued throughout her life. She made several gilded, paneled folding screens that derive from rococo designs.[7] During a stay in New York between bouts of traveling, Stettheimer designed a four-part screen with portraits of herself, sisters Ettie and Carrie, and one of the few extant images she was to make of her brother Walter (figs. 14–15). Each panel depicts one sibling shown

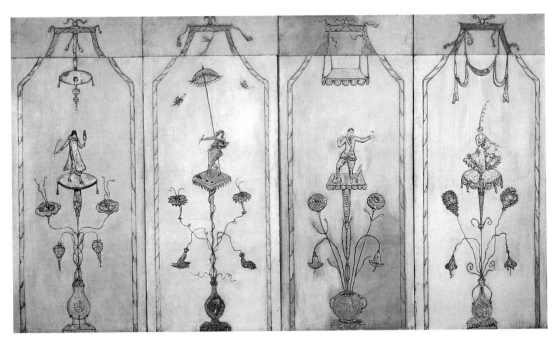

14. Four-panel screen (Portraits of Henrietta, Florine, Walter and Caroline Stettheimer), n.d. Gilded and painted plaster on wood, .a & .b: 7′3⅝ x 35⅞ in.; .c: 7′3½ x 35⅞ in.; .d: 7′3⅜ x 35⅞ in. The Museum of Modern Art, New York. Barbara S. Adler Bequest. Photograph © 1995 The Museum of Modern Art, New York.

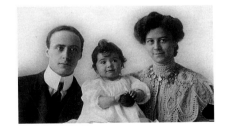

15. Walter Stettheimer with family, Florence Neustadter Stettheimer and Barbara Stettheimer (Adler), age ca. 18 months, ca. 1904. Courtesy Barbara Adler Katzander, New York.

with her (or his) most characteristic attributes. Every aspect of each panel—from the shape of the urns at the bottom to the objects above the figures' heads—reflects the siblings' personalities.[8]

Stettheimer ignored chronology in the screen portraits, making it difficult to date the work precisely. She depicted Walter in jodhpurs and high socks playing with two of his beloved terriers.[9] Carrie's portrait is the most extravagant and theatrical.[10] Everything about her portrayal suggests high fashion, from her characteristic dog-collar necklace to the luxurious feather rising from her small hat. A theater motif, conveyed by masks of comedy and tragedy, is also evident in Stettheimer's depiction of her sister Ettie, but it alludes to her temperament rather than her fashion style. Stettheimer portrays Ettie pacing across a platform, her characteristic eyebrows

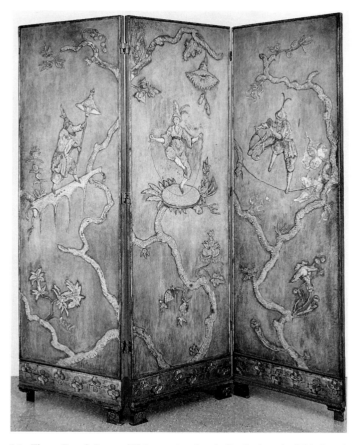

16. *Three Panel Screen* (Chinese Acrobats) (*Le Jeu*), n.d. Gilded and painted plaster on wood, each panel 6′4³/4 x 23³/4 in. The Museum of Modern Art, New York. Barbara S. Adler, Bequest. Photograph © 1995 The Museum of Modern Art, New York.

furrowed, her face wearing a stern expression. In one hand she holds a long quill pen representing her vocation as a writer; in the other she holds a mirror topped by an owl, alluding to both her intellect and her vanity. As usual, Florine represented herself as a professional artist. In the screen portrait she wears an artist's beret and functional harem pants with voluminous hip pockets, the effect of which is offset by the addition of red high-heeled shoes. In one hand she holds a paintbrush, in the other a palette, and her stance and wide-eyed facial expression is that of an artist stepping back to view a painting from a distance. Instead of a canopy, a fringed parasol is positioned above her head to ward off the sunlight while she works. The flower stems below the figure of Florine are the most unrestrained of the group.

During the next decade, Stettheimer began work on another three-panel screen, which she titled *Le Jeu* (The Game), where she combined oriental and rococo motifs in the manner of eighteenth-century French designers. The screen portrays three men, dressed in oriental-style costumes, demonstrating gymnastic skills on the branches of an ornately curved vine (fig. 16). In the first panel, a bearded man, holding a parasol in both hands for balance, walks across an arched beam that rests tentatively between two branches. In the central panel, a younger man jumps rope by leaping up from a flattened flowerhead; and in the last panel, a man, holding an exotic bird with a golden ring in one hand and a mirror in the other, steps gingerly across a tightrope.

Throughout her life, Stettheimer enjoyed experimenting with and borrowing traditional art-making techniques. She often did so, however, without understanding the means of preserving the integrity of selected materials and techniques over time.[11] On her rococo screens, for example, she decided to make the decoration stand in relief against the wood-paneled background. While in Rome in 1909, she visited the Borgia apartments in order to study how this might be accomplished: "[I wanted] to see how high & how much relief was in the architectural part," she noted. "I have begun trying some gold decoration but unsuccessfully so far—I may improve *Le Jeu* when I return to New York." In making her screen, Stettheimer initially drew the outlines of the decoration in watercolor or gouache over unprimed wood. She covered the wood surfaces with a light celadon green paint to resemble patinated metal. Using a mixture of plaster and gesso, she built up a three-dimensional relief for the figures and ancillary vegetation. She then covered the plaster with a thick gilding of gold paint, which she tooled to give it a varied surface texture. The composition of the *Jeu* screen is asymmetrical, and though in desperate need of conservation, it is a strikingly beautiful example of rococo-revival decoration. Linda Nochlin has categorized Stettheimer's mature painting style as "Rococo Subversive," indicating that the early lessons the artist learned from the rococo taught her to camouflage personal iconography beneath layers of a highly artificial and complex style. Traces of rococo influence are evident throughout Stettheimer's subsequent work.

Politics and psychology continued to interpenetrate the decorative arts during the first decades of the twentieth century. French psychology of the 1890s reverberated with the notion that furniture and decorative arts could denote personal expression. A "cult of the self" emerged to compensate for the challenge to individuality brought on by machine-age technology. Personal memory and fantasy were injected into common objects, charging interior spaces with powerful personal meaning.[12] The influential French tastemaker Siegfried Bing, for example, redefined modern interior design as "ingenious eclecticism," a space where objects of diverse periods and national origins produced a harmonious environment.[13]

Throughout his writing, Marcel Proust, Stettheimer's favorite author, articulated a definition of interior space as the index of personal memories: "That composite, heterogeneous room has kept in my memory a cohesion . . . alive and stamped with the imprint of a living personality. . . . The things in my room . . . were . . . an enlargement of myself."[14] Such ideas permeated popular culture and helped form the basis of a new psychological language that presaged Freud's psychoanalytic thought, surrealism, literary modernism (Joyce, Conrad, Stein), and, to a large extent, Stettheimer's later aesthetic.

By 1898, the three Stettheimer sisters, now in their twenties, were again peripatetic travelers, spending most of each year wandering with their mother through Italy, Germany, and France. Florine was resentful at having to travel with her family since it prevented her from painting in the New York studio she maintained overlooking Bryant Park. (This particu-

larly bothered her when she could not find a tenant to sublease the studio and therefore lost forty-five dollars a month on rent.) The Stettheimers sailed from New York each year and, except for bouts of seasickness, usually crossed the ocean without incident. On occasion there was a mild flirtation with fellow passengers, such as a naval doctor named Ricci (whom Florine met by dropping her book and speaking to him in Italian),[15] or worry that drinking too much Pilsner beer during the crossing would make them fat. In 1900 the Art Students' League celebrated its twenty-fifth anniversary by organizing an exhibition of its alumni at the New York Fine Arts Society Building. Stettheimer was still in Europe, but she arranged to have a painting sent. It is the first recorded exhibition of the artist's work, and she was listed in the catalogue as a nonresident member of the League.

While traversing Europe during the first decade of the new century, the Stettheimers continued to be socially active. The theatrical productions they frequented indicate keen interest in contemporary issues. Their taste was eclectic, but highly progressive. Florine and Ettie often chose entertainment that featured strong heroines and examined women's themes.[16] Between 1907 and 1910, the Stettheimers attended a number of exceptional performances, including Oscar Wilde's *A Woman of No Importance* in London, Mrs. Patrick Campbell as *Electra* in New York, and Richard Strauss's infamous interpretation of *Salome* at the Berlin Operahaus in Berlin. In 1917 they saw *Salome* again, this time in Paris, with the notorious young Russian performer Ida Rubenstein in the leading role. The latter performance included a version of the "Dance of the Seven Veils" in which Rubenstein revealed her nude body by shedding individual veils until, according to Jean Cocteau, the last, "most difficult of all, came away in one piece like the bark of the eucalyptus tree." Stettheimer's less poetic but no less rapturous reaction—"she [Rubenstein] looked wonderful . . . bust absurd . . . beautifully staged, blue predominated"—again refutes stereotypes of her as a cloistered spinster.

Florine kept diaries of many of their trips. Although posthumously all "personal" material was excised by Ettie, the diaries still provide unique impressions of the artist during this period of her life. Written during her twenties and thirties, the pages are full of references to Stettheimer's likes and dislikes among men (potential and old suitors, good-looking cadets, actors, and dancers), European food and accommodations, and artworks, both contemporary and old masters. The diaries reveal that the artist was a complex personality who held a number of ambivalent, even contradictory attitudes. Besides being politically independent, particularly regarding women's issues, Stettheimer was a snob, and she expected others to treat her with proper nineteenth-century Victorian decorum. She was highly critical and fastidious, and often began her frequent crossings of the Atlantic by commenting on her fellow passengers, noting her family's "usual bad luck—we are at table with the most underbred people aboard. I don't know the others but I cannot imagine them as bad." She tended to keep to herself:

The world is full of strangers
They are very strange
I am never going to meet them
Which I find easy to arrange.[17]

By age thirty, despite having spent so much of her early life in Germany, Stettheimer had developed a deep loathing for the German people and their culture. Although she admired a "pretty" artillery Lieutenant Forseter, her aversion to anything German is evident throughout her diaries. Her caustic remarks about friends, family, and the German people can be scathing. She observed of a room clerk and hotel manager in Munich that they "don't know their place, horribly German, we looked for rooms elsewhere." One morning in Germany she found herself unable to write in her diary because a German man refused to remove his hat when she entered the room, forcing her to leave and work elsewhere. Commenting on the audience attending a performance at the Künstler theater, she complained that they "smelt as usual, the way only a German unwashed audience can smell," and in another entry she stated, "A bath is still a luxury in Germany—in fact an acquired taste—oysters they are trying to master—but a bath is still a thing of the future." Stettheimer never voiced similar views on the French, Italian, or English cultures.

Not surprisingly, Stettheimer had particular contempt for the German word *Pflicht* or "duty," demonstrating a very twentieth-century attitude toward any kind of enforced authority. In the late nineteenth-century, *Pflicht* represented the ideal moral code of the German middle class, denoting that individual effort should be guided toward the public good, with personal restraint as the hallmark of respectability. In the wealthy German-Jewish families of New York and Europe, children were expected to have an attitude of *Pflicht und Arbeit* toward their parents, despite the irony that many of their parents, by virtue of their immigration, had themselves been rebels and risk-takers. Meanwhile, Florine was writing with characteristic rebelliousness:

Oh horrors
I hate Beethoven
And I was brought up
to revere him
adore him
oh horrors
I hate Beethoven
I am hearing the Fifth Symphony
Led by Stokowski
it's being done heroically

cheerfully pompous
Insistently infallible
It says assertively
Ja-Ja-Ja
Jawohl-Jawohl
Pflicht-Pflicht
Jawohl
Herrliche Pflicht
Deutsches Pflicht
Ja-Ja-Ja-Ja
and heads nod
In the German way
Devoutly affirmatively
Oh horrors
And now
Pianissimo
And firmly tender
So-So-So-So
Jaso-Jaso
Gut-Gut
And heads nod
In the German way
Piously ecstatic
Oh horrors
I hate Beethoven.[18]

Throughout her life, Stettheimer wrote short poems on various scraps of loose paper. The author's loathing for pretentiousness or "high cultural affect" of any kind (especially when touted by men) is apparent in her use of vernacular language, popular imagery, and firsthand experience.[19] The bald, seemingly simplistic structure of these poems, which after her death were edited and privately published by Ettie, reflects the same modernist sensibility as Stettheimer's mature paintings. Despite her relatively luxurious familial upbringing and evident personal snobbery, Stettheimer was attracted by vulgarity, flaunted artifice, and popular idioms; and all eventually found their way into what Linda Nochlin has termed the "Camp sensibility" of her painting and writing.[20]

Between 1900 and 1914, Stettheimer continued to travel with her family but often found herself caught between familial responsibilities and the struggle for privacy in which to paint. To combat this lack of creative time, whenever her family was in one place for any pe-

riod she rented a studio and took art lessons from local instructors. In Munich, Stettheimer worked with several instructors, including an art teacher she called "Herr Apotheker F." Under his guidance she explored the properties and techniques of working with casein, a method of painting by which a derivative of milk is used to create a chalky surface similar to fresco painting. This conversion of the natural into the artificial delighted her:

> *Casein was once milk*
> *And then it was cheese*
> *And now it is pictures*
> *How wonderful*
> *At noon came my "Meister"*
> *In white tie and tails*
> *To look at my work*
> *How wonderful*
> *Casein looks like fresco*
> *and Herr Apotheker F. said*
> *"red vill last foreffer"*
> *How vonterfool*
> *I shall paint the walls*
> *For tout New York*
> *On my return*
> *Most wonderful*[21]

Stettheimer eventually became dissatisfied with casein and desired a more brilliant medium to create depth in her paintings of laurel trees. Another of her instructors, Rafaello, invited her to visit him in his studio and view some of his "Proben," in which he was also trying to achieve warm depths. That evening she wrote in her diary, "I learned some important things from Schuster-Woldan's experiments. He [Rafaello] said that I was lucky to just step in and learn the results of ten years of hard work. So I went to Bruggers and got some Copal varnish and hope to get at those laurels tomorrow."[22]

Attractive men figure conspicuously in Stettheimer's diary during her final years in Europe. In Italy, while riding in a carriage in the amphitheater of the Borghese gardens, she was presented with red roses from two different men, but commented, "If they had been more picturesque looking it would be a very interesting souvenir!" While visiting Santa Maria Maggiore she reminisced, "Last time I was there I was flirting with Versack." Back in Munich, Stettheimer had tea with a former admirer and his wife. She observed that his "eyes glisten as of yore when they gaze upon me . . . he again told me the days of his youth and love for me were the happiest of his life—he is still a Schwein (schweinischer?) . . . his wife is housebound and tells pointless tasteless stories about her babies."[23]

In Europe, when in her early thirties, Stettheimer had a romantic interlude with James Loeb, son of Solomon Loeb, founder of a major New York banking house. The flirtation between the artist and the handsome scholar and esthete, who was an avid collector of Greek figures and rare books, lasted several years. As she remarked in one of her German diaries, "James Loeb spent a few hours with us in the afternoon. He looks so capable. He told me he had a statue cast in bronze—and he is going to build a house here—but he does not encourage modern art—I should like to see what he has contributed to it." Early in their flirtation, Stettheimer lunched with Loeb at the Continental in Munich and revealed her independent spirit and the importance she associated with being taken seriously as a professional artist: "I objected to being classed with the woman who is a mystery—I tried to make clear to him that she has become obsolete. He does not treat me en artiste [*sic*]. I am afraid he knows more faddists than artists. And still I was amused." She recorded several meetings with Loeb, from sharing a beer, to a visit to his house, which she decided "suits him, a good expression of his taste, his museum is very attractive."

In November 1913, when the Stettheimers boarded the *Amerika* for their journey back to New York, Florine was surprised to find a "distraction" on board in the form of Loeb. "He claims to have forgotten that I was to be aboard although I invited him to come on our steamer & thought he looked very pleased when I did!" Unfortunately, Ettie cut the following five pages out of the diary, and when Florine again mentions Loeb, some years later, it is without emotion. One of Stettheimer's poems describes a flirtation onboard ship and may provide clues to the remainder of the journey:

We flirted
In New York
On the Jersey Coast
In Paris
On the Riviera
In Munich
in the Engladine
For years and years
"I am sailing
for home on the Rotterdam."
"I am booked on the Majestic."
"Quel malheur!"
We flirted
On the Rotterdam
We passed the Narrows
Flirting

We passed the French Liberty
Flirting.
"Let's celebrate
this faithful
long flirtation
give a fête
invite many
They shall give us
Crystal things
Diamonds
Venetian glass
Perhaps
we could accept
Sapphires
Perhaps
We could build
a treasure house
all of glass."
His glasses
strangely
dulled.
His eyes
They became
An opaque barrier
on which
Our flirtation
Shattered
in a thousand
Splinters[24]

After this incident, most traces of romantic relations disappear from the diaries—at least from those pages that escaped Ettie's scissors. Stettheimer's attitude became, if anything, increasingly cynical over the years. Later in life she wrote a poem titled "J.L." (or "J.S."—the handwriting is ambiguous); it may refer to James Loeb and clearly manifests her changed, cynical attitude toward men:

He came to my studio
He had begged

"it's years since I've been
I'm crazy to see your paintings
I love to chat with you
I adore having tea with you."
He bores me
I let him come
I gave him tea
I did not chat
He did some chatting
Then suddenly I heard
"You have a superiority complex"
And I never knew it—
So it was funny after all.[25]

Romantic interludes during these years were not the only subject Ettie deleted from her sister's diaries. The location of the excisions indicates that whenever Florine became cranky or moody, Ettie removed the direct evidence, reinforcing for posterity the false impression that her sister was constitutionally shy and good-natured. In fact, she was often out of sorts and occasionally ill-tempered toward her family, particularly when they refused to "take risks" by visiting new places, or insisted on leaving a city and its art collections before she was ready to do so. Stettheimer often chafed against family routines. In one instance, instead of continuing a leisurely drive, she and Carrie were forced to return to dinner with the family, leading her to note: "Meals are ridiculous institutions—we are such slaves to them. We were not hungry and 20 minutes more on the Appian way would have given us enjoyment but we had to go to dinner." On the occasion of her birthday in 1909, Stettheimer and her sisters visited Aix-en-Provence in Aunt Lala's car. That evening they watched baccarat played at the Villa des Fleurs (Aunt Millie's birthday gift was a baccarat ticket), an activity which Stettheimer observed "would make a socialist of any human being with a mind." When she developed tonsillitis in Italy, she became irritated: "I am out of sorts, my counterpane is so dirty . . . and if I have the maid in to change it she will hang about and talk—and if I tell her I don't understand she will explain until I have to and Urbino is so near and I shall not see it—and in this place nothing ever happens or if it did, I can't imagine how it did. And I am reading a childish book by the 2 Marguerites. I don't know why it took two men to write it—unless they are grown together and have one brain between them [the rest was deleted by Ettie]."

Relations between the two sisters were not always amicable. In Munich in 1909, Florine painted a portrait of Ettie in which she characterized her younger sister as Medusa, the mythological Gorgon whose face and hair, made up of writhing snakes, were so ugly that

men went blind from the sight of her (fig. 17).[26] In the painting, Ettie is recognizable by her level gaze, unrelentingly straight, close brows, and critical expression. The painting is signed with the artist's initials intertwined in the form of a snake. In a later diary entry, she described being in a museum in Italy when a custodian pointed out that the object under her gaze was a Medusa, whereupon she told him in no uncertain terms that she was well acquainted with the subject.[27] After Florine's death, Ettie voiced surprise that there were not more critical comments from her sister that needed to be deleted: "In fact my critical sister criticized so little & exercised such discretion that I wonder whether she suspected that these entries might be read by others."[28]

European hotel accommodations and food were another source of continual irritation and discontent among the Stettheimer women. Like so many Americans of their class, they valued their creature comforts and regularly changed hotels before finding one they deemed satisfactory. Even so, except when visiting museums or at work in one of various studios she rented, Florine was often bored: "All we seem to do is have breakfast—then sit about for an hour or so because it is so cold and looks like rain again—if it isn't raining then go out and have lunch and come home after lunch and then it rains so we have to stay home."[29] Nonetheless, Rome held a warm, dry place in the artist's heart:

> *Rome with streets of palaces*
> *Villas and Roman baths*
> *Diplomats and savanti*
> *Archaeologists and galanti*
> *Litterati and padri*
> *Camellias and olive trees*
> *Battaglie de Fiori*
> *Music on the Pincio*
> *Magnolias and fireflies*
> *Dreaming in the Villa d'Este*
> *Having pearls put in my hair*
> *By a painter who proclaimed me*
> *Not unlike Pinturricchio damosels fair*[30]

On her arrival in the eternal city, Stettheimer changed into a white linen suit, in order to look less like a tourist, and ventured out, making note of the dignity and stateliness of the Roman people. Besides being the home of the Sistine Chapel, which she considered "the *most* marvelous thing ever created by an artist," the city also boasted fine accommodations, including an apartment with three bedrooms, bath, and parlor provided by a Mr. Haase, "the only person I know who has lived up to his ideals: he told me before he built this hotel that he

17. *Medusa* (1909), 22 x 14 in. Columbia University of the City of New York, Gift of the Estate of Ettie Stettheimer, 1967.

was going to make it fit for civilized women to live in."

Despite her lack of religious faith, Stettheimer was continually drawn to theatrical aspects of the traditional Roman Catholic service. While in Italy, she made numerous watercolor sketches recording the deep purple robes and prescribed actions of the priests during the ceremonies. In 1909, Florine attended a service in Santa Maria della Minerva, Bishop Ireland officiating, and with her characteristically cynical eye noted that the service did not go off without a hitch: an Italian prompter (or "master of ceremony") had to stand at the bishop's sleeve and remind him of his different moves. The artist later inserted similar "interpreters" into her costumes and scenery for the opera *Four Saints in Three Acts* and into her final painting.

Between 1906 and 1910, Rome and its surroundings served as the subject for a number of Stettheimer's sketches and paintings. The Italian countryside provided a varied topography, and Stettheimer conceived of "stacks of new landscapes." In between sightseeing with her family, shopping, and taking Italian lessons, she sketched. Among her favorite sites were the Villa d'Este, with its beautiful cypress trees, and the Villa Borghese, where she spent many weeks painting and sketching in the gardens. On one occasion she was joined by a French abbé, who feigned that he was lost in prayer as he wandered in back of the artist to get a glimpse of her sketches.

Italy's monumental landscape prompted Stettheimer to paint panoramic compositions. When traveling, however, she rarely had access to sufficiently large canvases. In order to overcome the small size of her sketchbooks, the

18. *The Poplars* (1909), 32 x 50 in. Columbia University of the City of New York, Gift of the Estate of Ettie Stettheimer, 1967.

artist covered facing pages of her notebooks with a single watercolor wash, over which she painted images ranging from huge gnarled trees to towns set in the Italian hills. During an Italian sojourn in 1909, Stettheimer painted a quietly evocative work titled *The Poplars*, in which a small faun sits gazing up toward the sky. The tiny figure hugs its knees and props its back against the trunk of a tree (fig. 18).[31] As a result of its composition, the painting resembles a theatrical stage set: its layering of cypress trees and its deep vista appear as though seen by a viewer seated in a high central box seat looking down upon a stage. Other paintings from these years, including brightly fauve-colored landscapes such as *The Fountain*, share many of the theatrical effects of *The Poplars*. They, too, are painted from high vistas and feature layered movement back in relatively shallow space. This device is facilitated by the dropped foreground, which allows easy entry into the compositions.

From 1900 to 1914, Stettheimer tried her hand at a variety of media, from colored crayons on paper to oil applied thickly with a palette knife on rough, unprimed canvas. Although she would later go through at least one "purge," destroying large quantities of these early works, Stettheimer's remaining sketchbooks and paintings show her working in a myriad of styles, from symbolism through pointillism, and demonstrate her use of diverse color palettes, from grisaille through fauve. Not all of these experiments were successful. A number of paintings from these years are heavy-handed and awkward in their execution. This may have been due in part to the disjointedness of the Stettheimers' lifestyle. Throughout her diaries from these years, she notes the effects of constant traveling on her ability to paint: "I am as unfit for hotel life as ever. . . . I have sketched very little—rain and cold"; "I think I could paint something if I lived up in more beautiful bare mountains for a while."

The few large paintings Stettheimer executed during these years were painted in her Munich studio, with its "beautifully white" rooms and long staircase that she speculated would keep her body "in form" to climb the steps of Notre-Dame Cathedral the next time she was in Paris:

Munich with its Carnival
Rosenkavalier Parzival
Künstler Feste Bals Parés
Satisfying my costume craze—
The gay youths had chic ways
And fortunately fantastic arrays
And I tried many a new painting medium
Which prevented any tedium[32]

During the same time that she was relentlessly working her way through a host of recent painting techniques and styles, Stettheimer continued to devour art and books about art. Several years after Florine's death, Ettie recalled that her sister had "begun to show her love and gift in early school days, and after she left school she attended art classes continually for many years, both here and abroad where she also traveled as extensively as possible to see European art. When finally she felt that she had got all she could from being trained and taught and 'shown,' she had her own studio here in New York where she spent practically all the hours of all her days working. Her evenings at our family home she spent reading. I think she must have read everything concerning art published in English, French, German up to that time."[33]

The common denominator in all of the artist's extant diaries is her continuous and single-minded interest in looking at art. Stettheimer was a highly opinionated, critical connoisseur, and she maintained a proprietary attitude toward the works she saw in her travels. Her views are generally well-based and knowledgeable, if occasionally irreverent. She assiduously recorded the revelations, from the Brueghels in Vienna's Kunsthistorisches Museum, which she found "awfully effective," to paintings Bernard Berenson attributed to Lorenzo Lotto, some of which she declared fakes. Stettheimer tended to classify everything she saw in art-historical terms. In Naples she termed gazelles from Herculaneum "quite German Secessionistic" and found the frescos "quite like Dietz." In essentially the same manner as so many privileged male artists before her, Stettheimer taught herself about art by constantly looking at and reexamining examples wherever and whenever she found them. Her eye and interests were highly eclectic and well tuned by decades of looking at the best work available in Europe's public collections.

Stettheimer regularly revisited her favorite galleries and works of art, and she collected and kept reproductions of an eclectic group of preferred paintings and statues, generally of nude men.[34] In Florence she found it a "joy" to again see Michelangelo's *David* and Botticelli's *Primavera*, but she could not refrain from offering her opinions on perceived failings: "David's proportions looked a little worse than ever to me today—I could not even imagine him placed high enough to get him right. . . . If he were only heavier and longer from his waist to his knees!" Stettheimer silently reproached the Uffizi for hanging Botticelli's golden-haired Venus against light-chocolate walls and mused that she would like to donate to the Uffizi a beautiful gold frame for the painting, with the proviso that the walls be painted white. Despite her deep admiration for the artist, she reserved a particularly scathing comment for the figure of Flora in *Primavera*, declaring that she is "too fat to move and has not any curves to her busts—she would have been greatly improved by a well developed under-arm curvature. That muscle is most attractive, why did he not see it—she certainly had it!"

Back in her studio in Munich, in December 1912, Stettheimer tried her hand at "im-

proving" Botticelli's fig-
ure (fig. 19). Stettheimer's
Flora, or *Spring*, is a par-
ody of Botticelli's paint-
ing, although she chose to
eliminate the seductively
rich color of the original
and instead limited her
painting to sepia, gray,
and white tones. The pose
of Stettheimer's figure em-
ulates that of the Italian
master in the position of
her right hand, the twist of
her body, and the forward
thrust and shape of her
right leg. In both works,
the figure stands amid a
landscape populated by

19. *Spring* (1907), 60 x 80 in. Columbia University of the City of New York, Gift of the Estate of Ettie Stettheimer, 1967.

small animals and varied flora, the landscape more closely resembling an elaborate carpet
than an actual meadow. Stettheimer's *Flora* is slimmer than its fifteenth-century counterpart,
but its pronounced waist and bosom lack the original's symbolic aura of fecundity. Stett-
heimer's figure, wearing a modern diaphanous dress, carefully arranged hair, and fashionable
high heels, is robbed of its essential, timeless impact. Florine recognized this a month and a
half later when she noted in her diary, "My Flora is kitsch." Nonetheless, the artist later in-
cluded the painting in her only solo exhibition, four years later.[35]

Botticelli's influence on Stettheimer's work extends beyond motifs and subject matter.
During one of their long sojourns in Munich, the Stettheimer family rented a light, spacious
apartment which they filled with Persian rugs, eclectic furniture with floral slipcovers, and
numerous fresh flower bouquets. Within the living room a small, framed reproduction of San-
dro Botticelli's *Venus* was prominently displayed on top of the wainscoting covering a stylized
column. English Pre-Raphaelite painters had revived Botticelli's work around 1867–71, res-
cuing his reputation from obscurity. Believing that the Italian artist represented a "primi-
tive," more feminine sensibility than his contemporaries, the Pre-Raphaelites widely dissem-
inated images of his work throughout Europe and the United States. Botticelli used strong,
dark outlines to accentuate details and create movement within his compositions, particularly
when constructing a figure's body or facial features. The English artist John Ruskin was

20. *Self-Portrait in front of Chinese Screen*, unstretched and awaiting restoration. Columbia University of the City of New York, Gift of the Estate of Ettie Stettheimer, 1967.

among the first to note that Botticelli's vision was centered in the outlines, and declared that he was "one of the greatest poets of line whom history records."[36] This use of thick contour lines had a long-lasting influence on Stettheimer's subsequent work.

A previously unknown self-portrait, painted sometime between 1912 and 1914, demonstrates her experimentation with the Italian fifteenth-century master's style (fig. 20).[37] Stettheimer portrayed herself with the attributes of the professional artist, thereby granting herself the same form of self-assertion as past artists from Vigée-Lebrun to Courbet. In the painting, the artist stands against a beautiful oriental screen embellished with exotic plumed birds. She wears a white smock and turban, which covers all but her front bangs. In her hands she holds three paintbrushes and a palette, and she looks up as though we, the viewers, are interrupting her work. The three-quarter turn of her face is characteristic of Botticelli; he used it repeatedly in his religious and mythological paintings and in his secular portraits.[38] Following the example of the Italian painter, Stettheimer during this period painted faces by applying surface shadow over a flattish white background to denote cheekbones and chin. Individual features such as the eyes, mouth, and nose are modeled in profile, using a dark line to outline each and set it off against the contrastingly light skin.

Botticelli's *Portrait of a Young Man with a Medal* shares both its mood and its manner of execution with Stettheimer's painting.[39] Like the Italian artist's unknown sitter, the artists's expression in her self-portrait is somewhat guarded, and her eyes and mouth are large and rounded. In both portraits the face is turned slightly to the right while the sitter's eyes gaze di-

rectly out at the viewer. A highly unusual feature of Botticelli's portrait is the insertion of a raised, gilded gesso medal between the sitter's hands. This is the only known Renaissance painting that features this device. Botticelli's use of it is particularly interesting in terms of Stettheimer's later work: in several of her mature paintings, she occasionally inserted a gilded gesso motif in relief against the flatly painted canvas.[40]

During 1912, Stettheimer spent the majority of her free time honing her critical opinions of the history of Western art.[41] The four Stettheimer women left New York on April 11 and sailed for Paris. Florine regularly visited museums, art exhibitions, and galleries, all the while making judgments and comparisons between paintings and daily life: "I have seen many things—Manets—very fine ones—his bar maid—a woman on a lounge resting her face on her hand—a face the way it looks when a hand it rests on draws it one-sided,[42] Berthe Morisot who is tame. . . . Cézannes that were interesting and Cézannes the kind that are swamping the market. Renoirs that are all woolly like the Cézannes that are too many. A marvelous Eve-Rodin's." Stettheimer found Monet's new Venice paintings "the most attractive things he has done so far."

After one of many visits to the Louvre, Stettheimer reacted ironically to the news that the Mona Lisa had been stolen: "I suppose if the general public realized the beauty of [Rembrandt's] *Henrickje Stoffels* she would disappear also. The light is very disagreeable in the Louvre. . . . I am not surprised somebody wanted to see *the Gioconda* in a becoming light." On another outing, she visited the Gustave Moreau Museum, where she was astonished at the amount of work Moreau had executed. She wondered "why he should have attempted large paintings he could not control. . . . Although they mostly have charm of either color or technique, not one in particular has remained with me as particularly beautiful excepting the copy of Carpaccio's *San Georgio*."[43]

After traveling to Biarritz in 1912, the Stettheimers ventured into Spain for the first time. The artist noted a Cistercian monastery complete with "poplars and daisies and little blue pinafored bodies with their priests and angora sheep and black-gowned Spanish women—it was all so pretty," and she painted an oil sketch to commemorate the image. When touring the cathedral, the sisters took turns speaking Spanish to their guides in order to determine whether the money they had spent on twenty Spanish lessons was worthwhile: "Ettie can even speak some, Carrie speaks Italian and I make expressive gestures."

Arriving at the Hotel Ritz in Madrid, Stettheimer immediately sought out the Prado Museum, where she was able to see, firsthand, works she had heretofore only seen in reproduction. "I have seen wonders," she wrote, "such Titians and Velasquez and a Guercino the kind I never knew he painted. . . . I can't remember when I saw so much that appealed to my sense of beauty. The Tintoretto portraits—and everything, yes everything except the miserable painting called a Leonardo Mona Lisa. They should throw her out or sell her to an American.

We met the Blumenthals in the Velasquez room—she has just been painted by Boldini and looks as nervous as his pictures."

In subsequent visits she noted, "There is no joie de vivre in Spanish art—no warm flesh adorned with gems, their earthly purgatory is really tragically felt and realistically depicted.—[However,] . . . the Titian *Venus* and *The Danae* are intoxicatingly beautiful." The one exception was the Spanish artist Velázquez, long one of Stettheimer's favorites. On seeing Velázquez's paintings in the Prado she raved. "To my surprise [*Las Meninas*] had the quality of realism attributed to it by those who write about it—no reproduction does it justice, it is more real than the spectators before it—and it has the silvery quality of atmosphere that it is supposed to have." On the other hand, viewing paintings by El Greco in Toledo, Stettheimer admitted, "I am not wildly excited over him—I can't see that he is a marvelous colorist—I do see intensity of sentiment and [that he] sacrificed almost everything to expression." She was not impressed by contemporary Spanish art, calling it "miserable." On the train back to Madrid, she wrote, "I am disgusted—we are going out of Spain tomorrow—Carrie coughs and mother is nervous—and none of the family came here with great enthusiasm—and in consequence no risks will be taken."

The artist's increasing self-possession is evident in an incident reflecting her ambivalent attitude toward religion and toward being Jewish in Europe. On May 26, 1912, en route to the shrine in Lourdes, she sat in a train compartment with a French lady, "with one of those mourning draperies suspended from her apex which the French seem to think de rigueur if anybody on a visiting list dies." The woman apparently

> made it her business to find out about my religious faith. I took pleasure in telling her I was not a Christian—in fact a Jewess—and she could not believe it—I was not "le type"—and was my mother a Jewess also—and were there other Jews in America. I told her all her Saints and her Sauveur and her Vierge were Jews—she did not believe it—and said the only one she knew was Judas Le Traitre Escariot! none of the other disciples. She chucked me under the chin! and said she would pray for a change of heart for me in Lourdes—I asked her how she would like me to pray for a change of heart for her in my church! I did not tell her I have never attended a service in that same church.

The Frenchwoman's remarks continued to bother Stettheimer, and sometime later, when visiting Versailles, she described the incident to a priest who "seemed to live there. . . . I wanted to know about the pious lady who only knew about Judas the traitor as the only Jew in the Bible—whether that was the usual religious teaching—I suggested it might be politics—he spoke well and was very fluent and assured me such ignorance was deplorable—I think he must be a Jesuit!" She later found out that the priest was in fact the bishop of Tours.

When she finally arrived in Lourdes, Stettheimer found it disappointing. She attended vespers at the church of the Rosary, hoping to see a "miracle." Instead, she found the famous grotto "disgustingly unsanitary." The high point of the trip came when the train first pulled up to the station and Stettheimer, looking out the window, saw a hill near the grotto covered with abandoned crutches and corset. Her reaction reveals her rapier wit and "liberated" self-image: "Someone left a corset behind—I should think lots of women would do that. I shed mine long ago—but never thought of donating it to anything."

Back in Paris, Stettheimer's attitude toward the art world was no less cynical. She attended an exhibition at Georges Petits, noting with irony that *"c'est delicieux* was applied to everything. . . . Boucher's very indecent young female exposing her charms was certainly called *delicieuse,* chairs were *delicieuse,* and Chardin's oyster still life was *delicieuse* which was quite appropriately expressed." With an increasingly prosperous middle class seeking new status symbols, the art market burgeoned. By the first decades of the twentieth century, the development of a substantial network of independent art dealers and collectors in Paris had rendered academic training and the official sanction of the Salon largely irrelevant. Culturally and economically, the main influences on contemporary art were the galleries and the auction market.[44] Stettheimer divided gallery-goers between "all sorts of people who looked as if there were no art in their lives—and others who were interested commercially," and she tended to view the influence of art dealers and the commercial market with a great deal of skepticism:

> *Cows*
> *Sheep*
> *Even chickens*
> *Hang*
> *In heavily gilt ornate frames*
> *On your*
> *Old rose*
> *Old gold*
> *Satin brocade walls*
> *You live*
> *Sedately*
> *Dignifiedly*
> *With your treasured*
> *Costly cattle portraits*
> *They replace*
> *Ancestors*
> *Even flowers*

Pompous
Bearded painters
Painted them
Pompous
Picture dealers
Sold them to you
In red plush sanctums
Cows
Sheep
Even pigs
Watch you
Sit
Satisfiedly
Dignifiedly
On gilt velvet tufted chairs[45]

In 1912, the sale of a painting by the French artist Henri Regnault received extensive newspaper coverage and attention.[46] While in Paris, Stettheimer visited the gallery where Regnault's painting was on view. She was taken aback, calling the painting "an abomination—I can't see how even the worst most ignorant collector could be taken in by it. I remember it as a piece of poor quality crude yellow satin (cotton backed) in a black frame—they must be mad." Given her appreciation of many Renaissance and contemporary nudes, Stettheimer's criticism of the painting was not based on its licentious subject matter as much as on its retardataire, academic painting style.[47] Its eventual sale did little to alter her cynical view of the commercial dealings of the art world, although she later noted the painting's high auction price in her diary.

In addition to the growth of the commercial art market, one of the main cultural tenets of the years before World War I was the notion of *Gesamtkunstwerk* or an integration of all the arts. This concept was popularized by the composer Richard Wagner as a fusion of high drama, music, and lyrics in the form of grand opera. It was also the underlying idea behind the Russian impresario Serge Diaghilev's newly formed Ballets Russes, which was to have a significant effect on Stettheimer's work.

It is difficult today to comprehend the metamorphosis which the first performances of the Ballet Russes wrought on the decorative arts in Europe and America. By the end of the nineteenth century, ballet in most of Europe had degenerated into a display of prettiness, with pleasantly controlled steps and attractive costumes. Stage design was not considered an art form but was a craft left to artisans. Diaghilev's goal with his Ballets Russes was to challenge and change

this by producing a *Gesamtkunstwerk*. He believed that opera fell short of being a "total art form" because of its overconcentration on words and its use of stationary positioning. Instead, he suggested that only ballet—by displaying the best of the arts, dance, music, and design— had the potential to act as the true *Gesamtkunstwerk*. To accomplish this synthesis, he gathered many of the most innovative artists of the time into his company. With its radically new incorporation of challenging design, brilliant color, bold costumes, energetic choreography, and modern music, the Ballets Russes captured the imagination of an entire generation. The young poet Rupert Brooke, after seeing the Russian ballet in 1912, declared that "they, if anything, can redeem our civilization. I'd give everything to be a ballet dancer."[48]

Over the next decades, the Ballets Russes influenced most of the arts, including literature, theater, interior decorating, and fashion. In Diaghilev's hands, art was not intended to imitate or teach; its purpose was to excite, provoke, inspire, and unlock experience. The Ballets Russes, in the interest of bridging the gap between popular and high culture, fostered an increasing appreciation of folk culture. This intermingling of the refined and the bawdy was one aspect of the Ballets Russes that Stettheimer internalized. Under the Ballets Russes' influence, the muted and mixed colors of fin-de-siècle taste were overwhelmed by a flood of pure bright color which almost immediately found itself the height of fashion. The Stettheimer sisters' favorite couturier, Paul Poiret, was one of many to introduce the Ballets Russes' violent colors and patterns into the clothes he designed.[49]

By the time she saw a performance of the Russian ballet, Stettheimer's aesthetic already included many of its

21. Baron Adolf de Meyer, *Nijinsky, as the Faun in L'Après-midi d'un Faune*. Photograph reproduced with permission from the Eakins Press Foundation. © Eakins Press Foundation.

basic concepts. Living, traveling, and studying abroad for thirty-five years had already exposed Stettheimer to a much wider range of influences than most other American artists. Nonetheless, the Ballets Russes had an immediate and formidable impact on all of her subsequent work. Its underlying ideation as an integrated art form was critical to the development of Stettheimer's mature aesthetic. It is to a large extent because she so fully absorbed this concept—of integrating forms rather than working within exclusive definitions of art—that her work is not immediately recognizable as "modernist" and does not resemble that of other painters working at the time.

Diaghilev opened the first season of his company in Paris with the ballet *Le Spectre de la Rose*, with Vaslav Nijinsky and Karsavina dancing. It was a huge success, and four new ballets were planned for 1912, including *L'Après-midi d'un faune*, choreographed and danced by Nijinsky. Not only was the style of dancing in *L'Après-midi* utterly new, but the subject matter was sexually explicit in a way no other ballet had been. The program notes—"A faun dozes. Nymphs tease him, a forgotten scarf satisfies his dream, the curtain descends so that the poem can begin in everyone's memory"—gave no indication of the provocative and incendiary nature of Nijinsky's ballet. Nijinsky interpreted Debussy's ballet score by breaking the rules of traditional classical ballet. As the faun, he executed his gestures flat-footed and in profile, through a series of angular, intentionally abstracted lateral movements. The effect was as if stylized images from the sides of ancient Greek vases had come to life. Nijinsky wore only coffee-colored leotards (considered improper at the time) with brown painted patches that overlapped his skin, producing the effect of merging the human and the animal into a mythical creature complete with horns, a short tail, and a garland of leaves around his hips (fig. 21).[50]

Nijinsky caused an uproar by ending the opera with the faun undulating his hips, as though simulating orgasm, over the abandoned scarf of the favored wood nymph. Gaston Calmette, editor of *Le Figaro*, refused to publish a review of the ballet. Instead, he wrote a front-page article calling the faun "lecherous" and his movements "filthy and bestial in their eroticism . . . whose gestures are as crude as they are indecent." He termed the production an "offense against good taste."[51] Not everyone inveighed against the ballet: the sculptor Auguste Rodin and the author Marcel Proust (both favored by Stettheimer) defended the work; Proust described how the "charming invasion" of the Ballets Russes "infected Paris with a fever of curiosity."[52]

Florine Stettheimer was similarly caught up in the excitement when she saw the performance on June 8, 1912, only ten days after its premiere. Her reaction was ecstatic: "I saw something beautiful last evening. The Russian Ballet *L'Apres midi d'un faune*. Nijinsky the Faun was marvelous—he seemed to be true half beast if not two-thirds, he was not a Greek faun, for he had not the insouciant smile of a follower of Diogenese [*sic*], he knew not

civilization—he was archaic so were the nymphs—he danced the *Dieu Bleu* and *The Rose* in which he was as graceful as a woman—and *Sheherazade*. He is the most wonderful male dancer I have seen—and I imagine the rest of the world has never seen better. . . . [Léon] Bakst the designer of costumes and painter is lucky to be so artistic and able to see his things executed."

Drawing on the Ballets Russes' concept of modernism as a culture of sensations and events, energy and fleeting moments, Stettheimer immediately began to design her own ballet. She titled the work *Orphée des Quat'z-Arts* and spent several years planning the sets, costumes, and libretto. She set the ballet in modern Paris, emphasizing the theatricality of the city's daily routines as the street life shifted from hour to hour. The introduction of electric lamps along the Champs Elysées and the Place de la Concorde had turned Paris into a city of lights and had extended its night life well into the morning. Every evening, as the sun went down, crowds of fiacres—horse-drawn cabs for hire—their polished lamps shining, jammed the streets. Outdoor street cafés filled with people watching others promenade along the Champs Elysées, while in the Latin Quarter, young artists and art students gathered for theoretical disputes about color and form.[53]

Later, remembering this period of her life, Stettheimer wrote:

> *Paris—living in the Latin Quarter*
> *And flanéing in the Bois*
> *Going to staid dinner parties*
> *In Callot gowns chez moi*
> *Rather bored by my painting master*
> *Rather charmed by a blonde Vicomte*
> *Approving of French tools*
> *Also of French art*
> *Thrilled by the Russian Ballet*
> *And cakes made by Rebattet*
> *Liking Marquis chocolate*
> *and petit pois à la française*[54]

Stettheimer began writing the libretto for *Orphée* in fluent French, changing it to English in subsequent drafts. The ballet is crucial to Stettheimer's development, as the artist's later painting style grew directly out of the ballet's notion of performance as a progression in time with no apparent goal, a narrative not oriented toward any final resolution. Like Diaghilev, Stettheimer conceived of her work as a *Gesamtkunstwerk* or "choreographed drama." In shedding inherited, traditional form and perceiving existence as continuously varying relations instead of as absolutes, the ballet was a precursor of cultural modernism.[55] In *Orphée*, as

22. Costume design for the artist's ballet "Orphée of the Quat'z Arts," n.d. Gouache, metallic paint, pencil, 9¼ x 15 in. The Museum of Modern Art, New York. Gift of Miss Ettie Stettheimer. Photograph © 1995 The Museum of Modern Art, New York.

in her mature paintings, Stettheimer's figures move across space in seemingly random but carefully choreographed figural "chains." All of the elements of the ballet—the characters, setting, libretto, and actions—work together (fig. 22).

The final draft of the ballet's libretto reads:

It is a starlit mid-spring night. . . . Behind the great trees on the right of the stage are seen the lights of the restaurant "Les ambassadeurs."[56] *. . . From the left an apache and his girl come on fooling and playing. A short dispute, whether to stay or go on follows, which ends in their sitting on a bench on the roadside under a tree immobile in close embrace.*

The last couple now rise from their table and depart. . . . The night becomes quiet and dark . . . suddenly the quiet is dispelled by music and a wild rush of revelers, artists and models coming straight from the quartz-arts ball . . . Orpheus with his charmed lyre leads the procession . . . nymphs, fauns, satyrs, bacchantes . . . take up the dance and it becomes a wild bacchanalia . . . the cortege is composed of animals . . . artists and models impersonating gods and animals charmed . . . by Orpheus' music. First Eurydice and her snake 2) Aphrodite on dolphin drawn by a wave, 3) Adonis on boar drawn by worshippers 4) Leda and swan drawn . . . 5) Francis of Assisi and his beasts 6) Ariadne on her panther with Dyonisis [sic] 7) Andromache & Dragon & Perseus, 8) Mme de Mondaircon & Unicorn & two swans 9) Diana on her stag—drawn by night.

. . . Eurydice does a snake dance and the Apache fascinated draws near and dances with her. A fiacre drives up from the left in which M. Dupetit and his daughter Georgette are seated, homeward bound from a ball. . . . They are waylaid by the revelers. . . . Orpheus hands Georgette out of the fiacre, her father follows . . . gradually the music forces her to rhythmic dancing which becomes bacchanalian—while dancing . . . her gown is removed and the artists drape her in some of their glittering things and bedeck her with flowers. Orpheus and Georgette dance, M. Dupetit

dances a grotesque dance in which the models join him. Just as the sun begins to rise Mars appears on a white and gold charger . . . Georgette is helped with her wrap and lifted into the fiacre followed by M. Dupetit . . . they depart off right . . . Orpheus and his revelers . . . dance off toward the arc de triomphe . . . a girl, with a pushcart full of spring flower blossoms comes along, stops and looks after the revelers shading her eyes with her hand.—La fin.[57]

Stettheimer appropriated the theme for her theatrical production from actual incidents that took place in Paris in the 1890s. Aside from its modernist tendency and radical design, the ballet reveals that by 1912 Stettheimer was already chronicling contemporary history and painting modern life. For centuries the various guilds in Paris had celebrated an annual carnival. Only the arts guilds had no organized festivities. To correct this, in 1890 the students at the Ecole des Beaux-Arts met with members of the four artists' guilds (painting, sculpture, architecture, and literature) and decided to hold an annual ball arranged by a committee of representatives from the Ecole des Beaux-Arts, the Latin Quarter, and "guests." The first ball, held at the Moulin Rouge in Montmartre, aroused enormous excitement. In the early hours of the morning, crowds of masked participants surged out into the streets and made their way home past Parisians hurrying to work.

The Bal des Quat'z-Arts continued for several years; the main attraction was the huge floats, on which costumed artists and models mimed various themes. As one participant recalled, in 1893 the theme was Cleopatra's court: "On a platform borne by Egyptian slaves Cleopatra lay surrounded by a group of girls forming a beautiful *tableau vivant.*" They were all models whose bodies we knew by heart so that their clothing, or lack of it, was of very little importance. But a certain senator, M. Beranger, Pere-la-Pudeur as we called him, took it in his head that the public had been scandalized by these naked bodies from the Bal des Quat'z-Arts and put the whole ball committee into the dock."[58]

The incident at the 1893 ball had serious repercussions. A French court produced witnesses to testify that the Bal was a menace to public morals, including a key witness, La Goulue, a star of the Moulin Rouge, who decried the moral depravity of the youthful artists. The court pronounced a severe fine of one hundred francs on the students and their models, none of whom could afford to pay it. In response, on July 2, 1893, the students organized a protest. The students held further demonstrations on July 3 and 4, and the government ordered out detachments of police. Skirmishes developed, and soon the entire Latin Quarter was up in arms. Students overturned buses, set them on fire, and looted shops. A heavy metal object thrown from the sidelines killed a twenty-year-old student named Antonin Nuger, who rapidly became a martyr for the cause.

As an artist living and working in Paris, Stettheimer was undoubtedly aware of the his-

23. *Orpheus*, studies in pencil, Yale Collection of American Literature, Beinecke Rare Book and Manuscript Library, Yale University.

tory of the Bal des Quat'z Arts when she chose it as the theme for her ballet. Her personal and emotional allegiance to the artists shows throughout the story line, particularly in the figure of Georgette, who, as Florine herself must have wished to do, moves with ease between the disparate worlds of society and bohemia. When introduced, Georgette wears an elaborately designed and fitted coat. Later, when she joins the wild revelries of the artists, they transform her clothing into a diaphanous layered sheath, and for a while she becomes one of them. Eventually, as in her own reality, Stettheimer returns Georgette to the safety and comfort of her father's carriage. Even so, there is no moralizing in her story—and no clear outcome or conclusion. In effect, *Orpheus* is about transience of time, of revelry, and of dance. The description of the dances outlined in the libretto indicates that, like Diaghilev's productions, Stettheimer intended the choreography to be unclassical, unexpected, and very modern.

Stettheimer completed her final sketches and three-dimensional models for the ballet over several years. She spent hours in libraries in New York and Paris researching mythology and Greek life and customs (fig. 23).[59] Eventually she painted more than forty watercolors in which she designed the costumes and "animal floats" for each of the ballet's characters. From a number of the watercolors, the artist also made a series of related bas-reliefs. Using a wide variety of materials, she re-created figural arrangements within large pieces of framed cardboard. For Georgette's entrance costume, for example, she designed an embroidered coat trimmed with fur. On the figure of Eurydice, thin green straps over her breasts attach to a pearl-studded halter around her waist; her gold scarf and harem pants are covered with tiny, hand-strung golden beads. In another relief study, the figure of Venus sits on a dolphin constructed of plaster gesso overlaid with tooled silver foil. A figure with green skin with a thin skein of cellophane dances nearby. This very early use of cellophane in stage costume and design presages the use Stett-

24. Costume designs for the artist's ballet "Orphée of the Quat'z Arts," n.d. Oil lace, beads and sil-
ver foil sewed and pinned to canvas, 17 x 24⅞ in.; oil, putty, cloth and cellophane on wood, 16⅞ x
25 in. The Museum of Modern Art, New York. Gift of Miss Ettie Stettheimer. Photograph © 1995.
The Museum of Modern Art, New York.

heimer made of transparent material twenty-two years later in her designs for *Four Saints in Three Acts* (fig. 24).

Stettheimer based the main characters in *Orpheus* on two of the principal Ballets Russes dancers, Nijinsky and Adolphe Bolm. She modeled several three-dimensional wire and plaster figures after the two men, giving them specific roles in her ballet. For the figure of Mars, for example, Stettheimer designated Bolm as her model. The figure is covered with bright red paint and wears tooled metal armor, including a breastplate bearing a detailed head of Medusa and shin guards. Stettheimer also made a three-dimensional model of the white horse on which Mars rides to welcome the dawn. The face and graceful gestures of a third, green-skinned figure wearing a purple veil echo the distinctive features of Nijinsky.

The *Orpheus* ballet represents Stettheimer's first overt steps toward abandoning academic training and formulating her own unique style.[60] It was four years before anyone outside of the family saw her designs for *Orpheus*. Nonetheless, the artist's conception and ballet designs represent a turning point in her work. As a result of the ballet, related issues of performance and audience became deeply ingrained in Stettheimer's aesthetic sensibilities and can be seen throughout her ensuing work. The theatrical device enabled her to explore a variety of materials and modes of art-making foreign to her past fine-art training. If Stettheimer had continued in this mode, she may have achieved notice as a "modernist" designer far sooner than as a painter. At this point, however, she was still differentiating between the style she used in her furniture and theatrical designs and that of her paintings. It would be several years before she would allow herself to incorporate into her paintings the fine, fluid, quirky contours and characterizations evident in her ballet drawings. Instead, she concurrently executed largely traditional landscapes and figural paintings.

During the remainder of 1912–13, the Stettheimer women continued to travel and live abroad. Florine's caustic humor found various outlets. Upon viewing the work of a German artist named Hess she wrote, "He approaches all his subjects with apparently the same feeling—be it a jug, an orange, a plucked chicken or his wife's portrait. I think I detected a trifle more sentiment in the case of the plucked chicken." She described the house that the family rented in the hills of Florence as "a Swiss chalet—a horror—not only in idea is it monstrous—but in reality also—and the family is going to rent it—I suggest goats & cows with Swiss bells attached grazing in the garden." She painted sporadically, beginning a full-length portrait of Ettie in a black Japanese coat (now lost or destroyed). Carrie, meanwhile, took music lessons "at inconvenient hours."

Now finding herself "much more worldly wise," Stettheimer was nonetheless increasingly restless. While the Giottos in Santa Croce were "a delight forever," even the Ghirlandaios failed to provide their usual pleasure, and her first viewing of an airplane proved disappointing because she had already seen one on the cinema screen. She spent the

majority of her travel time visiting museums in Italy, France, and Germany, and she collected reproductions of works that pleased her, such as Daumier's *In the Theater* and a Goya still-life, which were found loosely inserted in her diary of 1913 along with reproductions of several works by Van Gogh. Attending an exhibition of flower paintings by Van Gogh, she found the works a "very great surprise and very attractive." Stettheimer also visited an exhibition of self-portraits by contemporary artists at the Uffizi, which was rather depressing, as it reminded her that she was neglecting her own painting. Instead, she filled her days by buying Venetian paintings with gold and white frames, taking photographs, and collecting *vues d'optiques* of exotic sites in Egypt, China, and the Dardanelles,[61] all the while complaining that she was not painting and had no place to paint. When the family returned to their "Swiss chalet," she purchased supplies and proceeded to execute several paintings of the monumental cypress trees that dotted the Italian landscape. She took great umbrage when a former German admirer claimed that she lacked the *lust* (joy) to be a true artist. She quickly retorted, "That time never was."

In March 1913, before Lent, the Stettheimer women attended the Fasching festivals in Germany. Florine enigmatically noted in her diary, "This carnival has been the means of revealing much," indicating again her interest in the theatrical aspects of popular culture. At concerts the Stettheimer sisters took a theater box with Irene Guggenheim, but Florine was not particularly moved by the lieder, and noted, "Our German bringing up is wearing off." By winter the Stettheimers were living in Paris, where Florine had an operation on her eyelid, dieted, attended the Salon d'Automne, took tango teas at the Olympia Hotel, and read voraciously.[62]

In spring of the next year, Florine and Rosetta went to Mardi Gras in Paris, where the artist declared, "The French throw confetti more lavishly than the Germans." At the same time, Ettie and Carrie visited Carnival in Mu-

25. Photograph of Florine, Carrie, and Ettie Stettheimer, ca. 1914, photographic collage. The background is a commercial postcard view of Berne, Switzerland. Formerly in the collection of Kirk Askew, Jr. Present location unknown.

nich. The women wrote to each other almost daily. When war broke out in mid-summer, the Stettheimer women were marooned in Bern, Switzerland, and cut off from their usual haunts (fig. 25). In September, Florine fell ill, and she wrote to Benjamin Tuska, her lawyer in New York, asking him to amend her will. In the letter she declared her past will, in which she had requested that her paintings be buried alongside her body, "too fantastic." Now she stated that she wished to give them to her mother, Carrie, and Ettie so they "might sell them if they wish, but I request them not to give any of them away." It is ironic that this request is the opposite of her final wishes and what ultimately happened to the works.[63]

A reporter later observed that the war had taken its toll on Stettheimer and had a major impact on her work. Stettheimer, the reporter noted, was horrified by the plight of refugees pouring into Switzerland, and she "discovered that between her and the past a wall of memory had been reared. . . . Another personality asserted itself—a personality to which the past and its ways was abhorrent. It sought the immediate, the untouched; it expressed itself in these strange, gay, fluent forms. . . . They are not realistic—they release the emotions aroused in the artist's mind by things she sees about her. They express what she feels, and in painting them, she has the happiness of one delivered from bondage."[64]

Escaping from impending war, Stettheimer left a number of her works and clothes in storage at the Hotel Wagram in Paris and was only able to recover them seven years later. In 1914, at age forty-three, she returned with her family to New York determined to create new "American" work.

3

Return to New York

There comes a point when the accumulation of an increasing skill in the mere representation begins to destroy the expressiveness of the design, and . . . the artist becomes uneasy. He begins to try to unload, to simplify the drawing or painting by which natural objects are evoked, in order to recover the lost expressiveness and life. He aims at synthesis in design . . . he is prepared to subordinate consciously his power of representing the part of his picture as plausibly as possible, to the expressiveness of the whole design.—Roger Fry, in his and Desmond McCarthy's Manet and Post-Impressionism *(1910)*

I n 1914 Stettheimer, her two sisters, and her mother sailed past the Statue of Liberty into the port of New York City. Florine later wrote a poem describing her return to New York. The poem's intermingling of noises, colors, and movements reflects an evocative, sensory, and empirical (rather than factual) report—a weave of sights, sounds, and visual spectacles that resembles a Bergsonian theatrical performance produced by Diaghilev:

New York
At last grown young
with noise
and color
and light
and jazz
dance marathons and poultry shows
soulsavings and rodeos
gabfests and beauty contests
sky towers and bridal bowers
speakeasy bars and motor cars
columnists and movie stars.[1]

One day while living in Paris in 1912, Stettheimer and her sister Ettie went to the Collège de France to hear Henri Bergson deliver a lecture. (For some reason, Bergson was unable to appear, and the lecture was canceled.) Stettheimer was already familiar with the philosopher's theories, although his fame was not to reach America for another year. Bergson was considered the most authoritative spokesman of the so-called new vitalism and, for a brief time, was one of the most influential thinkers in the world. He espoused a modernized practical idealism by declaring that evolution was both creative and unpredictable, and that organisms played a major role in their own fate. Reality, according to Bergson, was to be found in the phenomena of movement and change, and he conceived of life as "a continuity of flowing." Similarly, his view of time was as an experience of duration, rather than a succession of isolated moments. For many artists, including Stettheimer, Bergson's theories represented an alternative to academic illusionism as taught in the past. Instead, they fostered a search for equivalents that would express the intangible aspects of life.[2]

Bergsonian concepts increasingly found their way into Stettheimer's painting style after 1914, as memory, subjectivity, and temporality formed the content of much of her work. For Bergson, consciousness defined itself through momentary vision, intuition, memory, and personal idiosyncrasy.[3] Life consisted of essential sensations of being and change, a stream of consciousness he termed *la durée,* which connoted the rational activity of the mind and its simultaneous sensing of the past, present, and future: "Let us seek, in the depths of our experience, the point where we feel ourselves most intimately within our own life. It is into pure *durée* that we then plunge back, a duration in which the past, always moving on, is swelling increasingly with a present that is absolutely new."[4] These ideas found resonance with what Stettheimer had learned from the Ballets Russes, with its denial of linear narrative and the use of integrated design to evoke emotional reactions and richly overlapping layers of information.

Five years after their return to New York, Stettheimer also captured the experience in a painting titled *New York* (fig. 26), which she originally intended to commemorate President Woodrow Wilson's visit to the International Peace Conference in Paris. The painting includes a small figure of Wilson on the deck of a destroyer at the lower right corner. Even though the work ostensibly records a contemporary event, its overall mood is more personal and generalized than this reading implies. Instead, the painting, which bears the alternate title *Liberty,* is the visual equivalent of Stettheimer's experience and emotions on returning to her native land. It can be read as an acknowledgment of the "liberation" she felt in exchanging the strict disciplines and academic tendencies of her past for a new life.

The painting is an homage to New York's past and future. At the bottom, the city's seal, bearing its name and the date of the painting, is surmounted by an American eagle. Traditional renditions of a Dutch sailor and a Native American with feathered headdress stand on either side of the plaque, symbolizing the mixed ethnic origins of the city. The distorted per-

spective and scale of the composition give the impression that the viewer is onboard the destroyer sailing into the harbor. The high-relief rendition of the Statue of Liberty (recalling the gilded plaster coin inserted into Botticelli's *Portrait*) stands prominently on the left side of the painting. The statue serves as a monumental marker of boundaries between cultures and eras, "the spot where America begins and the authority of the Old World holds no sway."[5] The painting's color palette reinforces the "American" nature of its subject. With the exception of the gilded statues of Liberty and George Washington and the Courthouse dome, Stettheimer limited her palette to red and blue against a white background. The flat, neutral gray shape of the destroyer at right is partially covered by a large, billowing American flag. The extraordinary frame, surmounted by the large, three-dimensional gilded wooden eagle, is made of turned wood and is also painted red, white, and blue.

New York offers an interesting mixture of the old and the new. The artist pictured the Manhattan skyline as a melange of traditional and modern architecture, from the Greek Revival–style courthouse, with its diminutive statue of George Washington, to the towering skyscrapers of lower Fifth and Park avenues. As usual, the artist took liberties with details, moving buildings and areas of the city around to create what she saw as the most interesting composition. A mixture of technologies is also apparent in the various forms of transportation she chose to include in the painting. Several flag-bedecked destroyers skirt the tip of the island, while the Staten Island Ferry can be seen either entering or leaving its terminal at the right. In the center of the painting, a small paddle boat crosses in front of figures promenading along the boardwalk. On either side, the sky contains varied means of flight, including a dirigible at

26. *New York/Liberty* (1918), 60 x 40 in. Collection of William Kelly Simpson.

the right, a hot air balloon in the center, and a propellered biplane that soars upward at the left.

Stettheimer never again left the United States, except for a short vacation to Canada many years later. When she returned to New York, the artist was a mature woman whose mind was filled with four decades of European life, culture, and art, but who lacked a sure sense of past and future accomplishment. For Stettheimer, New York not only signified a returning "home" but also offered a fresh beginning, an opportunity to shed everything she had learned and tolerated for the first forty years of her life and to begin again. The New York of her childhood, with its rigid rules of proper conduct and confining atmosphere, had itself altered almost beyond recognition:

> *Then back to New York*
> *And skytowers had begun to grow*
> *And front stoop houses started to go*
> *And life became quite different*
> *And it was as tho' someone had planted seeds*
> *And people sprouted like common weeds*
> *And seemed unaware of accepted things*
> *And out of it grew an amusing thing*
> *Which I think is America having its fling*
> *And what I should like is to paint this thing.*[6]

In her desire to create a new art to reflect this "thing," Stettheimer searched for visual equivalents. Initially, she drew on her knowledge of the recent decorative sensibilities, colors, and techniques used by modern European artists.[7] Among the many events that had taken place over the last decade, few were more influential in advancing American's awareness of contemporary "post-impressionist" art than the International Exhibition of Modern Art, or Armory Show, that opened on February 5, 1913, at the Sixty-ninth Regiment Armory Building.[8] The American public, used to viewing Ash Can School paintings as modern, was suddenly faced with examples of every variety of contemporary European art—fauvism, expressionism, primitivism, cubism—as well as works by artists exploring increasingly abstract styles.[9]

In March 1913, Stettheimer's diary records her living in Germany, and there is no evidence that she visited New York earlier in the year or attended the Armory Show. Given her constant monitoring of the art world, however, there is little doubt that she was aware of the exhibition and its after-effects. What is important to note is that the works in the exhibition, although they appeared radically new and even frightening to an American audience, were already familiar to Stettheimer because of her many years seeking out and attending contemporary art exhibitions across Europe. For two decades before the Armory Show had its impact

on many of her American colleagues, Stettheimer had already explored and experimented with many contemporary European styles.[10]

Post-impressionism offered artists such as Stettheimer the possibility of spontaneity, pure color, simplified forms, coherent structure, and spatial ambiguity. Unlike preceding art movements, post-impressionist work was synthetic. Its emphasis was on paint surface, rhythmic application of brushstrokes, flat arrangements of pure color and simplified forms often resembling ornamental patterns. The resulting works complemented the theories of Henri Bergson and were encouraged by the popularity and widespread influence of other theoreticians, such as William James and Arthur Wesley Dow.[11] Like many European and American artists searching for a new visual language, around 1915 Stettheimer began shaping an independent path by taking post-impressionist artists such as Henri Matisse as her guide.

Sometime during the years 1909–11, while living in Europe, Stettheimer executed a brilliantly colored series of pointillist paintings. The works closely resemble Henri Matisse's well-known *Luxe, calme et volupté*, painted five years earlier. In both artists' works, a group of enigmatic, nude women gather by a wooded body of water in the late afternoon, forming a *paysage décoratif*, or decorative landscape. As Gil Perry has observed, in this context the adjective *décoratif* signified a "schematic or abstracted image, and could be connected with concepts of the *barbare* or *naïf*, whether these terms were being used pejoratively or as a measure of the innovatory status of the work."[12]

Like Matisse, Stettheimer appropriated aspects of the pointillist technique to capture the effects of changing sunlight on the surfaces of trees, water, and skin. In Matisse's painting, the sun has passed below the horizon, and it re-

27. *Landscape #2*, 30 x 26 in. Columbia University of the City of New York, Gift of the Estate of Ettie Stettheimer, 1967.

flects back on the scene the jeweled colors of dusk. In Stettheimer's version, the artist chose a much softer palette: the sun has moved well below the horizon, and it casts long purple shadows against the grass and the figures' bodies. The purples and soft yellows are heightened by intermittent dashes of pure red (fig. 27). Matisse's technique in *Luxe, calme et volupté* demonstrates his experimentation with neo-impressionist techniques; unlike true pointillism, however, his dashes of color occasionally follow distinct contour lines and do not all lie in the same direction.

Nonetheless, as Jack Flam noted, the "shimmering halo-like neo-impressionist light" created by using the pointillist technique gave Matisse's work a surreal and enigmatic atmosphere.[13] Stettheimer attempted to capture this same mood, but she was unwilling or unable to dissolve the underlying structure of her works. She retained even stronger contour lines than Matisse, and her dashes and dots of pure color are added on top of the painted surfaces of the trees rather than directly against the primed canvas.[14]

28. *Flowers #6*, 30 x 36 in. The Dayton Art Institute, Gift of the Estate of Ettie Stettheimer.

Stettheimer had many opportunities in Europe to become familiar with works by Matisse.[15] In 1904 Matisse's first one-person show opened at Ambroise Vollard's Gallery in Paris, showing forty-five paintings and one drawing. That same year Matisse sent fourteen paintings and two sculptures to the Salon d'Automne. In 1908 (the year Ettie received her Ph.D. from the University of Freiberg) Stettheimer was living in Paris when Matisse entered his *Harmony in Blue* in the Salon d'Automne.[16] Meanwhile, in New York, two exhibitions of Matisse's work were presented at Alfred Stieglitz's 291 Gallery on Fifth Avenue. In 1910 Stettheimer wrote in her diary that all sorts of new directions in art had appeared, and that "some followers of Matisse are exhibiting canvases in frames with their names on them. They are idiotic." This aside demonstrates not only Stettheimer's knowledge of Matisse's work but also her awareness of his influence.

Once in New York, Stettheimer began a series of floral still lifes in which she actively emulated various of Matisse's styles

29. *Flowers with Aphrodite*, 32 x 32 in. Columbia University of the City of New York, Gift of the Estate of Ettie Stettheimer, 1967.

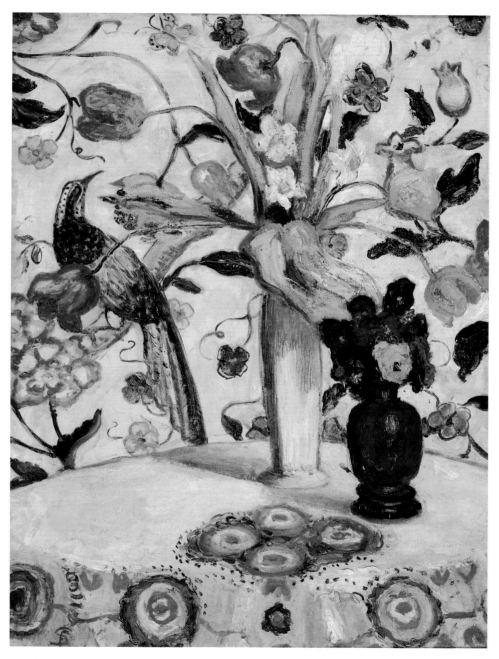

30. *Flowers Against Wallpaper* (1915), 40$^{1}/_{2}$ x 30$^{5}/_{8}$ in. Memphis Brooks Museum of Art; Memphis, TN; Gift of the Estate of Miss Ettie Stettheimer, 60.21.

and techniques. In them she explores surface textures and lighting, alternating between plac-
ing objects against a white or dark, almost black, backdrop. Stettheimer often covered the
ground of these paintings with a thick china-white paint over which she laid pigment directly
from the tube. Although finding these works somewhat lacking in form, one critic later noted
that Stettheimer "believed that, with such colors as red, blue and yellow at her disposal, there
is no reason why she should treat life as if it were all neutral brown or neutral gray. White is
white, black is black and red is red."[17] Stettheimer's flower paintings manifest an evolution
away from naturalism. A number of the paintings represent fairly traditional still lifes, with a
grouping of disparate objects arranged on a tabletop viewed from a single, high vantage point.
In most cases, however, as in many of Matisse's earlier still lifes, the tabletop tilts down or ex-
tends beyond the lower edge of the canvas, offering the viewer a seamless entry into the
painting.

In several of her still lifes Stettheimer placed female figures among floral bouquets, a
device Matisse used several times in works of 1906 (Yale University Art Gallery) and 1908
(Pushkin Museum, Moscow). In one of Stettheimer's paintings a small bronze figurine bal-
ances on one leg between two vases filled with flowers on a white covered table (fig. 28). In
another work, a figure of Aphrodite stands on a table covered with a gold-fringed white table-
cloth set against a black background (fig. 29). Aphrodite's pose, with one hand covering her
genitals and another across her breasts, dates from classical antiquity. The pose was well
known to Stettheimer from the Hellenistic *Venus de Medici* statue and Botticelli's *Venus* from
the Uffizi Gallery. Stettheimer's representation, however, is subtly different from traditional
depictions, in which the figure's gestures serve to emphasize rather than to conceal her sex.
Her Aphrodite is awkwardly posed, as though trying to conceal her body from prying eyes.[18]

The curtain hanging to the left of the *Aphrodite* still life was a motif Stettheimer used
in a number of paintings from this period. In one work, Stettheimer's wallpaper fills the upper
two-thirds of the canvas; its colors and patterns are echoed on the adjoining
embroidered tablecloth (fig. 30).[19] The objects and the surrounding space interpenetrate each
other. By creating an interdenominative space where objects and surfaces imperceptibly
blend, Stettheimer, like Matisse, gives equal importance to the tactile and the visible, invest-
ing both with expressive meaning.

From 1914 to 1916, Stettheimer painted numerous floral still lifes, a subject she re-
turned to repeatedly throughout her career. The focus was less on the individual blossoms
than on the overall arrangement: explosions of color spilled out of a variety of vases on table-
tops with adjacent long-plumed parrots, bronze figurines, Japanese prints, and horses.[20]
Florine was never literal in her painted descriptions of flowers; they were intended for con-
templation. She called her painted bouquets "eyegays," a word she invented to emphasize
that her flowers were not for the nose but for the eye. In these paintings, as the art critic
Henry McBride later described them, the blossoms "wiggle upward with a whimsicality in the

stems that is not to be outmatched for waywardness in the 'automatic' paintings of Miro" (fig. 31).[21] Unlike many of her contemporaries, who were painting flowers for their symbolic associations, Florine did not intend her painted flower arrangements to be metaphors; they stood only for what they were. In a later poem titled "The Revolt of the Violet" she noted:

This is a vulgar age
Sighed the violet
Why must humans drag us
Into their silly lives
They treat us
As attributes
As symbols
And make us
Fade—
Stink.[22]

31. *Shallow Bowl/Flowers #3, against Blue Green,* Collection High Museum of Art, Atlanta; Gift of the Estate of Miss Ettie Stettheimer, 56.106.

Soon after arriving in New York, Stettheimer moved with her sisters and mother into her aunt Caroline's brownstone on West Seventy-sixth Street. By that time, German-Jewish migration to the Upper West Side of Manhattan (particularly between Seventieth and Eightieth streets, Central Park West, and Columbus Avenue) had caused that part of the city to be nicknamed the "Jewish Fifth Avenue." Friends later remembered the Stettheimers' dining room as being painted a warm, pale gray with gold molding on the panels, Venetian red taffeta draperies, and red brocade upholstery, "like a room in a royal palace." The focal point of the vast room was Florine's mural painting *Flora.*[23] The room also contained the artist's rococo-style screen with the relief figures of the Stettheimer siblings. When the family entertained, Stettheimer created magnificent floral arrangements, turning each into compositions her friends remember as being "comparable to paintings by Van Huysum or by Florine herself":[24]

All morning
for hours
I have been putting flowers
together
in vases
I strip them of their green
They look more brilliant
become more effective
more "garish" our former timid interior
decorator Mr. B. would have said.

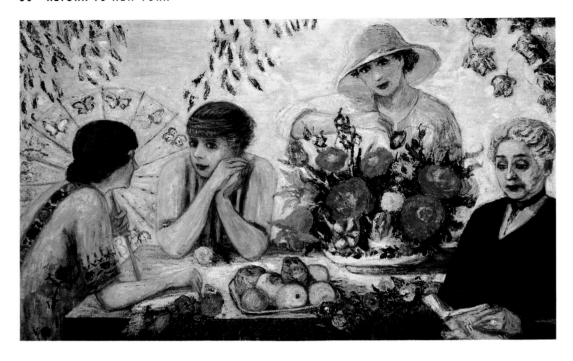

32. *Family Portrait Number 1* (1915), 40 x 60 in. Columbia University of the City of New York, Gift of the Estate of Ettie Stettheimer, 1967.

33. *Portrait of André Brook*, back view, Columbia University of the City of New York, Gift of the Estate of Ettie Stettheimer, 1967.

34. *Portrait of André Brook*, front view (1915), 28 x 34 in. Columbia University of the City of New York, Gift of the Estate of Ettie Stettheimer, 1967.

The bouquet I like best
I put on the dining room table
On the filet lace round
On the light gray painted boards
It helps—it satisfies
But tomorrow
my flowers
will show the ravages of time
They will wither
They will smell
I will have a disgust for them
I shall dislike changing the water
and I shall feel sympathy
with Marcel [Duchamp]
for preferring
imitation flowers.[25]

When the family was in Manhattan, Stettheimer purchased flowers daily to make arrangements. Once the family began renting summer estates, she rose at seven in the morning and devoted hours to raising her favorite varieties of flowers. She would "cater to their requirements with shears, trowel and watering pot. She preferred flowers that bloomed in many colors, such as zinnias, petunias and portulacas, all of which she grew in rainbow profusion."[26] Stettheimer gradually added portraits to her painted "eyegays." Initially, these were only peripheral additions, but by

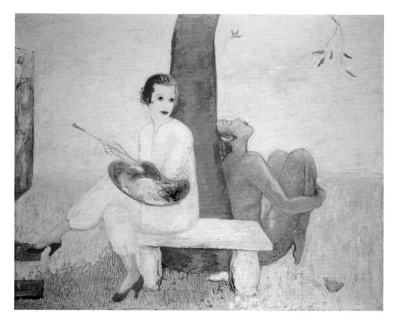

35. *Painter and Faun*, 60 x 72 in. Columbia University of the City of New York, Gift of the Estate of Ettie Stettheimer, 1967.

1915–16 she progressively slipped from flower painting to portraiture.

Stettheimer began her series of portraits by painting family members. In 1915 she painted *Family Portrait No. 1* (fig. 32). In it, she depicted her family as it would remain for the next twenty years—herself, her two youngest sisters, and her mother. Within a shallow painted white ground, the artist pictured the four women situated like a decorative frieze around a cloth-covered table bearing a bowl of Cézannesque fruit. Rosetta, dressed in a characteristically black gown and wearing a neck choker and a prominent diamond ring, sits at the far right of the composition, reading a copy of her daughter Ettie's recently completed book, *Philosophy*.[27] Florine, wearing a broad-brimmed sun hat to protect her face from the sun, pauses from adjusting a magnificent flower arrangement to glance out at the viewer. Ettie and Carrie engage in discussion at the left.

In the same year Stettheimer emulated an early American folk tradition by painting front and back "portraits" of the Revolutionary-period summer estate, located in Tarrytown, that the four women rented for several summers. The painting of the house's back view centers on multilayered formal gardens with abundant flower beds, ivy-covered trellises, central fountain, and two elongated trees, one on either side of the small stream running through the center of the painting (fig. 33). Stettheimer used this garden as the setting for a number of later works. In the front view of André Brook, with its vast circular drive (fig. 34), Stettheimer included the figures of her two sisters at the right. On the left she placed her mother, in black, and herself, in a painting costume of white smock, gathered harem pants, and sun hat. The artist pictured herself in the act of stepping back to view a canvas (with a view of André Brook) which is set on an easel and angled toward the house. This device offers viewers a sense of voyeurism—as though we are seeing the painting of the painting that we are viewing.

During this period Florine painted another self-portrait, again wearing her "work uniform" of harem pants, smock, and high heels (fig. 35). Holding a long paintbrush and palette, she sits on a white bench by a tree trunk against which an orange-skinned faun rests, draping his arms around his knees. The faun recalls Nijinsky's performance in the role Stettheimer admired in Paris, and it replicates the pose of the small faun seated leaning against a tree in her earlier *Poplars* painting. As in *Poplars*, Stettheimer uses the faun to symbolize some private reverie or association. In the portrait, all dark outlines are eliminated, and the colors are highly keyed with large expanses of yellow, white, and red. Even the figures are outlined in bright colors. The only dark color in the painting is used to depict the artist's eyes, a feature Stettheimer would accentuate in all her self-portraits. Her hair is nasturtium red, with streaks of orange, and the artist carved into the paint of the hairline with the back of her brush.[28] Stettheimer continued to depict herself as a thirty-five- or forty-year-old professional artist, with even features and reddish-brown hair, until the end of her life.

At this time Stettheimer also painted several figural works, including one titled

Jenny and Genevieve, in which an unidentified woman sits, her elbows propped on a table crowded with objects. An expanse of brightly colored floral wallpaper extends vertically and horizontally across the background, limiting the depth of the picture plane. An African-American woman in uniform enters at the left, carrying a plate of fruit. The motif of female servant carrying fruit into a brightly patterned room is reminiscent of Matisse's 1908 painting *Harmony in Red.* In both works, the maidservants hold dishes filled with oranges, apples, and grapes. In addition, both servants blend into the decorative design of the background walls. Matisse alleviated the flatness of his foreground and background by placing a window with a landscape view at the left. Sometime after 1916, Stettheimer similarly altered her work to increase the depth of her composition (fig. 36). She further reemphasized the "uniform" aspects of Jenny's dress, changing it from a dark to a light color and heightening the stiff white scalloped collar and matching apron pocket. The artist also added a cigarette to the forefront of the small table on which the figure of Genevieve leans, sulking. The cigarette, a sign of autonomy, furthers the painting's mood of modern dissipation.[29]

The motif of a woman servant bearing gifts also recalls Edward Manet's 1863 painting *Olympia,* which caused a scandal when exhibited at the 1865 Salon in Paris. Stettheimer greatly admired Manet's work, and she borrowed motifs and compositions from the French artist throughout the next decade. The similarities between Manet's *Olympia* and Stettheimer's *Jenny and Genevieve* do not, at first, appear to extend beyond the fact that both have black female servants and white mistresses, but there are other, albeit subtle, resemblances between the two works. In each, the artist exploits the formal effects of the servant's rich dark skin against the lighter fabric of backdrop and dress. Both of the black women stand mutely, in passive postures, while the pose and demeanor of the central redheaded white women suggests that they are waiting for a man to approach.

The importance Stettheimer accorded Manet's *Olympia* is even more apparent in another, startling work that she painted around 1916 but never publicly exhibited (fig. 37). The painting displays an almost life-size, red-headed nude who props her head up with one hand while holding a bouquet of fresh flowers with the other. She gazes directly out at the viewer and reclines on a bed with an embroidered ivy-patterned cover indented by the weight of her hips. A gold beaded necklace lies at the lower edge of her pillow. The composition of the painting is quite shallow because of gathered drapery that hangs directly behind the bed and encircles it on all sides. The painting is Stettheimer's response to *Olympia.* In both works, a red-haired nude with legs crossed at the ankles reclines on a white bed covered with a fringed shawl. Both paintings are complex and contradictory, and reflect a conscious skepticism on the part of their makers of "the ways that likeness is normally secured."[30]

For centuries the nude as a subject in art has been the site for construction of sexual difference. The polarization of gender roles in Western thought was first codified by Aristotle,

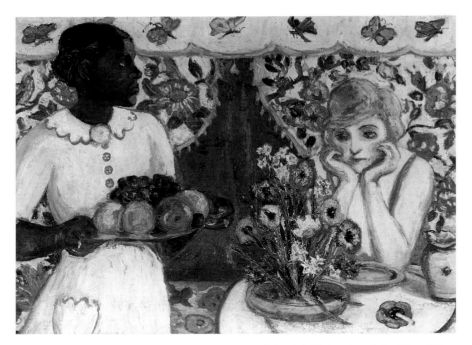

36. *Jenny and Genevieve*, late version, 32 x 42 in. Columbia University of the City of New York, Gift of the Estate of Ettie Stettheimer, 1967.

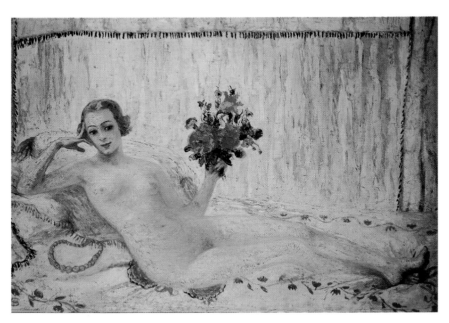

37. Nude *Self-Portrait* (ca. 1915–16), 47 x 67 in. Columbia University of the City of New York, Gift of the Estate of Ettie Stettheimer, 1967.

who stated, "Man is active, full of movement, creative in politics, business and culture. The male shapes and molds society and the world. Woman, on the other hand, is passive. She stays at home as is her nature. She is matter waiting to be formed and molded by the active male principle."[31] This concept has been widely followed through the centuries by artists such as Titian, a reproduction of whose painting of Venus and Cupid was among Stettheimer's private papers. The term *nude*, unless qualified, is generally taken to mean a nude *female* who is placed in a provocative pose to accentuate and passively display her physical attributes for the delectation of male viewers. In most examples of the genre, the nude, whether painted or sculpted, was created by male artists as the focus of male sexuality. Florine was clearly aware of this implication when she composed the following poem:

> *Must one have models*
> *must one have models forever*
> *nude ones*
> *draped ones*
> *costumed ones*
> *"The Blue Hat"*
> *"The Yellow Shawl"*
> *"The Patent Leather Slippers"*
> *Possibly men painters really*
> *need them—they created them.*[32]

Traditionally, the nude has had little purpose other than as an erotic subject for male consumption. As John Berger observed, the male spectator, the principal protagonist in most European paintings, is never painted, yet everything in the painting is addressed to him and his voyeuristic sense of power and control over the image.[33] With few exceptions, the male artist has traditionally constructed the female nude as the perfect, pliable partner: passive, receptive, and available. To emphasize this, artists often depict the woman with her eyes closed as though sleeping and either oblivious to the male gaze or unwilling to take any responsibility for it. Occasionally, in paintings such as Goya's *Maja Desnuda* (which Stettheimer found "very piquant looking"), the sitter does not avert or close her eyes but glances out at the implied male viewer, suggesting a disconcerting receptivity to and collusion with his gaze.[34]

When Manet's painting was first publicly exhibited, it was Olympia's arrogant gaze, normally a prerogative of the male viewer, combined with her alert pose, that scandalized French audiences and critics, who called the painting "impure" and "bestial." In fact, Manet's painting, like those by Goya and Stettheimer, is one of the rare depictions of the female nude as an integrated human being. Many art historians have pointed to certain features of the painting as showing that Manet represented *Olympia* as a prostitute, whose physical at-

tributes are literally for sale and will be more freely available once payment has been made. Her bold gaze is therefore a willful, daring invitation intended to challenge the brave male spectator to step forward and sample her half-hidden wares.

Nudes in art are usually shown with ample hips turned slightly forward and their left legs crossed at the knees in a "presentation" pose contrived to display their breasts, pelvic area, and legs to best advantage. The left hand of Titian's *Venus of Urbino* crosses over her belly, and her fingers curl inward as though stroking her pubis. Manet's *Olympia* splays her left hand against her right thigh in a manner that coyly obscures her genital area from view. In contrast, Stettheimer's nude holds a bouquet in her left hand, at the exact center of the composition, directly above her fully exposed red pubic hair. With her head slightly cocked to the left, her expression suggests that viewers choose between the two colorful options.

Typically, painters of nudes emphasize body parts as a sign of sexual availability and use various accessories and props within the composition to reinforce this idea. The frequent inclusion in such paintings of a curtain hints at actions normally hidden from view, and the rich material settings and jewelry surrounding the nude suggest a form of slavery by implying that the woman in the image is figuratively "owned" by the viewer. Stettheimer acknowledges this tradition in her painting by including a curtained bed, gold necklace, and flower bouquet. At the same time, however, her painting pointedly lacks specifics—the flower in the nude's hair, the "tied" black neck ribbon, the easily slipped-off shoe, the black cat, and the black maidservant displaying an admirer's bouquet—that help to establish Manet's sitter as available for hire.

Instead, in a move so audacious even her friends failed to recognize it, Stettheimer's painting is a self-portrait, painted when the artist was around forty-five years old.[35] The likeness can be seen by comparing the painting with a contemporary photograph and other contemporary self-portraits of the artist (fig. 38). In each, Stettheimer's face has the same distinguishing features, including bobbed hair, an oval shape with a high forehead and somewhat weak, pointed chin, large brown eyes, and a long nose (figs. 39–42).

38. Florine Stettheimer, ca. 1917–1920. Florine Stettheimer Papers, Rare Book and Manuscript Library, Columbia University.

39. Detail from Nude *Self-Portrait* (ca. 1915–1916), Columbia University of the City of New York, Gift of the Estate of Ettie Stettheimer, 1967.

40. Detail from *Family Portrait Number 1* (1915), Columbia University of the City of New York, Gift of the Estate of Ettie Stettheimer, 1967.

41. Detail from *Painter and Faun*, Columbia University of the City of New York, Gift of the Estate of Ettie Stettheimer, 1967.

42. Detail from *Soirée* (1917–19), Yale Collection of American Literature, Beinecke Rare Book and Manuscript Library, Yale University.

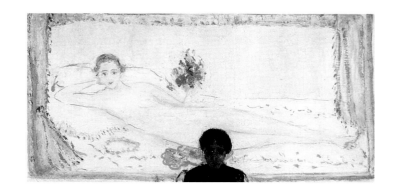

In constructing a nude, an artist traditionally negotiates a subtle relationship between specificity and generality, including details of the body to provoke and arouse the male viewer and generalizing areas in which the sitter's individuality is too apparent. As a result, in most depictions of the nude the sitter's hands and face are hidden or dealt with generically.[36] The opposite is true in Stettheimer's nude self-portrait. Here the artist reserved her most detailed treatment for rendering the subject's hands, feet, and face. She painted the curiously unsensuous body cursorily, with vague, light strokes. In a manner subtly different from the challenging stare of Manet's *Olympia*, Stettheimer's facial expression in her nude is knowing and quizzical as though she is taunting the viewer to recognize her characteristic facial features above a rather sexless, but nonetheless nude, body. It is as if Stettheimer consciously turned herself into an object of sight in order to visibly record consciousness of the gap between ideology and experience and to challenge conventions of the nude.

Moreover, by emphasizing her facial features and causing her eyes to meet and hold those of the viewer, Stettheimer's nude controls the spectator's perception of her body. She is in possession of the gaze rather than being the object of it. The artist thereby creates a tension between expectations of what it is to be a woman, as mythologized visually by the genre, and the reality of female experience. The individuality of the image and its refusal to compromise with notions of age and ideal form makes her nude the site for visualizing the varied experience of existence as an attractive, middle-aged woman. The body itself, although treated with less detail than the extremities, could be Stettheimer's, with its small breasts and slender legs. Through its handling, Stettheimer's painted nude body appears less available to a voyeuristic gaze than those of her predecessors, and more an acknowledgment of woman's experience of her own body, an exaltation in the reality of being female.

The artist was proud of her slim body. She compared it to that of the Australian champion swimmer and outspoken feminist Annette Kellerman, who established the precedent of linking feminine beauty with athletic ability. Kellerman modeled skin-tight dark underwear for American women's magazines and designed a one-piece bathing suit intended to allow greater freedom in swimming. Her attire caused her to be arrested in 1917 for indecent exposure on a Massachusetts beach.[37] Kellerman wrote a popular beauty manual in which she spoke of women's enslavement as man's "toy" and emphasized the need for women to pay attention to their physical appearance so that they would not "grow fat at forty" or "shrivel up at fifty" and lose their husbands to younger women. Stettheimer's awareness of the eventual lessening of a woman's value as a commodity in a man's eyes is apparent in a poem she titled "Civilizers of the World":

> *They like a woman*
> *to have a mind.*
> *They are of*
> *Greater*
> *interest they*
> *find.*
> *They are not*
> *very young,*
> *women of that*
> *kind.*[38]

The artist's physical identification with Kellerman diminished after a dinner date when she and an artist friend went to the cinema and saw the swimmer in a starring role. Stettheimer's reaction was typically caustic: "I shall no longer say I think I am shaped somewhat like Annette Kellerman. Having nothing on, it was easy to judge her looks." Nonetheless,

Stettheimer's depiction of herself as a recumbent nude implies not only an ironic deprecation of a widely accepted genre but also a blatant differentiation by the artist between the self she shows to others and her "true" self. This enigmatic distinction is a highly modern concept.[39] As with Georgette, her surrogate in the early *Orpheus* ballet, Stettheimer's self-portrait as Olympia consciously places her in an ambiguous context. She is neither working artist's model nor courtesan. Her social class is unclear, as is her objective. In reality, Stettheimer, like Georgette, was a member of the upper middle class; yet as evidenced by her paintings and her poetry, she believed that her true self was invisible to those who knew her. Over time, she learned to play on others' blindness and her own invisibility in creating her best work.

During the summer of 1916, after a flurry of packing and organizing the servants, the Stettheimer women set out on their "first auto trip in [our] own auto in our own country." The artist remarked on the unusualness of a journey where luncheon was a mere incident and not the entire reason for their outing. On June 22, driven by their chauffeur Richard, the women began their New York state tour. They stopped at various sites before arriving in Saratoga, which Stettheimer wrote had "heaps of character." From Lake George, they continued north toward Lower Saranac. During the drive Stettheimer dreamed of living in a cobalt-blue room with dull walls and ceiling, complete with small, cream oyster-white silk curtains with gold fringes. She made small sketches of what the room would look like in her diary. Arriving at Camp Massapequa, Stettheimer found it "a very perfect camp according to the accepted idea of a camp," for it had piled logs, a menagerie of stuffed birds, beasts, bear skins, moose heads and fish, a stone fireplace, a Victrola, various "weapons," Native American rugs, electric lights, brass utensils, cows, and a frisky calf.

Nonetheless, restless at not being able to paint, Stettheimer grew increasingly annoyed with the camp: "Atmosphere is not to be found—I have waited for it for two days . . . we made the round of the lake in our fastest launch yesterday—we have eaten homemade bread—and still this camp does not produce it. I want to get to work—there is nothing in this vacation, so far it all bores me—and I see boredom ahead. As soon as I got here I chose the most uncamplike room for mine. It is painted white, has white furniture and a bright pink rug.—I hung some Japanese prints on the walls I brought from my room at 102 [West 76th Street in Manhattan]." Eventually, with Richard's help, she made one room into a working studio with furniture and a wood-burning stove. In addition to displaying Japanese prints, the artist strung unbleached muslin curtains from wall to wall, put out flowers, and hung designs she had made earlier for her ballet *Orphée des Quat'z-Arts*. As a result, she found the studio quite comfortable and was no longer bored with the lake visit, "at least not since I got to work." The alterations are a further example of Stettheimer's inclination to transform environments to suit her personal aesthetic. She continually conceived of her work as part of an ensemble of harmonious design. The basic

44. Carrie Walter Stettheimer, *Art Works in the Stettheimer Doll House*, Artists: upper row, left to right: (.39) Marguerite Zorach, (.34) Claggett Wilson, (.38) Gaston Lachaise, (.36) Louis Bouché, (.37) Gela Archipenko; lower row, left to right: (.31) Alexander Archipenko, (.32) Albert Gleizes, (.30) Carl Sprinchorn, (.33) Albert Gleizes, (.35) "Nude Descending Staircase," by Marcel Duchamp; Albaster Statuette by Gaston Lachaise in foreground. Museum of the City of New York, 45.125.30–39, .43.

43. Carrie Walter Stettheimer, *Stettheimer Doll House*, ca. 1920 (façade lifted to show front rooms), Museum of the City of New York, 45.125.1, Gift of Miss Ettie Stettheimer, Photo: Helga Studio.

elements of her aesthetic—white or cobalt-blue walls, gold trim, and diaphanous materials—appear again and again in her mature interior decorations and stage designs.

Florine was not alone among the Stettheimer sisters in using interior space as a site for her aesthetic experiments. During the Stettheimers' 1916 stay at Lower Saranac, an epidemic of infantile paralysis broke out. Women in the adjoining camps organized a bazaar to raise funds to combat the disease. Florine's sister Carrie gathered a number of wooden boxes from the local grocer and created a dollhouse with "an enchanting set of rooms . . . out of whatever she did get." Carrie was inspired by the idea of creating a work that was valuable and at the same time contributed to a worthy cause. As a result of this experience she began a second, more extensive dollhouse. Adding to it occupied her free time for the rest of her life (figs. 43–44).[40]

In September, after spending a forty-fifth birthday "full of flowers" by the lakeside, Florine prepared to return to New York, noting, "I am going off by myself for the first time in my life." Although she had visited Manhattan at least one other time during the summer, she was always accompanied by her mother or Carrie. Now enjoying her solitude, she slept in her studio overlooking Bryant Park and compared the view from the long balcony window to that of the Tuileries in France. The artist reveled in city life, where her weekly activities included taking

French lessons from a young French artist, Marcel Duchamp, who had arrived in New York aboard the SS *Rochambeau* on June 15, 1915. The Stettheimer sisters were very taken with Duchamp. Before one of the lessons Florine commented in her diary, "It's Duchamp day."[41]

Stettheimer also spent various evenings dining with Avery Hopwood, her older sister Stella, Stella's son Harry, and their aunt Caroline Neustadter. The only cloud on the horizon was learning that Stella's oldest son, Walter, had passed the physical examination for the army and would soon be joining the troops in Europe. His aunt noted hopefully, "They don't think it will be France." There is little extant information detailing how the Stettheimer sisters viewed the war. Throughout 1916, Ettie wrote to Henri Gans, a French soldier she had known before the hostilities began. Her letters indicate that she supported the Allies, and she attended social gatherings at the home of her relative, George Beer, which was a center for Allied supporters.[42] There is no information on Florine's reactions to the war, but Carrie, with characteristic generosity, rolled bandages for the Red Cross.

The primary reason for Stettheimer's return to Manhattan was anticipation of having her first one-person exhibition at Knoedler & Company, a major New York gallery.[43] During the 1900s, Knoedler's had twice held exhibitions of work by the artist Albert Sterner. Some time around 1915 they hired his wife, Marie, to curate a series of contemporary exhibitions that would give the gallery a reputation of being up-to-date and offer a site "wherein those artists working in less thoroughly explored fields may show the results of their labors to a partially won if somewhat skeptical audience."[44] Stettheimer was among the people Sterner contacted to offer an exhibition at Knoedler's. On returning to New York from Lower Saranac, the artist called Sterner to confirm whether her exhibition remained on schedule for October: "I asked Marie whether Roland Knoedler the owner of the concern knew he was exhibiting me—that thought came to me when we were framing the invite in his name. 'Dear me no' was the answer, 'they will all have fits when they see the paintings,' I asked if he would not perhaps close the ex. if he felt that way—she said 'no.'"

Stettheimer visited the gallery and was introduced to the owner, Roland Knoedler, by Sterner, who announced that she was about to exhibit Stettheimer's paintings. He responded cursorily and proceeded to discuss the recent death of a valued customer. Stettheimer's reaction was mixed. On the one hand she was delighted at the prospect of having an exhibition, and on the other she was somewhat put out by the gallery owner's lack of interest in her work: "He permitted it!! and took no interest as if we were two children and might as well amuse ourselves . . . possibly he thinks nobody will see the show. . . . It's certainly of no importance to them whether I have an X [exhibition] or not."

Her family's reaction was somewhat better, although it did not reflect a particularly strong belief in the quality or reception of the work. Ettie, always the pragmatist, wrote in her diary that she was delighted that Florine was having the exhibition: "Even if the critique is

adverse in part, it's bound to do her good indirectly and some people will surely like her work." She wrote a letter to her sister suggesting that Marie Sterner bring critics to the Stettheimer show from the Howard Gardiner Cushing exhibition, which would be on view concurrently at Knoedler's.

Stettheimer's excitement over the upcoming exhibition was augmented by the prospect of actually having her ballet, *Orphée des Quat'z-Arts,* produced by the Ballets Russes. In September she received a letter by special delivery from a Ballets Russes member, Adolphe Bolm, who was performing at the Booth Theater the following Monday. Stettheimer immediately ordered six tickets and notified her sisters of the event. On October 4 she contacted her lawyer, Mr. Tuska, and arranged for him to bring Bolm to her studio so that she might show the dancer her sketches and ideas for *Orphée.* In preparation, the artist unpacked the ballet designs and figures and decided to use the empty storage case as a stage on which to pantomime the work for her visitor. She painted the interior of the case cobalt blue and added a white and gold fringed curtain, a green floor, and an electric lighting arrangement to effectively illuminate the miniature "stage." When the dancer and lawyer arrived, Stettheimer informed them that the ballet was based on the incidents that had taken place around the Bal des Quat'z-Arts in Paris. Bolm gleefully informed her that he had been one of the evening's revelers and himself had plunged into the fountain at the Place de la Concorde on one such occasion.

Bolm was impressed with "the grotesqueness" of Stettheimer's designs for the ballet, which he called "grand theater." While discussing the production of *Orphée,* he periodically got up and danced to illustrate his ideas, and he invited the artist to attend rehearsals of the current Ballets Russes productions. Bolm was somewhat disappointed that the title role was "effeminate," a sign that it had been written for his fellow dancer, Nijinsky. Stettheimer quickly reassured Bolm that she would create another, more appropriate role for him. At the end of the evening Bolm agreed to produce the ballet if they could find the right composer. He mentioned the French composer Duclos, but as it would take too long to contact him, he suggested instead Leo Orinstein. Stettheimer was jubilant: "He is going to look him [the composer] over, it seems quite too good to be true."[45]

After the meeting, Stettheimer impatiently called Tuska and asked whether he thought the presentation had been a success. The lawyer reassured her that Bolm liked the ballet, "understood" the artist's intentions, and felt they could work well together. He then suggested to Stettheimer that she popularize her ballet by bringing in the war at the climax of the frivolity. Stettheimer's reaction was caustic: "I see his point, it would possibly popularize it, and positively make it inartistic. My composing the ballet was a means of getting away from the War like the way the Greeks invented their gay mythology to make life possible for their melancholy dispositions according to Nietzsche." Meanwhile, from the Adirondack camp, Ettie was wistfully fantasizing about which role in the ballet she might fill: "maybe Europa or the Apache!"

Even though she was in the midst of preparations for the Knoedler exhibition and exploring the possibility of having her ballet produced, Stettheimer had occasional bouts of depression. "I am so tired—I am all alone again. . . . I am living a quiet life—no body seems anxious to play any role in it." She spent time making certain her paintings were properly stretched and framed for the exhibition, and orga-

45. *Morning/White Curtain*, revised version, 32 x 36 in. Boston Athenaeum.

nizing her furniture and belongings for a move to another studio. As her things were being moved—by three upholsterers, two porters, four electricians, her housekeeper Miss Sheridan, and Rose, her maid—Avery Hopwood called, and Stettheimer abandoned the move and ran off with him for a noon drive. The two then boarded the 5:12 train to Long Branch to see a production of one of his plays. Afterward, Hopwood continued with Stettheimer to Irene Guggenheim's house, where they had dinner. She remained for the weekend, soaking in the ocean and summer breezes.

As the date for the Knoedler exhibition neared, Stettheimer decided to decorate the gallery rooms to replicate her own rooms where the paintings usually hung. She wanted the gallery rooms to appear intimate, as though viewers stepped from the street into the salon of a private home. She felt compelled to present her paintings as part of an integrated environment, as she believed that an appropriate context was crucial to viewing her work. She had the walls covered with white muslin material, and on one wall she added a cellophane fringed canopy similar to the bed she designed in her bedroom in the family's apartment. Working with four maintenance men, Stettheimer "rehearsed" the gallery lighting to ensure that it complemented the installation.

On October 10 the artist attended the opera and then returned to her studio at the

Beaux Arts Building for a party. Among those attending were Isadora Duncan, who danced with the society sculptor Prince Troubetskoy and the photographer Arnold Genthe. The next day, at Adolphe Bolm's invitation, Stettheimer attended a rehearsal for a production of *Sadko,* and she had the paintings in her exhibition photographed by the professional photographer Peter Juley. Two days before the official opening, she visited the gallery and had an uneasy reaction: "My pictures are hanging at Knoedlers—I am very unhappy—and I don't think I deserve to be. I thought I might feel happier after dinner—but I have had dinner." The morning of the opening on October 16, Stettheimer stopped in early to "see if the floor was swept & the drapery folds not too untidy." While there she ran into Roland Knoedler, who pointed out that the paintings were not numbered and had no prices listed. Stettheimer and her nephew Harry quickly wrote out tags for each work. Knoedler then mentioned that he liked her work and that the gallery "need[ed] modern paintings." The exhibition's first public visitor was Eugene Seligman, and Stettheimer noted sarcastically that as soon as Knoedler realized that Stettheimer was related to the Seligmans, he treated her with much more respect.

The Knoedler exhibition included twelve Stettheimer paintings, described by a critic from *American Art News* as "oils in which flowers, young and elderly women and a country mansion figure. A somewhat effective allegorical canvas is called *Spring*."[46] In addition to the grisaille *Spring,* which received the most favorable critical attention, the artist included both versions of *André Brook* and her paintings *Family Portrait, Jenny and Genevieve, Morning* (fig. 45), and *Still Life with Aphrodite.* She also showed five floral still lifes, but not her nude *Self-Portrait.* Instead she limited the exhibition to works with a high-keyed palette and more decorative ambiance. One reviewer, from the *New York Evening Post,* unkindly compared Stettheimer's work to the way "an orchestra sounds when all the instruments are playing independently," but continued, "Miss Stettheimer's work is not nearly as crude as this comparison would imply. Her work, while lacking form, is courageous and straightforward, and if her independent beliefs develop into an abiding faith, her next exhibition will show a proportionate advance." The critic for the *Evening Mail* noted that the "paintings are properly secluded in one of the upper rooms in Knoedler's where the glare of publicity is not too strong for their modest art constitutions."

Not all of the reviews were so unfavorable. One referred to her as an exponent of modernity who "does not care who knows it,"[47] while on October 21, 1916, a reviewer for the *American Art News* stated that the artist "wields a vigorous brush, has good color sense and a supreme disregard for local truth. . . . The figures . . . are agreeably handled, but curiously colored." The *New York Times* critic, whose review was titled "Clever Paintings," described the work as being "very modern as to color, not without weakness in construction and design, and filled with a pleasant sense of humor and fantasy." The article went on to describe the gallery as "beautifully hung to make the most of the brilliant color schemes against a warm, white background with ample spacing," and Stettheimer's *Family Portrait* as "a cheerful

mingling of portraiture and generalization, a pleasant picture to have about in an unsentimental home."[48] The most positive review was by Frederick Eddy for the *World*: "An exhibition in the Knoedler's galleries . . . reveals Miss Florine Stettheimer as a versatile and pleasing painter. Most of the work is done with a bold, confident brush, in which color contrasts are emphasized in floral pieces, bits of landscape and figure groups. The chief attraction of the display is a panel painting of *Spring*. . . . The panel might have had fitting place as a fresco on the walls of a Louis XVI chateau. Its setting within a frame shows to rare advantage the artist's inventive skill."

Stettheimer wrote remarkably little about the exhibition in her diary. She stopped in at the gallery every day and noted that, according to the elevator man, quite a few people had been in to see the exhibition. In spite of this, Stettheimer speculated that the visitors must have been friends of the family, because "only one party asked to see the price list." Her main source of amusement was in seeing her name on the gallery marquee, visible from Fifth Avenue. On October 24, she went there to meet Marcel Duchamp ("he looks thin, poor boy") and found Elizabeth Duncan (sister of the dancer Isadora), Arnold Genthe, Marquis de Buenavista, and her two sisters speaking admiringly of her work. As the date for the close of the exhibition grew nearer, her comments were terse: "I met my successor Raukin and his work! . . . Mr. Fatman dropped in—and out." Her surprise at the lack of the exhibition's success is evident: "I am not selling, much to my amazement."

Within two days of each other, the Knoedler exhibition and the New York performances of the Ballets Russes ended. During the last weeks of October, Stettheimer and Adolphe Bolm went with Ettie and Duchamp to hear Swendam's *Carnival de Paris* a propos of having the composer work with them on the *Orphée* ballet. Stettheimer tried to enjoy the concert but found that it sounded like "a new kind of civic recruiting" and decided she did not want him for the ballet. She and Bolm visited the Central Park Zoo and discussed using live animals for the production, and they searched through music stores for possible scores. But the subject of Stettheimer's ballet quietly died and was apparently never brought up again.

On October 28, the last day of the Knoedler exhibition, Stettheimer spent the afternoon in the gallery. Her diary records only the statement "sold nothing." That evening, the artist attended the Russian Ballet to see Bolm dance in three numbers. She was pleased that he had done his makeup for the character of Sadko in a manner she had suggested and that, as a result, he "looked much handsomer—funny!"[49] On the thirtieth of the month her diary records only "X [exhibition] over . . . Russian Ballet over—Bolm rang me up to say good-bye."

Much has been made of Stettheimer's disappointment with the Knoedler exhibition. Parker Tyler, her primary biographer, who described the artist as "naturally timid and hypersensitive," called the exhibition a "shocking annihilation."[50] Despite the fact that the reviews of the exhibition were generally fair, most biographers have implied that her disappointment

with the exhibition led her to retreat from the "white light of publicity," and she never again agreed to a one-person exhibition of her work. Only Henry McBride, an art critic who later befriended her, suggested that "this was early in her career, before her style had crystallized."

McBride's is the most reasonable explanation of Stettheimer's failure to sell or receive significant attention from the Knoedler show. Stettheimer had only been living in America for a year and a half when the exhibition opened. The collection of works she exhibited represent the rather clumsy efforts of an artist who had only recently begun exploring a new style and manner of painting. The works as a group employ bright, pure colors with heavy impasto and thick contour lines around both figures and objects. Given the earlier evidence of Stettheimer's ability to create delicately drawn, anatomically correct figures, it is clear that the heavy-handed treatment of the figures in these paintings reflects a conscious effort to create a new visual vocabulary of form. However, the paintings also show that stylistically the artist was still in a transitional phase.

When Stettheimer returned to the United States in 1914, she chose, like many of her contemporaries, to explore the ideas of Bergson and Matisse through a form of primitivizing. In a conscious reaction against traditional academic means of art making, she worked to create an expressively simple style that was unconcerned with the subtleties of drawing or nuances of color. Instead, the paintings on exhibition at Knoedler demonstrate Stettheimer's desire to eliminate everything from her work that is not necessary to achieving the effect of "engaging the whole personality." In these works, she experimented with pure color in order to "render emotion without admixture, and without means of construction."[51]

Stettheimer later revised several of the paintings in the Knoedler exhibition, eliminating figures and altering the sense of space in several works.[52] Ettie was disappointed in the exhibition and blamed Sterner's promotion: "Florine's exhibition was very interesting; she got good notices on the whole but sold nothing. I don't think Marie did all she could in the matter. It's too bad she didn't make more noise and sell. A number of people admired her work very much f[or] i[nstance] Genthe."[53] There was no serious falling out between the women, however, because Stettheimer continued to send works to exhibitions organized by Sterner and added Marie's portrait to several of her later paintings.

In April 1917, Stettheimer submitted her portrait of Hopwood and the painting *Jenny and Genevieve* to the First Annual Exhibition of the Society of Independent Artists, held at the Grand Central Palace. Marcel Duchamp was one of the society's organizers and was head of the exhibition's hanging committee. He proposed installing the works in alphabetical order rather than according to size, medium, or style. The exhibition was also distinguished by not having a jury select the works, by not offering prizes of any kind, and by guaranteeing entrance to any artist who paid the fee.[54] In the end, the exhibition included 2,500 works stretching over almost two miles of wall space. For the next twenty years, Stettheimer contin-

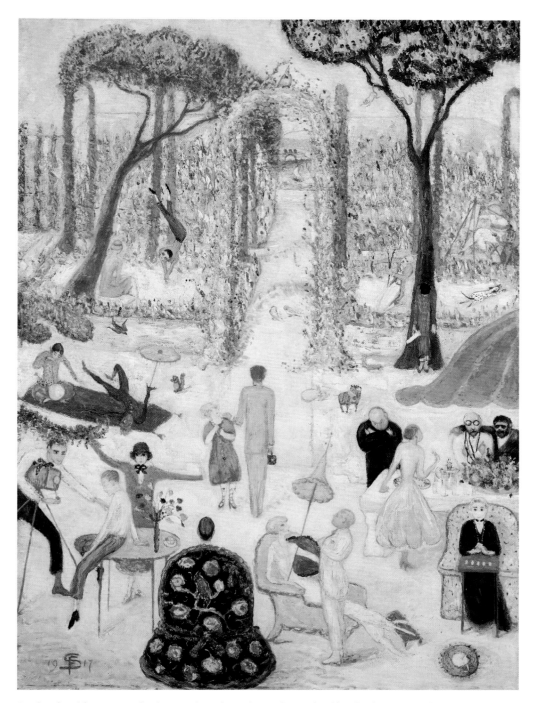

46. *Sunday Afternoon in the Country* (1917), 50¹/₂x 36¹/₂ in. The Cleveland Museum of Art, 1995, Gift of Ettie Stettheimer, 48.28.

ued to enter works in the society's annual exhibitions. That she chose to do so indicates that rather than running away from critical judgment after her disappointment with the Knoedler show, Stettheimer found that she preferred showing her work in noncompetitive situations. The works included in the Knoedler exhibition are the first manifestations of Stettheimer's "new" style of painting. By the next year she had moved beyond the Knoedler experience. Her integration of figural groups gradually became more personal and sophisticated as she refined her style and created paintings that stand among the strongest in her career.

During the first half of 1917, the war in Europe increasingly intruded into the Stettheimers' lives as the United States prepared to join the fighting. In February, Ettie wrote Henri Gans, congratulating him on winning a medal and commenting that although it seemed clear that the United States would soon enter the war, "there is immense disgust at being forced into it." Her own view was that America was obliged to enter "to prevent a decisive victory for Germany." Although she notes that she is a "marraine" to a French soldier (and Carrie a godmother to seven!), no mention is made of Florine's views or actions concerning the war.[55]

On May 12, the three sisters and Marcel Duchamp attended a pro-Allies event at City Hall. The parading troops of schoolgirls with flags, schoolboys in khakis, and uniformed soldiers drew so many onlookers that the women decided to view the spectacle from inside an adjacent building. They convinced the manager to let them in, as they were "ladies." Duchamp was also permitted inside, since the event was being held to honor French dignitaries. "This was funny," Ettie remarked, "because one of Duchamp's most positive ideas is that he won't fight."[56] Stettheimer woke at six a.m. on the morning of June 5, and lay in bed listening to whistles and "something that sounds like a saluting gun, if it's not some other kind of gun." Conscription for the war had begun. Stella's son Walter volunteered and was accepted in the air corps.

Ignoring the fighting in Europe, throughout late June and into July the Stettheimers held weekend parties at André Brook and invited members of their growing New York circle to come for a day in the country. On June 21, Duchamp came to give the women their weekly French lesson. They were joined in the afternoon by the dancer and painter Paul Thévenaz, whom Florine described as "a very young faun [who] turned somersaults on the green, danced, smiled and seemed unconsciously happy—he suited the garden. I hope he will play about in it again." The following day the Stettheimers held a highly successful "rowdy" party with guests, including Duchamp (who had stayed over), the fashion photographer Baron de Meyer and his wife, Carl Van Vechten and Fania Marinoff, the architect Paul Chalfin, and the Marquis de Buenavista (the Peruvian ambassador to the United States) and his wife. Although Van Vechten later stated that the subject was a "pure romantic fancy of the artist,"[57] Stettheimer combined incidents from several of these parties into a painting she titled *Sunday Afternoon in the Country* (fig. 46).

The scene in the painting takes place in the back gardens of André Brook. A small, cultivated stream runs through its center, and the Hudson River is visible through a vine-covered trellis. The artist varied her painting style in different areas of the canvas. For the background landscape, she adapted a loose pointillist technique and bright fauve colors. For the figures in the middle ground and foreground, she modified her recently developed method of using pure areas of color within clearly delineated outlines.

The painting's composition is arranged like a proscenium with a densely designed curtain backdrop. The middle ground is virtually empty, except for two small gray pigeons placed slightly above center. The rest of the composition is filled with twenty figures, eighteen of which are arranged in two loose bands in the lower half of the canvas, plus a central strip containing twelve small birds and animals. Each of the figures can be identified, and their placement suggests that the composition is a composite derived from actual experience. At the upper left of the painting, for example, Paul Thévenaz executes a handstand in the grass while Marie Sterner looks on.[58] Stettheimer later wrote a poem describing her impressions of this gymnastic demonstration:

Narcissus
You play in my garden
You are very young
You are beautiful . . .
You see in the red rambler arches
Frames for your posturing
In the full-blown peony borders
Boundaries for your dance . . .
In the smooth lawn
A carpet for your somersaults . . .
In the clear pool
Yourself reflected . . .
To my eyes
Your selfworshipped self idolized.[59]

Meanwhile, Adolphe Bolm, dressed in a green costume with body paint, lies upside-down on a purple carpet with his legs in the air. The Indian performer Ratan Devi, dressed in traditional costume, sits on the carpet and plays a tambour.[60] In the left foreground of the painting, Edward Steichen adjusts his standing box camera in order to photograph Marcel Duchamp, who is wearing bright green shoes. Duchamp leans against a yellow table behind which Ettie stands guard. In her usual officious manner, Ettie shields the photographic process by holding out a leafy branch.[61]

In *Sunday Afternoon*, Baron de Meyer is seen from the back seated in an elaborately upholstered chair. To de Meyer's right, his wife, dressed in white, sits talking with Paul Reimers, a well-known baritone. Rosetta Stettheimer sits in a bright yellow spotted chair playing a game of patience, facing the lower right corner of the canvas. Behind Rosetta, her daughter Carrie is dressed in a white dress with a scalloped hem and stands at a table under a red scalloped canopy. The lawyer Alfred Seligsberg is positioned behind the table. He stands with his arms crossed and head lowered, the sun glinting off his balding crown.[62] To his right, the sculptor Jo Davidson stands with his arm slung across the shoulders of Albert Sterner. In the lower center of the composition, the elongated figure of Arnold Genthe stands wearing a gray suit and carrying a brownie camera. His hand rests on the shoulder of Bolm's small blonde wife. At the right, the Marquis de Buenavista leans enigmatically against a tree, a letter or manuscript in his hand. Behind him, the architect Paul Chalfin rests on his knees gathering flowers. Several yellow squirrels, hanging by their tails, populate the middle ground of the canvas.

Barely discernible in the upper right corner of the painting, and isolated from her guests, Florine sits working on a canvas resting against a red easel. Stettheimer portrays herself as an observer rather than a participant in the events taking place around her. She again wears her artist's "uniform" and a yellow straw hat to protect her face from the sun. Preoccupied with painting, she ignores the rose offered by a red-skinned faun kneeling at her side. The faun self-consciously curls his body inward, his eyes glancing shyly toward the artist.

Like Stettheimer's earlier painting *Spring*, *Sunday Afternoon in the Country* depicts an Edenic coexistence between the human and animal kingdoms. A simple palette unites the composition. Stettheimer used four colors as accents—red, green, yellow, and black, weaving elements of the composition together against a predominantly white ground. Red accentuates the four corners of the canvas. Clear lemon yellow is used to highlight inanimate objects such as chairs, tables, and parasols in the foreground, and flowers in the background. Black is reserved for accenting the human figures in a manner causing the viewer's eye to circle around the lower third of the canvas.

The painting's combination of highly sophisticated vision and deliberately childish technique, each retaining their independence, heightens the effect of the whole. Stettheimer used details to make her figures identifiable and to localize the scene, creating deliberate tension between this specificity and the generalizing style. The painting's meaning is both obvious and obliquely mysterious, representational and abstract. The small scenes take on an ironic humor and, to quote Robert Goldwater, "become microcosmic comments on a larger world."[63] One of the primitivizing traits evident in Stettheimer's American work is the lack of psychological relation and active interaction among the figures. In *Sunday Afternoon*, the artist structured a composition of individual figures who stand, sit, or lie about in isolation, and who look out of the picture frame but almost never at each other. There is no

unified action that brings them into mutual play. The figures' poses and gestures have no apparent exterior motivation but are seemingly compelled solely by each one's interior mood. Not bearing any relation to each other, they have an undetermined relation to the viewer. As a result, the viewer's eye follows the composition's separate parts rather than grasping it as a whole. As Goldwater has noted, this ambiance is also found in works of the Fauve artists (Gauguin, Matisse, Derain), in Munch and Hodler, and in painting that derives its inspiration from children's art.[64]

Throughout the late nineteenth century, many artists sought out exotic, naive, and so-called primitive art as a means of achieving greater simplicity in their work. This was true in the popular admiration of styles such as Art Nouveau, the paintings of Gauguin and Van Gogh, Japanese woodcut prints, Persian miniatures, and in the esteem in which artists such as Matisse, Picasso, and the German expressionists held African and Oceanic art. Even in the decorative arts, the tendency to explore alternative earlier methods and modes of design was apparent. Owen Jones, in his influential *Grammar of Ornament,* noted that to develop a fitting ornament that would truly balance form and color, artists and artisans should "return to a more healthy condition, we must even be as little children or as savages. . . . The ornament of a savage tribe, being the result of a natural instinct, is necessarily always true to its purpose; whilst in much of the ornament in civilized nations, the first impulse that generated received forms, being enfeebled by constant repetition."[65]

In 1911, while Stettheimer was still living in Europe, Wassily Kandinsky published his essay "The Art of Spiritual Harmony," in which he mentioned a renewed interest in forms that express the inner feelings of an earlier age. Kandinsky noted the importance of the art of children, placing it on a par with the primitive: "In addition to his ability to portray externals, the talented child has the power to clothe the abiding inner truth in the form in which this inner truth appears as the most effective. . . . There is an enormous, unconscious strength in children . . . which places the work of children on as high (and often on a higher) a level as that of adults. The artist, who throughout his life is similar to children in many things, can attain the inner harmony of things more easily than others." Fellow Blaue Reiter member August Macke added, "Are not children creators who build directly from the secret of their perceptions, rather than the imitators of Greek form?"[66]

In his New York gallery, Alfred Stieglitz organized an exhibition of children's drawings in 1912 and encouraged Americans to see the show and confront the aesthetics of primitivism. In the July 1912 issue of *Camera Work,* the art critic Sadakichi Hartman described the exhibition at Stieglitz's gallery, commenting that the drawings recall some "elemental qualities that art has lost and which might do much . . . to imbue it with a fresh and exquisite virility." What Hartman has to say about the children's naïve work is similar to his description of Stettheimer's mature paintings: "Fond of startling contrast and glaring colors, they see things vividly and express them strongly, genuinely, without subterfuge. Every new object

they encounter, every incident of life they witness is an event full of curiosity and wonder. . . . They are romanticists by force of this fervency to receive impressions. . . . The directness of the performance triumphs over all technical obstructions . . . it does not strive for a certain perfection of representation. . . . Artists . . . remain simple as children but unconsciously in their art become identical with the object of their creation."[67]

The idea of recovering the freshness and simplicity of childhood in art was not new. Charles Baudelaire had noted it half a century earlier in his *Peintre de la vie moderne*: "Genius is nothing more nor less than *childhood recovered* at will—a childhood now equipped for self-expression with manhood's capacities and a power of analysis which enables it to order the mass of raw material which it has involuntarily accumulated."[68] Although as a woman Stettheimer was not the sort of artist Baudelaire had in mind as "painter of the modern world," her work illustrates the same basic desire to discard and renounce traditional forms and methods of art making. After 1915, Stettheimer consciously worked to create a new style that reflected the spontaneity, clear perception, and freshness of the child by renouncing her French academic training and returning instead to the more chaotic, decorative, orientalizing, romantic Germanic aesthetic tradition of her childhood.[69]

The concept of a return to childhood was bound to appeal to Stettheimer. By never marrying or having children, she and her sisters were able to retain a kind of virginal youth that belied their chronological age. They emphasized this through their manner of living and style of dress. Their return to live permanently in New York represented a new beginning for the artist and an opportunity to make up for the years "lost" in Europe. Throughout her mature life, Stettheimer wrote nursery rhymes reminiscent of the untrained voices of childhood. Her poems, like her post-1915 paintings, may seem childish at first glance, but they are written with the underlying modernist irony of a mature observer of contemporary life. A flea "likes people full of blood, and the world, full of mud." A sardonic young leopard reasons that one day "he will end up as a sack, on the back, of a thin girl or fat, with an Alice-blue hat." The subjects of the verses are anthropomorphized, much like the figures in the artist's early scrapbook. There are distinct feminist strains in some of the poems.

One influential vestige from Stettheimer's childhood, aside from her scrapbooks and fortune-telling cards, is a group of

47. Stettheimer sketch of an Islamic prince, Florine Stettheimer Papers, Rare Book and Manuscript Library, Columbia University.

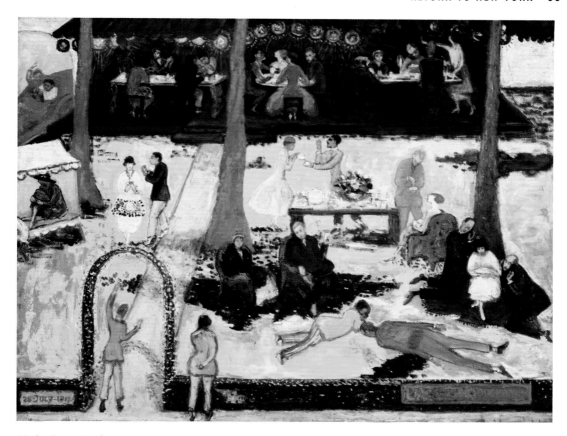

48. *La Fête à Duchamp* (1917), 35 x 45½ in. Private collection.

small, mass-manufactured German paper-picture scenes found with her correspondence. Each miniature scene originally featured blank areas over which one of the Stettheimer children glued matching paper figures, like puzzle pieces, onto scenic backgrounds. The scenes show winter sports for children, the weekly market, an elegant flower garden, and an outdoor breakfast laid by servants. The composition in each scene is dispersed across the surface of the canvas and is not localized in a central or horizontal zone. Every scene depicts solitary or paired figures who do not relate to others in the composition but are each involved in exclusive, individual activities. The scattered composition, subject matter, and bright primary colors bear many resemblances to Stettheimer's paintings, such as *Sunday Afternoon in the Country*. Both the miniatures and Stettheimer's work reveal a similar childish innocence.

Stettheimer had long admired Persian paintings, as is evident from an early sketch (fig. 47) and the inclusion of an Islamic prince in her *Orphée* ballet.[70] The influence of Persian art, particularly that of the fourteenth and fifteenth centuries, can be seen in stylistic el-

ements in Stettheimer's paintings as well as the progressive "miniaturization" of her painted figures. The most prevalent motif that she borrowed from Persian art is the use of a background color, generally green or gold, that extends to more than three-quarters of the composition. The ground usually terminates in a high horizon line made up of either a natural landscape element, an architectural element, or the meeting of floor and wall. In many instances, Stettheimer substituted a clear, bright yellow or white ground for the traditional Persian gold leaf.

The use of the Persian high horizon line allowed Stettheimer to dispense with Renaissance perspective and place her figures vertically up the length of each canvas. It is interesting to compare her *Sunday Afternoon* with such works as the Cleveland Museum of Art's double-frontispiece of the Shiraz *Shah-nama* of ca. 1444. Although the Persian composition is horizontal and Stettheimer's is vertical, there are a number of similarities between the two. Both feature outdoor fetes, with abundant food and musical accompaniment taking place among groomed gardens with leafy trees and a flower-lined stream. In each work, the ground plane tilts up and lies at an oblique angle to the surface of the paper or canvas. The horizon line is very high and partially obscured by vegetation, so that the figures appear to "float" on the flattened, ambiguous ground. Each composition includes figures seated beneath an umbrella-like canopy and ones seated on rectangular rugs. In both works, the viewer's eye is directed through the composition by the use of red and yellow or gold accents.[71]

The Stettheimers continued to hold weekend parties at André Brook throughout the summer and early fall of 1917. On July 28, they threw one for Marcel Duchamp's thirtieth birthday. Until the last moment, they were not certain if the weather would hold out, but the occasion was a great success—so much so that Florine declared the party "a classic" and determined to paint it. She titled the work *La Fête à Duchamp* (fig. 48) which would become, she noted, yet another advertisement for Duchamp to add "to the already long list." The birthday party unfolded in several stages. In the afternoon, guests took refreshments under a large maple tree, then adjourned to the covered terrace of the house. There, in the light cast by Florine's blue, green, and yellow lanterns, they had dinner and offered Duchamp a number of toasts as the sky darkened. Some guests described the atmosphere of the party as French, others as Italian.

The most striking and innovative aspect of Stettheimer's painting is the manner by which she included various sequences of time within one canvas, something Duchamp later termed her multiplication virtuelle. The notion of reality as a composite of multiple sensations and perceptions corresponds to the theories of Henri Bergson and the writings of Marcel Proust. In designing the composition for Duchamp's party, Stettheimer created a "journey" through her memory of the event. Although the canvas is horizontal, the artist's placement of figures and colors makes the composition work vertically. The viewer traces the day's

occurrences in the manner of oriental "journey" scrolls, early Renaissance predellas, and the small German pasted pictures from the artist's childhood.[72]

The painted events begin on the far left side of the canvas as Duchamp arrives in a red convertible sports car driven by the French artist Francis Picabia.[73] Waving at the guests scattered throughout the lower gardens, Duchamp and Picabia (whom Ettie called a "fat, womanish, enfant terrible, self-centered Bohemian"), wearing tan jackets and white pants, enter the garden through a flower-covered trellis at the bottom of the painting. Stettheimer steps forward to greet them and disengages herself from the artist Albert Gleizes. She is dressed in a white outfit trimmed with a band of flower embroidery that is identical to the outfit she wears in one of the few extant photographs.

After they enter the painted gate, Duchamp and Picabia separate. Duchamp goes to sit in a covered swing at the left with the actress Fania Marinoff, who is wearing a black straw hat. Picabia moves to the right front lawn, where he lies on his stomach talking with the French writer Henri-Pierre Roché. Roché lies face-down and spread-eagled on the grass near where Ettie Stettheimer is sitting "sur l'herbe" and reading aloud from a novel. Double images of Leo Stein surround the figure of Ettie. In a rather cruel caricature exploiting his hardness of hearing, Stettheimer shows Stein kneeling at Ettie's side, holding his hand to his left ear to better hear her recital. He is also painted at the right, crouching forward and straining to listen with his other ear.[74] Further to the right, the green-suited Van Vechten lounges in a green wicker chair, talking with Elizabeth Duncan. Behind a table laden with an abundant bouquet, tea, and pastries, Carrie, ever the perfect hostess, serves tea to the darkly elegant Marquis de Buenavista. At their right, Avery Hopwood, stirring his tea, stops to talk with Juliette Gleizes, whom Ettie described as "a refined Emanuelle, interesting, European and feminine."

The final sequence of the event takes place in the back third of the composition, where, under the lantern-lit verandah, the guests sit at three dining tables. At the far right, Ettie stands and raises her glass in a toast to Duchamp. She is flanked by the writers Roché, Hopwood, and Stein and by Elizabeth Duncan. At the middle table, Carrie sits with her back to the canvas plane, with Carl Van Vechten at her right, Buenavista at her left, and Mme Gleizes opposite. Along with Fania Marinoff, the remainder of the guests at the left-most table are artists, including Florine, Gleizes, and Picabia, who are deep in conversation, and Duchamp, who rises to accept Ettie's toast. Duchamp prepared special place cards for the event. On one side of a sheet of paper he wrote elements of each guest's first name and included the remaining fragments on the reverse. The name could therefore only be read in its entirety by holding the sheet up to a light, which made the cards translucent and so legible.[75]

In *Fête*, Stettheimer again used red to stabilize compositional elements: tree trunks, the sports car, and highlights in Florine's dress and Carrie's hat. White and green are used as ac-

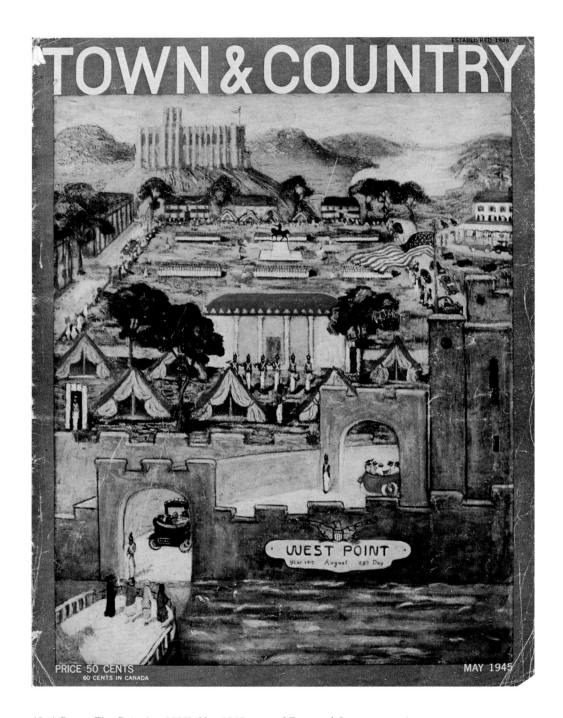

49. *A Day at West Point* (ca. 1917), May 1945 cover of *Town and Country* magazine.

cents, the former to identify the three Stettheimer sisters—the three "virginal" ladies among the participants. Besides mixing separate events and time sequences, Stettheimer here juxtaposed two kinds of light. There are few shadows against the bright, flat, yellow foreground of the afternoon sun. The lighting is reversed on the terrace, however. There it is night, and the ground, floor, and walls are indistinguishable by the light of the lanterns. Only those guests whose upturned faces are directly under the light are clearly visible; the remainder are half lost in shadow.

Stettheimer included *La Fête à Duchamp* in the 1918 Exhibition of Independent Artists that opened in mid-April with a special reception. Henry McBride, the art critic for the *New York Sun*, reviewed the opening:

> *I agree with Mr. Walkowitz that one of the most joyous of the paintings is the "Birthday Party" by Mrs. [sic] Florine Stettheimer. . . . All the people at the party, Mr. Walkowitz says, are extremely well known in the most advanced Greenwich Village circles. . . . Not to know the fair artists of the picture is to argue oneself unknown, I dare say, yet I cannot recall having heard of Mrs. Stettheimer before. I say "fair" advisedly, for the lady has some rather good things to say for herself. One of the gentlemen at the fete is lying face downward on the turf, and yet his toes point skyward. I believe it is Mr. Duchamp. At any rate he is very clever and could do it. One of the trees is painted scarlet and one a bright blue. The shadows are such colors as pleased the artist, and that is the reason, I think, they now please others. . . . Mrs. Stettheimer appears to be a good provider. The more I think of it the more miffed I am that I wasn't asked to that party.*[76]

In her diary of 1917, Stettheimer noted another memorable evening event at André Brook when Bolm, his wife, and Ratan Devi visited the Stettheimers' country house for dinner. The guests missed their return train to the city and stayed overnight, camping out on the lawn under one of the tall elm trees. Bolm borrowed one of Rosetta's frilly white batiste nightgowns and performed an impromptu dance by moonlight for his delighted hostesses. Meanwhile Ettie noted in her diary that her friend Elizabeth Duncan, "without being married or anything," had bought herself a big house in Tarrytown that used to be the Louis Stern place, "and it *is* clever, however she managed it."[77]

During the end of August and early September, the four Stettheimer ladies took several trips in their chauffeured car. On August 29, they drove to Garrison, New York, and took a ferry to West Point to watch a cadet review. Florine, showing the nationalistic admiration of the recently returned expatriate, found it "more like a hippodrome performance than anything militaristic I have ever seen—the perfect day—the beautiful setting like a stage background, the immaculate cadets, light and graceful marching to light music."[78] Stettheimer decided to capture the day in a painting (fig. 49). As with her *Fête à Duchamp*, the artist

composed *A Day at West Point* as a sequential narrative played out on a vertical, two-dimensional canvas.

At the lowest level, on the left side of *West Point,* the Stettheimers stand by the railing at the front of the arriving ferry. Florine distinguished the four women by color: Rosetta is shown in black, wearing a veil, while the three sisters are differentiated by wearing red, yellow, or blue coats.[79] After boarding an open, chauffeured car, the women pass under the stone-gray entrance arch of the academy and drive by a small army band playing before khaki and red tents. The women then move up to the level of the parade grounds at upper right. There they watch the cadets march in formation around a bronze copy of the 1853 Union Square equestrian portrait by Henry Kirke Brown.[80] The women stop at the academy hotel, with its wide verandah, before reentering their car and touring the rest of the grounds. Stettheimer bounded the painting's central imagery with water at its bottom and a view of the Hudson River at the upper right. This reinforces the composition's vertical lift and its winding, progressive, narrative nature.

Penelope Redd, one of Stettheimer's most perceptive reviewers, noted, "Miss Stettheimer carries the art of painting to its completest power of expressing a number of incidents occurring simultaneously. A book requires pages to relate concurrent events; a drama requires words to do the same, but a painting by its very nature may express events simultaneously in a way so satisfactory that the smug would label it 'efficient.'" Another critic, who saw the painting at an exhibition of the Independents at the Waldorf Astoria, related the organization of Stettheimer's painting to a children's game: "She gets everything in and your eye travels up the canvas through the various depicted events much as in the childhood game one arrives at the 'Mansion of Happiness' after successive stages of joy and despair."[81]

The artist included *West Point* in an exhibition of "American Paintings and Sculpture Pertaining to the War" that Marie Sterner organized at Knoedler Gallery. The exhibition included works by Cecilia Beaux, George Bellows, Jo Davidson, Guy Pene du Bois, William Glackens, Childe Hassam, Robert Henri, Rockwell Kent, George Luks, John Sloan, and Gertrude Whitney among others. All proceeds from the entrance fees were invested in Liberty Bonds.[82]

The impending war increasingly asserted its presence into the Stettheimers' lives. Carrie continued working for the Red Cross when she was not attending Rosetta, whose health was declining. Ettie wrote to her friend Gans that she had "offered myself to my country for any purpose not resembling Red-Cross work, for which I am unfitted, or addressing and licking envelopes, for which I am fitted but of which I am not enamored." She eventually sat on the draft exemption board and translated German papers as "one of the legal advisers. It was interesting work and absorbing and wearing on the sympathies. . . . We are too gay and yet it requires a strong dose of the harmless narcotic of distraction to distract one from the war."

Florine, on the other hand, reacted to the war more personally and emotionally because of the imminent involvement of her nephew, Walter Wanger. In her diary Ettie matter-of-factly reported that Walter had joined the air corps and was "full of excitement and anticipation; [he] doesn't take his job lightly." By contrast, Florine's attachment to her nephew, who later became a Hollywood producer and ladies' man, seems somewhat exaggerated, particularly as they were almost twenty years apart in age. Nonetheless, in late August 1917, Walter visited her, and they had a long talk. As the artist noted, it was "perhaps our last—I was awfully upset . . . we are very good friends—I love him dearly . . . I felt happier because he had said he missed me often, that he often felt like writing to me (but he doesn't), that he even thought of keeping a diary when he leaves—for me. He ended up promising it and letters and I am to write . . . something has happened—and he may be gone already."

A few days later Walter's orders came through, and Stettheimer, reacting with greater emotion than one would expect from an aunt, worried less about the potential dangers of battle than about his lack of consideration for her feelings: "[I] went to town in the evening to try and see Walter & say good-bye. He had received his marching orders for the next morning. I waited at Stella's. . . . Stella, Harry, he, some new friends were to dine—he did not ask me—although I was alone and came in for him—I am now glad of it—I have no heartache left. . . . I mourned the death of my affection for him that night." (The following pages were excised by Ettie.)

In early September the Stettheimers traveled through Connecticut and Boston, much to Florine's annoyance, for she was "in a working mood, and, when not painting, in a very unhappy mood." The car broke down outside Waterbury, Connecticut, so they took a trolley into the city and explored the streets on foot. Through one drugstore window, Florine noticed a youth in a sailor suit having corns removed "by a man who spoke through a megaphone to a crowd of spectators advertising the remedy. Otherwise I saw nothing to distinguish this place from others." In Boston, where they stayed at the Copley Plaza Hotel, Florine immediately went across the street to the public library to see the John Singer Sargent murals. On their return trip, a tire blew out, "with a sharp retort, I thought it was a shot," and the women were assisted by two young soldiers, to whom they then gave a lift. Florine commented in her diary that they were "nice boys, going to the Front shortly—its horrible," again asserting her dismay at the war in Europe.

The Stettheimers stayed at André Brook through October, until they were finally driven out by the cold and the caretaker's failure to fix the furnace. On November 5, they returned to their house at 102 West Seventy-sixth Street—"the same stuffy little house . . . looking out on the elevated railroad," wrote Ettie. "I always have called it 'Salle d'attente deuxieme classe' but we stick to it because it is the 'easiest' thing to do and most other houses and streets are equally without charm in New York. No two of us want to live in the same locality, so it seems the best solution that we should all live where nobody wants to."[83]

4

Social Relations at War's End

Our Parties
Our Picnics
Our Banquets
Our Friends
Have at last a raison d'être
Seen in color and design
It amuses me
To recreate them—
To paint them.
 —Crystal Flowers, *p. 82*

The year 1918 brought some of the most fully integrated works Stettheimer was ever to paint. She continued to work in smaller and smaller forms, and the details of her compositions became more finely drawn as the artist gained greater control over her new manner of painting. The André Brook estate was not available for the summer, so the Stettheimers rented the Rupert Hughes estate in Bedford Hills, New York. Ettie lamented in her diary, "We have a tennis court we don't use, and a lake too dirty to bathe in, but not dirty enough not to want badly to bathe in, pigs, cows, horses, chickens etc. geese, whom Florrie calls the Germans; 'here come the Germans' she says when they approach the lake. I suppose we shall feel obliged to eat them when the weather gets cooler."[1]

Florine used the Hughes estate as the setting for one of her strongest paintings of this era, a loose variation on Manet's *Déjeuner sur l'herbe*, which she titled *Picnic at Bedford Hills* (fig. 50). Like many of her contemporaries during the interwar years, Stettheimer often referred to and "played-off" earlier subjects and images from the history of art as a means of establishing meaning and expression in her works.[2] Stettheimer's *Picnic* is, like Manet's *Déjeuner,* "a charming canvas, in which Miss S. has gently caricatured the doing of city folks amid the life of the country."[3]

In *Picnic,* Stettheimer juxtaposed images of rural workers, who depend on the land for their livelihood, with images of idle urbanites, who venture into the country for leisure and

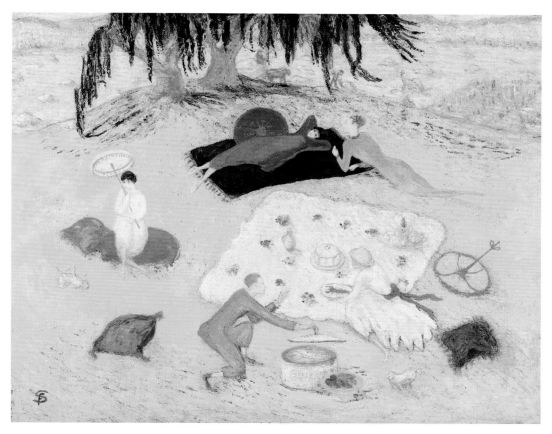

50. *Picnic at Bedford Hills* (1918), 40⁵/₁₆ x 50¹/₄ in. Pennsylvania Academy of the Fine Arts, Philadelphia. Gift of Ettie Stettheimer.

relaxation. To accentuate these differences, the painting is divided by style, color, and subject matter into two unequal zones. The upper quarter of the canvas, framed by two large shade trees, is painted in a loose impressionist technique of dashes of pure purples, blues, and yellows. The contrasting colors create a hazy effect, as though background images are seen through a layer of gauze. The artist intended this area of the composition to illustrate the repetitive work patterns of the harvest. On the far left, mounds of drying hay await loading in a horse-drawn wagon barely discernible behind the central pink tree trunk. Meanwhile, one farmer at the right rakes the hay, while another drags a heavy sack in the manner of Millet's gleaners, prototypical images of rural working life. At the far right, haystacks stand in irregular rows awaiting retrieval.

In contrast, Stettheimer painted the lower three-quarters of the composition in bright,

pure primary colors. The flat, broad, yellow ground is modulated only by the sparse sprinkling of five figures and assorted cushions and blankets. Oblivious to the work taking place behind them, the figures in the foreground are relaxed, amorous, and somewhat sexual, as though the natural landscape were a catalyst for flirtation. In this, the painting follows such prototypes as Watteau's rococo *fêtes gallante,* works by the sixteenth-century Venetian artist Giorgione, and the allegories of Peter Paul Rubens.[4]

Picnic's foreground composition revolves around the three Stettheimer sisters. The artist used the painting to give visual shape to the distinct and disparate personalities of herself and her two sisters: Carrie the hostess, Ettie the siren, and Florine the onlooker. Marcel Duchamp, dressed in a lilac suit, raises the lid on a pot near Carrie, while Elie Nadelman, in a gold body suit, lies on his stomach facing Ettie. The paired figures mirror each other in complementary poses: Duchamp and Carrie half-kneel with arms outstretched, while Nadelman and Ettie lie with elbows bent and legs crossed at the knee. Nadelman's feet terminate in points, reminiscent of the attenuated feet in his sculpture.[5] Meanwhile, at the left, Florine sits alone, looking away from the others. Clearly separating herself from their activities, she watches the rapturous wiggling of an adjacent white dog.[6]

As in many of her subsequent portraits, in *Picnic* the artist used props—in this case umbrellas—to mimic the personalities of the three women. Each sister is isolated in her enjoyment of a distinct activity. Carrie bends over a flowered blanket, preparing an elaborate meal of lobster, soup, and dessert. She is so intent on the meal that she does not notice her abandoned yellow parasol lying upside-down at the right. Ettie lies on her back, engaged in flirting, her favorite pastime. She provocatively glances up at Nadelman, while her purple and red umbrella is propped up on its side to accentuate the rounded lines of her hips and imply her availability. Florine sits on a rounded pillow. Of the three sisters, only she actually grasps her fringed parasol (on which her name is inscribed), using it to shield her skin from the sun and the prying eyes of strangers.

Florine commented in her diary at the end of the summer, "The only things that amuse me nowadays are my own paintings in the making."[7] She spent the next two years painting the summer of 1918. That she painted these incidents long after each had taken place indicates that she valued her associations and memories over timeliness and chronological accuracy. On July 22, 1918, the Stettheimer sisters held an intimate party to celebrate Rosetta's birthday. A year later, Florine commemorated the event in a painting she titled *Heat,* set in the backyard of their rented Bedford Hills summer home.[8] Carl Van Vechten described the painting as one "in which the corseted parent in heavy black sits bold upright, while her daughters [including a fourth daughter, Stella Wanger, Walter's mother], exhausted by the humidity, recline, wilt, and expire in informal positions."[9]

Stettheimer composed *Heat* like a vertical flag, on three wide bands of red, yellow, and

green (fig. 51). Within these bright, "hot" color fields, the figures are disposed clockwise, with Rosetta at the top and her birthday cake, lit with candles, at the bottom. Beginning at the right, her daughters Carrie, Florine, Ettie, and Stella react to the temperature with individualized poses based on variations of a sinuous, rococo *s* curve. *Heat* exemplifies what Charles Demuth wrote of Stettheimer's paintings: "There is to be found here a quality which is found in the 18th Century French, a quality of the slightly ennuied, not exhausted, just a trifle of fatigue, and not expecting but constantly demanding great surprises and thrills from a period too completely understood to furnish them. She is more in the know of the Trianon than Marie Laurencin who is generally acclaimed its modern interpreter."[10]

At the painting's right, Carrie pauses from her knitting to smoke, while Florine turns away from the others. A fan in one hand, she leans forward and plays with a small, exuberant cat. Ettie, with her prominent brows and rose-embroidered dress, stretches her arms as though awakening from a nap, unlike the curled cat sleeping at her feet. The elegantly dressed Stella is shown in profile. Her knitting lies abandoned, while she animatedly gestures to her mother, who sits like an enthroned Buddha at the apex of the triangular group. The languid poses of the women echo the sagging branches of the willow trees at the top and the cherry blossom branches in a jar at the bottom. The artist borrowed these elements from Japanese woodblock prints and used them for aesthetic effect rather than veracity—cherry blossoms are out of season during hot, humid Westchester summers.

Toward the end of July, Duchamp arrived at the Bedford Hills house with a miniature version of his infamous painting *Nude Descending a Staircase,* painted especially for the gallery in Carrie's dollhouse. Because of increasing American involvement in the war in Europe, in which he refused to participate, the French artist was uncomfortable in the United States, and he made plans to leave for Buenos Aires. Three times he asked Ettie to accompany him on the trip, leaving her somewhat baffled.[11] On August 12, Duchamp sent Florine a small drawing, mapping his trip to Argentina. Titled *Adieu à Florine,* the work superimposes an overscale drawing of their Westchester house on a map of the Northern Hemisphere, on which Duchamp wrote "cool" in large outlined letters and noted "two years and twenty-seven days," from 1915 to 1918, which was the amount of time he had spent in the United States. A large map of South America takes up the bottom half of the drawing. Duchamp described the continent as "Hot" and covered it with a large question mark.

On November 3, the Allies signed an armistice with Austria-Hungary. During the next few days, as peace with Germany as well seemed likely, the people of New York celebrated. Ettie heard the city of New York go "crazy with delight . . . following the premature report that Germany had signed the Foch armistice—stores closed, shop girls kissed all soldiers, deafening noise." On November 12, the Stettheimer sisters were awakened by bells and whistles announcing that the armistice between Germany and the Allies had taken place. Florine pes-

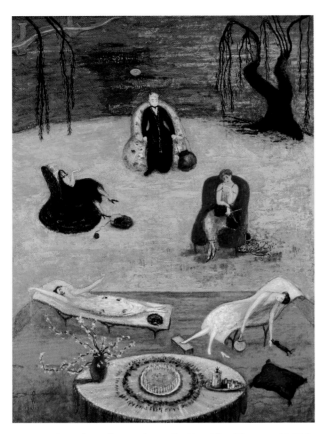

51. *Heat* (1919), 50³/₈ x 36¹/₂ in. The Brooklyn Museum 57.125, Gift of the Estate of Ettie Stettheimer.

simistically recorded the date in her journal and indicated her efforts on behalf of the war: "the first day of the new warless age—is it?—I hope but doubt it. I am tired, yesterday I was alive for so many hours, at five the whistles told of the armistice— at seven I got up before ten— Fifth Avenue was a joyful mass of humanity—I left my studio and went to the Red Cross—I celebrated that way—I sewed goods and watched the windows opposite the library, Mother and Carrie called for me at lunch. . . . We marketed and I cooked the chops in my studio, then we all returned to the Red Cross—the Gleizes dined with us—we spoke—Gleizes did— politics." In general, the Stettheimers' reaction to world events was subdued. Economically, the war did not greatly affect their lifestyle, and their affinity for the Allies was tempered by their years of living in Germany.

The four Stettheimer women continued to entertain many members of New York's social, cultural, and literary avant-garde over the next two decades. Carrie was responsible for the elaborate meals served in the Manhattan apartment and weekend country houses. She did the shopping and trained a series of German cooks. Afternoon parties consisted of rich Viennese or German torte served with tea or Madeira. Even during Prohibition, evening activities at the Stettheimer household began with rum cocktails or champagne served in the drawing room. Dinner in the large dining room was always prepared by a live-in chef.[12] There is disagreement among guests at the Stettheimers' social gatherings as to whether they constituted a salon like those of eighteenth- and nineteenth-century France or Gertrude Stein's circle in

Paris. In an article on Florine Stettheimer's paintings, the critic Paul Rosenberg predicted that the Stettheimers' social evenings would

> *figure in all accounts of the modern art movement in New York. It was a genuine*
> *gathering place of its sort; not one of those which, in the wit's words, "set out to be sa-*
> *lons and succeed only in becoming restaurants." The celebrities in the world of art*
> *and literature periodically appeared there. God knows, on many occasions they formed*
> *notable collections of freaks. But one also met Henry Mencken, Sherwood Anderson,*
> *Georgia O'Keeffe. Artists indeed voluntarily went there and not at all merely because*
> *of the individualities of the trio of women and their tasteful hospitality. They went for*
> *the reason that they felt themselves entirely at home with the Stetties—so the trio was*
> *called—and the Stetties seemed to feel themselves entirely at home in their company.*
> *Art was an indispensable component of the modern, open intellectual life of the place.*
> *The sisters felt it as a living issue. Sincerely they lived it.*[13]

Others disagree with this description. Carl Van Vechten, one of the Stettheimers' most frequent guests, noted that they made no effort to "capture lions," and he recalled that the composer Virgil Thomson once reacted to mention of the Stettheimers' salon by declaring, "They have no salon. They entertain their friends, most of whom happen to be celebrated" (fig. 52). The art critic Henry McBride later remarked that the Stettheimers' gatherings "had considerable to do with the shaping of the intellectual and artistic impulses of the past . . . [and were where] hardy ideas were put into words which echoed sooner or later in other parts of the city." They were quite unlike other contemporary New York salons, where "something unexpected was apt to happen." "It should be firmly understood," he noted, "that there was nothing unexpected in the proprieties that prevailed there and which were fairly Bostonese in character. Occasionally a gifted refugee from Greenwich Village drifted in, but if there were too much of Eighth Street in his manner, he was unlikely to reappear." McBride vehemently

52. Carl Sprinchorn, sketch of *The Stettheimer Salon* (1944), watercolor and ink on paper. Estate of Florine Stettheimer, Joseph Solomon, Executor.

asserted that "the Stettheimer salon was more *convenable* than most! . . . the conversation was far from routine," ranging from political and religious issues to a discussion led by Ettie on the actress Mae West's recent arrest, "to the great enhancement of her [West's] reputation."[14]

For his biography of Stettheimer, Parker Tyler interviewed a number of the artist's friends after her death. In discussing the social evenings, he tends to conflate the Stettheimers' social gatherings in the family's apartment with Florine's occasional receptions at her Beaux Arts Building studio to celebrate the "unveiling" of new paintings:[15]

> *No hot, lethal debates on artistic issues ever took place in this consecrated, serene atmosphere. Polite hubbub did, disloyally loud . . . but never open warfare, never pitched battles! The New York artists who participated in the Stettheimer rites knew that such issues had to be settled elsewhere. Men such as Gaston Lachaise, Eli Nadelman, Marcel Duchamp and Alfred Stieglitz, all of them her [Florine's] friends, had become and would become, much better known than their hostess as the years of deflation and inflation waxed and grew fretful. The struggles and victories of these artists remained moot matters within the confines of the Stettheimer studio-salon.[16]*

At most social occasions Stettheimer assumed the role of silent observer. Van Vechten recalled that "she seldom attended any except those given by members of her own family, and even at these she was frequently inconspicuous."[17] Henry McBride also recalled that Stettheimer "seemed often a furtive guest rather than one of the genii loci which she undoubtedly was, for her demure presence invariably counted. The artists who came to these parties came there because of her, most of them in the avant-garde, such as Gaston Lachaise, Charles Demuth, Pavel Tchelitchew, et. al. but all the others in attendance, the writers, singers, dancers, and sometimes even scientists, were definitely interested and amused by Florine's paintings."[18]

Notwithstanding how others classified these events, Stettheimer recorded her view of the soirées in her studio in a painting titled *Soirée*, which she executed between 1917 and 1919 (fig. 53).[19] The painting is one of her most complex and sophisticated works. It is an exploration of the act of looking, or, to borrow a phrase from Norman Bryson, "overlooking," and satirizes the posturing and "blindness" so often mistaken for art appreciation.[20] The painting is one of Stettheimer's early "conversation pieces," since each of the figures can be identified.[21] At the top left, Ettie, Isabelle Lachaise, and Maurice Sterne gather below a copy of Florine's *Family Portrait No. 1*, in which the figure of Rosetta and a portion of the central bouquet are visible. On the lower left, Gaston Lachaise and Albert Gleizes, both artists, stand facing a canvas visible to the viewer only from its back. Avery Hopwood and Leo Stein sit in the central area; behind them is the Hindu poet Sankar[22] sitting directly before Stettheimer's nude self-portrait on a large easel. At the right, Mme Gleizes, Florine, and a partial figure wearing a Harlequin costume rest on a red and white couch.

As in many of the paintings of this period, Stettheimer included in *Soirée* a number of

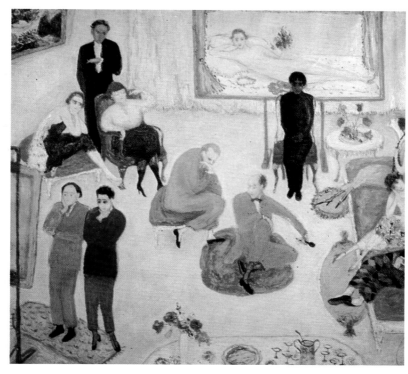

53. *Soirée* (1917–19), 28¼ x 30 in. Yale Collection of American Literature, Beinecke Rare Book and Manuscript Library, Yale University.

allusions to well-known artists—in particular, two proto-modern artists, Velázquez and Watteau, whose work is marked by ironic ambiguity and skepticism about the nature of representation in art. Watteau is credited with inventing the genre of the *fête gallante*, which, at the same time as it claimed freedom for the artist from specificity in subject matter, treated human nature psychologically. In his most ambitious paintings, he linked a series of significant moments into an artistic whole, a psychological ensemble resembling a "miniature Mozart operetta."[23] Similarly, Stettheimer's *Soirée* captures the moments directly after the festive unveiling of a new work in the artist's studio. The guests, having each offered their initial reactions, compliments, and pleasantries, sit back to reflect. Only two of the figures in the composition still look at the picture in question.

Soirée represents the modern, urban equivalent of Watteau's *fête gallante*, now taking place indoors. The most obvious reference to Watteau is the partial figure of Harlequin with folded hands, at the right of the composition. The costume recalls the French artist's well-known painting, *Gilles*, in which the lone figure of a man, in similar costume, stands dejectedly in the center of the canvas. Harlequin was a preferred means of representing the male

figure in the works of many modern artists, including Picasso, Gris, Derain, Severini, and Metzinger. Recalling images from the *commedia dell'arte*,[24] the Harlequin in *Soirée* might also be an oblique reference either to Duchamp, who had already left the country at the time the work was painted, or to Nijinsky, who played Harlequin in a Ballets Russes production of *Carnaval*.

In *Soirée*, the mounted canvas at the lower left refers to a similar device used by Velázquez in *Las Meninas*, which Stettheimer admired in 1912. The conspicuous placement of the two-dimensional rectangle, whose subject we cannot see, reinforces the reading of Stettheimer's work as a conscious exploration of the theme of art making. Her painting captures and elevates a self-conscious moment for posterity. The figures gathered within Stettheimer's composition, like those in Velázquez's work, embody a form of "royalty," the close circle of friends, eccentrics, and artists who made up the Stettheimers' avant-garde "family." And just as Velázquez included his own portrait in the right rear of his painting, so Stettheimer included a self-portrait along the far wall of hers.

The most telling gestures in Stettheimer's painting are the hands of the four frontal male figures.[25] They sit like the monkeys who hear no evil, speak no evil, and see no evil. Lachaise holds his elbow with one hand, while the other covers his right ear and the side of his face.[26] Next to him, Gleizes cups his chin and seals his lips; both men gaze at the unseen painting without expression. This device is repeated in the center of the painting, where Hopwood sits with the back of his palm covering his mouth, while the semi-deaf Leo Stein holds his hearing aide as far away from his body as possible, preventing any communication.[27]

Only Mme Gleizes appears to notice the resemblance between the features of the large nude hanging at the back and those of her hostess seated at the right; and she raises her hand to her chest in a gesture of astonishment. The darkly opaque head of the Hindu poet, his hands folded neatly over his crotch, conveniently blocks the view of the nude's genitals. The nude figure in the painting within a painting rests her head on her right palm and looks somewhat derisively at us. As if to reinforce the likeness between them, the figure of Stettheimer seated at the right holds her head in exactly the same pose. She leans forward and stares out of the canvas as though acknowledging our presence and asking us to share in her amusement at the scene. Meanwhile, the other figures are too caught up in their own thoughts to notice the "art" on the walls and thereby to "recognize" Stettheimer as a serious artist.

Stettheimer's studio was the "room of her own," within which she could seriously pursue her painting undistracted by her mother and sisters. In 1919, Ettie enviously noted, "If the family were only in good health, I'd take a studio as F[lorine] does and absent myself during the day and work." Stettheimer could be quite particular about the contexts in which her paintings were shown. During the spring of 1919, she was asked to participate in two exhibitions, both of which she declined. The first, arranged by Mrs. Lydig, was to be hung in Dr.

Stickney Grant's church. Stettheimer's refusal was based on her lifelong dislike of what she perceived as religious hypocrisy and the fact that she did not respect churches that baptized "fashionable Jews." The second exhibition was organized by Hamilton Easter Field as a sort of *salon des non-invités* to the Luxembourg Exhibition. Stettheimer again refused to participate, insisting that her refusal was not from sulking that she had not been asked to participate in the Luxembourg show.

By July, the Stettheimers were staying at the Seligmans' Camp Calumet, on Lake Placid, where they were visited by Elizabeth Duncan, Maurice Sterne, and Elie Nadelman, who "was most charming, amiable, vivacious and agreeable and free with his favors." Stettheimer captured the atmosphere of the 1919 summer in a painting entitled *Lake Placid* (fig. 54).[28] When it was shown at the Exhibition of Independent Artists the next year, S. Jay Kaufman, the critic for the *Globe*, cited the work for its exuberance and charm and suggested that the artist title it "Symphony in Reds" or "Aquatic Sports" or "anything joyous. We recommend it to the editor of *Playboy*, whose magazine, he claims, is for youth and jocundity. *Lake Placid* is both, and it would make a pleasant spot on anybody's wall. It's a tonic."[29] Henry McBride concurred: "There is no doubt but that to her Lake Placid represents 'heaven.' The young lady swimmers all wear costumes from the smartest shops on Fifth Avenue, and the motor boats, gondolas, houseboats etc., are of the latest models. There are one or two young men at the swimming party, so Miss Stett's Aunt Kate, clad in severe black, chaperones everybody from a balcony. The water is pure white in this picture, and the outlines have been touched in with crimson and livid green."[30]

Because of its bright palette, Stettheimer's painting "apparently upset the other pictures on the wall" of the exhibition; "it needed a whole wall to itself" and so was moved. In the composition, at Rosetta's right, Florine, dressed in a sun hat and fringed robe, gingerly tiptoes down the stairs toward the water, glancing over her shoulder as if hoping to avoid her mother's eyes. Stettheimer had been ill earlier that summer and was recuperating; she did not, however, want to be left out of the fun. A large wooden platform with stairs and two diving boards floats at the lower right of the composition. On one diving board, the Marquis de Buenavista poses for the women, with his shoulders thrown back and his fine profile silhouetted against the water. To his right, Carrie sits in a dark suit and cap, shielded by a yellow parasol.

Stettheimer implied a temporal unfolding in the painting, as Carrie can be seen a second time, swimming toward the raft's left corner. Ettie is also depicted twice—once in the middle right, racing with the good-looking and popular rabbi Stephen Wise, and again, seated in her red suit and cap on the left side of the float. Marie Sterner, in a flowered bathing suit, sunbathes with elbows akimbo, while Nadelman, with his distinctive profile and curly reddish-brown hair, hangs off the right side of the raft. In the upper right, the Stettheimers' cousin Hazel Seligman water-skis at the back of a canopied motorboat with her father at the

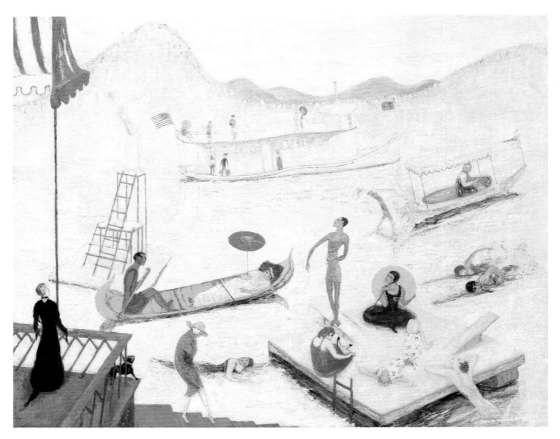

54. *Lake Placid* (1919), 40 x 50 in. Gift of Miss Ettie Stettheimer, the artist's sister. Courtesy Museum of Fine Arts, Boston.

helm. Although the critic for the *Boston Evening Transcript* called *Lake Placid* "silly, unbeauteous and insane," other critics found it "rib-tickling, midriff-stirring" and "delightful, a vastly amusing, whimsical view of the ludicrousness of people when bathing."[31]

At war's end, disillusionment with the old Western order and the promise held out by the Bolshevik revolution in Russia created a fashionable interest in communism within the Stettheimers' circle. In early February 1919 Ettie complained that "everyone is turning Bolshevik now anyway. . . . Florrie had a studio party the other night and everyone was, or thought he was, or pretended to be. It's very depressing; but so are the alternatives." Meanwhile, Florine continued to grapple with bouts of the doldrums: "Every morning I seem to start up into the day and the day comes down on me and we go fast on our different ways. I have been home two days—fighting a larynx cold—and tearing up letters from my friends of my schooldays—they are all gone now. I reread most of them. Those were my girl friends—

my boyfriends and swains will be destroyed the next time I have an ache."

In 1919 or 1920 Stettheimer met the Mexican artist and art teacher Adolfo Best-Maugard at Marie Sterner's 556 Fifth Avenue gallery. The Paris-educated Best-Maugard developed theories of basic form derived from Aztec and other indigenous styles. He traveled to the United States and wrote and published a series of books, beginning with *A Method for Creative Design* in 1926, laying out his design theories. Best-Maugard divided his method between step-by-step instruction for beginning students and a philosophic discussion of his theories on art. His system reduced every design in the world to seven symbols: circle, half-circle, wavy line, *s*-form, zigzag, straight line, and spiral. Best-Maugard occasionally visited Stettheimer in her New York studio and discussed his ideas with her. Several biographers have suggested that he significantly influenced her work, but for twenty years Stettheimer's style had been independently evolving along the same lines as Best-Maugard's teachings. Their works share such characteristics as linearity, simplicity, and avoidance of right angles, and were based on primitivizing and decora-

55. *Portrait of Adolfo Best-Maugard*, present whereabouts unknown.

56. *Music* (1920), 70 x 52 in. Rose Art Museum, Brandeis University. Waltham, MA; Gift of Mr. Joseph Solomon, New York.

tive traditions. It is doubtful that Best-Maugard's influence caused any crucial alteration in Stettheimer's already mature style of working,[32] although the two artists admired one another's work and may have had a milder mutual influence. Within the social circles the Stettheimers frequented, artists often painted portraits of each other. Best-Maugard painted Stettheimer's sister Ettie around 1920 wearing pantaloons and a fringed shawl, and standing in the moonlight in front of a garden statue resembling a Nadelman sculpture. The same year he painted a portrait of Florine. She is shown wearing a black hat and loose-fitting beige smock and holding her palette and paint brush. She stands beneath a red garlanded curtain on a small red rug bearing her first name. Her rather dour, neutral figure floats against an indeterminate celadon background filled with huge, stylized flowers.[33]

Around 1920, Stettheimer painted Best-Maugard's portrait, incorporating numerous images that were subsequently included in his published book (fig. 55). She depicted the artist as a long, lean, elegant figure gesturing toward seven symbols that she wittily arranged on his outstretched palm like an abstract flower. Best-Maugard is shown standing on a coiled rope device, similar to one he recommended in his book for drawing a bow knot. Stettheimer signed her name and that of her subject on a ribbon in the center of the painting.[34] Directly behind Best-Maugard she placed a cornucopia spilling pineapples, grapes, corn, lilies, assorted flowers, a snake, and a white plumed bird. The latter was probably intended to represent Quetzalcoatl, the plumed serpent of Mexican folklore. In the background, tracks of a tiny locomotive, painted in the manner recommended in Best-Maugard's manual, pass through an arch with Mexican and American flags. At the left, a still life with a statue is placed before a brightly decorated Mexican print fabric and leafy trees. At the right, a figure resembling one of Van Gogh's farmers walks toward the slowly descending sun, which shines brightly on the horizon. Above, two huge curtain tassels, again resembling those reproduced later in Best-Maugard's manual on creative design, suggest a theater curtain about to be brought down on the scene.

In 1920 Stettheimer painted a fantasy based on her memories of Nijinsky dancing with the Ballets Russes. *Music* (fig. 56) is among the most "surreal" of her paintings, and it reveals the artist's fascination with Freudian theory, self-consciousness, and dreams, concepts that were prevalent among fashionable circles of the avant-garde.[35] The significance of dreams and dream imagery to many theorists and artists during the modernist era lay in Freud's definition of the dream as representing that which was repressed in waking life. Dreams unlocked the unconscious and, through exploration of their manifest and latent content, provided access to the past as well as a relatively safe means of diagnosing and criticizing the present.[36] Henri Bergson claimed that "a human being who *dreamed* his life instead of living it would probably thus keep constantly in his sight the infinite multitude of details of his history," and Marcel Proust noted in the first volume of *A la Recherche du temps perdu*, "A sleeping man keeps arrayed in a circle

around him the stream of hours, the ordering of years and worlds." In his novel *La Prisonnière*, published in 1923, Proust described a girl sleeping: "She reminded me of a long blossoming stem that had been laid there . . . those drooping lids introduced into her face a perfect continuity, unbroken by any intrusion of eyes." In France Edmund de Goncourt had published a novel in which he lay half-asleep in his bed and imagined the bed's former inhabitant, the Princesse de Lamballe, and figures from a nineteenth-century Abusson tapestry coming to life, cavorting, and dancing around him.[37] In later years, Stettheimer placed *Music,* with its elaborate carved frame, in her boudoir so that it could be seen from her lace-veiled bed. Thus, as she lay down to sleep, she could watch herself dreaming (fig. 57).

In *Music*, the artist lies on a canopied bed, which is placed, like a theater box, at the left of the composition (fig. 58). As a

57. Stettheimer's bedroom, with artist-designed furniture. Florine Stettheimer Papers, Rare Book and Manuscript Library, Columbia University.

sleeping figure, Stettheimer is vulnerable to and unconscious of the watchful eyes of viewers (both Nijinsky and ourselves), and she lies suspended in dream time. This is her most essential self: removed from the mundane vicissitudes of conscious life, she is able to give free rein to her imagination and inner life. In this duality of watcher and watched, Stettheimer's painting functions as a "veiled" metaphor for perception, differentiating between vision, voyeurism, appreciation, and aesthetic response. All around her, within an illusionistic space, are images from her favorite productions of the Ballets Russes: Adolphe Bolm, in costume and body paint as the Moor in *Petrushka,* lies on his back, with arms and feet in the air (like the white dog in *Picnic* or Bolm's pose in *Sunday Afternoon in the Country*) juggling a coconut. In the center of the painting, surrounded by a nimbus of light, Nijinsky stands with his raised arms in a well-known pose from his performance in *Le Spectre de la Rose* (fig. 59).

Stettheimer deliberately took liberties with Nijinsky's costume in order to intensify the dancer's androgyny. Although the pose is familiar, Nijinsky's costume is quite different from the one he wore in the production of *Le Spectre*. Instead of a leaf-covered tunic, the artist placed Nijinsky in a one-piece, strapless body suit. Its bodice front reveals the impression of a woman's breasts and emphasizes the dancer's small waist and well-muscled legs. The figure

58. Detail of Florine asleep, from *Music*, Rose Art Museum, Brandeis University, Waltham, MA; Gift of Mr. Joseph Solomon, New York.

59. Detail of Faun, from *Music*, Rose Art Museum, Brandeis University, Waltham, MA; Gift of Mr. Joseph Solomon, New York.

poses with his feet *en pointe*, a position that was foreign to male ballet dancers and not part of Nijinsky's repertoire. By contrast, Stettheimer also emphasized the dancer's muscular chest and biceps as indications of his masculine identity. Nijinsky is clearly the star of Stettheimer's dream. In the painting, the dancer glances flirtatiously from under his arms at the sleeping figure of Stettheimer at the left. Although one is standing and the other reclining, their similarly tilted heads and crossed ankles create a resonance between the two figures. In daily life, Stettheimer studiously avoided all forms of physical contact and overt sexuality in her dress and actions.[38] Only in her dreams, paintings, and poetry did she allow herself manifest references to sexuality, desire, and difference or "otherness." She often effected this, as she did in *Music*, through transferring such imagery onto the figure of a male.[39]

In the painting, an unidentified pianist sits with his legs raised in front of a highly stylized instrument at the right, behind which hangs a colorful, flowered shawl or tapestry reminiscent of Bakst's design schemes for the Ballets Russes. It is amusing to compare the painting to a contemporary Christmas card that Bolm sent to the Stettheimers (fig. 60). On the ink-drawn card, Bolm's son, Olaf, dances at the right, while Beatrice Bolm sits at a grand piano whose bulbous legs, though not terminating in points as in Stettheimer's work, nonetheless resemble those of the piano in *Music*. The costumed Bolm, now the central figure, stands

against an elongated leafy stalk that, with the stars and lettering overhead, creates an impression not unlike that of the attenuated tree to the right of center in Stettheimer's work. As in Bolm's card, each figure in the painting is in a reverie and thus isolated psychologically and physically from the others in his/her own reverie. Like the new forms of music evolving during the 1920s, the figures in Stettheimer's painting are self-referential, nonsequential, disharmonious, improvisational, and individualistic.

The cultural renaissance of the 1920s set the stage for a tremendous music and dance boom reflecting the dynamism of the modern age. In 1924 the musician and critic Virgil Thomson wrote the first serious article analyzing jazz. According to Thomson, "the essence of the thing remains free melody with a fox-trot

60. Christmas card from Adolphe Bolm to the Stettheimers. Yale Collection of American Literature, Beinecke Rare Book and Manuscript Library, Yale University.

rhythm underneath. The rhythm shakes, but it won't flow. There is no climax. It never gets anywhere emotionally. . . . In that it is analogous to the hoochie-coochie beat."[40] Thomson's description equally fits Stettheimer's paintings. In an article about her work, Carl Van Vechten observed: "This lady has got into her painting a very modern quality, the quality that ambitious American musicians will have to get in their compositions before any one will listen to them. At the risk of being misunderstood, I must call this quality jazz. Jazz music, indubitably, is an art in itself, but before a contemporary American can triumph in the serious concert halls he must reproduce not the thing itself but its spirit in a most lasting form. This, Miss Stettheimer has abundantly succeeded in doing."[41]

The notion of performance runs through all of Stettheimer's mature work, from her early ballet *Orpheus* through her painted compositions, structured so that they seem to take place on a stage that is viewed from above. In earlier works, such as *Sunday Afternoon* and *Picnic*, the figures are in static positions; in later works, they leap and cavort across the canvas. The artist as choreographer has her performers moving to some inner rhythm against her synthesis of drama, movement, setting, and implied music.

In the 1920s, there quickly developed among avant-garde upper classes both in New

York and in Paris a taste for the "exoticism" of African-American culture. In Paris, Josephine Baker replaced Diaghilev in the forefront of avant-garde high culture. Black cabarets opened up all over Manhattan, as dances like the Black Bottom and the Charleston swept across two continents. *Shuffle Along,* which opened in 1923, was the first Broadway show produced and written by African Americans. It incited a craze for Negro music, speech, and dance styles. Even Stettheimer tried her hand at writing a poem in what was considered at the time to be "Negro dialect":[42]

> *The happy bride dropped all*
> *her clothes—*
> *Then powdered her broad*
> *but delightful nose—*
> *"An dis is what for is*
> *my bridal veil*
> *Covering me all up—*
> *I look quite pale"*
> *chuckled blissfully dusky ebony*
> *black Rose.*[43]

The poem is interesting not only in its perception of racial difference but also in the greater freedom and consciously ironic attitude Stettheimer accords Rose, her subject. Many of Stettheimer's friends in the arts were drawn to African-American music and imagery during these years as one component in their search for what was truly "American."[44] In all probability, Stettheimer's close friendship with Van Vechten introduced her to issues of African-American culture, although her interest was more aesthetic than political. Van Vechten was among the first whites to promote "Negro" culture. His parties, to which he invited the Stettheimer sisters, were famous for their racial mix of celebrities, from Paul Robeson and Bessie Smith to Helena Rubinstein and Somerset Maugham. Van Vechten himself spent a great deal of time in Harlem night clubs and literary salons during the 1920s, often accompanied by the caricaturist Miguel Covarrubias. A popular song of 1924, "Go Harlem," urged listeners to "go inspectin' like Van Vechten."[45] In 1926, Van Vechten published a novel, *Nigger Heaven,* which he dedicated to the Stettheimer sisters. The title refers to the slang expression for the topmost gallery in theaters, which was generally restricted to people of color. The novel explored the richness and authenticity of Harlem society, and the difficulties African Americans encountered in mixing with the white world. As a way of thanking the author for the dedication, Stettheimer wrote him a poem that she inscribed, "Dear Carlo, this is to you in admiration of your courage":

> *Darling Moses*
> *Your black Chillun*

Are floundering
In the sea.
Gentle Moses
The waves don't part
To let us travel free.
Holy Moses
Lead us on
To Happyland
We'll follow
Thee.[46]

In her diary, on August 4, Stettheimer copied out the poem and noted that she sent it to Van Vechten a propos *Nigger Heaven,* which she stated was "honest and courageous but I fear it will do them no good." This is the artist's most overt statement of advocacy for African Americans and desegregation. She never publicly voiced strong support for any social issues, and she was no more politically active on behalf of African-American causes than feminist ones. Yet her respectful empathy and singular ability to image what is, in Toni Morrison's words, "not the self"[47] can be inferred by the manner in which she portrayed black figures in her paintings, from the dignified, strong bearing of Jenny in *Jenny and Genevieve* to the elegantly graceful figures in *Asbury Park South,* painted in 1920.[48] As she later declared to Henry McBride, this was "long before [Van Vechten] had a colored salon."[49] A brief note in a letter written to Van Vechten from Atlantic City indicates that Stettheimer shared with him some interest in learning about and promoting African-American culture: "And there is a colored elevator man here, who is a poet—and whose poems I am going to give you—and I am sure they will amuse you, as much as the painting of the colored maid will me."[50]

During this period, the public beaches along the New Jersey coast were often segregated, with separate areas for people of color and for Jews. A stretch of the shore including Elberon, Long Branch, and Sea Bright became a German-Jewish colony. Termed "the Jewish Newport," it was where the Seligmans, the Guggenheims, and their relatives had houses resembling Italian palazzos, complete with gardens fashioned after those at Versailles. During the summer of 1920, the Stettheimers rented an old cottage in Monmouth Beach, where friends including Duchamp, Thévenaz, the Marquis de Buenavista, and Van Vechten often came to visit. On one such occasion, Van Vechten suggested that the group visit Asbury Park South, a "colored" beach. That same year, Stettheimer captured her memories of the trip on canvas (fig. 61).

The main focus of *Asbury Park South* is on the black beachgoers, who are delighting in their day at the shore. On the left, three lovely flappers saunter arm in arm, swinging beaded bags and wearing fringed gowns to accentuate their long, slim legs. At the right, a liv-

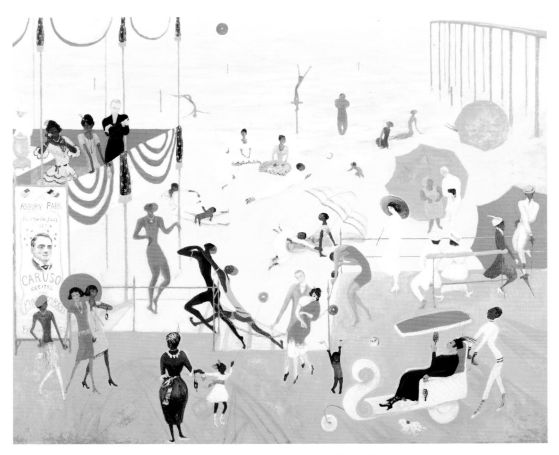

61. *Asbury Park South* (1920), 50 x 60 in. Collection, Fisk University, Nashville.

62. *Russian Bank*, revised version, 40 x 36 in. Virginia Museum of Arts, Richmond. Gift of Miss Ettie Stettheimer.

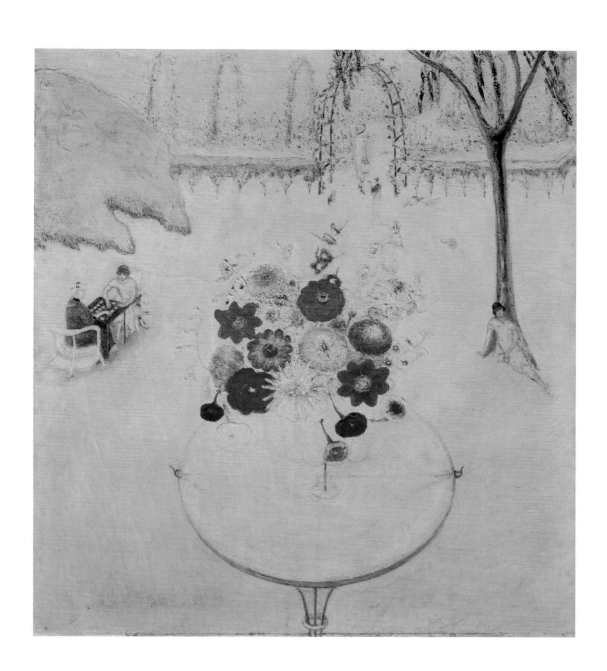

eried man, pushing an open cart on the boardwalk, escorts a dignified dowager with an elegant egret-feathered hat. An extraordinarily graceful man, with a young woman hanging on his neck, prances through the painting's middle ground; while in front, a young girl impatiently tugs at her mother's hand, urging her toward the beach. In the background, various well-dressed families relax on the sand at low tide, playing with children or watching a group of acrobats balance on a thin wire.

Stettheimer arranged the painting's few Caucasian figures in a straight line running from the work's front center to the right middle ground; and with the exception of Fania Marinoff, who was celebrated for her exoticism, the Caucasian figures tend to be stiff and angular in comparison with the African Americans. Van Vechten stands at the left, looking on from a decorated reviewing stand that supports an old poster advertising Fourth of July fireworks and a concert by Enrico Caruso. Slightly right of center, Marinoff, escorted by Marcel Duchamp, watches a tiny black boy exuberantly wave two small American flags. Directly behind them, Paul Thévenaz bends over a box camera and attempts to photograph a black man wearing a gold medallion. Always the observer, Stettheimer watches these proceedings from the right and shields her face from the bright sun's reflection off the sand. Avery Hopwood, the only white figure entering the cordoned-off beach, stands with a notebook tucked under his arm. He converses with a short, stout woman in a bathing dress and cap.

The work is startling. The bright yellow-orange color of the sand caused one reviewer to describe it as "a revel of unabashed color . . . a glorious joke to be appreciated by all except the concession owners of that famous resort."[51] "Florine Stettheimer has snap," wrote another. "She delights in it. . . . *Asbury Park* is a beach scene . . . sunlight which makes you close your eyes. She feared you mightn't see the picture so she added gilded flounces to her frame (to the consternation of those who were so unfortunate as to have their work hung near *Asbury Park*.) The art of Florine Stettheimer is entertaining."[52] Henry McBride, writing for the *New York Herald*, commented that the bursts of sunlight in Stettheimer's "careful and realistic study" were so bright that they caused John Sloan's adjacent painting, *Picnic on the Ridge*, to appear dark. "There never was such sunlight as it appears in this picture. It is so powerful that many persons with normal sight assure me that they can see great golden sun rays protruding beyond the frame."[53]

A second striking aspect of *Asbury Park South* is the elegant manner in which the artist rendered the figures. Most appear as simple gestures of sinuous movement. No one in the painting, except possibly Van Vechten in the reviewing stand (whose crossed arms are echoed by a muscular black man executing a plié in the far right background), is completely still and without movement or gesture. Everyone preens, stretches, prances, saunters, bends, or curves their arms and legs into momentary poses. This gives an impression of a hum of activity, a subtle but significant variation on Stettheimer's *multiplication virtuelle*, through which the

artist continued to explore notions of temporality. The composition's center consists of empty sand. The various figures scattered across the picture plane appear to be moving clockwise in a huge, shifting circle, like small, individual planets slowly revolving around a central, bright orange sun. Through the painting's use of color and movement, the viewer can almost hear the laughter and gaiety along the shore. A year later, in June 1921, Stettheimer composed the following poem, reinforcing her overall impressions of the beach:

Asbury Park
It swings
It rings
It's full of noisy things.
Its stretched
along the water
on a boardwalk.
Hooray
We are gay
is what the crowds say
lying stretched on land
along the water's sand.[54]

Although the African-American figures in *Asbury Park South* now may appear to be derogatory caricatures, the artist did not intend them so, as is clear from their lack of self-consciousness and proud bearing. Instead, she painted the figures with natural stylishness, poise, grace, pride, and vivacity. An unsigned note among the Stettheimer papers in the Columbia University library says that "Miss Florine herself thought this scene and these people very beautiful and the picture becomes a statement of her affection." Stettheimer's work was not meant either as social commentary or to decry the less fortunate circumstances under which many African Americans lived, nor was she painting a fantasy image of black and white cultures amicably coexisting. Instead, *Asbury Park South* shows African Americans existing and reveling in their own context, like any group at the beach. A decade later, Stettheimer would return to this idiom of depicting figures in a context different from the usual, predominantly white male-dominated one as a means for portraying women in several paintings.

Throughout the early 1920s Stettheimer submitted paintings to various exhibitions in New York and Philadelphia, where they were generally well received by artists and critics alike. On March 23, 1921, Gaston Lachaise wrote to her that he was sorry to learn that she had hurt her arm. He was impatient for her to recommence painting, he said, for the purely egotistical reason that he had returned several times to see *Asbury Park* at the Independents exhibition and, after viewing many sad and boring works, had found her painting "radiant."[55] In May, Florine and Ettie went to Philadelphia to see her paintings hung at the Pennsylvania

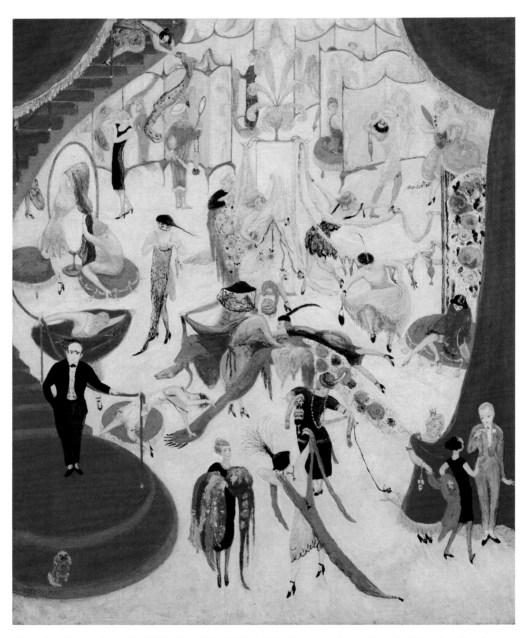

63. *Spring Sale at Bendel's* (1921), 50 x 40 in. Philadelphia Museum of Art: Given by Miss Ettie Stettheimer.

Academy of Art exhibition of new "American"-style painting. In his review Henry McBride declared, "The war has done a great deal to emancipate us and there are signs everywhere that we will shortly originate our own fashions . . . there are signs of it in this exhibition . . . [Demuth, Weber, Stella] and the amusing episodes from current history by Miss Stettheimer."[56]

In 1921, the Stettheimers again spent the summer at André Brook, where Florine painted a series of still lifes in which increasingly stylized flowers serve as the central compositional motif (fig. 62). A profusion of bright red, orange, and yellow flowers forms the center of another composition from 1921, titled *Russian Bank*. The scene is the André Brook garden. The title is based on the name of the card game that Rosetta and Carrie, seated in bright yellow chairs, are playing at the left side of the composition.[57] The artist is seen holding a watering can and heading toward the same area of the back garden that she occupied in her earlier *Sunday Afternoon in the Country*. McBride later recalled that Rosetta often sat in the garden playing Russian Bank while "her giddy daughters enacted the roles of Julie de L'Espinasse, Mme du Défend and Mme de Staël in modern dress."[58]

In September the Stettheimers returned to New York City. The spirit of the times was a craving for the new and a flaunting of social norms and mores.[59] Ratification of the Nineteenth Amendment in 1920, granting the franchise to women, ushered in changes in women's fashions and a burst of growth in the beauty industry. Rigid silhouettes of high-necked and ankle-length dresses gave way to low-cut, high-hemmed, unstructured sheaths that followed the body's natural contours. Dieting became chic, and even the suggestion of a curve was derided as demonstrating lack of self-control and nutritional incontinence.[60] Both younger and older women openly applied cosmetics, abandoned corsets, and bobbed or shingled their hair.

The Stettheimer sisters were in their early fifties at this time. Florine's paintings demonstrate, however, that by 1917 the three women already had assumed a "modern style" of attire that they often individualized to suit their disparate personalities. Friends remember Carrie in hobble skirts or Callot Soeurs gowns of "the utmost chic" with trailing satin or taffeta or velvet gowns adorned with lace. Ettie favored flowered brocade or black lace and, on occasion, a red wig worn to "brighten a dull party." The boyish flapper look suited Florine's slim figure, and bobbed hair allowed her to retain a youthful image well into her sixties. On one occasion, her friend Max Ewing spied her wearing "white satin trousers underneath a flowering overdress of spangled net."[61] The slim, boneless figures in Stettheimer's American paintings display the sensuous slouch affected by young flappers.

In 1921, Stettheimer made one of her most overtly humorous and ironic paintings, *Spring Sale at Bendels* (fig. 63), in which she turned a rather mundane subject into a fantastic balletic comedy of vivid color and frenzied action. The painting captures a generally unseen

aspect of daily life among upper-class women. At the same time, it destroys any notion of these ladies as sedate models of controlled, decorous behavior. As one reviewer noted, "It must be true since all Miss Stettheimer's works are autobiographical."[62] The ironic character of the painting increases when one remembers that the artist was a member of the same social circle she was ridiculing.

In *Spring Sale*, a voluminous gold-fringed red curtain, pulled aside on either side of the composition, reinforces the idea that viewers are gaining behind-the-scenes access to a special performance. The composition, like so many of Stettheimer's most successful works, is arranged like a stage set, with layers of overlapping activity drawing the viewer's eye back past a variety of paneled and mirrored screens. Slim saleswomen in plain black dresses patiently wait while their customers prance, whirl, twist, and contort their bodies in order to glimpse their newly clothed figures.

Each woman is isolated in her self-absorbed reverie. Seeking the very latest fashions, they act out a frenzied dance across the floor, leaping up to catch sight of elaborately patterned stockings under a fringed skirt, holding up a diaphanous, form-fitting lace overdress, adjusting the trim across a broad posterior, or struggling to disentangle their hat from a slinky green sheath. The painting contains many signs of wealth: the sweeping, carpeted staircase, the tuxedo-clad store manager, a Pekinese in a monogrammed sweater, and masses of luxurious fabrics. Nonetheless, the composition resembles a mad brawl, with bargains as passionately contested as though the scene were taking place on the Lower East Side. In the middle ground, a woman in an elegant feather hat, in the ardor of acquisition, practically throws herself across a table of sheer fabrics, attempting to grab one before it is noticed by her turbaned and veiled neighbors.

Most reviewers delighted in the painting. In a typical comment, David Lloyd said that Stettheimer had sent in "one of the genuine joys of the exhibition."[63] The box-seat perspective and circular composition of *Spring Sale* were emulated two years later by the illustrator Tony Sarton on the cover of the November issue of *Vanity Fair*. Despite their highly populous compositions (Stettheimer's painting includes more than twenty-six figures), both works avoid a feeling of claustrophobia by the scattered placement of the figures and the use of a flat, light-colored background. Although there is no direct evidence that Sarton's illustration derives from Stettheimer's painting, comparison of the two indicates once again how closely Stettheimer's work replicates the rhythm and popular culture of the moment.[64] Sarton's costumed, dancing figures kick up their heels and gesticulate in a manner much like that of the women in *Spring Sale*. His composition is framed by two semicircular gathered curtains that are temporarily parted so that the scene below can be viewed by the amused and costumed audience seated in the box seats along the illustration's lower perimeter.

5

Friends and Family: Portraiture

During the 1920s, focus on personal psychology gradually replaced notions of community. One of the manifestations of this increased emphasis on individual and subjective experience was the adoption of portraiture by avant-garde artists, writers, and popular illustrators. At the same time, Stettheimer, having achieved facility in handling her new style of painting, turned almost exclusively to portraiture.

Why did the experimental avant-garde turn to a genre that in recent history had been considered conservative and pedestrian? As Wendy Steiner has observed, portraiture as a genre epitomized many of the problems of modern art. The main issue of portraiture—individual identity—lay at the heart of the modernist concerns explored by William James, Marcel Proust, Sigmund Freud, and Henri Bergson. For Bergson and others, portraiture involved an exploration of the sitter's motives and circumstances as well as the motives and reactions of the artist: "Our eye perceives the features of the living being, merely as assembled, not as mutually organized. The intention of life, the simple movement that runs through the lines, that binds them together and gives them significance, escapes it. This intention is just what the artist tries to regain, in placing himself back within the object by a kind of sympathy, in breaking down, by an effort of intuition, the barrier that space puts up between him and his model."[1] The notion of identity—how the sitter is "known" apart from the perceiver, and the problems inherent in portraiture as a work of art and as a document—were explored at length by artists and writers on both sides of the Atlantic.[2]

Gertrude Stein's "word-portraits," written during the first decade of the century, were an important influence on many literary and visual modernists. Stein wrote her portraits by arranging unrelated words in an insistent, repetitive style intended to capture the psychological essence of her subjects rather than any physiognomically visible "truths." Her main contribution to the work that followed was this differentiation between modern notions of portraiture and the traditional concept of likeness. In a 1912 issue of *Camera Work*, Alfred Stieglitz published Stein's word-portraits of Matisse and Picasso.[3] He prefaced the work by noting that they functioned on an evocative rather than a narrative level, and that they relayed subliminal experience as well as optical facts.

During the late 1910s and early 1920s, artists in the United States and Europe sought to create visual equivalents for Stein's literary explorations. These "object portraits" exclude all figurative and retinal images of the sitter.[4] Instead, the sitter's personality and character are implied by salient objects, numeric equations, and letters that are collaged or grouped in a manner intended to expand and clarify references to the sitter's personality or vocation. The French artist Francis Picabia was already familiar with Stein's work when he returned to New York in 1915, two years before he appeared in Stettheimer's "portrait" of Marcel Duchamp's birthday party. By borrowing from advertisements, media images, and mail-order catalogues, Picabia created "mechanical" portraits in which he represented his friends Paul Haviland, Marius de Zayas, and others by machinery parts and reproduced them on the pages of Stieglitz's magazine *291*. In his portrait of Alfred Stieglitz, for example, alluding to the photographer's German origins, Picabia represented him as an old-fashioned camera pointing toward the word "Ideal" that is written in fraktur.

64. Marius de Zayas, *Portrait of Alfred Stieglitz* (ca. 1912–13), charcoal, 24¼ x 18⅝ in. Metropolitan Museum of Art; The Alfred Stieglitz Collection, 1949 (49.70.184).

Between 1904 and 1910, Marius de Zayas explored the conventions of caricature through widely published political cartoons and social satire. De Zayas alternated between traditional representational caricatures, in which he exaggerated prominent facial or body features, and a radically new form of "absolute" caricature, in which a specific incident or psychological insight triggered an image that retained little obvious reference to the physical description of the subject (fig. 64). An unidentified writer for *The Bang* called de Zayas "the exposer of the soul," because his portraits concentrated less on surface appearance than on representations of the sitter's interior visage. In 1914 *Camera Work* published a series of these "relative" and "absolute" portraits caricaturizing members of the Stieglitz circle. In describing the works, de Zayas wrote, "These caricatures are not the expression of my physical self, but the intrinsic expression, as I perceive it, of the individuals themselves." He further claimed that the geometric forms and abstract equations used in making these portraits represented the equivalents and spirit of his subjects.

Other American artists, many of whom were regular members of the Stieglitz circle and friends of the Stettheimers, also worked on variations of the object portrait during the next decade. Marsden Hartley became friendly with Gertrude Stein in 1912. Later, in Germany, he executed a number of boldly colored abstract paintings in which numbers, letters, and military insignia were meant to convey "portraits" of a young German officer. A decade later, Charles Demuth, also a frequent visitor to Stein's salon, painted a series of portraits of artists

in the Stieglitz circle (fig. 65), as well as portrait homages to the poet William Carlos Williams, the playwright Tennessee Williams, and Stein. In some of these works, such as his poster portrait of Georgia O'Keeffe, the reference is clearly named in the composition. In others, such as his portrait of Bert Stern, the use of the calla lily as a metaphor for the female impersonator was obvious only to initiates and intimate friends.[5]

A significant characteristic of all of these modernist portraits was their self-consciousness and reciprocity. The artists and writers collectively understood the centrality of their role as avant-garde, and they felt justified not only in creating permanent records of themselves and their intimates but also in seeking new means of portrayal. The sitter was invariably a friend and colleague of the artist, and the procedure often involved artist and sitter exchanging portraits, as in the case of Picasso and Gertrude Stein, Stein and Virgil Thomson, and Duchamp and Stettheimer.

During the 1920s, Stettheimer also turned almost exclusively to portraiture, executing more than a dozen complex portraits of her family and friends.

65. Charles Demuth, Poster Portrait of Arthur Dove (1924), 20 x 23 in. Yale Collection of American Literature, Beinecke Rare Book and Manuscript Library, Yale University.

Charles Demuth described her paintings as "free from the morbid chase of the real. . . . Portraits she calls them. . . . Portraits they are; only they are for the few. . . . Their sense of arrangement more than their color holds them together, although the color is good and very in our time—very of these states."[6]

Stettheimer's portraits reveal the same familiarity and self-consciousness as do works of the other modernist painters, but there are significant differences. One of the difficulties in categorizing Stettheimer's work is that it appears unlike contemporary work by modernist painters and illustrators. During the 1920s, for example, the work of O'Keeffe, Hartley, Demuth, and Arthur Dove grew increasingly abstract and simplified as single, central motifs dominated their compositions. The Stieglitz circle shared general spiritual concerns in their approach to art. They relied on Bergson's notions of intuition and evocation to push their painting closer to abstraction than Stettheimer would have tolerated. Stettheimer's paintings, in contrast, became increasingly figurative and compositionally cluttered. Unlike most of the American modernists, she avoided generalizing forms in her paintings and consciously sought specificity and detail. In addition, her portraits concerned themselves less with spirituality and inner expression than with factual aspects of her sitters' lives and accomplishments.

Although it is tempting to see the influence of Gertrude Stein and Dada object portraits,[7]

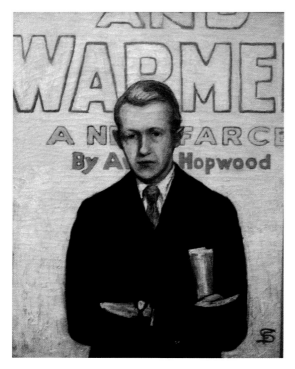

66. *Portrait of Avery Hopwood* (1915), The Hopwood Awards Program of the University of Michigan.

Stettheimer's portraits, like so much of her earlier work, represent an amalgam of techniques and conventions borrowed from the history of portraiture and contemporary avant-garde practices. In contrast to the works of her contemporaries, Stettheimer's portraits are more literal and retain a central, figurative image. Each portrait was conceived as a mini-biography, recording the inner world of the sitter through the unfolding of his or her experience in a succession of elaborate situations. The multifarious objects and references surrounding the central figure became the vehicles for synesthesia in which the past, present, and future commingle, offering clues to the sitter's life and personality.

One of the most anomalous works in Stettheimer's early career, and her first mature portrait of a man, is her 1915 painting of the playwright Avery Hopwood (fig. 66). When the Stettheimer women returned to New York in 1914–15, "driven hitherward by rumors of war," Avery Hopwood introduced them to actress Fania Marinoff and her husband, Carl Van Vechten. A decade younger than Stettheimer, Hopwood graduated from the University of Michigan in 1905 and came to New York with ambitions to produce commercial theater and make a great deal of money.[8] During his lifetime he wrote at least thirty-three plays. One, *The Gold Diggers*, was the inspiration for countless other plays and films; but his greatest success was a bedroom farce called *Fair and Warmer* that opened to rave reviews at the Eltinge Theater on November 6, 1916.[9]

Hopwood figures prominently in Stettheimer's diaries of 1915-16, and there may have been a mild flirtation between them.[10] During the fall of 1915 the artist commemorated her friend's success by painting his portrait, posing the top three-quarters of his body against a large sign publicizing *Fair and Warmer*. Hopwood's features are realistically and delicately portrayed in subtle tones, as though Stettheimer copied the composition from a publicity photograph. Hopwood faces front and wears a traditional business suit. Behind his head, fragments of words identify the title of his successful play. In addition, portions of his name loom over his shoulders. Just enough of the letters are cut off by the canvas's borders that their

meaning is apparent only to viewers already familiar with Hopwood's first name and the play's title. Stettheimer's experimentation with combining images and words in this manner curiously foreshadows her friend Charles Demuth's poster portraits, painted a decade later.[11]

The Hopwood portrait demonstrates that by 1915 Stettheimer was already interested in notions of likeness created by juxtaposing elements of the sitter's vocation and habits to assist in identification. As she increasingly focused on portraiture in the 1920s, Stettheimer's imagery became more complex. In addition to including clues as to the sitters' career achieve-

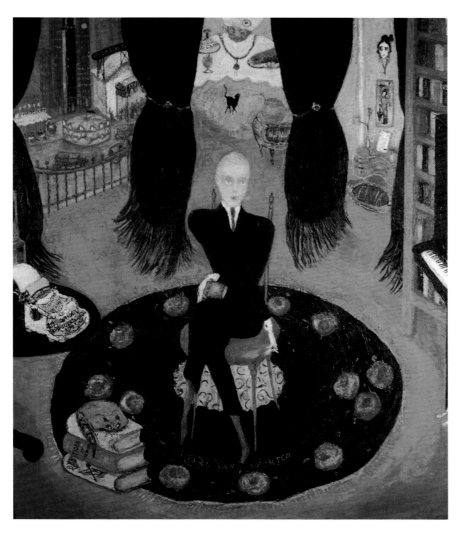

67. *Portrait of Carl Van Vechten* (1922), 28 x 26 in. Yale Collection of American Literature, Beinecke Rare Book and Manuscript Library, Yale University.

ments, habits, and physiognomy, she added symbols of their personality. In these portraits, sight became insight, as Stettheimer freely synthesized attributes of the sitter's visual appearance, character, and behavior with elements in the environment recalling specific incidents and episodes in their lives. The resulting portraits convey intellectual as opposed to visual reality. They include features of her sitters that were known to be part of their makeup, regardless of whether such traits and features could be visually present at the same time.

Stettheimer's portraits rely on the sitters' experiences over time and on specific details and events which, in turn, imply a temporal unfolding. The portraits should be read as visual texts which, although lacking a story line, nonetheless reveal themselves through the accumulation and interaction of details. To contribute to these "readings," viewers need be familiar with the sitter, and indeed Stettheimer increasingly controlled the audience for her works, inviting to her unveilings only friends and intimates. Recalling his years with the Stettheimers, Henry McBride later noted that the "sitters" for Stettheimer's portraits, many of whom were not aware that they had been chosen for that honor, were encouraged to invite their own guests to the debut parties at the Beaux Arts studio. What followed resembled a performance, as sitters and their guests bandied interpretations of the symbolic aspects of the paintings.

With few exceptions,[12] the closest correlation to the portrait series that Stettheimer executed in the 1920s lies not with the modernist painters but with earlier *portraits à l'apparat* by Manet and Van Gogh, and with novels by Joseph Conrad, James Joyce, Marcel Proust, and her friend Carl Van Vechten. In their novels, the narrators' perceptions actively contribute to their "readings." The protagonist's personality and lifestyle is revealed not through obsessive physical description but through the character's actions, reactions, and the contexts in which they are shown. Throughout her mature work, the setting and context for a figure or an event was critical to Stettheimer's aesthetic. In her paintings before 1920, she continually included sufficient detail to make not only the figures but also the site clearly identifiable, whether André Brook, Asbury Park South, or Bendel's department store. By the 1920s, this emphasis on specificity combined with Stettheimer's sensory, emotional, and remembered reactions to her portrait subjects.

When painting her portrait of Van Vechten in 1922, Stettheimer seeded her composition with myriad references to his life and to that of his alter-ego, the protagonist of his autobiographical novel *Peter Whiffle, His Life and Works* (fig. 67).[13] The resultant double portrait is one of Stettheimer's most successful paintings. In order to catch the portrait's many hidden references, which would have been obvious to their mutual friends, it must be read together with the novel, which was completed on April 29, 1921, and published the following year. Van Vechten inscribed a copy "For the sisters Stettheimer, this quest of disillusion." Peter Whiffle, like the author, was born in the Midwest in the 1870s. He soon runs off to New York

and Paris, where he seeks the purpose of life. In the opening scenes of the novel, Van Vechten and Whiffle meet while Van Vechten is having his portrait painted by Martha Baker, whose capturing of her sitter's flaws causes the author to note, "Posterity might have learned more from such portraits than from volumes of psychoanalytic biography."

Echoing Proust's and Joyce's notion of real time operating simultaneously on multiple levels, Van Vechten's Peter Whiffle declares that great art is not linear, just as "one might write a whole book of two hundred thousand words about the events of an hour. And what a book! . . . My intention is not to define or describe, but to enumerate. Life is made up of a collection of objects, and the mere citation of them is sufficient to give the reader a sense of form and color, atmosphere and *style*. And form, style, manner in literature are everything; subject is nothing. . . . All great art is a matter of cataloguing life, summing it up in objects."[14] Many clues to the iconography in Stettheimer's portrait of Van Vechten can be found in the "impressions and objects" found in Van Vechten's loosely autobiographical novel. At the opening of *Peter Whiffle*, Van Vechten (who is the narrator) is charmed by Whiffle's Paris apartment, with its ornate Louis XVI candlesticks, tables piled high with pamphlets, heaps of notebooks and stacks of books, and by his attitude toward life, which, like nature and art, is "always presenting two or more faces."

As the novel progresses, Van Vechten observes Whiffle caught up in many different causes and interests but never completing or accomplishing anything. The years pass; Whiffle experiments with assorted drugs and avidly reads the Book of the Dead and various Diabolists. When the author next encounters his protagonist, Whiffle is involved in satanic rituals, accompanied by a black cat named Lou Matagot, from the Provençal word for the Cat of Dreams and Sorcerers. In a room described as filled with amulets and talismans, stuffed serpents and divining rods, and " everything . . . that David Belasco would provide for a similar scene on the stage," Whiffle attempts to resurrect the spirit of the fiend Mersilde by combining various potions in a brass chafing dish.[15] The dish explodes, killing the cat and sending both men to the hospital. When he visits Whiffle for the last time, Van Vechten finds him terminally ill, having "curled himself into a sort of knot," smoking Fatima cigarettes, and declaring that the purpose of life is simply to live as fully as possible, like a cat, the only animal with true centeredness in itself. After Van Vechten's novel was published, Stettheimer wrote him a poem in which she noted her amusement with the many "portraits" concealed in it:

Carl
Carlo
Carl Van Vechten—
There is Fania
There is Peter
There is Mabel

There is Edna
There are cats
Past cats
Present cats
Future cats
There is music—
However
There are
Carl
Carlo
 Carl Van Vechten.[16]

Like Whiffle in his last incarnation, in Stettheimer's painting an elegantly (and unrealistically) thin Van Vechten sits with his arms and legs curled "like a knot," so that his upper and lower body turn in opposite directions. Van Vechten holds a copy of his fictionalized autobiography and stares into space while exhaling the smoke from a short cigarette held in his right hand. The smoke curls slowly upward through the composition and forms a massive smoky area in which Lou Matagot preens. Above, a second, more robust figure of Van Vechten enters the composition, wearing a turban and carrying a Victorian leaded lamp and a platter of food. Set off by heavily fringed curtains as though a dream or a spirit, this figure probably refers to both the drug-induced rituals conducted by Van Vechten and Whiffle, and to Van Vechten's reputation among friends for preparing a fine cordon bleu and his tendency to gain weight.[17] The painting is ablaze in reds and yellows offset by stark black forms. Van Vechten later noted that Stettheimer's use of the black is the "keynote" that draws all of her portraits together into a unified series.[18]

At one point in *Peter Whiffle*, further complicating the boundaries between reality and artifice, Van Vechten suggests that he and Whiffle visit the studio of the artist Florine Stettheimer, whose work he is certain Whiffle will like. Instead, Whiffle buys an Abusson carpet with garlands of huge roses of pale blush color. In her painting, Stettheimer makes reference to this homage by placing the central figure of Van Vechten on just such a carpet, into which she incises his name with the back of her paint brush. The portrait contains numerous references to Van Vechten's work as dance and music critic and as novelist. A piano and extensive book collection stand at the right, and at the left a manual typewriter sits on the ground with a sheet of white paper inserted, ready for the author's next words. In place of the typewriter's keys, Stettheimer inserted her own name and the date of the painting, one letter per key.

At the lower left, one of Van Vechten's many omnipresent cats, its eyes staring out at the viewer, straddles a stack of novels. Two of the bindings reveal titles of other works by Van Vechten, *The Blind Bow Boy* and *A Tiger in the House,* a series of "tales" the author wrote

about cats. Florine Stettheimer sent Van Vechten a gouache painting of a bouquet of cat's eyes and "tails" as a thank you for a present of flowers (fig. 68). Below the bouquet she wrote:

This is my Birthday bouquet
From you Carl Van Vechten
You big man with cat's eyes
You collect cat's tails
From men and women
And bunch them together
And give them to other men & women
I am one of them and thank you.

In addition to referring to his favorite animal companions, the "tiger" in the Van Vechten household could be an allusion to his second wife, the Russian-born actress Fania Marinoff. Although the marriage lasted for decades, it was marked by frequent, often explosive arguments (fig. 69).[19] In her portrait of Van Vechten, Stettheimer included numerous references to Marinoff: a small shrine at the right including a throw rug bearing her name; her dressing table and a Japanese woodblock print, both props for one of her roles; and a hanging mask that bears a striking resemblance to photographs of the actress and to portraits of her by other artists, including Best-Maugard, who depicted her as a Spanish maiden. At the upper left side of Stettheimer's painting there is a terrace looking out over New York City, with its noisy cars, outdoor cafés, tall buildings, and the Belasco theater (complete with a marquis featuring Marinoff's name), and the Café d'Harncourt, which Van Vechten used to patronize. Henry McBride later noted that Stettheimer knew very well that Van Vechten frequented cafes in Paris and New York, but "apparently she did not hold it against him."[20]

Among the critics who responded favorably to Stettheimer's Van Vechten portrait was Penelope Redd, a journalist who, in a letter of May 5, 1922, wrote to the artist:

Do you wonder that the fact that you exist and comment in paint is incredible to me? . . . Your simultaneous comment in paint is much more skillful and timely than comment in words. I am thinking of "Chrome Yellow" and of "Peter Whiffle." Mr. Van Vechten's device of concealment behind his vocabulary is amateur in contrast to your agile mask of diffidence in painting. Your physical being is even presented in your compositions and yet you achieve detachment towards all the others who are engaged in cataloguing each other. You contrive the omniscient observer and without the mechanics. It is great and fine art.[21]

When the Van Vechten portrait was exhibited at the Society of Independent Artists in 1923, the reviews were enthusiastic. In the March 11 issue of the *New York Tribune* Burton Rascoe called it "the funniest work in the show . . . a thing of many colors, including gilt and

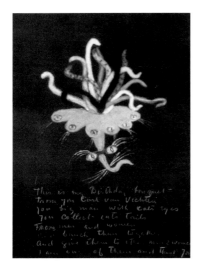

68. *Birthday Bouquet for Carl Van Vechten* (1924), gouache, 11½ x 8 in. Yale Collection of American Literature, Beinecke Rare Book and Manuscript Library, Yale University.

69. Carl Van Vechten and Fania Marinoff. Yale Collection of American Literature, Beinecke Rare Book and Manuscript Library, Yale University.

silver, and being, all in all, a dirty crack at Carl, but he says he thinks it is wonderful." Some reviews had racist overtones. Alexander Brook called the portrait

> *a remarkable piece of painting. The color is in defiance of that hackneyed phrase, 'good taste.' If one can appreciate a pair of colored people, dressed as they are on special occasion in gaudy colors, ear-rings, rings, shoe buckles, scarf pins, watch chains, and gold-headed canes, sitting within a yellow taxi-cab, then certainly one should be able to appreciate this portrait. It is beyond doubt the best canvas of hers that I have ever seen, and the black, which she uses exceedingly well, helps to make it so, again assisting my comparison between it and flashily dressed darkies. If France has its Marie Laurencin, we have our Florine Stettheimer and let us hope that we will be as proud of her as they are of Mlle. Laurencin.*[22]

Henry McBride noted that Stettheimer depicted Van Vechten "at his very best,—in fact, at the moment of creating 'Peter Whiffle.' His eyes dilate, his legs intertwine, his fingers clutch the air—he composes! The innocent public that always imagines writing to be mere play will be aghast at these revelations of the agonies of an artist, but Mr. Van Vechten's fellow scribblers will gaze at him in the moment of his apotheosis with peculiar sympathy."[23]

Van Vechten's *The Blind Bow Boy* was printed the following year, and Stettheimer suggested that he advertise the novel by placing her portrait of him in the window of Brentano's bookstore. *The Blind Bow Boy*, contains the first, albeit symbolic, sale of a Stettheimer painting. In the novel, Ronald, Duke of Middlebottom, purchases and hangs a Stettheimer painting of a bowl of zinnias in his West Twelfth Street home in Manhattan. In actuality, Stettheimer refused to sell her paintings, even to her friends; she continued, however, to send her work regularly to exhibitions.

Although many artists and critics of the time recognized Stettheimer's portraits of the 1920s as the works by which the artist "will be best appreciated,"[24] their reading of the portraits varied considerably. Marsden Hartley seemed unable to get beyond what he called the feminine qualities of Stettheimer's work. Ignoring their humor and irony, he termed them "fragrant portraits . . . [which seem to] exhale pungency's and sweetness on the air around them. . . . They are portraits of the qualities and essences that emanate from them (the sitters), from their minds or from their delicately adjusted or maladjusted spirits." Hartley added that the works cause a "certain delectable, social and esthetic enjoyment. It is as if these beings had come to bloom freely and clearly in spite of alien temperature and alien insistence, perhaps chiefly under glass, if you will, subjected to special heats, special rays of light, special vapors, but there they are replete in their own beauty, their own hypersensitized charm. There is, thank heaven, no trace of stolidity in them, they perform their singular effects by means of an almost clairvoyant veracity."[25]

Van Vechten, in an unpublished essay, wrote the most incisive description of Stettheimer's portraits. He noted that although the portraits represent the latest cycle of Miss Stettheimer's career, this "does not mean that they all represent one idea or even one technique. They represent to a certain extent a group of her friends, and admirers, her relatives. Each then awakens a special problem or tech-

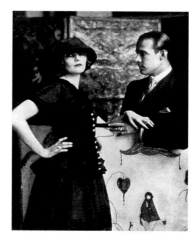

70. Edward Steichen, *Mrs. and Mr. Rudolf Valentino*, posed with Stettheimer's fire screen. Reproduced in *Vanity Fair*, November 1923, p. 50. Courtesy Vanity Fair. Copyright © 1923 (renewed 1951) by the Condé Nast Publications, Inc. Reprinted with permission of Joanna T. Steichen.

nique. . . . Miss Stettheimer does not ask her models to pose for her. Rather, in her own mind she creates a synthetic portrait, built up of details from the life of the person she is painting. Then the portrait gradually emerges in the secrecy of her studio."[26]

Friend and photographer Edward Steichen was also very taken with Stettheimer's portraits. He arranged a photographic shoot for *Vogue* magazine to take place in Stettheimer's studio in September 1923, with Doris Kenyon and the actor Rudolph Valentino and his wife photographed standing in front of one of Stettheimer's gilded folding screens (fig. 70).[27]

Early in 1922 the Stettheimer's Uncle Sylvan died, leaving each of the sisters ten thousand dollars. Ettie immediately bought a car to travel to their summer rental house at Sea Bright, on the New Jersey coast. There, during the summer and early fall, Stettheimer worked by the shore and exhibited paintings with the newly formed art society Modern Artists of America and at the Society of Independent Artists. Stettheimer grew close to Henry McBride, and he became a regular at the Stettheimer's Sea Bright parties. As art critic for both the *New York Sun* and the *Dial* during the 1920s, McBride was becoming increasingly influential in New York art circles. McBride sought the "American" in American art. In 1913, he met Gertrude Stein in Paris, and they became friends—so much so that in 1916 Stein composed a literary prose piece she titled "Have They Attacked Mary. He Giggled," which included a written "portrait" of the critic.

McBride apparently came closer than anyone else to actually "sitting" for Stettheimer. There are few clues to Stettheimer's manner of beginning her compositions. One evening, while visiting the women at their Sea Bright house, he noticed Stettheimer making furtive sketches of him, but she did not let him see them. A year later, when the finished *Portrait of Henry McBride* was revealed, he expressed surprise at some of the iconographic elements, particularly the heavy emphasis on tennis: "I have scarcely yet lived it down."[28] Although cluttered and somewhat claustrophobic in color and detail, the McBride portrait reflects the critic's interests at the time it was painted (fig. 71). The portrait is arranged so that images of those interests surround him, almost like a multiscreen cinematic backdrop. Within the different scenes, the art critic appears at least four other times, once in each corner of the painting. Each quadrant reflects a different aspect of his life—sportsman, farmer, defender of nineteenth-century American art, and admirer of new tendencies in modern art.

Every afternoon while at Sea Bright, McBride watched an international lawn-tennis tournament that was held there. Stettheimer made reference to this activity at the lower left side of the portrait. While four players dance and leap in contorted poses toward unseen tennis balls, McBride looks on as the referee, dressed in traditional black jacket and tennis whites and seated high on a laddered perch in the lower left corner. Wearing a similar outfit, the figure of McBride is repeated in the center of the composition, perching daintily on a plumply cushioned green- and red-trimmed chair of dubious stylistic lineage, above a scarlet

rug. McBride's eyes are cast down and to the left, as though he were watching the progress of the games, and in his hands he holds a pencil and a score-card with the players' names. Hilton Kramer, in a later review of the painting, noted the implication that, at least for an art critic, "keeping score" has multiple meanings.

Described in his eighties as "six feet tall, erect, hauteur in the carriage of the head, the face unlined, the blue eyes old man's eyes but with a boyish precocity in the open stare,"[29] McBride was fussy about his appearance throughout his life. In a series of letters he wrote to Stettheimer during the summer of 1922, he asked pointed questions as to what he should wear and bring to Sea Bright: "Is it a très dress affair? Do gents wear smokings? You see I

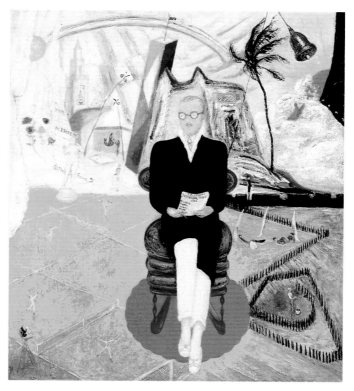

71. *Portrait of Henry McBride, Art Critic* (1922), 30 x 26 in. Smith College Museum of Art, Northampton, Massachusetts; Gift of Ettie Stettheimer, 1951.
72. See p. 270.

come in a suitcase and I have no one to advise me but you—so if I take a wrong step in this affair it will be all your fault."[30] In Stettheimer's portrait, McBride is a tightly controlled, highly elegant, somewhat vain man in his early fifties, with a neat, trim mustache, receding, slicked-back gray hair, and tiny, pursed mouth. The two rounded ends of his chair peak out on either side of his arms, making him look like a prissy, middle-aged angel wearing owlish glasses.[31]

When reviewing his portrait at the Society of Independent Artists exhibition in 1926, McBride offered further clues to the veracity of Stettheimer's portrayal:

> *The protagonist in this portrait is none other than the humble scribbler of these notes. My old friend Royal Cortissoz was horrified by the guile of the artist. He said, "When I gaze on the behemoth that you are and then turn to the slender reed she tries to make you out, I consider it the most flagrant piece of flattery in all portrai-*

ture." But my friend doesn't know the half of it. The fact is I have two silhouettes at my command. Every spring about this time, with unfailing regularity, I become behemothic, and every summer, with equal regularity, I become willowy. It was at the Seabright tennis tournament some years ago that Miss Stettheimer caught the glimpse of me she chose to immortalize, and I was undoubtedly reedlike then. If all art is selection, should not the artist select the best? I'll say she should.[32]

When restorations on his West Chester, Pennsylvania, farm became pressing, McBride wrote Stettheimer long letters describing his travails, which subsequently showed up in the portrait. After a bout of tonsillitis (note the high white scarf protecting his neck), McBride hired a seventy-eight-year-old man, Sam Bonsall, to put a new picket fence up around the farm's property. When Bonsall finished, McBride undertook to paint the fence, a task that assumed enormous proportions, as he wrote to Stettheimer: "Ever try painting a five hundred rail fence?" In answer, Stettheimer included a picket-rail fence on the lower right side of the portrait. Initially fencing in a group of beachgoers on two sides, the railing soon turns into a maze that traps a man in overalls—McBride—holding a paint brush in the portrait's center.

The entire background of the McBride portrait is given over to symbolic representations of artworks by the critic's favorite artists: Winslow Homer, John Marin, Demuth, Lachaise, and Stettheimer. In the upper right corner, a top-hatted McBride stands along the edge of a stone wall looking out over a bright orange sunset and the stormy sea. The ocean view is taken from a Homer painting, complete with an unhinged black sheet flapping in the wind, a

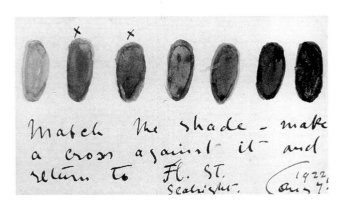

73. Postcard to Louis Bernheimer with shades of skin. Pen and ink, and watercolor (1922). Yale Collection of American Literature, Beinecke Rare Book and Manuscript Library, Yale University.

74. *Portrait of Louis Bernheimer* (1923), Robert Hull Fleming Museum, University of Vermont, Gift of the Ettie Stettheimer Estate, 1958.14.

manned, perilously angled row boat, and a green bell clanging a warning. Adjacent to this is a tall, wind-bent palm tree, reminiscent of Homer's numerous watercolors of the Bahamas.[33]

In the back portion of the original McBride portrait, several brightly colored, angled structures resembling buildings by Marin frame the sitter's head. A thin rainbow arches above a tall, cylindrical building with an American flag. Below, a lean, hatless figure of McBride with a walking stick stops to view a scene in back of a small fountain, where a Latin man offers a rose to a woman leaning toward him from a wrought-iron terrace. This resembles a scene from one of the watercolors Homer made during his visits to Santiago de Cuba in the 1870s. Behind this scene, an elderly woman in a lace collar peers out the lace-curtained window of a large, angular, white, Demuth-like church. McBride considered Demuth one of America's leading artists and particularly favored his watercolors. Beside the Demuth church, Stettheimer painted a laddered pyramid on which she wrote letters from both the sitter's and her own names. The names are broken up and repeated in a rhythm that recalls Stein's writings.

Below the laddered names, Stettheimer painted a replica of a statue by Gaston Lachaise. As early as 1918, McBride had seen a Lachaise *Woman* and declared it to be a masterpiece. In McBride's portrait, Stettheimer included a statue of a Lachaise woman standing high on her toes, with her arms raised as though in surprise. (This pose is also characteristic of a sculpture by Elie Nadelman, another artist McBride admired.) To the far left of the painting, one of Stettheimer's characteristic floral still lifes is placed as an anagram for the artist, beside her characteristic bowed white curtain, which reinforces the theatricality of the overall scene.

During the summer at Sea Bright, both Florine and her sister Ettie corresponded often with a young relative by marriage, Louis Bernheimer, affectionately known as LuLu. Bernheimer, whom Ettie referred to later as "a tragic boy," was an amusing, extremely good-looking younger man. In early summer, he wrote to Ettie describing how he intended to rent a room on Nantucket, where he would "swim naked every day until I approach the cutaneous condition of a coffee bean, and become, if possible, younger than ever. I have invented a religion, called protoplasmism: one endeavors, by intense effort of silence, to regain the naive simplicity of the amoeba." [34]

This description must have intrigued Stettheimer, for she wrote to Bernheimer in early August, sending him a postcard containing seven paint samples ranging in color from yellow to very dark brown. She urged him to compare the swatches of color to his skin color and to "match the shade—make a cross against it and return to Fl. St. Seabright" (fig. 73).[35] Bernheimer marked the two shades that were the closest to his current skin color and wrote to the artist in some excitement at the possibility that she might be painting his portrait. The resultant portrait shows the handsome Bernheimer, his skin deeply tanned, casually leaning against a doorjamb, his hands in the pockets of pin-striped summer pants (fig. 74). The frame, which Stettheimer designed and had made specifically for this portrait, has traditional,

75. *Portrait of My Sister, Ettie Stettheimer* (1923), 40⅜ x 26 in. Columbia University of the City of New York, Gift of the Estate of Ettie Stettheimer, 1967.

76. *Portrait of Myself* (1923), 30 x 28 in. Columbia University of the City of New York, Gift of the Estate of Ettie Stettheimer, 1967.

white-painted rectangular wooden slats surrounded by interlacing white-painted wooden loops to resemble lace.

During the years 1922–25, Stettheimer was very prolific. She painted at least ten portraits including individual portraits of herself, her two closest sisters, and her mother. The sea air at Sea Bright inspired her to work on a number of paintings simultaneously. In a diary entry for August 16, 1922, she noted, "started the painting of Ettie's portrait—in my bathroom/boudoir/studio," and the next day, "started to paint my portrait." The two paintings, which she completed over the next year, appear to have been made to complement each other. Both are the same size, and the women's bodies are aligned in opposing directions, so that when placed together they bracket each other as embodiments of night and day. Although sharing the artist's predilection during this period for hot, tawdry colors, the works are quite different from Stettheimer's contemporary portraits of Van Vechten and McBride. In *Portrait of Ettie* and *Portrait of Myself,* the sitters float in amorphous space against red-painted supports. Unlike her portraits of male friends, these works feature simple compositions and surreal, almost mystical conceptions.

In Ettie's portrait (fig. 75), the subject lies against a red cushion before an opaquely purple-black evening sky complete with full moon and stars. Languishing on a scarlet shawl, Ettie wears a low-cut black gown with a black lace train. She stretches her bare arms and shoulders as though she has recently awakened, but her face with its conspicuous eyebrows wears an expression of perplexity or deep thoughtfulness. McBride later described the portrait as looking "wide-eyed, for the mystery of life . . . as happy a blend of her worldliness and spirituality as any psychiatrist could ask for."[36]

Stettheimer gave visual definition to Ettie's theatricality by the setting in which she placed her portrait. Directly to the right of her sister's bent arm, also apparently floating in outer space, is a brightly decorated Christmas tree with a ribbon bearing Florine's name and the year, 1923. The body of the tree is filled with colorful strung lights, tiny lit candles, and elaborate ornaments such as stars, high-button boots, caged birds, hearts, glass balls, roses, a horn of plenty pouring out gold dust, and a red leatherbound book with Ettie's name prominent on the cover. The top is on fire, with large gold flames and bright-red, flamelike lilies rising into the midnight sky. At the white-hot center of the conflagration, a small nude putto, discretely covered by a winding blue ribbon, reclines in counterpoise to Ettie, who is surrounded by a circle of tiny round lights. In her diary entry for October 2, 1923, Florine noted that she had not yet completed the portrait, and she caustically remarked that the Christmas tree in the painting was "an outcome—of the burning bush of Moses," playing on her family's Jewish origins and ambiguous feeling about celebrating Christmas.[37]

Because Ettie edited all personal statements from the sisters' diaries and letters, it is not clear what the day-to-day relationship was between herself and Florine. While Florine

was gaining public acclaim for her work, Ettie, despite her early intellectual promise, did not. In 1923, Alfred A. Knopf published Ettie's second book, a long novel titled *Love Days*, which she wrote under the pseudonym Henrie Waste, an anagram of her own name (*Henrie*tta *Walter Stet*theimer). *Love Days* is a thinly disguised autobiography with caustic portraits of Nadelman and Duchamp. Many years later, when the novel was republished by a vanity press as *Memorial Volume of and by Ettie Stettheimer*, a reviewer commented in the *New Yorker* on the enormous diversity of the author's writing. Ettie, he wrote, was an unusual personality "who seems never to have been quite sure in what particular field her talents could be most successfully exercised." The reviewer could not help wondering "what it was that prevented so gifted and so actively intelligent a woman from achieving even more complete fulfillment as a writer."[38] Florine Stettheimer, by portraying her sister in a thoughtful state beside a conjoined symbol of spiritual, pagan, and mystical significance, alluded to this curious ambivalence in her sister's personality.

In painting her 1923 self-portrait (fig. 76), Stettheimer broke with portrait conventions when she symbolically transformed herself into a visionary, androgynous, sun-attracted dragonfly. Her body position, with one leg bent under the other, curved torso, and rounded head accentuated by a black beret, is an exact reflection of the small winged insect that hovers in the composition's upper right corner. The highly stylized insect pauses under the brightly shining sun, whose extended white rays appear to be sweeping the artist upward toward the same destination. Echoing the dragonfly's delicate, transparent wings, Stettheimer wears an ephemeral gown of white cellophane, whose cape, glistening on her shoulders, is attached at her neck by a small black bow.[39] Through the shiny glimmer of fabric, her nude body is evident, recalling her earlier recumbent nude self-portrait, in which the impact of her visible sexual body parts was neutralized by the artist's highly individualized treatment of her face, hands, and feet. In the later self-portrait, Stettheimer further distances herself from traditional notions of female sexuality. Wrapped in cellophane, she is portrayed as sexless and untouchable, with a bouquet of flowers now covering her genitals. Despite the fact that the décolleté of the dress extends halfway down her midriff, her body lacks apparent breasts, and her torso more closely resembles that of a slim young man than that of a fifty-two-year-old woman. Marcel Duchamp is said to have stated that Stettheimer "had no female body under her clothes [so that her] clothes hung on her," and the photographer Cecil Beaton described her has having "a powdery, delicate quality that was delightful."[40]

As is often the case with Stettheimer's paintings, clues to the iconography can be found within the history of art. The mayfly or butterfly had long been a symbol of metamorphic modes of transformation and concepts of the feminine. In Paris, the cover image for the Exhibition of the Arts of Woman in 1895 included a woman sketching "The Arts of Woman" on the wall. Over her head, a butterfly flies directly from the top of the letter *m* in the word

sprees his imagination goes." Hergesheimer's reaction was enthusiastic. To a friend he remarked, "What do you think of it, Burton: it's the horrible truth about me at last!" and his wife told the artist that the likeness was "uncanny." Upon returning home to West Chester, Hergesheimer wrote to Stettheimer that he was "incalculably in your debt.... Thank you again for a compliment, a portrait, that most certainly does neither of us a particle of injustice." Nonetheless, rumors that he did not sufficiently appreciate the work reached Stettheimer's ears, and by January 2 an apologetic Hergesheimer wrote to reassure her:

> You know very well I liked your picture of me immensely and I would have commissioned it like a shot. But the whole conditions of your work, of the painting of an imaginary portrait, were so unfamiliar to me that I never actually realized that, where they were concerned, they were under way. Then at your studio when the portrait was finished, I found myself in what I conceived to be an embarrassing situation—to be utterly frank, I didn't know whether I could pay you for your portrait of me or not; and so, instead of being direct and simple and reasonable, I merely floundered. That is as candidly as I am able to explain the awkwardness of a position my inattentive clumsiness brought about.

A month later, Hergesheimer again wrote to Stettheimer, this time stating more directly, "I would like to have my portrait for $500.00 dollars and as soon as I'm back, we will conclude this transaction."[57] An agreement between the two was never reached, and Stettheimer retained the portrait until her death.

Not only was Stettheimer prolific during from 1922 to 1925, but she also exhibited regularly at exhibitions of the Independents and in monthly exhibitions organized at the Wanamaker Gallery of Modern Decorative Art on Ninth Street. Her portrait of Louis Bernheimer was reproduced in blue and red tones on the cover of the Wanamaker Gallery's January exhibition brochure.[58] In February 1923, Stettheimer entered her portrait of Van Vechten in the Society of Independent Artists exhibition at the Waldorf Astoria. The artist included her early painting, *Aphrodite*, and another flower painting in the March Wanamaker exhibition. The exhibition was organized around the notion that the introduction of "modernism" had created something of a renaissance in the decorative arts. Works by Hunt Deiderick, Robert Chandler, George Biddle, John Storrs, William Zorach, and Charles Prendergast were also exhibited. In May, Stettheimer sent to a Wanamaker exhibition another early painting, *New York*, based on images of the city in all media.

The Stettheimers spent the summer of 1923 at Sea Bright, where the artist continued to work. She enjoyed being near the water and watching the bathers at the shore, and noted in her diary, "The beaches are wonderful—America's youth have discarded all they can—and look well—unfortunately and funnily America's middle-aged fat and old fat are doing the

same." While at the shore, she painted two versions of her neighbors, "The G's" (probably the Guggenheims), resting near the water. Later she destroyed both of these paintings, and the only remaining evidence of them are professional black-and-white nitrate slides.[59]

Although Stettheimer had her paintings photographed by Peter Juley, she refused to have her own likeness recorded, even though many of her friends, including Van Vechten, Beaton, Stieglitz, Steichen, and Baron de Meyer were prominent photographers. De Meyer, credited with being the first "fashion" photographer, was born Demeyer Watson in Paris in 1868. When World War I broke out he was living in England, and rather than suffering repatriation to Saxony or internment in an English prison-of-war camp, he and his wife moved to New York, where he took a job with Condé Nast as photographer for *Vogue* and *Vanity Fair*. The de Meyers quickly became members of the Stettheimers' social circle and appeared in a number of Stettheimer paintings of the 1910s.

Throughout the 1920s, de Meyer's photography developed a high-key, soft-focus style of dazzling light effects, with halo-like backlighting and poses of ultracasual sophistication. Exclusiveness became his hallmark, and sitters received only one print of their portraits. De Meyer was particularly drawn to the texture and sheen of satin, the cobweb nature of lace, and the design of art-deco wrought iron. As one reviewer stated, de Meyer "chooses stuffs or screens of telling design to form his background. It is not an exaggeration to say that he is unrivaled in his instinct for the appropriate detail significantly placed."[60] De Meyer's images of American celebrities, taken in ornately elegant settings, brought him a great deal of attention and influenced Hollywood during the early days of filmmaking.

In 1923, the year de Meyer left Condé Nast for *Harper's Bazaar* (where he was made responsible for designing entire issues of the magazine), Stettheimer painted his portrait (fig. 78). To commemorate his success, she included in the background of the painting an embroidered hanging plaque on which she inscribed "B de M/in pleasant Remembrance/FS/1923." The accuracy with which she rendered his facial features and physical appearance suggests that she worked from a photograph (fig. 79). In the painted portrait, de Meyer leans lightly against a tall black pedestal on which a group of flowers is arranged beneath a glass dome. The hermetically sealed and perfectly preserved atmosphere of this still-life detail pervades the

BARON DE MEYER—A SELF PHOTOGRAPH

Baron de Meyer's tastes in the fields of art are so varied that it would be hard to consider all of them adequately in an article as brief as this,—so that the author of this paper has confined himself to three phases of the Baron's artistic activities: decoration, costuming and photography. In the latter field he must be familiar to readers of this magazine, his photographic portraits having appeared exclusively in it—and in Vogue—for a period of a little over three years

79. Baron de Meyer, *Self-Photograph*. Reproduced in the November 1920 issue of *Vanity Fair*. Courtesy Vanity Fair. © 1920 (renewed 1948) by the Condé Nast Publications, Inc.

painting. The photographer is dressed in a black velvet smoking jacket with a brocaded grid design at collar and cuffs, a pink silk vest, long gray pants, and elegant black and white spats. The stiffness of his pose suggests that he is in the midst of being photographed and so must stand in place until the shutter of the camera closes. In recognition of de Meyer's "royal" connections, Stettheimer included an ermine and red velvet robe lying across the arm of a heavily flounced white chair. She accentuated the photographer's love of fine fabrics by using a black lace mantilla in place of the usual plain, opaque cloth over the box camera. At the left, a heavy blue drapery bound with golden rope and full tassels hangs over the sitter, while at the right hangs a corner of a dark material embroidered with exotic birds, compositionally balancing the dark pedestal.[61]

During the early 1920s, Marcel Duchamp temporarily reentered the Stettheimers' lives. Leaving Buenos Aires on June 22, 1919, he set sail for Europe, and by December he returned to New York. There, the Frenchman began experimenting with optics and film, and with Man Ray's assistance he constructed a motor-driven machine, called *Rotative Plaque verre*. On April 29, 1920, with Man Ray and Katherine Dreier, Duchamp founded the Société Anonyme, Inc., the first museum in the United States devoted to the display and promotion of modern art.[62] A number of Stettheimer's friends were involved in the venture and in its programs, including Dr. Phyllis Ackerman, Abraham Walkowitz, McBride, and Hartley. Stettheimer joined the new "museum" as a founding member, although she never exhibited with the Société and did not renew her membership.

80. Man Ray, *Rrose Sélavy* (ca. 1920–21), gelatin silver print, 8½ x 6¾ in. Philadelphia Museum of Art: The Samuel S. White III and Vera White Collection.

Despite superficial impressions that they were unlikely friends, Stettheimer and Duchamp enjoyed each other's company and respected each other's work. Known for his physical beauty and seductive charm, Duchamp was born in France in 1887, sixteen years after Stettheimer. Duchamp, like Stettheimer, was a private person and had been raised in a European environment. Both artists were modern-day dandies or flâneurs, using elegance and aloofness as a way of distancing themselves from others. Charles Baudelaire defined the flâneur as a compulsive observer of modern life, "always on the outside, distracted and fragmented by the experience of modern life." Both Stettheimer and Duchamp were critical observers who strolled through life maintaining their psychological distance, mingling with the crowd but never quite joining it.[63]

During his 1919–20 visit to New York, Duchamp

consciously evolved several distinct personae: the art dealer/businessman, the inventor/engineer, and the female impersonator Rrose Sélavy (fig. 80). Rrose Sélavy first appeared in 1920–22 in a photograph taken by Man Ray, and her signature adorns Duchamp's *Fresh Widow* of 1920, the model of a French window that the artist commissioned to be built. The title of the work not only puns on "French window" but also plays in the notion of Duchamp as a "bachelor," a term he also used to describe Stettheimer. Duchamp as inventor/engineer created a number of imaginative machinelike configurations, and as a prospering art dealer/businessman he purchased art for private collectors as well as acting as Constantin Brancusi's representative in New York.

In 1923, soon after Duchamp returned to Paris, Stettheimer incorporated all of his personae in a portrait in which she capitalized on Duchamp's obsession with his public self (fig. 81). She designed the frame as a running frieze of the sitter's initials, each individually applied, like a line of type, to a painted wooden support. This notion may have derived from Duchamp's cover design for the 1921 publication *New York Dada,* on which an image of Rrose Sélavy is inserted against a background of typed letters. Stettheimer repeated this motif in her painted portrait by running letters of type across the back of Duchamp's chair.

Henry McBride, writing about Stettheimer's portrait, acknowledged Duchamp's enigmatic private persona—"Marcel in real life is pure fantasy"—and noted Stettheimer's sly reference to Duchamp's public persona as a conscious fabrication: "If you were to study his paintings, and particularly his art constructions, and were then to try to conjure up his physical appearance, you could not fail to guess him, for he is his own best creation, and exactly what you thought. In the portrait (by Stettheimer) he is something of a Pierrot perched aloft upon a Jack-in-the-Box contraption which he is surreptitiously manipulating to gain greater height for his

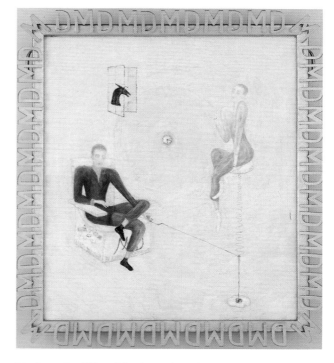

81. *Portrait of Marcel Duchamp* (1923), 30 x 26 in. Collection of William Kelly Simpson.

To Katherine Dreier
Knight of the Société anonyme
for her birthday 1951
marcel duchamp

82. Man Ray/Marcel Duchamp, *Head of a Laughing Ass*, logo for the Société Anonyme.

apotheosis. . . . The most complicated character in the whole contemporary range of modern art has been reduced to one transparent equation."[64]

Stettheimer reinforced the ephemeral, intangible nature of Duchamp's personality through her palette. Abandoning the bright, saturated colors and high-contrast blacks and whites used for her other subjects, the artist executed Duchamp's portrait in pale color washes against a barely visible green-tinted background. The figure of Duchamp, at the left, is wearing a conventional jacket, pants, and high-topped boots in muted, neutral tones of brown and gray. Seated in an armchair decorated with the French and American flags, his intertwined initials, and the phrase "Marcel Duchamp by Florine Stettheimer," Duchamp strikes a desultory pose. He holds a lit cigarette in one hand while his other hand, curiously tucked under a folded leg, turns the metal handle connected to an apparatus at the right. The long crank attaches to a thin, cylindrical pipe that is fastened to a scalloped base. From the top of the cone-shaped tube, a decreasing zigzag of wire or metal, reminiscent of the shadowed corkscrew in Duchamp's painting *Tu'm*, extends upward and supports a small round platform bearing the name of the figure who is perched on it, Rrose Sélavy. Duchamp's feminine alter-ego wears a shoulder-padded jumpsuit painted in variations of rose. She sits on the fingers of one hand and holds the other out, palm up, in a questioning pose. Her legs are twisted in a manner mimicking the spiral of the stool. Although the features remain recognizable as Duchamp's, Stettheimer's subtle alterations of the chin shape and underlying bone structure give Sélavy's face a more feminine, flirtatious expression than the preoccupied, almost sullen scowl of the figure at the left. As Virgil Thomson later noted, Stettheimer painted Rrose's shoulders and back to resemble a large pink heart.[65] The lefthand figure of Duchamp, with its traditionally masculine pose of ankle over knee, is angular, while the coy figure of Rrose, at right, is serpentine, seemingly boneless, typical of Stettheimer's tendency to portray the "feminine" aspects of her male friends through use of the sensuous *s* curve.

The portrait of Duchamp has much more empty space than Stettheimer's other works and is closer to Picabia's earlier mechanomorphic portraits. The paint, although thickly applied, is barely discernible, and the work is largely linear. This corresponds to Duchamp's denunciation of "retinal" art and his desire to "get away from the physical aspect of painting. I wanted to put painting once again in the service of the mind."[66] The spare motifs Stettheimer did include in the portrait refer to various of Duchamp's art constructions and interests. The faint rounded circle barely visible at the center of the canvas alludes to Duchamp's *Precision Optics* and his experiments with rotating optical discs. Years later, Duchamp interpreted the small clock at the center of the circle as referring to a discussion he had with Stettheimer on time as the fourth dimension.[67] And since Duchamp was an avid chess player, Stettheimer may have meant the clock as an allusion to the ones that chess players use in timed games. The horse's head at the upper left side resembles the knight in a chess game as well as the emblem for the Société Anonyme—the head of a laughing ass—designed for use on its membership cards (fig. 82). The horse or donkey head is caught in a window with a grid reminiscent of Duchamp's ready-made *Fresh Widow*.[68] By structuring her portrait of Duchamp within an ambiguous space and surrounded by floating, displaced objects, Stettheimer made reference to the French artist's concern, not with the intrinsic beauty of "things," but with the conventions and prejudices by which works of art are traditionally valued and viewed.

Henry McBride, visiting Duchamp in Paris during the summer of 1923, described Stettheimer's double portrait to him in "glowing terms." Stettheimer painted another, earlier portrait of Duchamp, in which the Frenchman's head floats in an ambiguous space and appears to radiate intense energy (fig. 83). The painting is entirely *en grisaille*, like her earlier Botticelli-inspired *Spring*, except for a slight orange tinting on the sitter's lips. Although the work is difficult to date, the close-cropped hair and detailed facial features—slightly cleft chin, irregularly shaped nose, and prominent brow bone—show that it was painted while Duchamp was in the New York area some time in 1922–23.[69]

In mid-February 1923 Duchamp returned to Europe and settled in Paris, where he remained until 1942, except for occasional trips to New York. On one short trip in the mid-1920s, he executed a portrait drawing of Stettheimer that remains one of the few extant images of the artist not by herself (fig. 84). He gave the unsigned charcoal drawing to Stettheimer who inscribed it in pencil "Portrait of me by Marcel Duchamp." As she would have wished, Duchamp depicted her as an intelligent-looking woman of indeterminate age. The facial features are lightly rendered, with emphasis on her longish nose, dark eyes, and cryptic expression.[70]

Stettheimer composed one more portrait of Duchamp, but in words—a curious poem titled "Duche":[71]

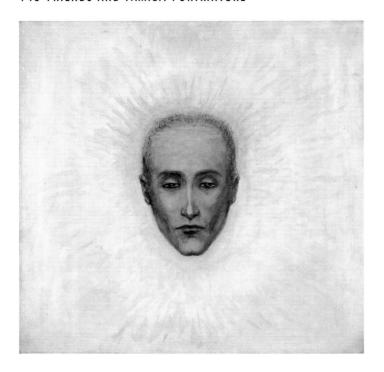

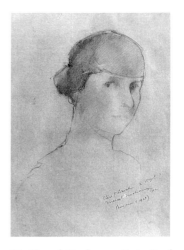

84. Marcel Duchamp, *Portrait of Florine Stettheimer* (1925/1952), pencil on paper, 20½ x 13¾ in. Collection of Timothy Baum, New York.

83. *Portrait of Marcel Duchamp* (ca. 1925–26), 23 x 23 in. Museum of Fine Arts, Springfield, Massachusetts; Gift from the Estate of Ettie and Florine Stettheimer.

A silver-tin thin spiral
Revolving from cool twilight—
To as far as pink dawn
A steely negation of lightning
That strikes—
A solid lambswool mountain
Reared into the hot night
And ended the spinning spirals
Love flight—[72]

The poem might have been written as a companion to her double portrait of Duchamp, or it may have been a response to the news, in 1927, that Duchamp had married "a very fat girl . . . very, very—fat," as described by Carrie, who met the couple in Paris two days after their wedding.

Duchamp's marriage ended in divorce a year later, and after the 1920s he virtually disappeared from the Stettheimers' life.[73] After Florine's death, Joseph Solomon offered Duchamp his portrait as a gift, but he refused it, indicating that they had drifted apart. Nonetheless, Duchamp worked with McBride and Julien Levy to ensure the continuation of Stettheimer's reputation as an artist, thereby reiterating his admiration of her work.

In 1923, Stettheimer paid tribute to her elder sister Carrie's achievements in a portrait she painted in which the dollhouse acts as a metaphor for Carrie's identity (fig. 85).[74] The dollhouse figures prominently at the left side of the composition, and it bears the date and a plaque with the sitter's name. Although Florine imaged herself through translucent veils of red and white, and her sister Ettie in saturated tones of black and red, she portrayed Carrie in pale pastel shades and laid emphasis more on the details of the setting than on the central figure of her sister, who, like a chameleon, blends into the background.

The portrait of Carrie is significant as Stettheimer used it to

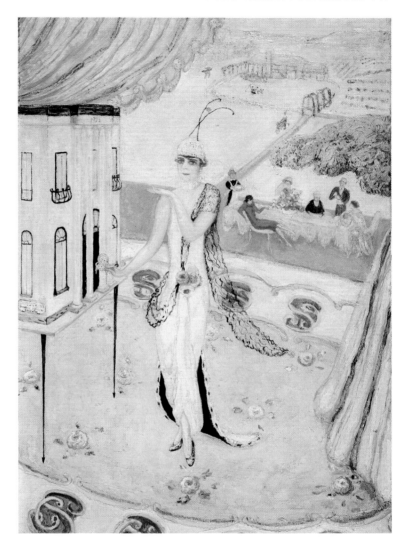

85. *Portrait of My Sister, Carrie W. Stettheimer* (1923), 40³/₈ x 25¹/₂ in. Columbia University of the City of New York, Gift of the Estate of Ettie Stettheimer, 1967.

bring notions of atemporal narrative (*multiplication virtuelle*) back into her painting. In the foreground, a pink, yellow, and blue curtain has been pulled aside to reveal Carrie standing on a rose-covered carpet bearing her monogram in gold along its oval border. Known as the most formal and regal dresser of the family, Carrie is attired in a pale gown with an ermine train and a dark lace shawl caught by a bunch of roses at her waist.[75] Forty years later, a

grandniece remembered Carrie always wearing a pearl choker around her neck and looking "like the Dowager Queen Mary."[76] In Stettheimer's portrayal, Carrie's choker is matched by hanging earrings and a white cloche hat from which two slender antennae extend. Her face, with its characteristic round, heavy features and blue eyes, is turned toward the viewer. In one hand she holds a cigarette, in the other a miniature upholstered chair intended for the dollhouse, which is prominently raised on a platform at the left.

In the middle ground of the multi-episodic painting, Stettheimer re-created a miniature view of an earlier image of her family seen in the painting *Family Portrait No. 1*. In this central detail Carrie is again visible, now hatless and wearing a diaphanous blue gown. Ettie slouches in a characteristically bright red dress in front of a lace-covered table, Rosetta sits at the center of the table on the other side, and Florine, in her straw sun-hat, stands next to her mother, arranging a bouquet.[77] A red path leads us from Carrie's shoulder in the foreground back into the composition. Passing next to the miniature family group, the path goes under a series of rose arbors reminiscent of the gardens of André Brook and circles a large farmhouse in front of which a woman sits milking a cow and a man pushes a wheelbarrow. This differentiation between rural and urban, background and foreground, recalls a similar device Stettheimer used in her 1917 painting *Picnic in Bedford Hills*. These devices allow us to read the painting both chronologically and metaphorically.[78] Ten years have passed since the Stettheimers enjoyed the gardens of André Brook and casually sat around the family table. During that time, Carrie has worked meticulously and continually on her dollhouse, which remains unfinished and unveiled before its time.

By juxtaposing images of rural workers in the background with the formal foreground setting, Stettheimer reinforces the notion that Carrie's endeavors in the dollhouse should also be viewed as work and physical labor. As she was well aware, time for Carrie's creative efforts had to be carefully squirreled away from household and familial administrative duties, thereby making such accomplishments that much more praiseworthy. Carrie, like her sister Florine arranging flowers in the portrait's middle ground, has not been content simply to sit around listlessly at the family table, but has followed a compulsion to create, allowing her sister to confer on her the title of "Decorator, Designer & Collector."[79]

Stettheimer used the same palette and delicate, intricate handling found in Carrie's portrait in a flower painting she made around 1923 titled *Delphinium and Columbine*. Set off by pale, scalloped curtains, the floral composition includes a single vertical vase from which extends an arrangement of hydrangea and hollyhocks. The floral still life appears metaphorically to echo the portrait of Carrie.

6

Amusements in the 1920s

The year 1924 opened with opposing critical reactions to the recent works of Ettie and Florine Stettheimer. Ettie's book *Love Days* was harshly reviewed by Bernice Kenyon at the end of January.[1] Florine's work, by contrast, was increasingly solicited for exhibitions where it was well received. She became more active than ever, exhibiting widely and searching out new subjects for her work:

> *For a long time*
> *I gave myself*
> *To the arrested moment*
> *To the unfulfilled moment*
> *To the moment of quiet expectation*
> *I painted the trance moment*
> *The promised moment*
> *The moment in the balance*
> *The mellow golden tones . . .*
> *Then I saw*
> *Time*
> *Noise*
> *Color*
> *Outside me*
> *Around me*
> *Knocking me*
> *Jarring me*
> *Hurting me*
> *Rousing me*
> *Smiling*
> *Smiling*
> *Forcing me in joy to paint them.*[2]

Stettheimer welcomed in the new year by reading Marcel Proust's *Swann's Way*. Proust provided her winter entertainment, and, according to friends she talked "endlessly" about the author, whose *Remembrance of Things Past* she read volume after volume, and when she had finished, she "reread all the volumes consecutively."[3] In January, Stettheimer was invited by the Carnegie Museum International to contribute to the prestigious exhibition. She immediately replied, writing, "I accept with pleasure your invitation. . . . I shall do my best to send a representative [painting]." Marie Sterner asked to take several of Stettheimer's paintings to Paris and London. During February and March, the artist held parties in honor of recent portraits, and in April she gave a tea party to unveil the completed portrait of Ettie. She invited an eclectic group of guests, including Helen Parkhurst, Fania Marinoff, Helen Westley, Mary Sinclair, Elinor Wylie, Carl Van Vechten, Edward Steichen, and Carl Sandburg.[4]

When the Carnegie International opened its doors in May 1924, Stettheimer relished the praise that *Russian Bank* received. The exhibition, organized by Homer Saint-Gaudens, had as its theme the different phases of contemporary art as practiced by academic, moderate, and "revolutionary" groups. Stettheimer's work was included in the American section, along with work by Cecilia Beaux, John Singer Sargent, Joseph Stella, Henry McFee, and Bernard Karfiol, among others. Within a few days of the opening, the art critic Penelope Redd, writing in the *Pittsburgh Sunday Post*, singled out Stettheimer's painting and wrote a favorable review that is startling in its perception of Stettheimer's innovations:

> *Florine Stettheimer invents a new mode of expressing symbolism as original as the Chinese in this painting. . . . Miss Stettheimer is the only woman painter in America, and indeed, there would seem to be few elsewhere, who project an individual point of view on canvas. . . . Miss Stettheimer, more than any other painter whom we know, has developed a symbolic and decorative type of painting that also engages us by its human interest.*[5]

In mid-May, Carrie and Ettie took a trip through Massachusetts. Florine remained in New York and complained in a letter that Rosetta bossed and nagged her. The artist worked in her studio and socialized with friends, including Charles Demuth. After years of absence, Adolfo Best-Maugard showed up at Stettheimer's studio, and the next day he brought the Mexican painter Miguel Covarrubias to see her paintings. In June, Stettheimer joined her family in Williamstown, Massachusetts. Rosetta's health continued to decline, and Stettheimer continued her reading of Proust's saga. Throughout July and August, the Stettheimers traveled in Massachusetts, stopping at Cape Cod and the Copley Plaza Hotel in Boston. Although Florine visited the Museum of Fine Arts and enjoyed some "charming" Indian and Persian paintings, in general she found the museum's paintings "dreadful things—they haven't even any color." In August, in a chauffeur-driven Packard, the women visited Plymouth, Falmouth, Hyannis, and Providence, Rhode Island, where Stettheimer's taste clashed

with that of a local shopkeeper. The elderly proprietress, who was "dressed in a deep lavender, colorfast wash gown," said "sneeringly" about a fan that Stettheimer admired, "Would anyone but the Chinese paint a red flower and decorate it with a yellow tassel? . . . The Chinese are so crude." Stettheimer willfully misunderstood the shopkeeper by replying, "Yes, *wonderful* color sense."

Stettheimer quickly tired of travel and keenly missed being able to paint. In Providence, she complained in her diary, "Everybody seems stupid here. I feel as if we were killing time all summer I have felt that way—it's dreadful—and I am so conscious of the scarcity of time—I feel like an unwilling, helpless accomplice—I have done nothing—felt nothing—a fruitless summer." By the end of August, she was again in her New York studio. But the scorching heat soon forced her to join the rest of her family in Atlantic City. While there, she sent postcards to Carl Van Vechten describing the performers, acrobats, racing greyhounds, and artistes on the Million Dollar Pier, "all go in bathing with us; the only abstainers are the Eden Museum waxworks."

Atlantic City in the 1920s was a place where strangers from across the spectrum of American society intermingled. Well-to-do patrons like the Stettheimers stayed in hotels along the boardwalk, while the less affluent stopped at rooming houses a few blocks back from the beach. In order to extend the summer season and increase tourism, the city started a beauty contest, which was scheduled to run during the first two weeks in September. Like so many beach activities, the contest occupied an ambiguous place in American society: it was exciting, but it also proposed that young middle-class women expose themselves in bathing suits before a jury largely composed of men. To head off protests, managers of the contest promoted its "youthful and wholesome" nature and publicly stressed that none of the contestants wore makeup or bobbed their hair.[6]

The Atlantic City Beauty Contest initially involved only contestants from nearby cities. This changed in 1921, when the competition was won by a contestant from Washington, D.C. By the next year, representatives from fifty-eight cities took part, and overnight the competition (eventually renamed the Miss America Beauty Contest) became a national event, enshrining the "bathing beauty" as a central symbol of American womanhood. One commentator, describing the event in 1922, wrote that the pageant's opening parade drew on "the splendors of the Orient, of jazz parlors, of bathing beaches, and even the circus. There were piquant jazz babies, who shook the meanest kind of shoulders; pink-skinned beauties of all types; tanned athletic girls; bejeweled favorites of the harem."[7]

Stettheimer was intrigued by the visual and aural cacophony of hot nights along the Atlantic City beaches. During her 1924 stay in Atlantic City, she announced her increasing interest in popular culture by painting a monumental depiction of a beauty contest. Titled *To the Memory of P. T. Barnum* (fig. 86), the painting is bordered by a white and gilded frame

86. Beauty Contest. To the Memory of P. T. Barnum (1924), 50 x 60 in. Wadsworth Atheneum, Hartford. Gift of Miss Ettie Stettheimer.

finely carved to resemble a theater curtain. The composition is an extravaganza of activity, color, sunlight, and sound. In the center, under an oval opening surmounted by American flags, the words "Beauty Contest" are written on glass balls on jeweled and beaded curtains. Miss Asbury Park stands, her arms held over her head, offering her swimsuited body for the delectation and scrutiny of the judges. At the right, another contestant, hoping to catch the judges' eyes, steps down the ramp and seductively adjusts the strap on her shoe. Meanwhile, Miss Deal Beach (whom Ettie later identified as a portrait of Marguerite d'Alvarez) stands draped in ermine, awaiting the judges' verdict. At the far left, the writer Edna Kenton, in a dark gown, the photographer Edward Steichen, with a box camera, and Florine Stettheimer, wearing an artist's beret and a translucent dress, watch the proceedings.

Although the contestants represent a variety of "types"—from the blonde Miss Atlantic City, with her lash-rimmed eyes and star-spangled swimsuit, to the sleek, sophisticated Miss Spring Lake Beach—their presence is not the focus of the composition. The artist treated the contestants summarily, so that they blend into a background filled with attendants, thin veils of translucent color, and palms in scalloped containers. Instead, Stettheimer drew attention to the two front sides of the composition, the circular platform within which black musicians and dancers perform at the left and the flag-draped judging box at the right. The latter would reappear in Stettheimer's stage sets for *Four Saints in Three Acts.*

The reviewing stand features two elegant gentlemen, both dressed in dark formal suits with ribbon sashes. The first stands erect at the edge of the booth. On the ledge closest to the viewer, a gold chalice filled with ribbons waits to be presented to the winning contestant. The second judge, his face turned toward the viewer, holds a large bouquet of red roses. Behind the judges, in the lower right corner, Stettheimer inserted a tiny but extraordinarily accurate portrait of Carl Sandburg, shown hunched over a manual typewriter.[8] With his long, straight hair hanging over his forehead, he looks out at the proceedings and types the work's date and title on a sheet of paper.

Also awaiting the contest's victor, a patriotically plumed and red-saddled horse prances in the foreground of the composition, its reins held by a swarthy man dressed as a Spanish bullfighter. He glances down at three small children: one holds a crown on a tray, and the other two struggle with a heavy ermine-trimmed wrap, all intended for the contest's winner. The horse and costumed man dance to a rhythm beat out by the trio of African-American musicians on a yellow balconied platform at the left, who are wearing white pants, red uniform jackets, and hats with gold trim and buttons. To their left, a tall, slim black man in a matching uniform dances atop a yellow table from which extends a long pole terminating in a red and yellow canopy. The position and posturing of the dancing figure is similar to stereotyped caricatures from contemporary magazines describing "Play-Boys and Girls of the Coloured Cabarets of Uptown New York City." For example, the June 1927 issue of *Vanity Fair* depicts "Sam, the dancing waiter, who, with the grace of a panther, serves his customers in perfect time to the complicated jazz-rhythms of the orchestra."[9]

In December 1924, Stettheimer entered a group of flower panels in the Twenty-third Annual Exhibition of Modern Decorative Art at the Art Institute of Chicago, where they were exhibited with ceramics, tapestries, furniture, and decorative arts designed by some of the foremost artists and designers of the era. The assistant curator of the Art Institute wrote to her, asking whether she was willing to lower the price on her *Flower Panel with Pink Curtains* because a Mrs. Walter Brewster, "a very influential and delightful person with more taste than usual and I think that her owning one of your pictures might possibly lead to others coming to Chicago," had expressed interest in purchasing it. Stettheimer refused, as she re-

mained unwilling to sell work, but she continued to submit her paintings to temporary exhibitions. A few months later, she entered her portrait of Louis Bouché in the spring exhibition of the Society of Independent Artists in New York.

The Stettheimer women spent the following summer along the New Jersey shore at West End, where they had many guests, including their neighbors, the Guggenheims. They occasionally returned to the city for parties. At a "colored party" at Van Vechten's, Florine learned from two of the women guests that "runner bands were infinitely more comfortable than garters" for holding up stockings. In August, she was thrilled "at last" to see a baby parade at Asbury Park. The Stettheimers watched the proceedings from a box opposite the Guggenheims', while a distant relative, Jeff Seligman, handed out toys to over a thousand babies who ranged, as the artist noted, from "a few months old up to about sixteen. No taste was displayed but some queer effects happened by chance—and there were some beautiful children." In the fall, the women returned to New York, and Stettheimer read, at Van Vechten's suggestion, *The Life of Marcel Proust*. She wrote to Van Vechten, "I liked the life of Marcel Proust, especially Pierre Guint's appreciation of the Proustian Art. But I like your appreciation of my art even more."[10]

On November 11, Rosetta, now in her eighties, called her lawyer to prepare her will. She appointed her brother William and two of her children, Walter and Carrie, to be her executors, and left everything to her three youngest daughters, stating, "I feel justified in this decision and act knowing that my son Walter and daughter Stella are well provided for otherwise." At the same time, Stettheimer began a portrait of her mother. This portrait (fig. 87), which Henry McBride later termed her best and most serious, completes the cycle of family portraits Stettheimer had begun two years earlier. As McBride observed, Rosetta's "is an idealized portrait done with great tenderness and love and yet touched with irrepressible wit. I call it witty the way the straggling carnations break the severe blacks of the piano. I call it witty the way the palm-leaves venture into the composition and the way in which the laces frame in the mother's dream-picture of her children in the background. The mother's faintly bewildered but uncomplaining expression as she thinks of these children is witty, too. It is a true apotheosis; and it is a picture, I believe, that will take permanent rank in the not too great an array of distinguished American portraits."[11]

Rosetta's health continued to decline, and when her portrait was painted she was very frail. Most of the artist's friends remembered her as delightful but socially inconspicuous. Her daughters never left her alone, and they acted as buffers between her and other people. Once, at a Sea Bright house party, McBride happened to find Rosetta sitting alone. She took the opportunity to ask him, "Do you really think Florine is a good painter?" a question reiterated by other family members throughout Stettheimer's life. Despite regular praise of her art in major newspapers and periodicals, Stettheimer's family tended to view it as more of a hobby than a

vocation. On this particular occasion, before McBride could answer, Stettheimer appeared and interrupted the conversation, scolding Rosetta for having committed a faux pas.[12]

Stettheimer's portrait of her mother is a tribute to the way of life Rosetta instilled in her daughters. Set off by a voluminous green taffeta curtain on one side and a circular black lace hanging on the other, the composition reinforces the notion that the painting traces the passage of a life from the pale, pastel spring memories of the background to the bold, jeweled winter colors of the foreground. Rosetta's central figure seems about to step out toward the viewer or into the void of the future. This sense of forward motion is reinforced by the projected corner of a card table at left (with a purple dice box and an exposed ace of hearts representing Rosetta's favorite pastime, card playing) and the parallel oriental red and gilt lacquer bookcase at the right. The books, their tooled leather bindings facing outward, include an atlas and volumes by Boccaccio, Smollet, Fielding, Richardson, and Paul de Kock, indicating the eclectic but ironic nature of Rosetta's interests.

Rosetta stands in the center of the scene, wearing a black velvet gown with transparent black lace cuffs and scalloped lace "wings" descending from her hips. The neckline is open to expose a white lace insert, and over it she wears a black velvet choker with a large stone. In one hand she holds her spectacles, in the other a copy of Ettie's latest novel, *Love Days*. Positioned at her left is a comfortable armchair covered with plump pillows, including a bright yellow one bearing the name "Florine" and the date "1925." Rosetta's white hair is neatly pulled away from her face to reveal an expression which, if not bewildered, seems lost in reverie.

The artist positioned directly above Rosetta's head, as if offering a clue to her thoughts, a small tableau of the sitter's four children playing with and performing for their nurse. Meanwhile, Maggie holds baby Ettie, the fifth child, in her arms. This scene, which in reality took place six decades earlier, is visible through an opening created by red-lined glass doors, trimmed with lace, and propped open by a flowering rose bush. In the middle ground, a small flowered piano stool rests in front of a black lacquer baby grand piano, partially obscured by large palms. At the left, a gilt and glass table holds a large crystal, a gilt container, and a purple jewel box. As represented in the portrait, Rosetta personifies for her daughter a cherished world of childhood memories, lace fantasies, wide-ranging culture, and elegance. The painting is a tribute to a highly feminine sensibility with none of the pomposity, rigid authority, or solemnity of traditional parental portraits.

During 1926, the Stettheimer women moved to Alwyn Court on the corner of Fifty-eighth Street and Seventh Avenue. The building's François I exterior decoration was "so alive with crawling salamanders and plump putti" that friends such as Carl Van Vechten referred to it as the "Chateau Stettheimer" (fig. 88).[13] Alwyn Court was perfectly suited to Stettheimer's aesthetic. She decorated the drawing room and dining room of the huge apartment in the same gray,

87. *Portrait of My Mother* (1925), 38³/₈ x 26⁵/₈ in. The Museum of Modern Art, New York. Barbara S. Adler Bequest. Photograph © 1995 The Museum of Modern Art, New York.

gold, and red color scheme as the residence on Seventy-sixth Street; but when she offered to decorate the entire single-floor apartment, Ettie and Carrie "protested volubly against this attempt to usurp their rights. So, her continuing efforts at contextual decoration were restricted to her white and gold bedroom."[14] Although the smallest, Florine's bedroom was the most whimsical of the three, and its white and gold decoration represented a rehearsal for the eventual decoration of her studio. In keeping with their disparate personalities, Carrie's bedroom was quietly and elegantly decorated in shades of green, while Ettie's room was painted in violent tones of blue and red with theatrical Chinese-style furniture.

88. Carl Van Vechten, *Alwyn Court Façade.* Yale Collection of American Literature, Beinecke Rare Book and Manuscript Library, Yale University.

By the summer, Stettheimer felt she could again paint "big" paintings, and she had a number of 50 x 60 inch canvases professionally stretched. On July 26, she began a painting she initially titled *Beauty Pool,* and she continued working on it through the summer at the beach.

When guests displaced her from one bedroom, she moved into another with her palette and paints. The finished work, *Natatorium Undine,* is one of the most unusual in Stettheimer's oeuvre in that it is explicitly concerned with the female gaze, the world seen from a woman's viewpoint (fig. 89). The work's palette is based on color washes of light green, deep red, and gold. The painting bears several similarities to *The Beauty Contest,* particularly at the left, where under a canopy

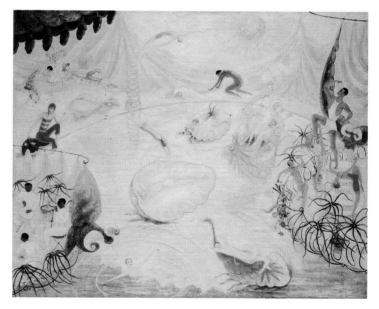

89. *Natatorium Undine* (1927), 50½ x 60 in. The Frances Lehman Loeb Art Center, Vassar College, Poughkeepsie, NY, Gift of Ettie Stettheimer, 1949.5.

the artist again arranged a trio of black musicians in white uniforms. In *Natatorium Undine*, however, the musicians' facial and body expressions are less caricatured than in the earlier work. The musicians face away from the activities and are prevented by a hanging curtain from seeing what is taking place in the pool. Nonetheless, they can undoubtedly hear the movements of the women swimming. This adds an element of titillation to the painted narrative.

The swimming pool in *Natatorium Undine* is exclusively for women. In Paracelsus's mythology "Undine" was a spirit; in ancient folklore the name referred to a wave or a water sprite who, through marrying a mortal and having his child, could acquire a soul. Stettheimer liked this title so much that she repeated it twice, once at the lower left edge of the painting and again on a column at the right on which she included the year she completed the work and her first name. A wasp-waisted, muscle-bound lifeguard posing on a half column at the right wears a shirt with the initials "N.U." He is the composition's most prominent figure, and he leads an exercise class for interested ladies. From the preening gyrations of the women who dance around him (including a heavy, bejeweled woman who pushes up her large breasts while gazing at the man's classical profile) it appears his "job" is to provide aesthetic or erotic interest for the guests.

Continually the observer, Stettheimer placed herself in the painting at the far left, in the same location and a similar position as that in *The Beauty Contest*. Dressed in a tube shirt with a low-cut halter neckline and short pants, she reclines on a rose-decorated chaise overlooking the pool. At her left Fania Marinoff, wearing a brightly colored shift, bends over and sips her drink through a straw. Ettie sits below, at the side of the pool. With furrowed brow, she dips her feet into the water and contemplates entering it. A bare-breasted woman lies by the side of the pool, stretching her legs; nearby, a plump woman, swaddled in white towels with a cigarette hanging from her mouth, relaxes in the sun while a dark-skinned masseuse kneads her hefty thighs. Aside from this duo, most of the women in the painting are slim and streamlined, their bodies the perfect manifestation of the fashionable silhouette of the period, in which the female form was made to resemble the letter "I."

Both the platform with wrought-iron grillwork on which the ladies prance, at the right, and the one holding the musicians, at the left, hover over a huge oval pool in which nine women enjoy the water. The three women in the foreground wear only jewelry. One, her earrings dangling, creates concentric circles as she sweeps the water with her left hand. With her right, she pulls the leash of a red dragon float on which another woman, wearing only a long string of pearls, reclines. A third nude woman lies smoking with her arms overhead, in a large, pink half-oyster shell in the center of the composition. Her body is slim with small breasts and hips, and she too wears a string of pearls. On her left, two suited women dive into the water from a tall turned spiral. One enters the water headfirst while the other executes a backward swan dive. Next to them, a woman in a salmon swimsuit rides on top of a swimming

tortoise whose shell is inscribed "Daddy." At the right edge of the pool, a woman stands on the back of a large ram float while her companion straddles a fish float titled "Jazz Baby."

Much as Stettheimer's painting *Asbury Park South* portrayed African Americans enjoying themselves in their own company, in *Natatorium Undine* Stettheimer accords the same privilege to women. The few men in the composition "serve" the women by offering musical accompaniment and aesthetic or erotic enjoyment, but the main theme of the painting is the notion of women luxuriating in their own company without the bother, distraction, or distortion of the male gaze. Stettheimer began two other works on a similar theme which she never completed, a sketch and a painting titled *The Bathers*. Both take place in the private yard of the Gould estate, where an intricate outdoor shower system was arranged for the women. In fact, the Stettheimers' diaries indicate that they indulged more than once in a "fountain bathe among the flower beds and rose arbors" of the Gould estate. In the *Bathers* sketch, one woman, nude except for high heels, reclines on a towel near a colonnade while another, dressed in a bathing suit, sits on the stone pier of a column. A third woman stands nude

under the shower spray and, wearing only high heels, sponges off her body. In the painted version (fig. 90), the colonnade is reversed and the seated woman eliminated. A slightly plump nude woman, probably Ettie, reclines in the sun wearing laced sandals while another nude woman stands under the shower.

90. *The Bathers* (unfinished), 26 x 30 in. Columbia University of the City of New York, Gift of the Estate of Ettie Stettheimer, 1967.

The idea of depicting women interacting in a public arena had been explored by Stettheimer in her earlier painting *Spring Sale at Bendel's*. In these later works, however, the meaning is even more explicit: in order to be relaxed, even hedonistic—to be themselves—women have to be in a situation without men. Linda Nochlin has noted a similarity in graphic stylishness between Stettheimer's *Natatorium Undine* and a slightly later cartoon by Fish published in the August 1927 issue of *Vanity Fair*, "Divers, Divers and More Divers." Fish's drawing, however, concerns itself mainly with the sport of diving, as enjoyed by socially registered divers of both sexes. It lacks the hermetic, self-congratulatory flavor and languid mood of Stettheimer's painting. If anything, the semi-clad women draped across animal floats in *Natatorium Undine* most strongly recall the artist's designs for her ballet of a decade earlier. Now the women, appreciably older and more worldly-wise, no longer need Orpheus's music to spur them to loosen social obligations and enjoy themselves.

In the late spring of 1927, McBride and Carrie left for Europe. In Carrie's absence Ettie

"ran things," and the sisters swam in the ocean by day and went to movies at night. Rosetta continued to need a great deal of care from her daughters, which prevented them from taking part in many outside activities. Carrie returned at the end of July, bringing her sisters elaborate Maison

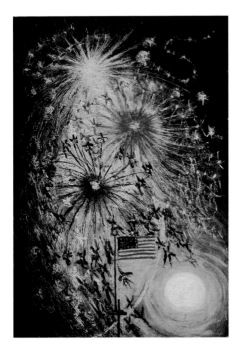

91. *The Fourth of July No. 1* (1927), 28 x 18 in. Gift of the Estate of Ettie Stettheimer. © Addison Gallery of American Art, Phillips Academy, Andover, Massachusetts. All rights reserved.

Giraud tea-gowns, but she too was soon worn out by the strain of caring for Rosetta. Florine and Ettie were alternately depressed and sick with asthma. Stettheimer found she had trouble painting due to "inner difficulties," but she began several works, including two versions of *The Fourth of July*, which she began in mid-August (fig. 91).[15]

Over the years, Stettheimer continued her ritual of picking a birthday bouquet for herself from the garden. In 1927 she painted a similar Redon-like bouquet for Ettie (fig. 92). The bouquet occupies center-stage of the canvas. It is set off against indefinable space by two parted curtains, giving the painting a decidedly theatrical air. Traditionally associated with the conclusion of a successful performance, the bouquet may have been Stettheimer's tribute to her sister's publication of her novel *Love Days*. The inclusion of bleeding hearts reinforces this notion.

Among the guests who visited the Stettheimers' summer house in 1926 and 1927 was Father Hoff, a handsome priest from a nearby parish. Hoff ate a number of meals with the Stettheimers and reciprocated by inviting Carrie, Ettie, and Florine to visit his chapel, with its five altars, garden of calla lilies, and wine cellar. As Stettheimer noted in her diary, "There's a cellar with ten bottles and now only nine for we have one—precious gift, a bottle of Toquay—pre-prohibition!" The next summer the four women returned to West End, and Father Hoff again came to tea. In her diary Stettheimer recorded their meetings with her usual cynicism, noting that Ettie had given the priest a Byzantine Madonna icon "for the pure fun of the thing. Most people are only half alive—and talk about the next life—possibly believe in another life—are saving up their vitality for it—that may also account for the stinginess in the world." On her birthday, August 19, she picked her annual bouquet and put on a gown she had created with her seamstress, which was made of oyster-white crêpe de chine with oversized shrimp-pink roses. Father Hoff gave her lady's slippers, which he planted in her garden. Carl

Van Vechten sent her a book titled *Johnny, the Autobiography of an Ex-Colored Man;* Ettie gave her a small set of tools and Carrie a pair of "gold stripes." That night, dressed in a "radium silk pink nightgown strewn with deep pink roses," Stettheimer took "a sudden fancy to make a Padre Carlos portrait." She called up Hoff and asked him to don his habit the next time they met so that she could take his photograph in preparation for work on the painting.

In her portrait of Father Hoff, Stettheimer included Ettie's icon in the background and in fact treated the entire painting as if it

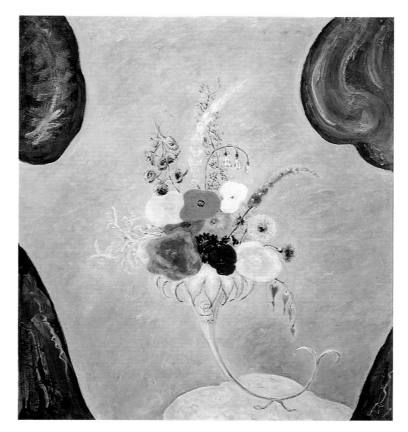

92. *Bouquet for Ettie/Blue Curtain* (1927), 50 x 60 in. Rhode Island School of Design. Gift of the Estate of Ettie Stettheimer, photography by Del Bogart.

were a religious retable (fig. 93). The work is strangely wooden and the characterization superficial, possibly because it was painted from a photograph. A second image of Father Hoff, now as gardener, is seen at the right of the composition, wearing a sun hat and watering his huge calla lilies. Stettheimer positioned the central figure of the priest near the ocean, standing before a tall wooden shrine. At the far left, five figures cavort in the surf. Hoff loved the sea and was an avid swimmer. Ironically, he died by drowning a year after the portrait was completed.

Rosetta's illness made life increasingly hard for Stettheimer, who had agreed with her sisters to divide her time so that one of them was always at home with their mother. In July 1928, she recorded in her diary, "This winter has worn me out very much. I look haggard—and feel

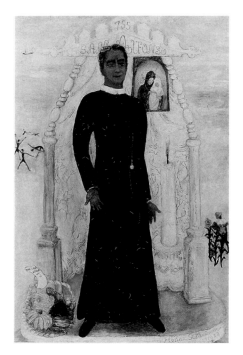

93. *Portrait of Father Hoff* (1928), 28¹/₈ x 18¹/₈ in. University Art Museum, University of California at Berkeley; Gift of the Estate of Ettie Stettheimer.

frustrated—I have had to watch time slip by while I sat in enforced idleness—when I could have painted. . . . I am suffering from nervous breathing—in fact all summer I have been bothered. I wish I could live somewhere in beauty for a while—I have tried not to suffer." That Ettie cut out many pages from her sister's 1928 diary indicates that her sister continued to vent her frustrations and anger on its pages. In order to have some contact with the outside world, Stettheimer corresponded regularly with Van Vechten and Demuth, who included in his letter something Gertrude Stein had said about Avery Hopwood. Stein, Stettheimer replied, does "not interest me very much—I only know her through her writings."

In the spring, Stettheimer painted a portrait of Alfred Stieglitz, which Hartley admired when he visited the Stettheimers at their summer house. "[Hartley] seemed to find my portrait of Stieglitz very amusing—and Father Hoff's very charming. 'Two feminine men' said he." Of all the sisters, Ettie was the closest to Stieglitz and O'Keeffe, but in 1927 and 1928 Florine also began to correspond with the pair on a fairly regular basis. Stieglitz's letters from Lake George, where he spent the summer, were largely complaints about his loneliness without O'Keeffe, an account of his burning of old negatives that he did not wish to survive him, and descriptions of various aches and pains. At the end of 1925, Stieglitz had opened the Intimate Gallery in room 303 at Anderson Galleries. Known to insiders as "The Room," the gallery was intended as the annual showcase for "Seven Americans: John Marin, Georgia O'Keeffe, Arthur G. Dove, Marsden Hartley, Paul Strand, Alfred Stieglitz and Number Seven (six + X)." Stieglitz's continual entreaties to Stettheimer to allow him to exhibit her work shows that the photographer had hoped sometimes to include Stettheimer as "X," as he did with Demuth, Picabia, Bluemner, and Lachaise, but this never materialized.[16] Despite the booming economy, by 1927 the art market was in a slump. The Room generated large crowds and a great deal of interest, but few sales.

In 1928, Stieglitz learned from Stettheimer that she had painted his portrait. When O'Keeffe returned from Wisconsin, where she had been visiting an aunt, she wrote to Stettheimer asking about the portrait:

How pleased I am—the idea of seeing it is one of the very few things that gives me
any feeling of pleasure when I think of returning to the city. I am very curious about
it—He is so many contradictory things that I can't help wondering what you chose
to put down—You undoubtedly don't see him as I do—no reason why you should.
But I like it that you have painted him—no matter what you have painted—He has
had a bad summer . . . but I don't know anything about ailing hearts—I only wish
it had happened some other time of year as this is my best time for painting—but
that is the way it goes. . . . Again I must say I am most curious about Stieglitz' por-
trait.[17]

Stettheimer, showing that she was highly conscious of the illusionism and modernism of her portraits, wrote back, "I don't think I have painted your special Stieglitz—I imagine I tried to do his special Stieglitz—but probably only achieved my special Stieglitz. I hope the real Stieglitz is pleasing you and himself in the matter of his health. . . . Let's make a date for the unveiling."[18]

Stettheimer's portrait of Stieglitz depicts the sixty-four-year-old photographer as a vigorous man striding purposefully around his gallery in a black cape, surrounded by images and symbols of the artists he championed (fig. 94). At the right, an ermine-cuffed hand opens the door, signaling the entrance of Baron de Meyer. At the left, an entering foot paired with a hand holding a cane symbolizes Demuth. Arthur Dove sits leafing through a book at the left, and various cards propped up from the floor bear the names of other artists represented by Stieglitz, including Marin, Hartley, and Paul Strand. The palette is largely black and white, parodying Stieglitz's vocation. Stettheimer did not include an image of O'Keeffe but inscribed her name in the Stieglitz portrait, written vertically and backward at the upper right, near a profile drawing of her head carved in paint. The artist also made reference to O'Keeffe through a dark spiral form that is barely visible against Stieglitz's cape. The curved spiral echoes a 1915 drawing by O'Keeffe which was among the works that first brought her to Steiglitz's attention. A dry-mounting press stands behind the sitter, and above hangs a painting of Lake George by O'Keeffe. At the far right, a small view of the Saratoga race track is visible beyond several New York skyscrapers. The depiction of Stieglitz is Stettheimer's last fully realized portrait. After this, although she continued to paint portraits, they became increasingly stiff and awkward as her focus turned away from the individual and toward larger social issues.

Stettheimer spent the final years of the 1920s painting subjects from memory, as though she were consciously attempting to reveal the past, as Proust suggested, by unraveling what had wrapped around it.[19] She began a series of memorial portraits of her aunt Caroline, her nurse Maggie Burgess, and her German teacher Fraulein von Prieser. As she "stained in" the background colors on the painting of von Prieser, she asked herself, "what would she [von

95. *My Birthday Eyegay* (1929), 27½ x 25½ in. Collection of William Kelly Simpson.

94. *Portrait of Alfred Stieglitz* (1928), 38 x 25½ in. Collection, Fisk University, Nashville, TN.

Prieser] have said, 1929, and not forgotten?" Unlike her recent explorations in narrative and contextual portraits, these works are based on traditional, formal portraiture as timeless memories rather than as fluid images taken from life.

In June, the four Stettheimers again traveled to a summer house in Tarrytown. Florine brought her easel and watercolors so that she could continue to paint. Rosetta soon became depressed, however, causing Stettheimer to note in her diary, "The longest day seemed long—but this one seems longer and the future ones are stretched out like flat noodles." For her birthday she not only picked but also painted a flower bouquet, which she titled *My Birthday Eyegay,* describing the painting as portraying "a heart aflame from which flowers blaze" (fig. 95).

During the fall, Stettheimer and her sisters continued to entertain at Alwyn Court, serving elaborate dinners to an eclectic group including the Van Vechtens, composers Virgil

96. *Cathedrals of Broadway* (1929), 60 x 50 in. Metropolitan Museum of Art.

Thomson and Aaron Copland, Eugene O'Neill, Mr. and Mrs. Philip Moeller, Muriel Draper, H. L. Mencken, Marie Sterner, Paul Reimers, Carl Sprinchorn, Cecil Beaton, Robert Morse Lovett, Mr. and Mrs. Lachaise, McBride, Demuth, Stieglitz, and O'Keeffe. The dishes Carrie prepared varied from mushroom timbale soup to halibut and shrimp in mayonnaise aspic; meals often ended with meringue filled with fresh strawberries. The stock market crash in October 1929 did not significantly affect the Stettheimers' lives. Their finances remained in the capable hands of their lawyer (and Ettie's former suitor) Alfred Cook, who persuaded the women not to sell their stock. They rode out the depression without much hardship or, apparently, much interest.[20] Despite the impact the depression had on the West, it is not mentioned in either Ettie's or Florine's extant diaries, and its results were treated ironically in correspondence by their friends.[21]

One of the few industries that thrived during the depression was motion pictures, which provided an escape from the realities of daily life. In a 1923 issue of *Vogue* magazine, John McMullin observed, "Modern life, and especially New York Life, is so dramatic that it is like a motion-picture film composed of a succession of thrilling moments with short captions. One might construct the memories of a New York night in the manner on which a 'movie script' is edited. The scene at dinner would be 'cut to' the second act of a play. The entr'acte would 'fade out' to the dancing floor of a cabaret which, again, would be 'cut to' the vision of some Broadway favorite standing in the spotlight."[22]

The introduction of sound in Al Jolson's *Jazz Singer* popularized the medium to such an extent that over seven million people were said to have gone to the movies in a single day.[23] Along with everyone else, the Stettheimers and their friends frequented the cinema, and the discussions at their parties often included mention of actors, actresses, and the latest films. At one such party at the Stettheimers' apartment, McBride recalled, Philip Moeller made such a fuss over the new James Cagney movie *Public Enemy* that Carl Van Vechten and Max Ewing got up and left in order to go see it.

Some time in 1929, Stettheimer began *The Cathedrals of Broadway,* in which she paid tribute to the booming popularity of film by making the movie theater into a secular shrine (fig. 96). In one review of the painting, a critic noted, "Those temples of pleasure, the Paramount and Roxy, can no longer complain that art has ignored them. Miss Stettheimer has summed them up in a way to entice all Europe to these shores." The painting remains one of the artist's masterpieces. When it was exhibited at the Whitney Museum in 1932, the critic Paul Rosenfeld called it "the sensation of the show . . . it is a piercing, an amusing, and elegant piece of work, and very brilliantly pigmented. Originality of idiom distinguishes it from the mass of derivative and compromising pieces necessarily evident in any omnibus show."[24] The conservative critic Edward Alden Jewell, writing for the *New York Times*, was less impressed. He described "shuddering at the too painfully vulgar tinsel of Florine Stettheimer's

Cathedrals of Broadway, with passages raised in relief, recalling Mr. Sargent's rococo prophets in the Boston Public Library."[25]

The painting's composition is arranged around a theatrical proscenium arch with a shallow foreground in the center. The impression that the viewer is an active participant in the events is heightened by the inclusion of a liveried man inviting us to move toward the ticket window at the far right corner, where an usher waits to direct us to our seats. A cordoned area in the center of the composition, surrounded by a line of uniformed ushers, encloses a rich red carpet inscribed with the word "Silence." This reprimand is echoed by a gilded statue, emerging from a central calla lily, whose finger is pressed against her lips. At the far left, Stettheimer, her elder sister Stella, and her nephew Walter Wanger enter through a glass door and pause as the artist looks up at a huge grisaille screen suspended under the Paramount arch. On the screen, a black and white film clip displays, in Paul Rosenfeld's words, "the vulgarly handsome mask of Jimmy Walker opening the baseball season; the derby atilt on his head; the face of him hard as a wisecrack; the baseball offensive in his twisted hand."

Disparate activities, all referring to forms of entertainment available on Broadway, take place on the deep stage below the motion picture screen. All suggest sound and motion, a multiringed visual circus of noise and color. At the right, a seal mounted on a large ball is egged on by a trainer to balance a ball on its nose. Its actions are accompanied by a seated woman at a huge sunken organ. The centerstage is filled with figures dancing amid a classical garden setting. At the left, an orchestra led by a conductor standing in a solar-styled podium provides musical accompaniment, while a lone skater pirouettes on the ice floor below. At the far left, an usher cordons off a crowd of people waiting to be let into the theater, and a tuxedoed man stands high up in a light booth waving toward the Stettheimers.

The background is a lighting extravaganza. A large red banner with gold letters proclaims the title and date of the painting and the artist's name. The names of famous theaters—the Mark, the Strand, the Rialto, the Roxy—are mounted on large signs or written in lights in the night sky. Many theaters have signs declaring "House of Talkies" and "All Talking," signaling the addition of sound to film. The gilded arch of the Paramount, which surrounds Jimmy Walker's image, is filled with ironic details. At the left, a niche holds a figure of a nun reclining on a bier (an image taken from Lillian Gish's film *The White Sister*), while at the right, a chandelier hangs over a nymph with a garland. Below, a prominent exit sign hangs over a painting of a bull by the French artist Rosa Bonheur.

Stettheimer based major compositions throughout her career on masterworks she admired from the history of art. In some cases, this was an overt homage; in others, she chose to emulate certain compositional elements because their identification reinforced the work's conceptual thesis. Like many of her contemporaries in other fields, Stettheimer seeded her works with clues that she expected to be uncovered and appreciated by connoisseurs.[26] It is

not known whether she understood how a film is technically produced in order to form a contiguous narrative. Nonetheless, in designing a compositional frame in which to convey the drama and excitement of Broadway, Stettheimer returned to precedents she admired in Trecento and early medieval narrative painting. Like Giotto's Arena Chapel in Padua, for example (one of the most cinematic of Italianate works and one that the artist greatly admired), Stettheimer laid out the composition of her *Cathedrals of Broadway* as bands of narrative in sepia, orange, and brown tones. The different episodes are placed so that they detail a visitor's progress through the streets of the New York theater district and inside an elaborate theater. The Arena Chapel's double-barrel vaulting is emulated in Stettheimer's painting by the central Paramount Theater arch that frames the composition and becomes a vortex, drawing the viewer's eye past the dazzling mini-storia taking place on either side. The search for a earlier construct on which to base overall compositional structure underlies all four of Stettheimer's *Cathedral* paintings, and their titles confirm a conscious restructuring founded on well-known historic and aesthetic building blocks.

Stylistically, *Cathedrals of Broadway* falls between two concurrent modernist trends. One, cubism, explores dislocation of time and space, allowing numerous activities and vantage points to be captured on a single canvas. The other reflects a progressive form of social realism, combining on canvas everyday scenes of daily life with images of popular culture (as practiced by many artists, from Reginald Marsh to Andy Warhol). Stettheimer had incorporated the concept of multiple events and multiple viewpoints as early as 1915, in works such as *Fête à Duchamp* and *West Point*. The year that she began *Cathedrals of Broadway*, John Marin, one of the artists of the Stieglitz circle, painted a watercolor, *Broadway Nights*, which shares with Stettheimer's work an intention to re-create the theater district's dazzling array of lights, movement, and entertainment by juxtaposing several viewpoints. *Cathedrals of Broadway*, however, is not merely a compilation of successive images but a cacophony of simultaneous sights and sounds. It is not a stopped or frozen action sequence but an evolving narrative.

One of the distinguishing features of *Cathedrals of Broadway* is that it illustrates overtly what her earlier genre paintings and portraits implied—that for the artist admiration and social criticism are far from mutually exclusive. The satiric humor of the painting was not lost on Paul Rosenfeld, who noted that the painting provoked a "hubbub" among viewers and among other artists included in the 1932 Whitney exhibition.

The Stettheimers' summer of 1930 was spent at a house rented at 35 Beach Street in Larchmont, New York, mainly because it had an elevator for Rosetta. Although the area had a picturesque little beach, Florine felt confined and uncomfortable, and complained at having to share a beach cabin with strangers: "People are so common in our country." She attempted to raise the social standing of the neighborhood by feeding a local squirrel Mallard's chocolate "marrons en manque de peanuts." Noting a newspaper editorial about the effete squirrels

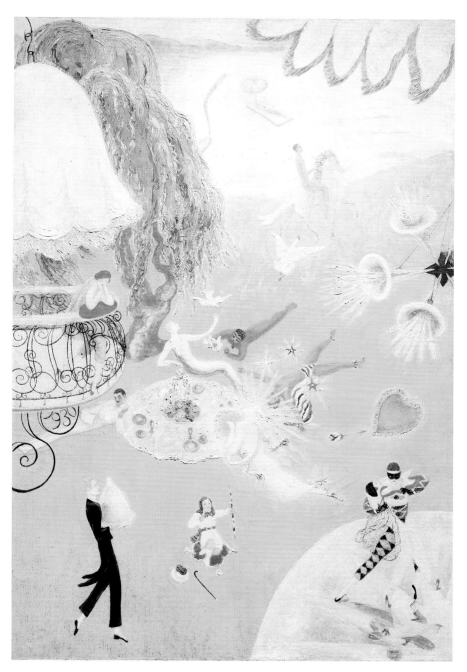

97. *Love Flight of a Pink Candy Heart* (1930), 60 x 40 in. Photograph © The Detroit Institute of Arts, 1995. Gift of Miss Ettie Stettheimer.

in Central Park, Stettheimer felt pleased that due to her efforts, Larchmont would soon be able to brag about a "debauchée" squirrel. She spent one weekend as a guest at the Briarcliff Country Club, which she described as "an expensive convalescent home," and was thrilled when the summer ended and her family finally returned to New York.

Stettheimer continued to receive recognition from her peers. Albert Gallatin, founder of the Gallery of Living Art in New York, asked to see her work, and the American Society of Painters, Sculptors and Engravers made her a member. Nonetheless, for her fifty-ninth birthday, her only diary notation is, "I had breakfast, I got up, I had lunch, I am about to have dinner and then I expect to got to bed." A month later she wrote, "I finished a history of my life that takes about five minutes to read."

In 1930, reflecting her mood of introspection and reminiscence, Stettheimer began a painting titled *Love Flight of a Pink Candy Heart*. She laid out the main compositional components of the painting in a preliminary sketch that is very loose and differs somewhat from the final version.[27] In the finished painting, Stettheimer replaced the figure of the blonde woman on the terrace with a self-portrait, and she eliminated the male partner (fig. 97). The artist, with eyes closed and elbows resting on a red pillow, leans on a balcony overlooking the scene below. She is dressed in an iridescent pink pantsuit. One of her legs is thrust through the intricate wrought iron of the balcony and the other falls out of her red high heels, furthering the impression that she is day-dreaming. This idea is reinforced by the undifferentiated ground of the painting and its virtually invisible horizon line, which causes figures to float across the space. The background is painted a saturated yellow reminiscent of such earlier paintings as *Picnic* and *Asbury Park South*, while the figures are predominantly pink.

Although the painting seems replete with romantic imagery and references to flirtations and former love interests, its meaning remains obscure. Stettheimer's poems and correspondence offer some clues to the artist's intention. Her poem "Duche" contains references to a "love flight," and two other Stettheimer poems feature "pink candy hearts" and carry poignant strains of nostalgia, some bitterness, and a sense of loss:

A pink candy heart
In fluted tin
A spun glass rainbow
On a lace paper sky
A toy peacock
That spreads its tail
A first beau's picture
With glossy curls
Were early cherished treasures.

I found pink hearts
soft to the touch
stuffed with fragrance
nestling among her underthings
I gently store one
jammed it
full of pins
and hung it up
my Saint Sebastian.

In the painting *Love Flight*, a circular cloth is spread across a yellow lawn and covered with settings for an elaborate picnic. As in earlier work, the artist used a picnic motif to suggest flirtation and romantic interludes. As our eyes move clockwise around the circular cloth, they are arrested by a young woman gesturing toward a white dove. In her dress and attitude the woman recalls the mythological figure Campaspe, who was the heroine in one of Van Vechten's novels, *The Blind Bow Boy*, based on an Elizabethan play by John Lyly titled Alexander and Campaspe. In the Lyly play, Campaspe was the concubine of Alexander, who received her as a gift from the artist Apelles. Apelles in turn fell in love with her while painting her portrait. Apelles' words in the Elizabethan drama offer clues to reading Stettheimer's painting:

Cupid and my Campaspe playd
At cards for kisses, Cupid payd;
He stakes his quiver, bow & arrows,
His Mother's doves & team of sparrows;
Loses them too; then, downe he throwes
The corrall of his lippe, the rose
Growing on's cheek (but none knows how),
With these, the cristall of his brow,
And then the dimple of his chinne
All these did my Campaspe winne.
At last, hee set her both his eyes;
Shee won, and Cupid blind did rise.
O Love! has shee done this to Thee?
What shall (alas!) become of me?

The cover of the Van Vechten novel, displaying a Cupid with his eyes bandaged and holding a quiver and bow, has the same ironic tinge as Stettheimer's painting. Her affinity for images from popular culture is suggested by a comparison with a contemporary *Vanity Fair* cover that features a small Cupid standing protectively in a guard house between a stylish man and woman.

In Stettheimer's *Love Flight*, two tanned men lie in the sand at Campaspe's feet. One, possibly Louis Bernheimer, is nude, and he stretches out on his stomach and smokes a pipe. The man on his left, wearing patriotic red, white, and blue swimming trunks, lies splayed out on his back and has small colorful bands around his ankles. The preening, unself-conscious posturing of these men, clearly aware they are observed and appreciated for their physical beauty, recalls another Stettheimer poem, "A Golden God," which reveals once again her sardonic attitude towards men:

I adore men
Sunkissed and golden
Like gold gods
Like Pharaoh-amber-anointed
Thus I mused aloud
Lying on a lace-cushioned-couch
On a verandah
Overlooking Lake Placid—
My August-guest
Heard me and smiled
And rose lazily
From the turkey-red cushions
He became
A golden speck
Paddling
Into
The
Blazing
Sun
Hours later
He came back
Looking self-conscious
and parboiled.[28]

In an unusual gender reversal, in Stettheimer's painting the men are the "things of beauty," the objects of at least aesthetic desire. A star-crowned Adonis lies against the lower right edge of the tablecloth. Wearing only a blue bandanna and blue-laced ballet slippers, Adonis is a vision in white against the yellow sand. Stylistically he resembles the small figure of the Apollo Belvedere, Stettheimer's "beauty norm," a reproduction of which the artist kept on the mantle over a small fireplace in her Alwyn Court bedroom. Directly under Stettheimer's terrace in *Love Flight*, Charles Demuth, looking uncharacteristically virile and fit,

lies on the left edge of the cloth and holds a large sketch pad in his lap.[29] Below, an elegantly suited, patrician Arnold Genthe enters the painting carrying a mysterious dome on a silver salver. Most of the men are completely self-absorbed and apparently not interested in pursuing any sort of romantic attachment. This corresponds to the reality of Stettheimer's life; in her fifties and sixties, the majority of her male friends were homosexual. Thus, while in the painting Stettheimer looks out musingly, over the men displayed below her, her attitude appears less one of yearning than of nostalgia.

In the middle foreground, a small figure has released a red, white, and blue arrow, which flies through the air and is about to pierce a floating, paper-trimmed pink heart. At the right, above a trio of blaring trumpets, a naked man rides off on a white horse. Finally, in the composition's lower right corner, Stettheimer again painted herself, now in a white pantsuit with black lace veil and wearing an artist's beret. She is leaning back and into the arms of her dancing partner, a masked man dressed as Harlequin. The identity of the Harlequin figure is unknown, but he also appeared in the artist's earlier *Soirée*. Over the years, the figure has been identified as Duchamp or Nijinsky; it is equally possible, however, that the Harlequin is Stettheimer's symbol for the fantasy man whom she long dreamed of but never met.

Years later, Ettie annotated a photograph of *Love Flight*, writing that it represented her sister contemplating "various friends of her youth whom she has portrayed with a mingling of symbolism and realistic observation." Enigmatic, nostalgic, transient, the various elements of Stettheimer's painting combine to invest the work with a sense of love fighting a losing battle against the realities of time—love as time's fool. As perceived by Stettheimer, the voyage of life is filled with isolated vignettes of love and arranged in the memory like miniature stage sets of a Mozart or Rossini opera.

Professionally, meanwhile, Stettheimer's reputation continued to grow. On October 3, 1930, Stieglitz again wrote asking her to exhibit her works in his new gallery: "We are wondering would you like to show some of your paintings during December—and during Xmas week you could add an Xmas tree if you wished to. Or would you prefer April for show? I'm sure your things would look very beautifully in The Place. Of course you have been hoping for a much larger place but why not try this? I know it would be a beautiful event." Stettheimer was not adverse to exhibiting her work, nor had she entirely abandoned the notion of a solo exhibition, but for some reason she refused Stieglitz's offer: "Your colossal generosity makes all my would be answers sound selfish—be they acceptances or refusals of your beautiful offer of a show. By now I am just paralyzed into inaction—there is not an effort I can make—excepting to thank you—I am grateful—and so pleased that you care to show my paintings. The summer I have just spent has made me more than ever indifferent to a public. I met old acquaintances who remembered I had gone to Art School and had I 'kept up my painting?' I had no room nor lights nor paints in Larchmont—and I am happy to be back where I belong." Stieglitz per-

sisted: "I received your letter & I understand. But I want you to know that I wasn't unselfish in asking you. First of all I care as little about a public as you do, but I feel that the [?] idea I have been following for years includes your work. And that without it my little 'building' will ever remain not quite complete." Nonetheless, despite Stieglitz's continuing efforts, Stettheimer continued to refuse him. In exasperation, Georgia O'Keeffe wrote to her fellow artist, "I wish you would become ordinary like the rest of us and show your paintings this year!"[30]

The winter of 1930 was often frigid, and Stettheimer saw many traffic accidents occur below her studio window. In mid-December she fell on the icy sidewalk in front of her studio and was helped to her feet. Fastidious as usual, she was horrified at the idea of being assisted and having her body touched by strangers: "'Tis ignoble to be ill—having to take recourse in outside help . . . doctors—x ray photographers—intensifies the horror . . . being helped up after a fall on glass pavement on the street—seven men from nowhere crowding about me—I smiled them away . . . they disappeared . . . a body that gets damaged should be able to turn on a healing apparatus. It's strangers that the body, at least my body, resents." (Ettie expunged the remainder of this passage.)

The following summer, the Stettheimers again rented the Jay Gould estate in Westchester County ("Truly on the Hudson this time . . . Mrs. Gould just died here") and hosted a number of parties. Several of their summer neighbors were artists, causing Stettheimer to complain, "There are four of us addicted to art within a few acres . . . there may be hundreds in Tarrytown—oh horrors—." With the whirl of social activities and the needs of her mother she seldom got a chance to work, but toward the end of the summer she finally set up a canvas and charcoaled in the beginning of a composition: "at last it looks as if I were going to paint."

Although Stettheimer never returned to Europe, her sister Carrie and many of her friends continued to travel abroad for the summer:

> *In spring my friends*
> *droop—they disappear—*
> *June is empty*
> *of them—In autumn they come*
> *swoop back*
> *Stuffed full*
> *of Europe.*[31]

Henry McBride spent the summer of 1931 in Paris and wrote to Stettheimer describing various quarrels between Virgil Thomson and Gertrude Stein. He also attended a Thomson concert, which "was not too hot as it might have been." As the editor for *Creative Art*, McBride arranged to have Marsden Hartley write an article on Stettheimer, which was published in the magazine's July issue. In the article, Hartley said that Stettheimer's work was

"the ultra-lyrical expression of an ultra-feminine spirit and must be considered as such if one is to enjoy the degree it is meant to convey." Hartley insisted that Stettheimer's name be added to the list of significant women artists, which included Mary Cassatt, Berthe Morisot, Marie Laurencin, Suzanne Valadon, and Georgia O'Keeffe. Stettheimer appreciated the article and wrote to McBride thanking him: "your choice of Hartley for that article was swell—he wrote a minuet—didn't he?"

Hartley's assessment of Stettheimer's work was quoted over and over by contemporary writers drawn to the perceived eccentricities of the artist. To a large extent, Hartley's article is responsible for the continuing misperception of Stettheimer's work as "delicate, fanciful": "distinctly chamber music meant to be heard by special sympathetic ears, it has about it an eighteenth century delicacy which has no place in the present-day broadcasting system. . . . [It implies] a definite degree of cultivation in the spectator in order to enjoy its almost whimsical charm. . . . One must wish for an ultra-refined experience in order to enjoy what it contains."

In fact, it must be remembered that the Stettheimers were among Hartley's few patrons, and that they periodically supported him financially by purchasing his work. In early January 1929, Stieglitz wrote to Ettie thanking her for sending money to "our mutual friend M.H. The check means one month of comfortable Paris for him. I'm glad you like the painting. It's a *real* Hartley." Thus, the relationship between Stettheimer and Hartley was hardly that of peers, and the *Creative Art* article was certainly composed to retain the Stettheimers' favor.[32]

Stettheimer enjoyed imaging herself as young and feminine, and so she appreciated a tribute that emphasized these attributes. Hartley's article accentuated the "refined obscurity" of Stettheimer's reputation by declaring that for reasons that are "too personal and special . . . this artist has wished apparently to remain the property of special friends." Hartley speculated that perhaps some day she would "set aside all forms of preference, self-imposed barriers and of stereotyped concepts of presentation, and let the casual spectator in at last upon a world of explicit charm, of quaint humor and incisive wit." Although his article goes on to mention Stettheimer's "iridescent wit . . . element of playfulness" and successful illustration of the "exquisite fatalities of heritage," his overall description of her work as "quaint" not only positioned her outside the norm but distinctly ghettoized her within her gender.

Not all of Stettheimer's friends agreed with this assessment. The photographer Arnold Genthe, on reading the article, immediately wrote to Stettheimer, declaring that he found Hartley's article "well and entertainingly written, but I believe that your *Broadway Cathedrals* painting deserves a little more space in a critical review than just a mention *en passant*. To my mind it is not only the most significant of your paintings but it is a unique and exceedingly brilliant and original presentation of a phase of modern New York which has never before received such an illuminating and rational interpretation. . . . And Laurencin, the painter with raspberry syrup and whipped cream and [?] does not deserve the honor of having

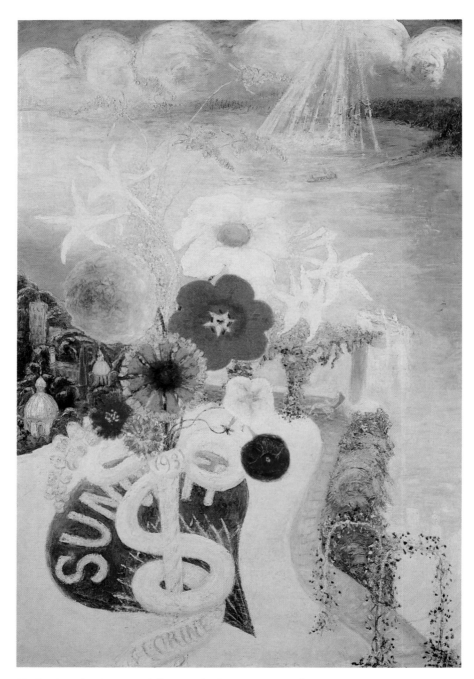

98. *Sun* (1931), 38 x 26 in. Collection of Whitney Museum of American Art.

her name in an article about Florine. Them be my sentiments!" Nor is Hartley's view accurate. Stettheimer regularly submitted her work to public exhibitions in which she had no control or say in how they would be displayed. In 1931 she was negotiating with Stephen Bourgeois of the Bourgeois Gallery about having "a show of [her] own" in the dealer's new gallery, which would accommodate the large size of her recent works. Nothing appears to have come of these discussions, but Stettheimer was clearly interested in continuing to explore the possibility of a solo exhibition just a year after she had turned down Stieglitz's offer.[33]

During 1930 and 1931, Stettheimer began several paintings, including two that confirm the ease with which she now worked. *Sun* (fig. 98) is painted from a high perspective, looking down on a terraced garden overlooking the Hudson River. The painting is unusually contemplative and was probably executed while the artist resided at the Gould estate. The work contains many by now familiar elements, particularly the central, oversize bouquet of flowers. The flowers stream out of a long, twisted, cylindrical crystal vase that is encircled by a curled ribbon or snake bearing Stettheimer's first name and the date. A veil of light breaks through the clouds and shimmers over the river. A trellised brick walk meanders around the terrace and passes under a vine-covered bower. The figure of a woman, possibly the artist, rests on a chaise in the shade of the arbor gazing out over the compressed landscape with surprisingly Italianate architecture dotted with trees. The tiny figure on the chaise is no match for the Antaean grandeur of nature.

Sun is painted in muted tones of blue, green, and pink, with golden accents on several of the flowers. Stettheimer designed a special frame for the painting, with a thin twisted inner wood band and a flange of scalloped mounds, their edges lined and cross-hatched to resemble fine lace. The whole frame is whitewashed, heightening the sense of light emanating from the painting's center.

Stettheimer designed many of her frames. The context and surroundings in which her works were shown continued to be, at least for the artist, an integral part of their presentation. She also designed virtually all of the furniture for her Beaux Arts studio and the Alwyn Court apartment, so that the paintings and furnishings together formed a coherent aesthetic installation. Stettheimer made numerous sketches of design ideas and, when satisfied, sent them to a frame maker to be fabricated (fig. 99).[34] On one such sketch she noted, "I should like to have the effect of embroidery—and the frame to incline toward the spectator." Stettheimer's frames and furniture were always painted white, with occasional elements picked out in gilt. This was the color arrangement of her "exceptional boudoir" at the Alwyn Court apartment, with its bed and matching artist-styled commodes, and it recalls the color scheme of her 1916 exhibition at Knoedler's. In her small Alwyn Court bedroom, Stettheimer hung her painting *Music,* with its faux fringed frame echoing in style a dressing table and small stool designed by the artist. Stettheimer hung her 1923 self-portrait above a lace-draped jewelry table, and

she suspended *Sun* above a commode with matching wooden and gilt trim (fig. 100).

The decoration of Stettheimer's Beaux Arts studio astonished all visitors. The artist's eye and idiosyncratic aesthetic was evident throughout the public and private spaces of the duplex. The studio looked out over Bryant Park, which Stettheimer referred to as the garden of her "estate," although there is no evidence that she ever set foot in it. McBride described the studio as "one of the curiosities of the town; and very closely related, in appearance, to the work that was done in it. The lofty windows (the studio was double-decked) were hung with billowy cellophane curtains, and the chairs and tables were in white and gold, the tables in glass and gold and I have a remembrance of lamps screened with white beads and unreal but handsome gilt flowers in vases. I certainly recall some gilt flowers in a golden bowl on the dining room table, reinforced by draperies of some golden fabric at the windows." Stettheimer adopted George Washington as an object of reverence and a metaphoric replacement for her invisible father. In her studio, adjoining the living room, was a small area she called her "patriotic room" because it contained a small shrine to Washington, including busts and figures of the "father of the country" and her paintings *Liberty* and *West Point* (fig. 101).

The bedroom of Stettheimer's studio was visible through arched windows partially draped with lace and looking out over the living room. On at least one occasion, the artist blocked the red-carpeted stairs to her alcove bedroom with a wide, white cellophane ribbon tied in a bow, forbidding access to the "cocoon of lace upstairs." She hung the walls of the studio bedroom with flower paintings in elaborate frames and draped her bed in Nottingham lace, with two plaster putti on either side (fig. 102). Stettheimer's continual use of lace in her mature paintings, frames, and furniture designs recalls a trip she made with her sisters to the cathedral in Orléans in 1909. She disparaged the cathedral's decoration: "they shirked work on it; instead of lace it merely looked like old-fashioned underwear embroidery." At some point, the artist also designed a table for the foyer in Carl Van Vechten's apartment. Reflecting her friend's interest in Afro-American culture, Stettheimer designed the table to be fabricated with a blackamoor figure at the base holding up a black mirror, on top of which she placed a reproduction of a large bronze Benin head from the British Museum's collection.

The aesthetic of Stettheimer's paintings, interiors, furniture, and theatrical design reveal that by the early 1930s she had achieved equanimity and conscious satisfaction in being distinctive from and peripheral to the major currents of contemporary art. Increasingly she turned her insider/outsider status to advantage, observing her surroundings and transforming events into playful, ironic satires often based on Old Master precedents. Between 1931 and 1932, she began the second painting in her *Cathedrals* series, using as its nexus a New York society wedding.

Stettheimer based the format of *Cathedrals of Fifth Avenue* (fig. 103), like her earlier cathedral painting, on Italianate precedents by borrowing architectural elements for the cen-

99. Sketches for furniture. Florine Stettheimer Papers, Rare Book and Manuscript Library, Columbia University.

101. Peter Juley, interior of Stettheimer's Beaux Arts Building duplex apartment, with cellophane curtains. Florine Stettheimer Papers, Rare Book and Manuscript Library, Columbia University.

102. Peter Juley, Stettheimer's Beaux Arts bedroom. Florine Stettheimer Papers, Rare Book and Manuscript Library, Columbia University.

100. Alwyn Court apartment, with *Sun* hanging over artist-designed commode. Florine Stettheimer Papers, Rare Book and Manuscript Library, Columbia University.

tral structure from works such as Giotto's Enthroned Ognissanti Madonna, which she admired in the Uffizi Gallery.[35] She adapted the Giotto's pointed vault throne and delicate gable (ornamented with crockets and open-arched wings) in its entirety, but she collapsed the realistic space created by Giotto's painted buttresses, replacing it with a hanging red awning. Giotto's Madonna represented, for its time, a new mingling of the mystical/spiritual with the human. In placing a similar architectural altar in the center of her canvas, Stettheimer also consciously conflated two ironic notions of wedding: the religious ritual (implied by the jewel-bedecked archbishop at the left and the simple monk at the right, their hands raised in blessing over the central canopy) and the commercialism and acquisitiveness commonly associated with the event among New York society women.

That a society wedding was both a sacrament and the occasion for ostentatious display was not lost on the popular media. Contemporary newspapers and magazines carried long articles detailing the decoration, fashions, and guests at prominent weddings. Illustrations in popular magazines poked fun at the spectacle of the "smart set" and their apparent need to see and be seen. In *Cathedrals of Fifth Avenue*, Stettheimer included specific references to the wedding's elegant site through the inclusion of the gilt figure of Victory leading the statue of General William T. Sherman on horseback at the right, which still stands at the entrance to Central Park opposite the Plaza Hotel. At the left, she placed the incised stone lions that guard the entrance to the New York Public Library at Fifth Avenue and Forty-first Street.

Stettheimer's diaries and correspondence make it clear that throughout her life she believed marriage to be a suffocating, conventional, commercial undertaking that benefited the man but not the woman. Her aesthetic treatment of a wedding thus incorporates all of the treacle of such events. Floating in the sky above the altar roof line are references to the raptorial movements followed by nuptial couples. The engagement period is represented at the right by red roses, boxes of Maillard chocolates, evenings at Delmonico's, French restaurants with buckets of champagne, and shopping trips to Bendel's and to Tappe's to purchase a designer wedding gown. At the left, the word "Tiffany" is spelled out in the sky by bright jewels and the gold bands of wedding rings. Below, the name of Altman's Department Store is made up of various furnishings: tables, chairs, curtains, linens, baby cribs—all essential for the well-to-do couple setting up housekeeping. Stettheimer herself frequented many of the same venues, and she consciously and immodestly incorporated into her paintings the very things she found diverting:

> *My attitude is one of love*
> *is all adoration*
> *for all the fringes*
> *all the color*
> *all tinsel creation*

103. *Cathedrals of Fifth Avenue* (1931), 60 x 50 in. Metropolitan Museum of Art.

I like slippers gold
I like oysters cold
and my garden with mixed flowers
and the sky full of towers
and traffic in the streets
and Mallard's sweets
and Bendel's clothes
and Nat Lewis hose
and Tappe's window arrays
and crystal fixtures
and my pictures
and Walt Disney cartoons
and colored balloons.

If Stettheimer paid little attention to the contestants in *Beauty Contest*, the bride and the groom fare no better in *Cathedrals of Fifth Avenue*. Although the wedding party is the composition's central motif, the artist treats them superficially in comparison to other elements of the work. The groom, in a formal suit, is conventionally tall, dark, and handsome and stands passively, like a fashion mannequin. The bride, surrounded by vaguely pink attendants, is a characterless mass of diffused white light, her facial features treated more summarily than anyone else's in the painting.

By contrast, most of the other figures are highly individualized and can be identified as either friends and acquaintances of the artist or local celebrities. This prompted Linda Nochlin to refer to the *Cathedrals* paintings as "secular icons presided over by contemporary cult figures."[36] A dapper Charles Demuth stands, holding his cane, at the right of the wedding party. He offers his arm to the blonde, stylish Mrs. Valentine Dudensing, wife of the prominent gallery owner, as she struggles to control her daughter's supervision of a large gray dog. Behind Demuth, Muriel Draper, dressed in bright red, looks up at the sky and rests an elbow on the back of fellow writer Max Ewing. In the left foreground, standing along the edge of a red carpet inscribed with the date and title of the painting, Arnold Genthe, in tall riding boots, adjusts his camera to record the wedding party. To his right is a woman in gold whom Ettie later identified as Mrs. Walter Rosen. At the lower right corner, standing in the front seat of a large, elegant convertible, the three Stettheimer sisters look out over the wedding as though they had just stumbled on the event en route to somewhere else. Carrie is shown in front, wearing a red fur cape with fur collar and green trim. To her right, Ettie wears a red dress with a black bow matching her hat, her face turned away from the wedding party. This is in character with the majority of the women in Ettie's novels, who struggle against the confines of marriage, often choosing the "life of the mind" over romantic attachments.[37] At the

far right, Florine peers at the spectacle from over Carrie's shoulder; she is half-hidden, as usual the most withdrawn of the three sisters.

Irony and overt humor are evident throughout the details of the painting, particularly in the attitudes of the various children involved in the ceremony. A bored choir boy holding a scepter at the left uses it to lift an edge of the bride's dress and peer underneath. Another boy holds an incense censor away from the aggressive dog. Two attendants carry a flower garland before the wedding party, but both these children are distracted from their duties: the small boy at the right is far more interested in the dog, and he steps off the wedding carpet to get a closer look; the tiny flower girl positions herself directly in front of Genthe's camera and poses, attempting to draw the photographer's attention away from the bride. At the far left, a red-faced policeman, mounted on a sleeping white horse, looks upward and waves as though responding to the benedictory gesture of the oversize Jesuit priest behind the red canopy.

Each of the compositions in Stettheimer's *Cathedrals* series encloses several worlds within worlds. Smaller, separate "ceremonies" take place within each painting so that there is a layering of ideas about commerce, art, ritual, religion, and entertainment. In the left section of *Cathedrals of Fifth Avenue*, Stettheimer painted a vignette showing Charles Lindbergh's ticker-tape parade through the streets of New York. Lindbergh's historic flight across the Atlantic came to serve as a public symbol that the creativity and innovation of modernism, with its connotations of youth, enterprise, and brashness, had shifted from Europe to the United States. The figure of Lindbergh also symbolized the transition in the 1920s toward recognition that in the modern world the individual was alone, "in permanent flight, devoid of footing," and that freedom was, above all, a responsibility to oneself.[38] In Stettheimer's painting, the Lindbergh detail acts as ballast to the religious spectacle in the painting's foreground. By balancing the central, generalized wedding group with individualized portraits of the three sisters on one side and Charles Lindbergh on the other, *Cathedrals of Fifth Avenue* is Stettheimer's ironic comment on the value of individualized achievement and on idiosyncratic choice versus conventional actions.

In the May issue of *The Nation*, Paul Rosenfeld again joined the champions of Stettheimer's work: "The canvases of Miss Stettheimer, indeed, stand well among the exceptional works of art now being produced in the United States." In an article devoted to Stettheimer, he placed the *Cathedrals* series and the artist's group portraits under the heading "Americana," calling them "grandiose, documentary caricatures of the land of the free." Of such works as *Asbury Park South*, *Beauty Contest*, and *Spring Sale at Bendel's*, Rosenfeld observed:

> they are full of marvelously chic and quite diaphanous persona; and if these puppets
> have the American seriousness mixed with the American childishness, and are all
> exalted and pompous about ridiculous things, they also have an elegance and
> elfishness which is not quite of this world. . . . Their spirit and their style are quite

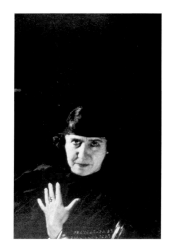

104-106. Carl Van Vechten, from left, *Carrie and Ettie Stettheimer*(1930s),*Ettie Stettheimer* (ca. 1930s), *Carrie Stettheimer* (1935). Yale Collection of American Literature, Beinecke Rare Book and Manuscript Library, Yale University.

as individual as the technique . . . the art . . . is an ornate, a feathery, a spangled one, full of trills and coloratura and floritura. . . . Those brilliant canvases of hers do resemble gay decorations in colored paper, and lacquered red and blue glass balls, and gilt-foil stars, and crepe streamers, and angels of cotton wadding, and tinted wax tapers. This is because she has a highly refined decorative sense combined with a certain predilection for the ornamental, the frivolous, the festive; indeed a sense of the poetry and humor and pathos. . . . There are serious people who claim that she is one of the three most important women painters in the country, the other two being Georgia O'Keeffe and Peggy Bacon.

A number of Stettheimer's friends and acquaintances congratulated her on the article, among them the influential Hilla Rebay, who commented, "I enjoyed so much what Paul Rosenfeld wrote, only I could very well miss O'Keeffe and Bacon and find you not the best only of the women painters (which means very little unfortunately), but the man painters also, all included, I don't know one of them whose work is as fine and original visionair and well done as your works. I said this to McBride the other day. But it is nice they begin to write about you because you deserve it so."[39] Stettheimer's reply is not known, but she wrote "funny" on the outside of the envelope of Rebay's letter.

Throughout the spring and early summer of 1932, Stettheimer corresponded with McBride from the Gould estate in Tarrytown and from her studio in New York.[40] In addition to

noting her current reading material, which included the letters of Baroness de Bode and the memoirs of women who knew Napoleon and lived through the French Revolution, Stettheimer speculated on the upcoming election, her continuing preference for Al Smith as president, and lectures she and her sisters attended, including one on Russia by Esther Murphy Strachey given at Muriel Draper's salon. Meanwhile, Carl Van Vechten, who had now turned his attention almost exclusively to photography, took detailed photographs of the facade of the Stettheimer's Alwyn Court building and asked to take portraits of the sisters themselves. Florine flatly declined; Ettie and Carrie, however, eagerly accepted (figs. 104-106). Their reactions to the results were less than enthusiastic: Carrie commented that the photographs "were a revelation: I think, I will get myself to a nunnery," and Ettie claimed that in the portrait Van Vechten had foretold her next incarnation, when "I shall return to earth as a male & be exactly like this picture—if I live long enough. . . . I must say I am crazy about this quizzical, experienced gentleman & would fall in love with him, if it weren't myself." The artist Carl Sprinchorn made watercolor portraits of each of the three sisters, again differentiating their personalities through their clothing and attributes. During this period he also cut silhouette portraits of them, using green construction paper and placing each one adjacent to the elegant black silhouette of a tall, dinner-suited man. Carrie is shown wearing a nineteenth-century gown with a train; Ettie is depicted as a stylish author and Florine as a slender artist striking a rakish pose and holding her palette (fig. 107).

This differentiation was fostered by the three sisters. Despite their close proximity throughout their lives, they viewed themselves as individualists and disliked the implication that they inevitably shared beliefs and interests. Later in life, recalling that she and Carrie had never been forcibly put out of Florine's studio, Ettie remarked, "I don't think it ever occurred to us to watch her . . . we were *not* a cooperative group. I never read anything to anyone that was to be published. Carrie never asked anyone advice or opinion in connection with the Doll House, and Florine spoke only in a general way of what she was painting or about to paint."[41]

In 1932, Ettie objected to the public exhibition of Alfred Stieglitz's explicit nude portraits of Georgia O'Keeffe, yet she made it very clear that this was her own view and not necessarily that of her sisters, by writing to Stieglitz: "My sisters belong out of it. I haven't discussed the matter with them so I don't know whether or what they think of any of it. We differ so often

107. Carl Sprinchorn, Detail of Florine, silhouettes of the Stettheimer sisters (1933–34), green and black construction paper. Yale Collection of American Literature, Beinecke Rare Book and Manuscript Library, Yale University.

& so much on general matters that I'm sure they resent this grouping of ourselves as much as I do. At any rate, they are entirely disassociated from me and from this situation."[42]

Florine Stettheimer was not immune to the difference that recognition and fame made in an artist's career, and she was often jealous of the interest and support given to O'Keeffe's work through Stieglitz's patronage. Hoping to garner a greater public reputation, she wrote McBride that she intended to paint a work portraying the ongoing celebrations taking place below her window in Bryant Park. She planned to make the painting a tribute to George Washington. In the same letter, she decried not having large walls to paint "such as Rockefeller City is parceling out to the allegorical soul dreamers" like O'Keeffe, and she mourned, "Shall I never be rescued from oblivion!—Marie Laurencin is to have a whole room at the Chicago Fair."

McBride was the wrong person to turn to for advice. Over the years he lamented in print that artists and writers too often "succumb at the first taste of success to the temptation to paint what sells," and he pointed out to his readers that Paul Valéry, Marcel Proust, and Romain Rolland "were almost fifty years of age before the first timid ray of renown touched their names." Further indicating his aversion to the sensationalizing of artists, he replied to Stettheimer's plea, "As for fame, you get it, as I often have told you, not by deserving it but by outraging public opinion. Georgia got hers by being so completely photographed. I mean publicity, of course, not fame. But it is publicity that gets you into Radio City and such places. As a matter of fact, you are much better off *out* of it. Concentrate on George Washington and forget the Rockefellers."[43] This advice offered Stettheimer little solace and neglected the seminal role that Stieglitz played in marketing his wife's career.

In November 1932, the Whitney Museum, under the direction of Juliana Force, held its first Biennial exhibition of Contemporary Art in its building at 10 West Eighth Street. Louis Bouché, Georgia O'Keeffe, and Charles Demuth all exhibited works, and Stettheimer included her *Cathedrals of Fifth Avenue*. Reviewing the exhibition for the *New York Sun*, Henry McBride declared, "Miss Stettheimer's *Cathedrals of Fifth Avenue* must be the most modern in method of all these pictures, for it is *cinematic*, historic, fantastic, realistic, mocking, affectionate, calligraphic, encyclopedic, Proustian and even portentous. In fact, it has everything and everything in proportion."[44]

7

Four Saints in Three Acts

As Stettheimer turned sixty, the lessons and aesthetic experiments of the last four decades came to fruition in stage settings and costumes she designed for the opera *Four Saints in Three Acts*, with music by Virgil Thomson and a libretto by Gertrude Stein. The opera is considered the prototypical *gesamtkunstwerk* of the modernist era. Despite the greater notoriety of the author and the composer, it was Stettheimer's contributions that received the highest praise. The opera offered Stettheimer public alliance with other artists, allowing her to savor the experience of working closely with other talented, creative people for the first time in her life. The collaboration was successful both personally and professionally. Stettheimer achieved widespread public recognition for her work and at last was able to see her opinions and wishes carried out within a context of myriad other, strongly egocentric personalities.

The close friendship between Virgil Thomson and Gertrude Stein began in the winter of 1925–26, when the young American composer attended a Christmas Eve party at Stein's Paris apartment. After agreeing to collaborate on an opera, the two chose to emulate traditional eighteenth-century Italian productions by including dual roles for the main characters. Stein initially wanted to have American history as the opera's subject, but Thomson vetoed the idea, saying that all American military uniforms look alike. Instead they decided to concentrate on the Spanish baroque saints, examining the lives of Theresa of Avila and Ignatius of Loyola. Inevitably, Stein's libretto contained more than four saints, and more than three acts. In March 1927, she wrote to Thomson, "I think it should be late eighteenth-century or early nineteenth-century saints. Four saints in three acts. And others. Make it pastoral. In hills and gardens. All four and then additions. We must invent them." Described as "a gorgeous procession of succulent vowels and noble consonants, meaning nothing. Absolutely," the language of Stein's libretto was "much cussed and discussed" by audience and critics alike when the first performances were heard.[1]

On Christmas night, 1927, Thomson played the first act for Stein, Alice B. Toklas, and Tristan Tzara in Paris. Stein had given Thomson permission to make whatever cuts in her libretto he deemed necessary, and he eliminated passages from some sections and incorporated "stage directions," set to music, in others. Stein offered the services of Pablo Picasso as

108. *Portrait of Virgil Thomson* (1930) 97.2 x 51.1 cm, Gift of Virgil Thomson, 1975.677. Photograph © 1994, The Art Institute of Chicago. All Rights Reserved.

stage designer, but Thomson declined, "preferring to remain, except for her, within my age group. [Picasso was fifteen years older than Thomson.] I did right then beseech [Christian] Bérard to consider designing an eventual production, though at the time he had not touched the theater. He said yes with joy and began instantly giving off ideas. . . . All these maneuvers, I remind myself, had to do with a work not yet in existence."[2]

In December 1928, the young composer arrived in New York, and Carl Van Vechten hosted an audition of the new score in his apartment. Among the select audience was Ettie Stettheimer. That evening, Thomson played the whole score, singing all the parts himself. At its conclusion, Mabel Dodge remarked, "This opera should do to the Metropolitan what the painting of Picasso does to Kenyon Cox." Ettie was also impressed, and she arranged for Thomson to play the score for her sisters. Florine was so taken with the opera that she invited the composer to visit her studio so that she might hear the work again, in seclusion. In her diary she wrote, "Virgil Thomson played his whole opera *Four Saints in Three Acts* to me today—it delighted me and his voice is so pretty—. He sang the whole—he makes the words by Gertrude Stein come alive and flutter and in sound have a meaning." Thomson, in turn, was astonished by Stettheimer's paintings and the decoration of her studio. McBride, who was present the night Thomson first visited Stettheimer's studio, recalled the composer's enthusiasm: "Why have I never heard of these things? What a *succès* they would have in Paris!" When someone suggested that Stettheimer design the sets for *Four Saints*, Thomson declared instantly, "That would be perfect." As McBride observed, "There was never any question after that but that Florine was to do them."[3]

Working on *Four Saints* gave Stettheimer a respite from family problems and a new kind of freedom that she was craving. The last year had been a difficult one owing to Rosetta's continual illnesses and depression. Florine and her sisters worked out a system by which each would take turns staying with their mother. As a result, the artist was exhausted and frustrated. Ettie and Carrie were vehemently against Florine's participating in Thomson's opera, declaring that it presented too great a risk of public humiliation. The opportunity to work on an actual theatrical production, however, was a welcome distraction, and Stettheimer was elated. As soon as Thomson departed for Europe in April 1929, the artist made a small drawing of his profile and wrote him a poem describing her anticipation of their project:

> *The thrush in our elm top*
> *has been singing*
> *questions*
> *for days—*
> *I feel clarified.*
> *This is my clarification*
> *My role is to paint*

your
4 active saints
and their props
in
side out your portrait—
St. Gertrude will protect
us all.[4]

In the flurry of excitement Stettheimer also painted a portrait of Thomson, which includes many references to the planned opera (fig. 108). The composition takes place in dream-space, an ambiguous area in which figures, words, and animals float among clouds and blue sky. At the lower left, a young Thomson accompanies himself at a piano inscribed with the opera's title repeated as a dual linear series: "3/4/3/4/3/4 . . ." and "STS./ACTS./STS./ACTS./STS." A pigeon offers him a bouquet of flowers. At the lower right, a yellow lion with the expression of a stuffed, kindly dog sits on a circular rug. The lion is one of a pair that would appear as an integral part of Stettheimer's stage design for the opera. (Some biographers have speculated on the resemblance between the lion and Stein's renowned French poodle, Basket.) The animal is chained in a manner similar to the sculpted lions in front of the entrance to the cathedral in Avila. In the painting, the chains wrap around an arch on which ribbons carry the names of the opera's main characters, Saint Theresa and Saint Ignatius. Stettheimer conferred saintly status on Thomson and Stein's names and abbreviated her own last name so that it is inscribed "Florine St.," a device she would often use in signing subsequent works.

At the apex of the painting, a theatrical mask of Gertrude Stein's face peers down at the scene like the Wizard of Oz's disembodied head. Stein's hands manipulate strings directing the gestures of four marionettes on a tiny stage below. Although numerous doves and design elements fill out the composition, Stettheimer is clearly suggesting that, while not necessarily visible to them, Stein is the force behind everyone's movements. Despite this early homage to Stein, Stettheimer was later quick to give Thomson complete credit for the opera production, ignoring Stein's contribution altogether. When a perceptive interviewer noted that many people imagined that they saw in Stettheimer's work qualities similar to those in Stein's writing, Stettheimer immediately contradicted her: "I've never met her [Stein]. In fact I've hardly read her. I've started to a number of times. . . . [I] got tired. . . . Why we are at opposite extreme ends of the pole you might say. . . . I put in infinite detail, as you can see . . . when things become so abstract that the artist merely suggests his idea, they are so abstract that the artist might as well retire from the scene altogether, and let his public find the idea for themselves in the first place."[5] Stettheimer's attitude toward the expatriate writer is summed up in a short poem she wrote for the amusement of friends:

Gertie met a unicorn.
It was black and waved
its Tail.
Gertie roared a big laugh
back—very male.[6]

Over the last months of 1933 Virgil Thomson wrote to Stettheimer from Paris, very excited about the planned opera. He begged her to send him one of her drawing designs— "the simplest kind of sketch would do, as long as the colors were either indicated or written down"—to show people how the opera would look. He noted excitedly that "there is even question of doing it or a part of it or of asking you and me to do a ballet for the Russians next year. Could you do such a thing? That would mean your coming abroad next spring, probably to Monte Carlo in April. . . . The ballet plans for next year envisage two American works, a fashionable & witty one by Cole Porter and Peter Arno, and a more serious modern one. George Antheil & Alexander Calder are being considered for the second. Also you and me. Ours would certainly be less *vieux jeu* than anything that pair could do."[7]

There was no funding available to produce *Four Saints* until 1933, when a group including Kirk and Constance Askew, Alfred Barr, and Chick Austin resolved that the opera would be sponsored by a nonprofit society, "The Friends and Enemies of Modern Music." Austin had formed the Friends and Enemies around 1928 in Hartford, Connecticut, where he was director of the Wadsworth Atheneum, considered at the time one of the most avant-garde museums in the country. The society offered a forum for contemporary, often controversial music. Since 1929 it had sponsored performances of works by Debussy, Stravinsky, Schoenberg, Antheil, Satie, Poulenc, Bartok, and Ives. In 1934, the Friends and Enemies contributed ten thousand dollars toward the production of *Four Saints*, their first premier of an original work. As soon as Thomson knew that the opera would be a reality, he wrote to Stettheimer, urging her to complete the set designs.[8]

As she had many years before with her *Orpheus* ballet, Stettheimer visualized her designs for the opera by making three-dimensional models of the figures and their costumes.[9] In an interview she described preparation for her stage designs:

I tried to put into it [the Thomson portrait] everything I know of Mr. Thomson, so that in the end I felt it was Mr. Thomson. Then I translated what I felt to be all the qualities that appeared in Mr. Thomson's portrait into the opera settings. . . . I made a miniature set and I put in everything to the tiniest scrap of lace on my puppets. I started working on it last summer, after Virgil Thomson sang it to me. He gave me no directions—just let me put in what I please. And as you see, Gertrude Stein has given no directions. I . . . created the ballads I wanted, that I felt would go with the music. When I had finished my puppet stage the stage technician came to me with samples

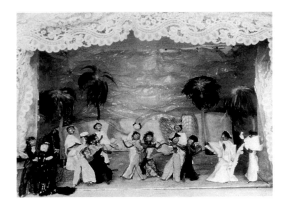

109. Stettheimer's model for *Four Saints in Three Acts.* The original model no longer exists. The dolls are in the Stettheimer Archives, Butler Rare Book and Manuscript Library, Columbia University; the photograph is in the Yale Collection of American Literature, Beinecke Rare Book and Manuscript Library, Yale University.

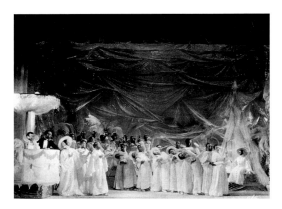

110. The 1934 Wadsworth Atheneum production of *Four Saints in Three Acts.* Yale Collection of American Literature, Beinecke Rare Book and Manuscript Library, Yale University.

of materials, and I passed on everything. What appeared on the stage finally is simply an enlargement of my miniature stage, a perfect enlargement.[10]

Close comparison of the final stage designs with Stettheimer's original maquettes confirms the overriding influence Stettheimer had on the look of the final production. She fabricated in miniature every element of her stage designs. She made small dolls representing the opera's characters out of wire and bits of silk and cotton, and she visited various theatrical supply companies to get material samples (fig. 109).[11] At the right side of the stage in the first act, she designed a white gauze and beaded tassel canopy recalling her canopy bed in her family's apartment, which she reproduced in 1916 for the interior of Knoedler's Gallery.[12] For Act II, she designed a gilt and white reviewing stand similar to the judges' stand in her painting *Beauty Contest.* The stand rests on the left side of the stage and holds the figures of the Commère and Compère, who act as interpreters for the audience (fig. 110). The sides of the reviewing stand are covered with white gauze and gold ribbon with a circular string of hanging goldbeaded tassels.

Fairly early in the production design, Thomson decided to use only black performers for the opera. Carl Van Vechten described a performance he attended with Thomson at the Lyric Theater of Hal Johnson's choral play *Run, Little Chillun,* which was enacted by black singers. During the intermission Thomson declared, "I am going to have *Four Saints* sung by Negroes. They alone possess the dignity and poise, the lack of self-consciousness that proper interpretation of the opera demands. They have the rich, resonant voices essential to the singing of my music and the clear enunciation

required to deliver Gertrude's text." This decision was applauded by the opera's producers and by reviewers. Van Vechten later noted, "The Negroes in their own persons proved to be more Spanish, more like saints, more even like opera singers than any group of white persons could have possibly" (fig. 111).[13]

Stettheimer got on well with the cast, declaring that they were acting not like saints but like angels. The only apparent problem arose when one of the prima donnas objected to a headdress Stettheimer had designed for the second act; after the singer flung the disagreeable object to the ground, the two women had a long conversation, and "everything was serene once more and the headdress was to be worn."[14] Stettheimer became concerned that the actors' varying shades of brown skin might prove distracting. She initially suggested that the faces in the chorus be painted white or silver to create greater uniformity of color. The others discouraged this idea, however, and eventually the choristers consented to cover their faces with a tannish-brown stage makeup.

Photographs of her cardboard maquettes show that Stettheimer originally intended the stage perimeter to be trimmed with several feet of white paper lace, so that each scene, at the rising of the curtain, would look like a box of fancy chocolate bonbons trimmed with a paper doily (fig. 112). She was persuaded to abandon this idea because it represented a potential fire hazard. Nonetheless, drawing from the aesthetics of her studio design, Stettheimer covered the back of the stage for each scene with cellophane crumpled to give the impression of windy haze and clouds. One critic, Pitts Sanborn, referred to the final effect as "Botti-cellophane," an unconscious but witty reference to Stettheimer's early aesthetic inclinations.

The actual cellophane backdrop took almost twenty-four hours to install on the Hartford stage. In each scene the cellophane was lit differently by Abe Feder, who was in charge of the lighting. As

111. Carl Van Vechten, one of a series of photographs of principal singers in the 1934 production of *Four Saints in Three Acts*. Yale Collection of American Literature, Beinecke Rare Book and Manuscript Library, Yale University.

remembered by the production's young director, John Houseman, "*Four Saints* was his [Feder's] big chance and he was determined to make the most of it, at no matter what human cost." At the time, stage lighting was largely a trial-and-error affair "of exasperated howling

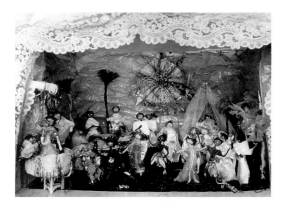

112. Stettheimer's model for *Four Saints in Three Acts*. Yale Collection of American Literature, Beinecke Rare Book and Manuscript Library, Yale University.

back and forth between the front and the back of the house." Feder made it clear from the beginning that he considered Stettheimer's cellophane decoration, with its dazzling, light-reflecting qualities, "a creeping bitch," particularly as Stettheimer insisted that she wanted the first act lit with pure, white light. The ensuing power struggle between artist and lighting director is vividly recorded in Houseman's autobiography, *Run-through*, and attests not only to Stettheimer's tenacity but also to the self-confidence with which she affirmed her aesthetic:

In vain, Feder attempted to explain to Florine, to Virgil, to me, to anyone who would listen, that there was no such thing as white light in the spectrum—that it was obtained by the expert mixing of primary colors projected through various shades of red, blue and yellow gelatin in the two hundred or more projectors with which he had covered the ceiling and sides of Chick's theater. Florine repeated that she wanted clear white light—as in her model. Feder refused to believe her. For three successive nights he had the escape artists and his crew clambering up and down ladders, changing gelatins, which he then blended with infinite care and skill at diverse intensities. And each morning, when he proudly exhibited his night's work to Florine, she would say quietly that what she wanted was clear, white light. Reluctant and unconvinced, he finally gave it to her at dress rehearsal, and she was grateful. He had a more rewarding time with the light blues and greens of the second act picnic and deeper cobalt of the Spanish sky darkening for the appearance of the Holy Ghost and achieving a livid splendor during the procession in the third.[15]

Henry McBride later disclaimed accounts that Stettheimer had been difficult to work with. Like Virgil Thomson, he felt that she had "taught the theater professionals a revolutionary lesson in lighting" and had stood by her convictions on all matters of design, large and small. In the final days before the opera's opening, Stettheimer discovered a number of mistakes in the stage and costume designs, and she demanded that they be altered back to her original designs. The costumes for the male angels' companions had their trains "wrapped around their bodies instead of hanging," and thus had "no style—couldn't make them understand." The novices' trains in the second act had been mistakenly trimmed, and Stettheimer

made flowers for the fourth act herself out of cellophane that she purchased at the local five and dime. She kept a handwritten list of these errors and inscribed next to each example, "I had to insist"—whether it was that the chorus's seats be draped, rather than painted, or that the chorus be arranged in a pyramid.

Stettheimer agreed with the scenarist Maurice Grosser's mounting of the opera as a parody of a Sunday school production, and she allowed Feder to substitute cellophane balls for globes of glass in creating the large double arch in the first act. But when it came to the huge cellophane cyclorama that she proposed, she had again to insist that it be in-

113. The 1934 Wadsworth Atheneum production of *Four Saints in Three Acts*. Yale Collection of American Literature, Beinecke Rare Book and Manuscript Library, Yale University.

cluded, despite protests that it would so dazzle the audience that it would detract from the performers. For many viewers, this strategic triumph "virtually decided the fate of the production," and some claimed that it was the most beautiful thing they had ever seen in the theater.[16] The reviewer Gilbert Seldes noted that the opera "has fantasy and vigor. It can be taken as a gigantic piece of mystification and a huge joke; it certainly should not be taken without laughter. It has taste and liveliness, humor and feeling." He described Stettheimer's contribution as having "a great sense of style . . . made of lace and cellophane and looking like a child's dream of rock candy. . . . How a sense of grandeur was begotten out of this material I do not know . . . it has life. It is not too thoughtful" (fig. 113).[17]

The premier of the opera in Hartford was a great civic happening. Chick Austin arranged concurrently to originate an exhibition of paintings by Picasso in the new wing of the Atheneum. By pairing the two openings, Austin created "the most important event of its kind anywhere in the world." The weather was a problem, as the temperature hovered near zero degrees. More than two hundred costumes and props for the opera had to be trucked to Connecticut from New York City. The cast, along with the choreographer, Freddy Ashton, arrived a few days early. They were greeted by the Negro Chamber of Commerce and "billeted in black households all over town." Three of the five performances were already sold out, but mostly to out-of-towners, so after the final run-through Houseman assembled the company and, at 1:30 in the morning, explained that they would not be paid until opening night.

On February 7 and 8, the New Haven railroad added extra parlor cars to its regular afternoon trains so that New York guests, press, and members of the international art world could attend the opera and see the Picasso exhibition. Mrs. Harrison Williams, the country's

perennial "best dressed woman," ordered a special dress for the occasion, which functioned as a cocktail dress for the train ride and loosened to a full-length gown for the gallery reception and opera. Buckminster Fuller made a grand entrance, escorting Clare Boothe and Dorothy Hale in the prototype of his Dymaxion car.[18]

Stettheimer spent the week before the opening in a frenzy of activity, so much so that she neglected to write in her journal. When she finally did, ten months later, her only notation was, "I have no record of my doings at the opening of *Four Saints*—it was frightfully cold and my radiator made a noise—!" At 3:30 on the afternoon of the first performance, McBride spied Thomson and Stettheimer leaving the museum's theater, looking "weary but happily confident." In his hotel room, two hours later, the critic got a call from the artist declaring that she was completely exhausted and could "do no more." She asked McBride to go to the nearest Woolworth's and buy two of the best artificial roses they had, for "the whole fate of the opera was at stake." He did so, and Stettheimer was grateful. During the opera's first entr'acte, McBride rushed backstage in time to see Stettheimer and Ashton embracing, "both of them in the kind of heaven that only artists know, at the way things were going; and I could not resist the thought that for Florine this was genuinely a coming-out party. . . . I have the idea that she scarcely missed a performance of the work."[19]

The reviews of the opera were mixed. Gertrude Stein's text was not well received by critics, who noted that "except for a few shining phrases," the words were "dully repetitive in their suggestion and often ugly and unsingable." Although some liked Thomson's score, others felt it too derivative and "at best, happily reminiscent and well-adapted to the form of the performance."[20] Ashton's choreography, the cast's performance, and Stettheimer's designs and costumes, however, met with virtually universal acclaim. The *New York Times* reviewer proclaimed that Stettheimer's settings "attain a gorgeous richness of effect," and the *Herald Tribune* critic, Lawrence Gilman, found her sets and costumes "slyly witty and captivating." The only disparaging review came, interestingly enough, from Henry McBride's own paper, the *New York Sun*. McBride was among those who lauded Stettheimer's contribution, but the theater critic Richard Lockridge noted, "The sets are pretty enough and quaint enough and made chiefly out of cellophane. They are, one might say, quite cute."[21] By contrast, the reviewer for the *Hartford Courant* raved, "The sets by Florine Stettheimer and the costumes were very near the pinnacle of the opera. . . . Altogether a great, sugary confection like the pink frosting-filled Easter eggs that you can look into and see pictures inside."

Stettheimer received an outpouring of congratulatory telegrams and letters from various friends. Georgia O'Keeffe wrote, "You certainly did your part well," and the sculptor Jo Davidson and his wife, Yvonne, complained, "Oh why don't you do more such work? It is so far above anything we have seen . . . never saw anything more perfect." The theatrical producers Harry and Elsa Moses, who were responsible for bringing the production of *Four*

Saints to New York and Chicago, praised the artist, as did Carl Sprinchorn, for whom Stettheimer obtained free tickets. Clagett Wilson declared enthusiastically, "Bless your merry dancing fancy and that twinkle in your eye. . . . Just to think, even before you die "they" may come to know you for what we few have been shouting aloud for a decade and more, a damned swell, fine artist. . . . I am pleased, happy, delighted and contented with your success. Tho' never for a moment do I lose sight of the fact that you really ride high above mundane recognition."[22]

Stettheimer enjoyed the public recognition, and it made up for the rather lukewarm reception her success received within her family. Stettheimer's relatives were generally surprised at the public fuss being made over her and the "consequent suspicion that one of their number might be a genius." Walter and his wife, Florence, impressed by seeing their sister's name praised in a *Time* magazine review, sent a telegram from California. Stettheimer's cousin Edwin R. A. Seligman, a noted authority on economics at Columbia University, met Henry McBride for lunch a short time after the opera's opening and asked the critic, "Is Florrie really so good? 'Sublime' [the word McBride had used in his review of the opera sets], you know, is a strong word." "It is the correct word," McBride reassured him.

More important, Stettheimer's sisters did not attend the premier of the opera. Carrie stayed home to watch Rosetta, and Ettie, ill with asthma, decided not to make the trip. She also did not attend the first night of *Four Saints* on Broadway, at the Empire Theater, a month later. Given the moment of the event, this absence may signal some disapproval or jealously of her sister's public success. Henry McBride and *Vanity Fair*'s editor, Frank Crowninshield, shared a box at the New York production with Carrie, while Florine and Carl Van Vechten sat in the front row of the orchestra and shouted "Hooray for Florine" when the curtain descended. According to a reviewer, "The young art enthusiasts howled for more than twenty curtain calls from the cast. . . . John Marshall burst his evening waist coat laughing and the fireman on duty in the rear of the auditorium said, 'Jeez, has everybody gone crazy or are they just stewed?'"[23] Despite having not attended, Ettie was aghast when she learned that Florine bowed to the enthusiastic audience without wearing white gloves. Chiding her elder sister, Ettie declared it "inelegant . . . it was INELEGANT!" Carrie quietly concurred.[24]

For the New York opening in March, the opera's cast held a reception for Thomson, Grosser, Ashton, Houseman, Stettheimer, and Mr. and Mrs. Harry A. Moses in Harlem at the Witoka Club at 222 West 145th Street. Stettheimer reciprocated by inviting cast members to tea at her studio. In the final days before the opening, Stettheimer decided that the fourth act of the opera needed some extra touches. She constructed, at her own expense, a decorative fixture made up of stars and symbols to hang in the air. She also made more than two dozen cellophane flowers and designed a new velour sun with cellophane clouds. The opening was crowded ("paid for!") and very festive. Everyone considered Stettheimer's recent additions a

distinct improvement, and the artist noted that "even John Houseman was enthusiastic." Stettheimer was escorted to the performance by Ettie's friend, the author Sherwood Anderson. Afterward, she and about twenty cast members, many in full costume, triumphantly walked up Broadway to the Astor Bar, offering onlookers "a treat."

As with everything, Stettheimer took her sudden notoriety with a touch of irony. A young New York University graduate student, Sidney Goldberg, asked the artist to allow him to make her work the subject of a "thorough and analytical" study for his thesis. In a rather pretentious letter, he suggested that the dissertation be written in the manner of the famous art historian Julius Meier-Graefe. Although nothing apparently ever came of his suggestion, Stettheimer was tickled by his interest and wrote to her sisters, "I shall have to keep a secretary like the star members of our cast." When McBride brought his libretto for her signature, she sarcastically noted, "Autographs & interviews—that is fame," and by April she was writing in her diary, "The phrase 'the most famous sets of 4 Sts' has become shopworn." Her costumes and stage sets permeated popular culture and were imitated in store windows along Fifth Avenue and on fashion showroom runways.

Stettheimer continued to entertain frequently in her studio, inviting such friends as Demuth, Moeller, McBride, and Sprinchorn to visit her after seeing *Four Saints* in order to gauge their reactions. She also attended various friends' parties, including a dinner given by the painter Leon Kroll and his wife. Stettheimer described the event in a letter to her sisters, observing how "the conversation was such as never occurs in our salon—childbirth—thoroughly gone into by the three women—when the men joined us—(sounds antiquated) stories of French—Paris—brothel life."[25] The artist maintained the momentum from *Four Saints* by entering her portrait of Virgil Thomson in a Salons of America exhibition held at the Rockefeller Forum. The final presentation of the exhibition, which was organized by Holger Cahill, horrified the artist, who termed it "the most awful rubbish heap of a show I have ever seen." In June, her portrait of Father Hoff was included in an exhibition of work by women of five different nationalities at Marie Sterner's gallery.

To escape the torrid heat of the New York summer, Ettie and Florine then spent three weeks in Atlantic City, where they were joined by McBride. In the evenings, the sisters walked along the boardwalk, commenting on women's dresses and the poor food. Following a visit to the circus, the three wrote postcards to various friends. McBride described the circus as being "a bit too strong for me; it takes robust appreciation,"[26] and he wrote to Carl Van Vechten, "The trapeze artist in pink silk tights astonished Florine: 'Why, she is the only one in Atlantic City who has anything on' said she." In September, the four women again rented the Gould estate and held evening parties on the back terrace.

In November, Harry Moses arranged for the original cast of *Four Saints* to travel to Chicago for a limited run.[27] Gertrude Stein, whose conspicuous absence at both earlier pro-

ductions was noted, attended the opening. She first stopped in New York City, where she gave a lecture at the residence of Mrs. John Alexander. Stettheimer was sent an invitation, but it is not known whether she attended. Stein then continued on to Chicago, where she stayed at the home of a Mrs. Goodspeed. Goodspeed hosted a dinner for the opera's principals, including Stein and Thomson, and she invited Stettheimer and her sisters, but none of the three women traveled to Chicago. Nonetheless, a friend who attended the dinner wrote to Stettheimer that when he raved about her contribution to the opera during the meal, Miss Stein "joined in enthusiastically & said immediately, oh, I want to send her a wire." The telegram from Stein to Stettheimer read, "It is perfectly beautiful and fulfilled a dream and made me very happy—Gertrude Stein." Stettheimer's cool, ironic, "Steinian" reply followed quickly: "Dear Gertrude Stein, I am so pleased that our production of the Four Saints Opera was not the way you do not like it—many thanks for the telegram. Perhaps you will find time to come to my studio during the week? Why not call me up some day at two o'clock and say when you could come. Greetings to you and Miss Toklas. Florine Stettheimer."

The opera was enthusiastically received in Chicago, and a number of Stettheimer's friends wrote to congratulate her on her success. One noted that the opera was "like seeing your paintings come to life—the next thing now is for a movie set—in Technicolor and you to do the scenario as well as the costumes."[28]

8

Independence and Fame

I have been painting like this for a good many years, I don't know why people are getting excited about it now. I exhibited for ten years in the Independent Artists' Show, but then I got tired of exhibiting, so I quit. I just kept on painting. . . . I never experiment. . . . It is this way because I couldn't do it any other way. . . . I can't do anything I don't feel like doing. . . . I mean I really can't.—Florine Stettheimer, 1934 interview

With the success of *Four Saints in Three Acts,* Stettheimer was at the height of her powers as an artist. Her daily life continued to revolve around her family, but the experience of public acclaim, despite familial disapproval, allowed the artist greater self-confidence in her work. As she moved further away emotionally from the hermetic life of Alwyn Court, she began a painting she would later call her "masterpiece." She decided to paint a second family portrait to show how far her work had progressed since the version she painted twenty years earlier.

Although Carrie, Ettie, and Rosetta are present in many of Stettheimer's paintings, the artist painted only two fully realized family portraits. In designing the second, she reached back and reclaimed frequently recurring compositional devices from earlier works. Foremost among these was a disproportionately large, central grouping of flowers. This motif is first evident in the paintings made around 1916 and featured in the exhibition at Knoedler's Gallery, including the first portrait of her family. In numerous works from this early period, the women's figures are dwarfed by central floral arrangements. Five years later, in *Russian Bank,* the artist again focused her composition around a central bouquet of flowers and scattered family figures around the periphery of the painting. In *Sun,* painted in the 1920s, Stettheimer reduced the number of blossoms in the axial floral arrangement and increased the size of each so that the middle ground was filled with large representations of a rose, a marigold, a daisy, and a poppy. Tiny, unidentifiable figures are barely discernible in the painting's background.

On her next birthday, dressed in a "greekish" white moiré gown with fringes and gold sandals, Stettheimer gathered her annual birthday bouquet. That same evening, she began work on a painting titled *Flowers with Snake* (fig. 114). She again built the composition

around a dominant floral arrangement and placed her sister Carrie and her mother, playing cards, at the far right edge of the canvas. In *Flowers with Snake,* Stettheimer shifted the scene from a rooftop overlooking the Hudson to the spacious, terraced estate they rented for the summer in Tarrytown. As in *Sun,* a coiled serpent inscribed with the artist's name and the date circles the base of a large, central vase.

The device of combining a central floral arrangement with adjoining figural portraits culminated in *Family Portrait No. 2* (fig. 115). There Stettheimer drew an analogy between the transitory beauty and distinctly different nature of each flower and the divergent character of the women behind them. A complex, sophisticated work, the painting is organized around three huge, hothouse blossoms: a pink rose, a white daylily, and a red poppy. Their stems are encircled by a vine, whose trellised arms sweep downward as though ruffled by a slight wind. The flower blossoms fill the center of the canvas, rising from the lowest edge up the surface plane and separating the viewer from the scene directly behind. Several of Stettheimer's biographers have paired each flower with one of the painting's figures—the red poppy with Ettie, because of her temperament; the rose with the mother, Rosetta; and the fragile yet regal daylily with Carrie. Parker Tyler floridly speculated that the serpentine fern symbolizes Stettheimer's art, the "ribbon holding them together," and signifies "the marriage that the three daughters have helped transform into a cult of immaculacy. . . . The languid, incandescent group of flowers in this painting . . . is the supreme ikon of a beautified castrata."[1]

The relationship between the four women itself resembles a still life. Although Stettheimer remained concerned with temporality in her work, often including multiple events and times within a single canvas, in *Family Portrait No. 2* her increasing objectivity toward her family caused her to memorialize its members as ageless forms forever frozen in characteristic poses. *Family Portrait No. 2* represents not a realistic transcription of daily life but an ironic testimonial to a rapidly disappearing era. The painting's dominant flower imagery, which in Western culture has often been used as a metaphor for women's beauty, recalls Shakespeare's *Twelfth Night,* in which he equated women's beauty with virginity: "women are as roses, whose fair flower / Being once display'd, doth fall that very hour."

The middle ground contains the figures of the four Stettheimer women. Stettheimer acknowledged the subjectivity of her vision by inscribing "4 Sts. seen by Florine/1933" on a ribbon-draped monument at the upper left corner. The women stand within the ambiguous space created by an elaborate baroque carpet on which their first names, the date, and their abbreviated last name are written. The carpet's bold gold-on-maroon border circles a star configuration and is continued on the left by a pattern of incised roses and blue birds. The intense red and gold colors of the floor ground the composition and give the bodies some sense of gravity, as though they are held in place around the carpet's semicircular perimeter by a

114. *Birthday Bouquet* (*Flowers with Snake*) (1932), 30¹/₁₆ x 26³/₁₆ in. The Nelson-Atkins Museum of Art, Kansas City, Missouri (Gift of Mrs. R. Kirk Askew, Jr., In Memory of her Husband) F79–65.

115. *Family Portrait Number 2* (1933), 46¼ x 64⅝ in. The Museum of Modern Art, New York, Gift of Miss Ettie Stettheimer. Photograph © 1995 The Museum of Modern Art, New York.

centripetal force. This creates an uneasy tension between them, the elaborate design, and the gigantic floating flowers.

As in her portraits of the 1920s, Stettheimer placed architectural elements alluding to the personalities and character of the four women adjacent to each one's painted image. Carrie enters the painting from the right, below a grisaille detail of the crowned dragon ornament characteristic of Alwyn Court's neo-Renaissance exterior. The address of the building, 182 West Fifty-eighth Street, New York, is clearly inscribed on its granite lintel. The juxtaposition of the architecture and her figure alludes to Carrie's personality as quiet and impenetrable as the stone; she is stylistically and intellectually caught between divergent centuries. An elongated red velvet drapery with gold fringe, hanging at the right of the composition like a gigantic bell pull, recalls the color scheme of the family's dining room. Its attenuated lines parallel the adjacent figure of Carrie, who stands rail-thin, in profile, wearing a white sheath dress, abundant jewelry, and black lace shawl. Delicately strapped, toeless high heels peek from under the hem of her gown as she pauses, a cigarette dangling from one hand, and glances toward the center of the painting. She is recognizable by her rounded features, which are identical to those seen in portraits painted thirty-five years earlier.

Rosetta Stettheimer sits enshrined in the painting like a sweet white-haired Buddha, in a gold scalloped throne chair immediately to the right of the composition's central rose. She gazes up and out at the viewer, her majestic posture and facial features little changed since the 1916 portrait. Wearing a black velvet choker and an elaborate lace mantilla over a heavily petticoated gown, she sits with her hands poised over yet another game of cards. Her feet are hidden by the hem of her dress and perch on a small wooden footstool. The table holding her game of solitaire tilts forward dramatically, so that viewers can read the face of individual cards. Directly behind Rosetta's head, in the background area filled by images from the port of New York, is a nebulous rendition of the Statue of Liberty seen from an aerial perspective on its star-shaped island. The image recalls Stettheimer's earlier painting *New York,* in which the gilded statue acts as an emblem of refuge, welcoming expatriates and foreigners to American shores. In a similar manner, the figure of Rosetta in the portrait is the familial concordance of security and comfort for her daughters. Henry McBride, in a letter to Ettie, noted that "I was thinking of the little portrait of your mother in the group. It does seem to me exact in some strange way—more like her than any photograph could have been."[2]

In *Family Portrait No. 2*, Ettie is seated in a nattier-blue tufted chair, one hand clutching the armrest, the other holding a red fan, a foil for her renowned hot temperament and pleasure in flirtation. In her first novel Ettie noted, "I flirt to arouse feeling irrespective of its nature, and in order to see something in the outside world happen through my instrumentality and thus quicken my sense of power and of life."[3] Stettheimer further signified Ettie's personality by placing her beneath two forms renowned for their clarity, sharp edges, and cool char-

acter: the Chrysler Building and a crystal chandelier. Reinforcing the reference to Ettie's autobiographical writing, an open book lies over Ettie's black-lace covered lap, its balance thrown slightly askew by her crossed legs. Her cloche-covered head rests against the chair's backrest. Her eyes staring skyward and her furrowed brow indicate that she is lost in thought, either analyzing her personal "philosophy," or reliving her "love days." Years later, at age seventy-six, Ettie would recall 1933 as the year "when probity vanished from most of the world and peace from all of it" with the election of Adolph Hitler as German chancellor. She expressed regret at not having a serious relationship with a man, noting that, for her alter-ego, Susanna Moore, "When a chance for true fulfillment in love came to her, she no longer had the wholeness to understand the character of this love and to receive it into her being." Stettheimer's representation of her sister catches her in a mood of longing and nostalgia.

When it came to recording her own image for posterity, Florine dispensed with the elaborate finery of her sisters and mother and chose to depict herself in a simple black velvet pantsuit suitable for work. If there was ever any doubt that she consistently envisioned herself as a serious professional artist, it is dispelled by her image in *Family Portrait No. 2*. The only concessions to vanity, beyond her continued depiction of herself as being in her mid- to late thirties (rather than her true age of sixty-two), are the red ankle-strapped high heels above which towers her lanky body. Stettheimer rests slightly back on her haunches and surveys the scene before her like a painter about to commit it to canvas. She seems emotionally distant from the rest of the composition, once again in her habitual role as observer. The background elements she chose to act as correspondences for her personality are the RCA Building and Radio City Music Hall, sites of popular entertainment; the tall, elegant silhouette of Cleopatra's Needle (a gift to the city from the Egyptian government); and an elaborately arranged swatch of white cellophane trimmed with gold fringe characteristic of her studio decor and the stage sets for *Four Saints*.

The painting's complex iconography and vivid coloration give it a precious yet sultry atmosphere, as though the scene were being enacted during a particularly hot, humid New York City summer. The florid color scheme contributes to this greenhouse effect, but it is the flowers and environment, not the women, that blossom and absorb the heat. The largely black and white figures are ghostlike accents trapped within the hothouse environment of the fashionable apartment. The composition's upper half is washed in blue and white with a bright red poppy completing the patriotic triad, while the lower part of the painting is saturated with intense shades of red and yellow so that the figures form a linear, black and white chain across the canvas.

Despite her continual need to be perceived as an individual,[4] Florine, like her sisters, cultivated detachment and separateness from the rest of the world, preferring to view herself and her siblings as exotic sunbursts of diamond fringes and tulle rather than as "mud

makers." This practiced, conscious Stettheimer persona, so cherished by the four women during Rosetta's lifetime, was described in one of Stettheimer's poems:

> *You are the steady rain*
> *The looked-fors*
> *The must-bes*
> *The understandables*
> *The undistinguishables*
> *The inevitables*
> *The earthmoisteners*
> *The great mud makers*
> *We are the sunbursts*
> *We turn rain*
> *Into diamond fringes*
> *Black clouds*
> *Into pink tulle*
> *And sparrows*
> *Into birds of Paradise.*[5]

Paul Rosenfeld, writing on Stettheimer's work in *Accent*, astutely noted within *Family Portrait No. 2* a subtle alteration in Stettheimer's attitude toward her familial surroundings, reflecting a greater distance and a more tangible irony. Rosenfeld perceived three underlying currents within the painting, which he described as having its forms assembled to "structure, surprise and divert the eye and mind." He remarked that on the surface "the shapes nearly all are dainty in proportion. . . . Meanwhile the total form rivals the theater, the opera and even the circus." Rosenfeld judged the work's style and conception to be "as manifestly and unmistakably feminine as is a boudoir: frail, delicate, ornate. Perhaps it is not quite characteristic of the run of women. . . . Still the personality addressing us is gracious, tender, animated, loyal; nor are we assailed by any selfish utilization of feminine charm such as we associate with some recent French women painters, Marie Laurencin, for example. We meet no affectation here; only truthfulness to a feminine temperament which happens to be uncommon." Finally, Rosenfeld perceptively detected in the painting a double meaning reflecting Stettheimer's growing awareness of the cloistered nature of the women's lives: "At first it [the painting] appears full of a lyricism of the life of complete self-sufficiency, aestheticism, independence. The four figures seem entirely engrossed in, satisfied by, an existence of amusements, beautiful decorations, art, literature. . . . Gradually, possibly because of the ghostliness of certain of the shapes and the ornamental quality of many of them, we receive a sense of elegant waste, a feeling that this life of independence and aestheticism is illusory, a

bauble, a bubble, and the two meanings together face us."[6]

Over the next few years, it became increasingly apparent that Florine Stettheimer found the life of her family stultifying, particularly given the acclaim and recognition she was receiving for *Four Saints.* As long as Rosetta was alive, however, the Stettheimer women remained a unit. In the fall of 1934, Stettheimer had little time to rest on her laurels. Several new projects appeared. The manager of the prestigious Valentine Gallery of Modern Art, on Fifty-seventh Street, joined the ranks of those wishing to organize a solo exhibition of Stettheimer's work: "With the new season and the new gallery I'm writing to ask you the old question—what about a show? You know how keen we always have been to show them and now we feel we could do them justice—plenty of space to show the big ones we like so much, and plenty of light. The pictures are grand. . . . Won't you think it over seriously and let us know? We should want to do a big show—not just a few pictures."

Although it took her a year to reply, Stettheimer declined the offer. "I have not been able to make decisions about anything these last months," she wrote. "And so—the very desirable exhibition you have offered me in your beautiful club has been postponed in my life until some time when I shall be able to cope with it more efficiently—that is if you will still want my paintings at some future time." Nevertheless, when Alfred Barr, the young new director of the Museum of Modern Art, requested that Stettheimer include a work in an exhibition he was organizing to suggest what a permanent collection of the museum might be, the artist immediately submitted her painting *Birthday Bouquet,* and it was well received and praised by Barr and by the media.

Six months after the opening of *Four Saints* in Hartford, Virgil Thomson wrote Stettheimer about creating a new work for the Ballets Russes. They agreed that their "American" theme should be the life of Pocahontas, daughter of Powhatan, chief of the Virginia Powhatan confederacy of Indian tribes in the early seventeenth century. The story offered numerous scenic opportunities of interest to Thomson and Stettheimer. In Thomson's account, when Captain John Smith was captured and brought before Powhatan in 1607, he was saved from certain execution by the intervention of thirteen-year-old Pocahontas, who laid her head on his. Six years later, Pocahontas, taken prisoner by the English, was transported to Jamestown, where she earned the respect of the colonists and was baptized with the Christian name Rebecca by the acting governor, Sir Thomas Dale. While in Jamestown, John Rolfe fell in love with her and secured permission to marry her from both Dale and Chief Powhatan, who sent representatives to the wedding, which took place in April 1616. The marriage marked the beginning of eight years of peace between the English and the Americans. Two years later, Pocahontas sailed for England with a retinue of native maids and was received with great honors by the bishop of London. Soon after, she was presented at court as an Indian princess and through her graciousness engendered a more generous attitude toward her people by the

English. She died at the age of twenty-two, while preparing to return to Virginia.

Thomson enlisted Frederick Ashton's agreement to work on the choreography for the *Pocahontas* ballet. Throughout the remainder of 1934 he and Stettheimer corresponded, exchanging ideas for the music and scenery. In a letter written in July, Thomson suggested:

> Why not have a major-domo presenting a miniature ballet of the John Smith beheading with Indian war-dances & peace-pipes & maybe even a wedding & then end with a pavane for King & Queen & entire court & Indians jumping and whooping (politely) at the same time? This makes a place for a pas seul of Poca, a mimic execution, a pas de deux with Smith & a pas de trois with Smith & Rolfe & then the debs as handmaidens to Poca for the wedding-party, the pages as ushers & a finale apotheosis with the couple being blessed by K&Q while the company does the big finale. . . . James Joyce is very desirous (rather insistent) that I do the music for a ballet of his [Children's Games], the story is good, the subject is charming, everything is right with it, only I can't get interested. Pocahontas amuses me a great deal more.

Stettheimer threw herself into the project by reading every available source on Smith and Pocahontas and spending hours at the Museum of Natural History making watercolor sketches of Native American tools, carved totems, rattles, feathered headdresses, and clothing (fig. 116).[7] For some obscure reason, Stettheimer and Thomson decided that rather than presenting Captain Smith and his men as English, they would be portrayed as Scottish, complete with kilts and bagpipes (fig. 117). Recalling her work on *Orpheus* and *Four Saints*, Stettheimer not only made numerous sketches of the figures, she also made drawings of the different scenes and eventually created three-dimensional dolls of each cast member using feathers, orange and white cellophane, red velvet, multicolored gauze, and silver foil.[8] Although the ballet was never produced, Stettheimer continued working on *Pocahontas* until her death.

In January 1935, Ettie and Florine hopped aboard the *Chief Crystal Gorge* for a train trip cross country to California. Ettie had problems with asthma, and although Florine felt the trip was rather a waste of time, she went along. (Carrie and Rosetta stayed in New York.) In Hollywood, the two sisters were escorted thorough the RKO movie studios by their friend Philip Moeller, now a producer, and were introduced to several movie stars including Katharine Hepburn and Charles Boyer, who were starring in Moeller's *Break of Hearts*. From Los Angeles they traveled to Palm Springs, staying at the El Mirador Hotel, where Florine read Pirandello's short stories and Ettie rested. Writing jointly to Carl Van Vechten, the sisters railed against the desert resort. Ettie said that it was like "living in the suburbs of a great bath tub—a communal tub in which everyone but ourselves and the dogs bathes or pretends to—the preliminaries are undressing and lying, greased, all over the garden . . . we feel that if we stay much longer we shall succumb to a permanent hallucination that we are bath attendants to some king." Florine in

116. Watercolor studies for *Pocahontas* ballet costumes. Florine Stettheimer Papers, Rare Book and Manuscript Library, Columbia University.

117. Sketch for *Pocahontas* ballet costumes. Florine Stettheimer Papers, Rare Book and Manuscript Library, Columbia University.

turn remarked that the only way she knew that she was surrounded by Hollywood celebrities was "when I read it in the papers—They all look alike with and without clothes." She enjoyed analyzing the guests at the hotel, noting caustically in her diary, "Millers shoe salesman lunched here today—the ultraviolet ray assistant was playing kino in the lounge, the six foot four masseur chats with guests in the lounge, the chauffeur who drives us sits in the lounge—its all the way it should be in a democracy."

The sisters traveled to San Diego in a chauffeur-driven car and then to Pasadena, where Stettheimer was "not thrilled" by any of the paintings in the Huntington Museum and Library and found a Frank Lloyd Wright house they visited "a beast." Olin Howland escorted them through the Chinese, Japanese, and Mexican sections of Los Angeles, and the sisters shopped and socialized with friends, including the Archipenkos, the Arensbergs,[9] and the poet George O'Neill, who invited fifty people to a party for the Stettheimers. Before leaving Los Angeles at the end of March, they spent the afternoon and had dinner with Gertrude Stein, Alice B. Toklas, and Man Ray, whom Stettheimer described as "very charming." They then traveled up the coast through Santa Barbara and Monterey to San Francisco, where they stayed, for the first time, in the Redwood City home of their brother, Walter. In mid-April, the two sisters attended an evening lecture by Gertrude Stein at Stanford University, and they renewed their acquaintance with Adolphe Bolm and his wife. Taking the train home from Oakland on April 15, the Stettheimers stopped in Chicago, where they met the curator of the Art Institute, the actress Ruth Gordon, and the writer Thornton Wilder, before returning to New York.

Sometime toward the end of her California trip, Stettheimer wrote a poem that proved prescient of upcoming events:

This summer is gone
I did not live it—
I killed time
It was like swatting flies
The hours fell dead
Noiselessly—
I did not ever hear them buss
I had no flowers—
Others had a few—
There were big trees
But they belonged to nobody—
Then we drove South-west
Over smooth roads—
That way we got ahead of time—
It's September now—
Children on roller skates
Art gratingly rolling over time—
I shall soon roll on wheels
Back to town
To take up time
And again become over-aware
Of its preciousness—[10]

Soon after their return, Rosetta Walter Stettheimer died. Her passing irrevocably altered her daughters' lives. In addition to arranging the burial, the Stettheimers' lawyer, Joe Solomon, made plans for selling the Alwyn Court apartment. At the end of August, Stettheimer recorded the imminent changes in the sisters' lives in her diary: "Expect to go home tomorrow. Home meaning a semi-dismantled apartment—and a search for a new home." On September 30, the day they moved out, Stettheimer noted:

The Collapse of Our Home
Good-bye Home
182 W. 58 St.
The Alwyn Court
Salamanders, Crowns
Cupids & Fleur de Lis
Farewell.

Expecting that the three sisters would continue living together, Ettie and Carrie looked at a number of apartments with Solomon, finally deciding to take a duplex apartment at the Hotel Dorset on Fifty-fourth Street. They did not, however, reckon on opposition from Florine. After spending the first six decades of her life in the company of her sisters, doing everything but her artwork as a member of a group, Stettheimer had no intention of continuing that lifestyle. She craved independence and the opportunity to concentrate entirely on her work. Declaring that she wanted to live alone, she surprised her sisters by moving permanently into her Beaux Arts studio, fourteen blocks south of the Dorset.

This action caused some "unpleasantness" among the sisters. According to Solomon, "there was no lack of communication, but a good part of the communication . . . [took] place over the telephone."[11] A decade later, Isabelle Lachaise showed great insight into the relationship among the sisters when she wrote to a friend, "Perhaps also, in spite of the devotion of the three there might come such a thing as a release—'a Room of One's Own,' so to speak. The tie between them, although a devoted one, I have felt might be almost too binding."[12] Relations with Ettie were never the same after Stettheimer moved into her studio, and Ettie's attitude toward her older sister became increasingly ambivalent. Nonetheless, the three sisters continued to vacation together, spending part of the following summer in Atlantic City. While there, Ettie grew so depressed over her mother's death and her sister's perceived desertion that Alfred Stieglitz urged her to get over the feeling that "the world is ugly and not worthwhile."

Moving away from her sisters and into her own space marked the third major stage in Stettheimer's life. The first, until age forty, was spent largely in Europe, receiving academic art training in Paris, Munich, and New York and experimenting with various styles and techniques of making art. For the next twenty years, living with her sisters and mother in New York, Stettheimer worked at creating and exhibiting her new style of work, negotiating the precious time between her career and her family's needs. Rosetta's death brought freedom from the constraints that often had prevented Stettheimer from concentrating on her work, and she reveled in her privacy and ability to paint or entertain on her own schedule. In the fall of 1935, she destroyed a number of her past works and became quite social, hosting teas in her studio home. She was taken care of by a "morning maid," Mary Walters, who brought her breakfast in bed and cleaned the apartment. Also, a "good-looking girl from Harlem," Corinne Davis, came in at three and cooked Stettheimer's dinner. Corinne's "equally good looking husband," Walter, handled the responsibilities of butler when the artist entertained. On one occasion, an apartment on another floor in the building caught fire, and the artist was desperately afraid it would spread to her studio, so she refused to leave the building. Corinne stayed with her until the fire was under control. Stettheimer telegrammed her sisters, who were vacationing in Charleston, South Carolina, to tell them about the fire, but despite their urging that she join them, she chose to remain in the city.

In October, Stettheimer faced the unhappy passing of two of her closest artist friends, Gaston Lachaise and Charles Demuth. In her diary she lamented, "Lachaise's death is sad—Demuth I shall miss. He was somebody to look forward to seeing." At the same time she valued her independence, and throughout the winter she continued to "stay home a lot. I like it." As she joked to McBride, "Mary, my maid, said that Heaven *should* look like my new abode—when I get bored with my new Paradise, I shall welcome serpents."[13]

The late 1930s was a period of professional and emotional upheaval for Stettheimer, who found that she tired easily and lacked energy and interest for anything but her work. After exhibiting with the American Society of Painters, Sculptors and Engravers for many years, Stettheimer tendered her resignation, despite letters from the society's board requesting that she reconsider.[14] In April 1937, she became depressed and turned down several social invitations, including one to see her friend Leon Kroll's newest paintings: "I am still weeping over having missed seeing your new murals—I had a bad day last Wednesday and my sister Ettie had to stay in and console me." She also eschewed a party at the Van Vechtens, to whom she wrote, "I wonder if you noticed that I did not arrive at your party yesterday—that may be my this year's trouble—I don't arrive anywhere—much to my regret." An undated poem affirms the artist's occasional malaise:

I'm tired
My sobs
rise
like
bubbles
in a siphon.[15]

In July, wishing to escape the city's heat and break the pattern of renting a house for the summer, the Stettheimer sisters set off together for a train trip north to Canada. It was Ettie and Florine's first venture out of the country in twenty-three years. Stettheimer was apathetic. She found Canadian paintings "thin and cadaverous" and everything else "a bore." As had been the case thirty years earlier, the women complained about the food and often asked the hotel management to change their accommodations. Since none of the three liked Canada, they traveled south to Lake Saranac in the Adirondacks, where they stayed at a former stopping place, the elegant Wawbeek Inn.[16] Stettheimer wanted to return immediately to New York, but Ettie persuaded her to stay a few weeks. She finally returned to her New York studio at the end of August, only to find that the ceiling over her lace boudoir had been severely damaged, for the fourth time, by water overflowing from tanks used by professional photographers in the apartment above.

Toward the end of the year, Stettheimer received a letter from Conger Goodyear, president of the Museum of Modern Art, requesting work for an upcoming exhibition of American painting, sculpture, architecture, graphic arts, photography, and film, which was scheduled to travel to the Jeu de Paume Museum in Paris the following spring. Stettheimer and O'Keeffe were the only women invited to submit works. Stettheimer initially accepted with eagerness: "You have honored me with an invitation to participate in the Museum's exhibition and that of the French government. I shall be most pleased to send to both." But for some reason, she then decided that the Modern's exhibition spaces were not to her liking and changed her mind. In October (the exhibition was to open in New York in November) she wrote to Goodyear, "I am sorry I have to withdraw my acceptance of your invitation to the Museum's November show—as I find I have no painting suitable for the present Museum walls."

Tom Mabry, the museum's curator and a close friend of Ettie's, wrote back in great dismay and pointed out to Stettheimer that Alfred Stieglitz (an adviser to the exhibition) "says there are going to be other very large pictures. We could put yours on one of the short walls, alone, so it would not irregularize the others." Recognizing Stettheimer's stubbornness once she made up her mind, he inquired, "At any rate, you'll send to the Paris show, won't you?"[17] To facilitate this, in January 1938, Mabry brought Goodyear to Stettheimer's studio to see her work and reinforce his belief that an "American exhibition in Paris without you would be unthinkable," pleading, "I know how you feel about the Museum. But I shall, personally, be broken-hearted if you are not represented. And I write this only because I want the exhibition to represent our *best* painters. We would lose much if none was in it by you. So—if you can, if you care, think of lending only to your poor friend Tom and not to the Museum, and I shall be ever and ever grateful and proud."

Mabry's heartfelt letter did the trick, and Stettheimer sent *Asbury Park South* to the exhibition in Paris, where it was well received by audiences and critics. Stettheimer also included a work in "Fantasy in Decoration," an exhibition in New York with work by an eclectic group, including Juliana Force, Hattie Carnegie, Lynn Fountain, Helen Hays, Pavel Tchelitchew, Mrs. K. V. Vanderbilt, Stark Young, and Richardson Wright, all of whom were cited for doing imaginative "non-boring" things.

During the winter and spring of 1938, the Stettheimer's energy returned, and she participated in a flurry of social activities. She had dinner with Ralph Flint and went with him to a production at the Mercury Theater, attended a dress rehearsal for Maurice Grosser's new ballet, *Filling Station* (with costumes and props by Paul Cadmus), and on Valentine's Day she watched a production of Virgil Thomson's opera *The River*. Georgia O'Keeffe brought Mabel Dodge Luhan to tea with McBride at Stettheimer's studio, and a few weeks later the four attended a cocktail party at Ettie's apartment that also included Louis Bouché, Marion Estace

Seligman, Paul Rosenfeld, and Arnold Genthe. Other spring pastimes included tea with Irene Guggenheim, an Urban League benefit with Ettie, lunch with Luhan, O'Keeffe, Ida Rank, and Phil Moeller, dinner with Baron de Meyer, and a reception for editors from *Vogue* magazine, who were curious to see the design of Stettheimer's studio. In April, the artist attended several exhibitions, including one at the Downtown Gallery, and went antiquing in the village, visiting a Salvation Army "Glory Hole" on Bleeker Street as research for a new work.

In mid-April, Stettheimer began to stain in the outlines of a painting she titled *The Cathedrals of Wall Street*, intended as the third in her *Cathedrals* series (fig. 118). Conceptually and visually, *Cathedrals of Wall Street* is an amalgam of two dominant images of the time: the pageantry and national pride sparked by the New York World's Fair of 1938–39 and the economic boom created by European orders for arms and military equipment. Initially, Stettheimer may have intended the painting to refer to a specific event, but as with her other *Cathedral* paintings, it evolved instead into a complex, generalized microcosm of the period, with strong references to prevalent themes. As Linda Nochlin recognized, the painting is Stettheimer's ironic representation of the 1930s confrontation of the old and the new, of big business and popular pageantry.[18] On January 2, 1938, Elliot V. Bell wrote a *New York Times* article titled "What Is Wall Street?" which happens to describe the exact setting of Stettheimer's painting: "The geographical center of the district lies at the intersection where Broad Street ends and Nassau Street begins. Here on one corner stands the Stock Exchange, on another J. P. Morgan's and on a third the outmoded temple of the old United States Subtreasury upon which the statue of George Washington stands with lifted hand to mark the site where the first President on April 30, 1789, took the oath of office."

Stettheimer had made reference to the Washington statue and the Subtreasury Building in *New York*, painted some twenty years earlier. Contemporary events of the 1930s brought these structures again to the forefront of popular imagery. In April 1938 began celebrations to mark the 150th anniversary of George Washington's inauguration by reenacting it for the public on the steps of the Subtreasury, with representatives of many patriotic, military, and naval organizations attending. The next day, the *New York Times* ran an article, "A Patriotic Ceremony on Wall Street," describing the event and including a photograph that is remarkably similar to Stettheimer's final composition.

An even more lavish reenactment of Washington's inauguration took place as part of the opening ceremonies of the 1938–39 New York World's Fair.[19] The artist and cartoonist Danys Wortman, dressed in costume, played the role of the country's first president. The main ceremony took place directly under an eighty-five-foot statue of George Washington designed by James Earl Fraser to show pride in the nation's history, one of the central themes of the fair.

At the end of June 1938, Holger Cahill, director of the fair's art exhibition, invited Stettheimer to attend when President Roosevelt laid the fair's cornerstone. She sat in the hot

118. *Cathedrals of Wall Street* (1939), 60 x 50 in. Metropolitan Museum of Art.

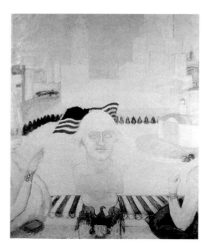

119. *George Washington in New York* (1939), unfinished, 60 x 50 in. Columbia University of the City of New York, Gift of the Estate of Ettie Stettheimer, 1967.

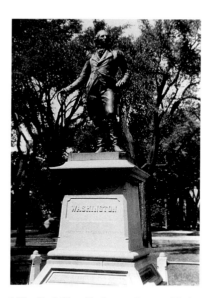

120. Carl Van Vechten, *George Washington monument* (ca. 1939). Yale Collection of American Literature, Beinecke Rare Book and Manuscript Library, Yale University.

sun through four hours and still found the president very charming and amusing. Because of her reputation and friendship with Cahill, Stettheimer was convinced that he would ask her to design a major work for the fair.[20] With that in mind, she enthusiastically visited the fair many times, seeking out ideas and models for potential paintings. She began one such work (fig. 119), in which she conflated aspects of the World's Fair with elements of downtown Manhattan architecture,[21] and included a rendition of the George Washington marble bust that stood prominently in her studio's "patriotic" niche. Stettheimer collected Washington memorabilia throughout her life, often with the assistance of her friends, like Carl Van Vechten, who sent the artist a photograph of Washington that he had recently printed for her to add to her collection (fig. 120). She immediately responded, "Dear Carlo, How wonderful to receive handsome Washingtons from you—with your help he is the only man I collect."[22]

Stettheimer was never offered a commission for the fair, and her work was not among the three thousand pieces chosen by the "selection committee of artists" for the fair's exhibition, "American Art Today." This is not difficult to understand, as regional artists committees chose what they considered "the most typical and representative American works," a definition not easily applied to Stettheimer's style or subject matter.[23] A year later, Cahill did ask Stettheimer to execute a painting on the theme "The World's Fair as I See It"; but having not been asked to paint the ceremonies marking the actual opening of the fair, she refused: "I am not sure you will feel as sad as I do that I shall not be able to paint [it] . . . owing to my not having seen any of you and the creators in action. . . . I should have enjoyed doing you all in the Fair surroundings, alas."

Throughout early 1939 Stettheimer continued working on *Cathedrals of Wall Street*. On Washington's Birthday she noted in her diary, "I put lots of gold on Washington," referring to the enormous gilded figure of Washington, dressed in his inaugural robes, that dominates the right side of the painting. Stettheimer based her rendition of Washington on Fraser's three-dimensional statue seen in profile. The artist positioned the figure so that it is in the act of entering the scene from the right. Her version faithfully but awkwardly emulates the hand gestures of the original, in which the hand rests on a Bible during the oath of office. In the painting, however, the book has been eliminated so that the president's hand hangs unconvincingly in the air, holding back the flag to give a better view of the Stock Exchange Building. Directly underneath Washington's statue, Stettheimer imaged herself in a long red dress, offering the figure of Washington a bouquet of red, white, and blue flowers and a banner inscribed with both their names.

In 1931, the French artist Fernand Léger described Wall Street as the symbol of "audacious America, which always acts and never turns to look behind."[24] The juxtaposition of politics, money, and ostentation was a theme also picked up by the media, as in a *Vanity Fair* magazine cover of December 1932, in which a leaning tower of money bags ("America's Monument to the Well Known Soldier") is viewed by a group of top-hatted politicians. Another popular illustration from the era, caricaturing Franklin D. Roosevelt's inauguration in 1933, also made much of the pageantry of the occasion—trumpeting angels, microphones, vine-trimmed columns, and famous personages. Stettheimer's painting features many of the same people, including Mr. and Mrs. Roosevelt, J. P. Morgan, Bernard Baruch, and various military officers. To this group Stettheimer added a gilt cameo of John D. Rockefeller. In the central circular plaque above she placed a gilded and raised portrait of President Roosevelt.

Throughout the summer, Stettheimer wrote to her sisters daily while they vacationed in Saratoga, but she refused requests to join them, preferring instead to stay in her studio and paint. "I painted all day. . . . I think I am looking quite healthy—the air in my lace bedroom is much better for me." She ventured into the city, researching possible sites for her painting. In *Cathedrals of Wall Street,* Stettheimer sowed references to specific sites, such as the blackened spires of Trinity Church in the shadows of the Stock Exchange and the wrought-iron light inscribed with the address "Wall Street." In Elliot Bell's article on Wall Street, he described "itinerant preachers [who] often take their stand outside the Banker's Trust at the corner of Wall and Nassau, exhorting the noon-time crowds of clerks and office boys to forsake Mammon and return to God." Stettheimer included a similar figure dressed in suit pants and shirt-sleeves exhorting passersby from the steps of the bank building at the painting's left edge.

In the interests of accuracy, Stettheimer had her hair shampooed in the same salon as Grace Moore so that she might see the well-known singer and get firsthand knowledge of her facial features. Moore appears in *Wall Street* singing the national anthem. The artist visited

the Seventh Regiment Armory in order to copy military uniforms, and she asked Joe Solomon to procure authentic ticker tape so that she could put it in the painting under Roosevelt's portrait. She also asked Van Vechten to introduce her to Eleanor Roosevelt and was very disappointed that he was not able to do so. Nonetheless, Stettheimer included the president's wife in in the center foreground, holding a bouquet of flowers. Next to Mrs. Roosevelt she painted Mayor Fiorello La Guardia, Michael J. Erikson (superintendent of the Beaux Arts Building), an American Legion veteran from Post 102, and Captain Clagett Wilson of the United States Marine Corps. Between Captain Wilson and her self-portrait, she placed the figure of a tall Native American standing in profile with gilt costume and full headdress. Like the figure of Washington, the American Indian was a prevalent historical symbol of the period and was prominent in posters advertising the fair.

As in the two earlier *Cathedrals,* implied sounds and noise are integral to *Wall Street.* Directly in front of the line of uniformed men Stettheimer painted a formally dressed marching band in white uniforms with gold trim. She depicted the paired musicians in the act of playing a boisterous rendition of "God Bless America," their gestures and positioning animated so that viewers virtually can hear the blaring of their raised trumpets and the rattle of the drumsticks. The band is led by a high-stepping drum majorette who marches forward with one hand on her hip, the other proudly waving a gold baton, her legs gaily echoing the rhythm of the band. A piano-playing member of the Salvation Army accompanies the band, while her two fellow Glory Hole members look on. Playing on the humor implicit in the name, the artist fashioned the rooftop of the Glory Hole in the shape of a gold tray resembling those passed around for donations. The cacophony is amplified by the addition of a young boy scout and his trumpet, the singing of Grace Moore, and, at the lower right, Florine, who in red high-heels marches smartly in time with the music.

The painting undoubtedly owes its overt patriotism to current events. On September 3, 1939, Stettheimer noted in her diary that war had broken out in Europe. Her reaction was characteristically oblique: she wrote the single word "horrors" in her diary (a word she tended to use interchangeably to describe both world events and painting exhibitions that she disliked). Later, she and Ettie went to Rockefeller Center to see a newsreel on the worsening European situation. Stettheimer left no further written comments about the war.

Despite the crisis in Europe, Stettheimer spent 1939 caught up in a swirl of social activities, often including visits and meals at various World's Fair pavilions that allowed the artist and her friends to eat in different "nations" every night. She and Ettie paid the ten-cent admission fee to attend the opening of the Museum of Modern Art. Her response was typically tepid: "Only two floors of art open, very dull with few exceptions—and many horrors . . ." (the rest of the entry was eliminated by Ettie). Stettheimer continued to entertain the avant-garde in her studio; unlike in earlier years, however, now her guests included a number of

prominent women—Fanny Hurst, Mina Loy, the portrait painter Romaine Brooks, and the Parisian hostess and poet Natalie Barney (with her sister Laura Dreyfus, a distant relative of the Stettheimers), in addition to such regulars as Georgia O'Keeffe, H. L. Mencken, Arnold Genthe, Juliana Force, the Van Vechtens, Kirk and Constance Askew, Paul Rosenfeld, Ansel Adams, the Archipenkos, Monroe Wheeler, Henry McBride, Muriel Draper, Aaron Copland, Sherwood Anderson, and Commissioner and Mrs. Robert Moses.[25]

In August 1940, Stettheimer hosted a small, elegant seventieth birthday party for herself. On the menu were rum cocktails, caviar, filet mignon with bernaise sauce, camembert and Roquefort cheeses, a hazelnut birthday cake, and Roederer champagne. The artist also gave a champagne cocktail party for Virgil Thomson, who had recently returned from Europe, and she had tea with her old friends Adolphe Bolm and Adolfo Best-Maugard, who again appeared on the scene.[26] Stettheimer had new cellophane curtains cut and hung in her studio. She and Ettie attended Bolm's newest ballet and went to the Picasso exhibition at the Museum of Modern Art. The sisters also saw films, including *The Great Dictator*, which Stettheimer announced revealed Charlie Chaplin as "fine—a great actor"; and *Wuthering Heights*, which she declared was "too tame." In October, the sisters and their friends celebrated Carl Van Vechten and Fania Marinoff's silver wedding anniversary, which the artist said was a "remarkable and pleasing event." John Houseman came to dinner at Stettheimer's studio and asked her to design the sets and costumes for his next directing venture, the play *Liberty Jones*, but she declined.

An ardent Democrat, Stettheimer eagerly listened to the presidential campaign speeches on the radio and was horrified to learn that her friends Henry McBride and Clagett Wilson favored Wendell Willkie. In her diary for November 5, 1940, she noted, "Have just registered my vote for Roosevelt," and the next day's entry reads, "I took off my telephone receiver at seven A.M.—'Roosevelt' said the voice instead of 'good morning.'" On January 20, 1941, she wrote in her diary, "Thank goodness it [the inauguration] came off,—heard Oath and speech . . . our most illustrious refugees—Matterlink, Paderevsky, Eve Curie etc." She also attended the premier of the ballet *Balustrade,* with Tchelitchew's stage designs, and Houseman's *Liberty Jones,* for which Guy Pene DuBois designed the decor. Stettheimer found herself tiring easily, and she carefully rationed her social outings, weighing their importance against the energy for work they would cost her. On May 27, she attended a rehearsal for an oratorio version of *Four Saints* led by Virgil Thomson that featured the original cast. She worked with Louise Crane and a dressmaker in Harlem to design new costumes for the recital. The production took place at Town Hall, with Alfred Smallens conducting.

In late September, the three Stettheimer sisters took a taxi down to the Battery and East Broadway to look at their grandfather Israel Walter's home, which was still standing, except for the horse stables. On an unusually hot October day, Virgil Thomson visited Stettheimer at

121. Virgil Thomson, *Musical Portrait of Florine Stettheimer* (1941), Yale Collection of American Literature, Beinecke Rare Book and Manuscript Library, Yale University.

her studio and, during two hours while she sat stringing glass beads onto her cellophane curtains, he composed a musical portrait of the artist, to the accompaniment of drums and trumpets (fig. 121). Stettheimer was not overly pleased with his characterization of her, believing it to have been inspired by noises made by military bands playing below her studio on Fifth Avenue. When Thomson played the portrait again for her in his apartment the following February, she described it in her diary as "not at all what I thought I was in his eyes and ears—I am very sad and dreary and suddenly become boisterous and even modernly screechy—he said the noisy quality is the color I use—that's that." A few months later, Thomson wrote the artist, "I am orchestrating a dozen or so of my portraits, including yours. . . . I think about you all the time. I love you dearly."

As usual, neither Stettheimer's work nor her correspondence show her reaction to the bombing of Pearl Harbor and the entry of the United States into the war. Her only written comment was in her diary—"more horrors"—but she listened avidly to radio speeches by Roosevelt and Churchill. She visited the Douanier Rousseau exhibition at the Museum of Modern Art and was scandalized at the amount of smoking so near the paintings. Over the last few years, Stettheimer had developed a close friendship with the painter and stage designer Pavel Tchelitchew, whose work she first admired at the Julien Levy Gallery.[27] She stopped by Tchelitchew's studio to see his "chef d'oeuvre," *Hide and Seek*, which the Modern had recently acquired, and when Tchelitchew's exhibition opened at the museum, Stettheimer attended, calling it "very impressive—even grandiose." She even wrote the artist a short poem:

Dear P
Your show at the
Museum is over
whelmingly you—
your mountainous
thoughts—your
fountainous talk
your leafy gestures

Are you keeping your
skyey laughter
and flowery accolades
for paradise?

Some critics attacked Tchelitchew's *Phenomena*; Stettheimer, however, praised it and was horrified when an "uncouth schoolgirl with the rubber and metal end of her pencil double scratched across part of the painting." She ruefully acknowledged, "I don't know whether there was real damage to the picture—there has been to my enthusiasm for exhibitions—which is not very great anyway."

On January 1, 1942, Stettheimer began the last of her monumental *Cathedral* paintings, *The Cathedrals of Art,* by staining in large areas of color over pencil outlines. In earlier *Cathedral* paintings, she had created dense statements detailing her highly ironic perspective on the worlds of popular entertainment, society, politics, and finance. In her last work, the artist decided to take on what she knew best, the world of art museums and the art market, with the Metropolitan Museum of Art as its high altar (fig. 122). She again modeled the underlying structure of her work on early Renaissance painting in which a central scene is bounded on either side by seemingly separate, pendant narratives. The content and formal composition of *The Cathedrals of Art,* however, more closely echoes that of a later Renaissance work, *The School of Athens,* which Raphael composed around the central figures of Athens' foremost philosophers, Plato and Aristotle, reflecting the apogee of classical Greek intellectual thought. They are each surrounded by clustered portrait groups of other respected Greek philosophers, shown in characteristic poses or activities.[28] Stettheimer similarly designed her *Cathedrals of Art* to encapsulate the main trends of art production at a particular moment in American life. At the time she was executing the painting, from 1942 to 1944, the New York museum world was caught in the public squabbling of coalitions and misalliances. Stettheimer shrewdly composed her work to reveal the delicate balance of power, competition, and interdependence of prominent art world figures by ironically depicting the big players among New York's three major art museums with the city's main art dealers looking on.

One of the original purposes in establishing the Metropolitan Museum of Art had been to encourage the development of native artists. In both collection and exhibition practices, however, primary emphasis was consistently placed on acquiring masterpieces from the past. Throughout the early part of the century, artists and critics widely criticized the Metropolitan's neglect of contemporary art, and this criticism directly contributed to the formation of the Museum of Modern Art and the Whitney Museum of American Art.[29] In 1939, the Metropolitan's trustees hired the energetic young Francis Henry Taylor as the institution's new director. Taylor was flamboyant and mercurial—"He had great charm, he had a touch of genius,

122. *Cathedrals of Art* (1942–44), 60 x 50 in. Metropolitan Museum of Art.

and was a naughty boy"[30]—but he was not particularly receptive to contemporary art. He viewed modern art as reflecting the moral crises of modern life and in private referred to the Museum of Modern Art as "that whorehouse on Fifty-third Street." That did not stop him, however, from trying to take over the collections of the other two museums.

When the Museum of Modern Art opened in 1929, it was called a "citadel of Freedom." The museum was conceived to support "the liveliest visual art of the twentieth century";[31] administrative issues, however, soon troubled the institution. While its director, Alfred Barr, Jr., was on a trip to Europe in 1939, the trustees forced his resignation, relegating him to the museum's acquisitions, exhibitions, and architecture committees. Meanwhile, Francis Taylor began going over Barr's head at the Modern and negotiating with the museum's president, John Hay Whitney, for greater cooperation and possible consolidation of the two institutions.

The Whitney Studio Club (later the Whitney Museum of American Art), which was established in 1914 by Gertrude Vanderbilt Whitney and Juliana Force, was intended primarily as a showcase for contemporary American art.[32] By 1929, the women had gathered an enormous collection of works by living artists, which they exhibited in a building on West Eighth Street. They soon outgrew this space and began searching for a new site; but as Whitney grew distracted by other interests, the original intentions of the women dissipated in a melee of internal squabbles and misunderstandings. When she died in 1943, Whitney trustee Frank Crocker, without informing Force, began secret discussions with Taylor concerning incorporating the collection into the Metropolitan Museum. Although the talks eventually broke down, the proposed partnership made Force, at least for a while, the director of little more than a "ghost museum."[33]

In *The Cathedrals of Art*, to capture these tensions, Stettheimer borrowed a device from *Four Saints*, using two narrators, a compère and a commère, as intercessors between the painting's composition and its audience. Compositionally, the positioning of the two figures, which bracket the left and right front centers of the "stage," recalls a traditional pyramidal arrangement used in many Renaissance religious paintings, such as *Madonna and Child with Saints Francis and Liberale,* by Giorgione (one of Stettheimer's favorite artists), or Flemish altarpieces where the donor was included in a lower section of the main scene. In her painting, Stettheimer reinforced the separation of her symbolic narrators from the rest of the composition by the addition of a screen and canopy.

Stettheimer designated her friend Robert Locher to act as her compère. Locher was noted for his good looks and style. Originally trained as an architect, he entered the firm of Baron de Meyer just at the time that the latter was experimenting with flamboyant and original color schemes in the interiors of private homes of the wealthy. In addition to working with advertising firms and magazine editors, Locher developed a significant reputation for theatrical design and worked on a number of productions: "producing enchanting costumes and settings for directors here and abroad . . . his determined thoroughness impelled him to try

subtle and new ways of lighting them." His theatrical style, academic training, and ease at moving among the moneyed classes gave him close affinities with the artist.[34] In portraying Locher as the compère, Stettheimer drew parallels not only with the pose of Apollo in Raphael's painting but also with that of the Apollo Belvedere, which is visible in photographs of her apartment.

In *The Cathedrals of Art*, Stettheimer chose to include herself as the commère, at the lower right corner of the canvas, standing under a cellophane and gold canopy trimmed with huge white calla lilies resembling the canopied bed in her Alwyn Court apartment. She portrayed herself not as an artist, with tools of her trade, but in a white dress, as a kind of conflated bride-bachelor. Although she was over seventy when the work was conceived and painted (fig. 123), Stettheimer imaged herself as eternally thirty-five to forty years old, continuing a practice she had long followed (fig. 124). In this, her last work, Stettheimer wears an expression of amused astonishment, an ironic reference to the ecstasy of Saint Theresa in *Four Saints*. In addition, her pose loosely resembles that of Minerva, goddess of wisdom, who stands within a niche on the right side of Raphael's painting. Stettheimer placed the portraits of herself and Locher outside the main action of *The Cathedrals of Art*, implying that neither artists' work fits within existing definitions of modernist art. Neither wholly European nor overtly American, their styles combined elements of the decorative arts and theatrical design with a wholly avant-garde flavor and attitude. As such, their work was at the time not obviously compatible with the growing permanent collections of the three major New York art museums.

123. Marguerite Zorach, *Portrait of Florine Stettheimer*, pencil drawing. Columbia Univeristy of the City of New York, Gift of the Estate of Ettie Stettheimer, 1967.

As if to reinforce this reading, Stettheimer placed the figures of three other influential "outsiders," Tchelitchew, McBride, and Everett Austin, Jr., directly behind herself and Locher. Although both Austin and McBride were highly influential within art circles— McBride as an acclaimed critic and Austin as the "young prince" director of the Wadsworth Atheneum—neither was heavily involved in the business of art. Stettheimer's image of Austin is rather cavalier; he is amused by the antics of the New York art scene without being part of it. Wearing a costume from a production of *Hamlet*, he leans back with legs and arms crossed, and gazes warily out of the corner of his eye toward

McBride. By contrast, McBride's posture is erect, with his elbows pressed tightly against his suited torso. An objective traffic cop, he guards the museum's entrance. In either hand he holds flags inscribed with the words "Go" and "Stop," satirically suggesting that the critic's role includes offering enlightened opinions as to which works are worthy of museum accreditation. His pose recalls both his profession and the situation as referee of the tennis matches in which Stettheimer placed him in her portrait two decades earlier.

Stettheimer originally titled *The Cathedrals of Art* "Our Dawn of Art," which she scribbled on one of the painting's stretchers. The implications of this title, and the arrangement of portraits and various devices within the composition, reveal her intention to satirize the New York art museums' burgeoning interest in contemporary art. Stettheimer's attitude toward the machinations of the art world was evident throughout her career but never was realized as humorously as in her final painting. At some point, in a short poem, she noted:

> *Art is spelled with a Capital A*
> *And Capital also backs it—*
> *Ignorance also makes it sway*
> *The chief thing is to make it pay*
> *In a quite dizzy way*
> *Hurrah—Hurrah.*[35]

Hilton Kramer later described *The Cathedrals of Art* as "comic opera . . . the whole scene is one of shameless hustling and posturing. It is a prophetic as well as a delightful painting."[36] In the painting, through repeated representations of a nude baby symbolizing the "New Art," Stettheimer parodied the different museums' responses to contemporary work. Harking back to her earlier use of *multiplication virtuelle*, the "baby Art" appears several times within the composition. The initial focal point is the naked infant lying at the base of a grand staircase in the foreground. Based on a third-century b.c. bronze statue of a sleeping Eros (acquired by the Metropolitan in 1943), the statue was widely publicized, and the reference would have been easily recognized. Stettheimer turned the child on its stomach. Instead of sleeping, her putto is drawing with a red crayon in its mouth as though it was born as a fully formed artist. The object of intense publicity, the creative infant is being memorialized by the renowned photographer George Platt Lynes.[37] The flash from Lynes's box camera clearly illuminates the small child, whose every utterance is recorded on a portable typewriter balanced on the bent knee of an art critic, who is wearing a spotlight directed at the baby's posterior. At the lower right, a beautiful woman, with a bouquet of flowers atop her long blond locks, gestures with her hands and makes cooing sounds to placate the child. She represents the adoring art spectator, who is willing to be seduced by all that is innovative and trendy.

The painting's composition is divided into three parts above the image of the infant Art.

On the left and right sides are characterizations of the Museum of Modern Art, titled "Art in America," and the Whitney Museum of American Art, titled "American Art." The central portion of the canvas is dominated by the Metropolitan's central staircase. The institution's name is spelled out in flowery script on the dome of the building's central hallway, with its characteristic gilded candelabra and magisterial, carpeted grand staircase. Describing a recent trip to the museum, Stettheimer ironically noted on an odd scrap of paper found among her diaries, "I couldn't manage to see the Havemeyer Collection . . . but as soon as got to the country [*sic*] I returned to town to visit the Metropolitan M. a hot day—those steps to the entrance and the grand staircase—Macy's, how much more comfortable their means of ascension—would escalators disturb one's art approach?"

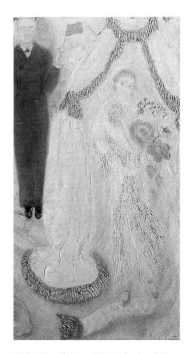

124. Detail from *Cathedrals of Art*.

In the painting, the artist included examples from the Metropolitan's vast, eclectic permanent collections. At the top of the stairs she placed a portrait of the Metropolitan's director, Francis Taylor, leading a beribboned child, another image of the "New Art," around the central lobby. Taylor points out the institution's treasured collections of Egyptian art, Old Master paintings, and arms and armor. At the right, Stettheimer put in a humorous portrait of the Metropolitan's curator of paintings, Henry B. Wehle, an accomplished ladies' man and a scholar of French eighteenth-century art.[38] Wehle had no use for modern art unless it portrayed pretty young women. In *The Cathedrals of Art*, Stettheimer mocked this inclination by portraying him with his arms around a nubile blonde wearing a sash that declares she has won "First Prize." The artist also accentuated the adjacent figure of a woman wearing an abbreviated gown and standing within a columnar shaft of bright, color-draining light. The mannequin stands, like Liberty, with a raised arm holding a crystal glass. One foot rests on a plinth bearing the title "The Cocktail Dress," which ironically refers to Taylor's and Wehle's notion of a "contemporary" art exhibition and satirizes the museum's recent temporary exhibition of contemporary costume, in which such a cocktail dress was exhibited.[39]

The surrounding light forms a gauzy veil in front of a Frans Hals painting of an older, more traditional woman.

At the left side of the painting, next to the title "Art in America," Stettheimer depicted two floors of the Museum of Modern Art. Reflecting the museum's unsettled administrative status, Director Barr sits in profile view like *Whistler's Mother*. Stettheimer portrays him as a

passive figure who is emotionally removed from the antics taking place around him. A prosperous-looking trustee stands on the museum roof manipulating strings with the names of such prominent artists as Miró and Picasso. Meanwhile, further indicating the museum's perceived preference for European paintings over works by American artists, Stettheimer included images from the Modern's permanent collections, among them two large paintings by Picasso.[40] Motifs from several works disengage from the walls and cavort along the hallways: two women from Matisse's *Women on the Beach* run in front of a browsing lion released from Henri Rousseau's *Sleeping Gypsy*, which Barr persuaded Peggy Guggenheim to purchase and donate to the museum in 1939, calling it "one of the great masterpieces of modern times."[41] At the same time, another image of the nude infant Art plays hopscotch, undisturbed, on a Mondrian painting lying at Barr's feet.

Stettheimer reserved the right side of the canvas, under a huge American eagle, for the Whitney Museum of American Art. In the foreground, society women sit gossiping at tables. The only art visible in the museum is the monumental sculpture that looms in the background by the institution's benefactress, the sculptor Gertrude Vanderbilt Whitney. Within this image of an almost empty room stands Juliana Force, the museum's director, not knowing whether she will have a museum to direct in the immediate future. Force looks out at the viewer with her arms crossed and a grim expression on her face, reflecting her tenuous position.

On either side of the central grand staircase, Stettheimer painted ironic portraits of members of New York's commercial art world. On the staircase itself, Alfred Stieglitz, draped in a dark, mysterious cloak, gazes furtively toward the exhibition halls of the museum that represents the philosophical antithesis of his gallery. On either side of a carpeted runner, clusters of art dealers and gallery owners line the steps, their features recognizable within tiny identifiable portraits. At the lower right, Marie Sterner struggles to hold a classical bust by Elie Nadelman while Monroe Wheeler, director of publications at the Museum of Modern Art, holds aloft three colored balloons bearing the names of renowned artists. He waves them vigorously in front of the viewers' eyes as though distracting us from the Metropolitan's collections behind him. He is partially restrained by an unidentified masked man, who holds onto his shoulders. Behind them, the artist Charles Demuth looks directly out at the audience. On the inner left edge of the staircase, the art dealer Julien Levy gazes up toward two balloons, one of which is inscribed "Dalí," referring to the Spanish artist's painting *The Persistence of Memory*, which generated great publicity when Levy sold it to a donor to the Museum of Modern Art in 1934. Stettheimer's friend and supporter Kirk Askew, Jr., stands with a hand on Levy's shoulder. He too holds a balloon, but instead of an artist's name it contains the picture of a flower, possibly representing Stettheimer's work. Behind him stands his wife, Constance.

The Cathedrals of Art endures as a uniquely perceptive portrait of art world infighting in New York during this brief era before the three art museums settled into their own separate

existences. The painting reflects the insularity and self-consciousness of the New York avant-garde as salon society slowly dissolved and the art world codified and aligned itself within the major art institutions. Over the next few years, negotiations among the three art museums fizzled, and many of the painting's major players died or disappeared from public view. Stettheimer continued to work on the painting until her death, and it remains unfinished.

During the remainder of 1942, Stettheimer occasionally went to openings or parties at friends' when she felt physically up to it. She was offended at not being asked to contribute a painting to Marie Sterner's Red Cross exhibition at Parke Bernet. In December, she attended the opening of the "Twentieth Century Portraits" exhibition at the Museum of Modern Art, where she was pleased to see her two entries: "Ettie, Duchamp & Rose Sélavy very well hung—on the wall of my choice." Monroe Wheeler organized the exhibition in various loose categories—"Eakins and the Eight," "Late Impressionism," "School of Paris" (Picasso, Matisse, and others), "Self-Portrayal," "Professional Portraitists," and "The Poetical Tradition"—which encompassed an eclectic group of artists besides Stettheimer, including Ensor, Rousseau, Redon, de Chirico, Chagall, Duchamp, Dalí, Ernst, Groz, Delvaux, Tchelitchew, Hartley, Bérard, and Berman. Wheeler, uncertain as to how to interpret Stettheimer's work, was puzzled by what he called her "primitive" manner in spite of her being "an artist of great culture":

> *Perhaps she pretends to be simple, or encourages a reputation of slight eccentricity in order to keep out of the critical limelight and the debating of aesthetics. Her art has been a private commemoration of the enjoyments of a lifetime in the circle of her family and friends. From picture to picture she has continued her account of things, like an album or a diary. To criticize or catalog it properly would require a knowledge and iconography of almost all the artistic side of New York life in the last three decades. . . . Perhaps it is incorrect to call this a poetical art; it is rather like a novel and in a way . . . it makes one think of Marcel Proust.*[42]

To celebrate the exhibition, on January 1, 1943, Ettie gave a party for Stettheimer's two portraits, inviting Wheeler along with the Askews, Duchamp, Tchelitchew, Charles Ford and his sister Ruth, George Platt Lynes, O'Keeffe, and others. By January 8, however, Stettheimer was experiencing a great deal of pain, and a doctor was called to take X-rays and perform other tests. To her diary she complained, "Pain in my chest now for sometime—Dr. L. [Lincoln] says it's nothing, but he hasn't the pain." The next day another doctor called to persuade Stettheimer to check into Roosevelt Hospital, and with uncharacteristic docility she acquiesced: "I obeyed everybody and let them do everything."

In early February, Stettheimer underwent surgery and was diagnosed as having cancer. Her sisters took a room at the hospital, and Ettie wrote letters reassuring their friends that "she has been wonderful & the Drs. are encouraging & Carrie and I are hoping for the best." Stett-

heimer was less philosophic and wrote short, amusing thank-you notes to friends for sending flowers, valentines, and small presents. She also summoned Joe Solomon to the hospital, where he found her considerably weakened but insistent: "Joe, there is one thing I'd like you to do if and when I pass away. I would like my paintings destroyed." The idea shocked Solomon, but he agreed. He stated later, "I find that when a person makes up his or her mind that that person has probably given considerable thought, so I said OK, I'll follow your wishes; it was a shock and I could not tell Ettie or Carrie what those wishes were." At her request, Solomon also revised Stettheimer's will.[43] Her former will stipulated that all of her paintings and other works should remain together as a unit and be given to some museum for its permanent collection. In her revised will,[44] the artist bequeathed everything she owned to her two sisters and left no specific instructions as to the disposal of her works. Ettie later theorized that Stettheimer came to no definitive decision because "of the pain of withdrawing her attention from painting—she was working on her unfinished painting, *Cathedrals of Art*, six weeks before her death—and focusing on practical and legal issues seemed intolerable to her."

Stettheimer spent three months in the hospital and a further three months in an apartment next to her sisters' at the Dorset Hotel. In an undated letter, Isabelle Lachaise observed that following her operation, Stettheimer looked "a little paler, a little more frail but quite brave," while Ettie was "caustic as always," and Carrie, "the angel of the house, [gave] comfort and ease to any arguments that might arise." When Stettheimer finally returned to her studio in July, her painting *Natatorium Undine* fell off the wall in what appeared to the artist and her friends to be an ill omen. Once back in her studio, the artist resumed her social activities, dining with Tchelitchew, Thomson, and her sisters. She discussed with Tchelitchew the possibility of appointing the art dealer Kirk Askew as her agent, a suggestion that Askew immediately followed up in a letter begging her to allow him to give her a solo exhibition. Stettheimer's unsent reply gives some indication of her state of mind regarding her recent illness and the disposition of her works:

> *That's a beautiful letter K. dear—both you and Pavlik are showing me real friendship. There is no one's integrity I trust/admire more than yours. Pavlik got going when I confided to him that a very stylish/elegant Exh. had been offered me—so far I have not accepted—altho' it would be very chic, however now that I have had a warning that I am not immortal—and I have made no* [blank space] *and whether my paintings may/are to disappear with me if a pleasing disposition of them cannot be found. . . . I have a few unrealistic ideas in their future which I should like to tell you about.* [The last sentence has a large "X" through it.] *When you come back I know I can hope for some understanding and possibly sympathy from you.*

In the fall, when Askew returned to the city, he and Stettheimer met and discussed the possi-

bility of his acting as her agent, but they never reached a formal agreement.

While her social activities were somewhat curtailed by continuing poor health, Stettheimer attended specific events when she felt she had a mission that necessitated her venturing back out among prominent social and art circles of the city. On New Year's Day, 1944, she and her two sisters went to An American Place to congratulate Alfred Stieglitz on his eightieth birthday. Although originally she declined an invitation to attend a party at the British American Art Center, Stettheimer went and circulated among the hundreds of people in smoke-filled rooms. She noted that she was very disappointed to find that none of her "'victims' for *Art in America,* I mean *Cathedrals of Art* were there—the reason for my going—to refresh my memory as to their appearances," indicating that, when physically able, she continued working on her painting.

Her intimations of mortality and physical frailty extended to her paintings. In February, John Taylor Arms contacted her, requesting that she reconsider a decision not to include works in the exhibition "Artists for Victory," which represented "the best artists in America," and was being sent to England, "so that our cousins across the sea may have some greater comprehension of what is being done here." Stettheimer's refusal was based on her fear that the works would be destroyed during the ocean crossing. Despite Arms's assurance that the insurance underwriters felt that the possibility of "enemy action in transit between New York and London . . . is negligible at the present time," Stettheimer did not include a work in the exhibition.

In early May, Stettheimer returned to New York Hospital for another operation. Ettie and Carrie secured the only double guest room in the twelve-hundred-room facility so they could spend most of their time with their sister. From the hospital, they wrote short notes to her friends stating that the artist was "comfortable most of the time, everything that can be done toward that end is being done. She has very good nurses, a good room and a great deal of medical attention." Solomon visited her daily, holding her hand and talking of things "of no great consequence." He never mentioned to either of her sisters the artist's earlier request that her paintings be destroyed. During the night of May 11, shortly after her sisters retired to their hospital room, Florine Stettheimer passed away.

Just six weeks later, while dining with Ettie at their Hotel Dorset apartment, Carrie experienced a pain in one eye, what the women called an "eye-migraine," and went to lie down in her room. When Ettie looked in on her several moments later, Carrie was in a coma, and she died within two hours without regaining consciousness. Although both sisters had handled Florine's death with what McBride termed "staunch" and "resolute" courage, Ettie was distraught at Carrie's death. During the years since Florine's "desertion," Ettie and Carrie had grown very close. Ettie, who claimed that since 1933 she had been "too disillusioned to enjoy anything," was not able to attend the internment of Carrie's ashes in the Walter family

plot in Salem Fields Cemetery. Her request that the newspapers run no obituary notices of her sisters' deaths struck some friends as rather odd. In the end, the *New York Times* did run a short obituary notice about Florine. [45]

Ettie, who was physically fragile during this period, felt particularly burdened as the executor of her sisters' works and began arrangements with Joe Solomon to have Carrie's dollhouse donated to the Museum of the City of New York. Making a decision about the disposition of Florine's works was a less welcome prospect, and Ettie asked Henry McBride, Kirk Askew, and Carl Van Vechten to assist her.[46] Over the next year, they priced a number of the paintings (between six hundred dollars for flower paintings and fifteen hundred dollars for the larger, more complex works) and arranged to have Askew oversee their sale as well as donate a number of works to museums and universities. Despite entreaties from friends and advisers to desist, Ettie began going through Florine's papers and diaries and destroying any references she felt were "personal" and did not relate directly to her sister's work.

Henry McBride, Marcel Duchamp, and Kirk Askew held a number of conferences to discuss mounting a retrospective exhibition of Stettheimer's work. Duchamp contacted Monroe Wheeler, the director of exhibitions at the Museum of Modern Art, who agreed, and the friends set about making plans. Duchamp put together a preliminary list of works to be included in the exhibition. He soon returned to France, however, and the others had to keep him informed of their progress through the mail. Although Ettie was consulted, she "showed no great enthusiasm" for the exhibition. Physically, her chronic asthma kept her weak, but her lack of enthusiasm for all "public" projects involving Stettheimer—her non-attendance at openings of *Four Saints in Three Acts,* her allowing the lawyer decide which paintings would be donated to various institutions, her screening out all personal matters from the diaries, holding Stettheimer's ashes for four years and then scattering them in the river rather than burying them in the cemetery with the rest of their family—indicates an ambivalence toward her sister that extends beyond mere disappointment that Florine chose to live apart from her and Carrie after their mother died.

Ettie felt morally responsible for preserving Stettheimer's paintings, even if she had little interest in actively participating in promoting her sister's reputation. In July 1944, Monroe Wheeler wrote to Ettie suggesting that she contribute the two-thousand-dollar fee for having a "definitive study" of Stettheimer written by the Chicago art historian Edgar Wind, to be included in the exhibition catalogue. Ettie declined, but a year later she agreed to pay five thousand dollars toward publishing ten thousand copies of the catalogue, for which Henry McBride wrote a general, chatty essay that he submitted to Ettie for her editing and approval.[47]

The Florine Stettheimer exhibition opened at the Museum of Modern Art on October 1, 1946. The granting of a solo exhibition confirms the singular status wherein the influential

members of the art world held Stettheimer's work. Since she was reluctant, however, to sell her work or to show it through a gallery, it was relatively unknown to the general public. McBride attributed this not to a "morbid" reluctance to exhibit, but to the artist's awareness that her work required an imaginative and sensitive context that was not available in most galleries. Stettheimer continually viewed her paintings as part of an overall *gesamtkunstwerk*, properly seen only in a setting like her studio, where every detail of the walls and furnishing contributed to the overall effect. In accordance with this idea, McBride and the others had hoped to design the museum's exhibition galleries with "typically Florine accessories" (probably cellophane, lace, and Stettheimer-designed gilt and white furniture). Eventually this was found impractical, and the "strangely new pictures, done in a painting language that possibly requires some getting-used-to, had to venture quite unaided into public notice."[48]

The evening before the opening, the Museum of Modern Art held a private viewing of the exhibition for the artist's friends and family. New York's governor Nelson Rockefeller and his wife invited Ettie, Joe Solomon and his wife, and the Van Vechtens to a private dinner at the University Club. Ettie sent her apologies, claiming that following a directive from her doctor, "I feel that I should be spending it with the paintings themselves." Just as in 1934, at the opening of *Four Saints*, the weather was terrible, but the exhibition was considered a great success in New York and in its other venues. In a reduced version, the Stettheimer exhibition traveled to Chicago's Fine Arts Club and to San Francisco's De Young Memorial Museum, where attendance reached more than thirty thousand visitors.

Despite acknowledging Stettheimer's firm refusal (had she been asked) to publicize her many short poems written on various scraps of paper over the years, Ettie had them published in a limited, private edition in 1949. Intended as a "souvenir for her friends and the friends of her painting," she sent out many copies of the book, which she titled *Crystal Flowers* at the suggestion of Van Vechten. The poems stirred a second outpouring of letters eulogizing Stettheimer and commenting on her poems as demonstrating her freshness of approach, her perception tinged with irony, and her watchful, outsider attitude. One friend astutely noted, "As I read Florine's playful verses, I could not avoid a feeling that a highly sensitive personality wished to conceal herself behind the simple swing of the rhythm, as she felt compelled to look at the artificialities of our time as a perpetual Carnival, played for her benefit by friend and foe. An enviable outlook, especially in our pessimistic age, which made her life, pictures and poems a unique adventure."[49]

Mark Pagano, who worked on the exhibition at the Modern, aptly described the poems as "made of glass—and they have razor edges and needle points—but they have smooth velvety places to touch too. Have they made Florine come alive!" One of the most poignant comments came from Alfred Barr, Jr., former director of the Museum of Modern Art. He wrote, simply, that the poems "make me wish I had known her better."

9

Epilogue

Florine Stettheimer was fortunate to be able to give free reign to her creative impulses. She took advantage of financial circumstances to paint, write, and design exactly what she pleased. The results were celebrated by many of the most influential artists and critics of the time. Two years after her death, a number of friends were angered by the cursory one-paragraph review that *Art News* gave to the Stettheimer memorial exhibition. Glenway Wescott chided the editor: "Like it or not, [Stettheimer] had originality which in the pictorial art of our country is rare and important. . . . [Her works are] finer in their way than any twentieth-century work except Bonnard's; and in fact her way was not unlike his." Wescott further described Stettheimer's work as "lasting, and it appeals to one's imagination, if one has any, and gratifies the sensuality of the eye, if one's eye is sensual. . . . Now that she is dead . . . her exhibition as a whole has indeed an elegiac sadness, a slightly bitter nostalgia." He sent a copy of his letter to Ettie, who thanked him but noted, "Anyway, Florine herself . . . [was] definitely not troubled by it as she rated herself relatively very high in the scale of contemporary painters."[1]

In the preface to Stettheimer's book of poetry, Ettie further observed:

I believe that few artists have gone on to achievement and mastery with as little encouragement or even so little professional fellowship as Florine. . . . Yet she did not thirst or starve into infecundity, her indomitable spirit was well nourished on her own confidence and enthusiasm. . . . To live this dedicated life that she loved, Florine withdrew . . . from social gatherings. . . . Whatever enjoyment she derived from these often visually attractive occasions was largely in connection with the use she might make of them in her work. It was her work, first and last, that she enjoyed, planning her next painting, experimenting technically, doing research for it, and finally painting it. For these exacting steps in production she took care of her delicately made body and strengthened it into an effective tool, and when outside events did not interfere with her absorption, she was content.[2]

Stettheimer saw the creation of works of art as the overarching aim of her life, and she believed in the validity of her efforts. She consistently represented herself as a professional artist, despite the fact that she refused to sell her paintings. To secure sufficient time and emotional space to do her work, she developed a complex persona to keep others at a distance. With no real models for independence other than male ones, it is logical that she had little interest in traditional women or their roles. She preferred instead to identify and spend her free time with like-minded—creative and artistic—men. Despite her diminutive stature and generally aloof demeanor, Carl Van Vechten specifically warned Stettheimer's biographer, Parker Tyler, against promoting the legend that she was "fragile." Instead, he pointed out that she usually worked alone in her studio, often handling fifty-by-sixty-inch canvases without complaining or asking for assistance.[3]

After close scrutiny of her life and work, Stettheimer emerges as a significant and complex, if underrecognized, modernist artist. Describing fourteenth- through seventeenth-century Northern European painting, the art historian Kenneth Clark termed it the "Alternative Convention," to distinguish it from the concurrent Southern Renaissance tradition. Correspondingly, Florine Stettheimer can be called an "alternative" modernist. For too long, the history of Western art has been defined as a linear process of innovation and distillation, through which American modernist painting evolved to achieve simple, dominant imagery and transcendent subject matter. A second, increasingly accepted definition, however, emphasizes alternative yet concurrent aspects of modernism, including the active subversion of traditional modes of perception and picture making, and investigates how concepts can originate and interrelate in different disciplines. This attempt by many writers, poets, and filmmakers to represent the world in terms of optical experience, "visualizing sight," and the flux of experience defines this alternative form of American modernism exemplified by Stettheimer's work.

Modernism was, above all, an outgrowth of urban culture, specifically in Paris and Munich. It developed during the pre–World War I period of Stettheimer's maturation as an artist. Unlike most of her contemporaries, she was molded by a European past and an American present. Stettheimer was one of the few American artists privileged to live in and be part of prewar European culture, and she is important as a carrier of that culture to a new location and a new century. Although American-born, her largely European upbringing allowed her to view her native country from a uniquely sophisticated and objective perspective. As a result, she was able to satirize the burgeoning newness of the modernist era to a far greater extent than many of her better-known contemporaries, such as Georgia O'Keeffe, Arthur Dove, and Charles Sheeler, who had limited exposure to European art. Paul Rosenfeld accurately described Stettheimer's work as "an expression of aspects of America, tinged with irony and merriment of a very perceptive and very detached observer."[4]

After returning to New York, Stettheimer became a principle member of the "jazz" age, the first generation to consciously break away from traditional strategies for living and categories of art making. Like many modernists, Stettheimer spent her life on the fringe, never feeling at home anywhere. Her position as a wealthy German-Jewish woman with no intention of selling her work ensured that she remained an outsider. Over time she used that status to her advantage in her painting and design, mixing imagery specific to her social circle and era with references to popular culture and filtering them through her highly idiosyncratic vision. Unlike many other contemporary women in her situation (including her sisters), Stettheimer was unwilling to settle for a life of luxurious eccentricity and frivolous socialization. Ettie once chided a young author who posthumously reviewed Stettheimer's work as dilettantish by referring him to the preface she had written to *Crystal Flowers* so that he could "be corrected in his view of Florine as an indolent party-goer."[5] Stettheimer consistently resisted that role, preferring instead to concentrate on her work, her *gloire.*

Stettheimer's paintings, poetry, and designs after 1917 have a distinctly modern flavor. With the combination of blithe naïveté and audacity considered by Europeans such as Bing so characteristically "American," she played in the history of art, using it as a base as well as a foil against which to create a new kind of art that reflects concerns unique to the first decades of the twentieth century, such as relativity and the growing consumer culture. Stettheimer shared with many of her contemporaries a desire to take things apart and start over. This meant questioning the most basic assumptions about color, perspective, chronology, form, and subject matter—the traditional grammars of painting and narrative.

Throughout her work, Stettheimer retained the asymmetrical structure and biting satire of the rococo revival, the bright, pure colors of Matisse, the linear decorative elements of Persian miniatures, and the theatricality and contextual integration of the Ballets Russes. Yet stylistically, in creating her mature style, she incorporated aspects of various contemporary art theories into her vision and retraced her art to its childhood origins in order to make new work in a new way. Technically, Stettheimer was highly experimental, often to the detriment of her works' longevity. During her lifetime, she tried her hand at many styles, palettes, and techniques, and she worked in a variety of media—wood and plaster (for furniture and frames), traditional and modern materials for costumes and sets, and oil paint, watercolor, pen and ink, and graphite on canvas, paper, and board. In her paintings, she incorporated the diverse influences of jazz rhythm, African-American and "folk" cultures, thespian revues, film, and many other arenas of early twentieth-century popular culture.

In terms of subject matter, Stettheimer categorically refused to acknowledge the disastrous events of the time—the depression and the war. Unlike some of her contemporaries, Stettheimer was not a social realist, and these concerns, no matter how pressing, were apparently not palatable to her personal sensibility and aesthetic. Nonetheless, her work does re-

veal a clear and perceptive social consciousness about certain matters that few other artists chose to record. She was continually interested in difference as an aesthetic choice, without proselytization. A number of her most significant paintings, for example, include respectful and imaginative imagery of African and Native Americans, women, and homosexual men, all shown in attitudes of self-confidence and humor with little sense of exploitation.

Whatever its specific references, Stettheimer's work was always "of her time." As Ettie commented, "Florine was one of the fortunate beings who live in the present because they love the present . . . and she loved the present because she was always occupied with painting and she loved to paint."[6] Betty Burroughs, an art reviewer for the *New York Times*, observed:

> *Few artists can have had the serene good fortune of Florine Stettheimer. She painted exactly as she pleased. . . . Florine Stettheimer was in her way a genuine spokesman of her time. Her pictures . . . become social documents . . . she was impelled to paint the world as she saw it. In fact, as we examine her puckish commentary on the post World War I follies, we have an uneasy feeling. This may well be where we came in. It is possible to imagine the historians of the future turning their backs on the Time Capsule and noting instead the satiric comment (combined with real footnotes on the life and times that produced them) in Florine Stettheimer's Cathedral pictures.[7]*

Once one looks beyond the superficial features of Stettheimer's work, one detects her atemporal sense of narrative, colors "that mean themselves," irony, and a combination of realism, memory, and dream imagery. Although she drew extensively on earlier art, her compositions were not merely puzzles intended to be solved by viewers. Just as John Elderfield noted in regard to Matisse, the complex coded images in Stettheimer's paintings are integral to their meaning. By inviting viewers to recognize individual portraits and motifs within the paintings, the artist prolonged and reinforced viewers' sense of reverie and slow exploration of her works.[8]

In a memorial article for *Harper's Bazaar*, Carl Van Vechten remarked, "There have been few important women painters in the history of art. . . . Florine Stettheimer is one of the most distinctive of the lot. She was both the historian and the critic of her period and she goes a long way toward telling us how some of New York lived in those strange years after the First World War, telling us in brilliant colors and assured designs, telling us in painting that has few rivals in her day or ours."[9]

Perhaps the last words properly belong to Stettheimer's friend James Rosenberg, who, in a letter to William Milliken, then director of the Cleveland Museum of Art, commented:

> *I consider Miss Stettheimer's paintings as unique, distinguished and important. I cannot recall another living painter who, without descending to caricature or propaganda, has wit. . . . Her color, of course, is superb but her social comments, in those brilliant and beautiful canvases of hers, are like nothing else that I know of, a comment of the life and mores of her generation. That alone, I realize, would make her a clever illustrator but her work is not superficial. It is profound, and in terms of pigment, color, design, drawing has individuality and great direction. However it is not necessary for me to make these remarks. . . . Her place in American art is already established and I am confident will become increasingly important as the years go by.*[10]

NOTES

Beinecke Beinecke Rare Book and Manuscript Library, Yale University
Butler Butler Rare Book and Manuscript Library, Columbia University
CF Florine Stettheimer, *Crystal Flowers* (Privately printed, 1949)
Ransom Harry Ransom Humanities Research Center, University of Texas, Austin

PROLOGUE

1. There is some disagreement regarding the date of the boat excursion up the Hudson. Solomon remembers the date as October 14, 1948, exactly thirty-three years after the October 14 opening of Stettheimer's only one-person exhibition at Knoedler Gallery. On September 26, 1948, however, Ettie Stettheimer wrote to Carl Van Vechten, "Yesterday Joe and I drove to Nyack where we had engaged a motor launch and we rode out on a very beautiful silver & blue & green river . . . we strewed the ashes to the wind." For whatever reason, Ettie chose to scatter her sister's ashes at the end of September, a date bearing no relation to her sister's exhibition schedule.

2. Nancy Miller, quoted in Caroline Heilbrun, *Writing a Woman's Life* (New York: Ballantine Books, 1988), p. 44. Heilbrun describes the problems of narrating the working lives of women, particularly those like Stettheimer, whose "lives include risk and the desire for individual achievements in the public world, as well as, or in place of, marital love" (p. 50).

3. CF, P. 19.

4. David Batchelor, "Contested Space," in *Realism, Rationalism, Surrealism: Art between the Wars*, ed. Briony Fer, David Batchelor, and Paul

Wood (New Haven: Yale University Press, 1993), p. 19.

5. Ibid., pp. 17–19.

6. Henry McBride, *Florine Stettheimer* (New York: Museum of Modern Art, 1946), p. 13 (my italics).

7. According to Solomon, although he contracted for a biography of Stettheimer by Parker Tyler in 1963, members of the artist's family carefully edited the manuscript before it went to press.

8. *CF*, p. 42.

9. Modris Eksteins, *Rites of Spring: The Great War and the Birth of the Modern Age* (New York: Doubleday, 1984), p. 3.

10. Rosemary Betterton, ed., *Looking On: Images of Femininity in the Visual Arts and Media* (New York: Pandora, 1987), p. 6.

11. All of Stettheimer's extant diaries and correspondence are in the Beinecke Rare Book and Manuscript Library at Yale University, where they were donated, after the artist's death, by her sister Ettie and Solomon. The diaries come in various sizes and shapes and are not numbered. In many cases, a single diary can cover several years. In addition, because they were subjected to Ettie's scissors after Stettheimer's death, it is difficult to cite specific pages with any accuracy. In some

cases paragraphs were removed, in others entire groups of pages. A number of pages have come loose from their original binding and have been reconstructed, by subject matter and general topical or geographic similarity, by the author. I have attempted to note the dating of her diary entries as closely as possible. Unless cited from a specific letter, all direct quotations from the artist come from the Beinecke diaries. In addition, I have tried not to include statements attributed to the artist unless from primary sources during Stettheimer's lifetime or from close friends and intimates who knew her well and are generally reliable in the information they have provided.

12. See *Realism, Rationalism, Surrealism,* op. cit. Surprisingly, recent scholarship in modernist decorative arts—by Nancy Troy, Ken Silver, Briony Fer—appears far more willing to transcend limiting terminology and present the diversity of styles and concepts that fall under the "modernist" appellation than does that of art historians investigating painting and sculpture of the same period. That artists of the time did not feel themselves bound by specific interpretations of these terms is demonstrated by Nancy Troy's discussion of the Maison Cubiste of the Paris Salon of 1912, where such painters as Albert Gleizes and Marcel Duchamp (later close friends of the Stettheimers), Marie Laurencin, Jean Metzinger, Fernand Léger, and Jacques Villon all included work in the decorative ensemble of the Salon Bourgeois. See Nancy Troy, *Modernism and the Decorative Arts in France* (New Haven: Yale University Press, 1991), pp. 77–102.

13. Shari Benstock, *Women of the Left Bank, Paris, 1900–1940* (Austin: University of Texas Press, 1986), pp. 32–34.

CHAPTER ONE: ORIGINS

1. Among the families in this group were (italics denote those directly related to the Stettheimers by marriage): Loeb, Sach, *Guggenheim,* Schiff, *Seligman,* Speyer, Strauss, Warburg, Lewisohn, Lehman, *Goodhart,* Bache, Altschul, *Bernheimer,* Hallgarten, Heidelbach, Ickelheimer, Kahn, Kuhn, Thalmann, Ladenburg, Wertheim, Cahn, Bernhard, Sheftel, Mainzer, Stralem, *Neustadter,* Buttenwieser, Beers, Hellman, Hammerslough, Lilienthal, Morgenthau, Rosenwald, *Walter,* and Wolff. All except the Guggenheims (who came from German-speaking Switzerland) traced their origins to Germany, primarily Bavaria. Most of the men made their fortunes as merchants or bankers. There was a great deal of intermarriage within the "One Hundred"—several Seligmans married Walters, and several married Beers. The Seligmans also followed the Jewish practice of marrying widows to the deceased husband's next unmarried brother, whereby several women became double Seligmans—as did Florine Stettheimer's aunt Caroline. Stephen Birmingham, *Our Crowd* (New York: Harper and Row, 1967), pp. 4–15.

2. The Stettheimer-Seligman marriage was not a happy one. Joseph Seligman gave his son-in-law, Max, and Max's father, Jacob Stettheimer, positions in his New York store and changed its name to Seligman & Stettheimer Dry Goods Importers as a symbol of their acceptance into his family. The arrangement was uneasy, for the Stettheimer men resisted Seligman's efforts to enter the international banking field. At one point Max and Jacob threatened to cut Babette off from her Seligman relations unless Joseph maintained the dry-goods business. Seligman eventually agreed to give Jacob Stettheimer a large financial settlement, allowing him to establish his own importing business. Seligman then gave Max a position with the Seligman family firm in Frankfurt, Germany. By the 1860s, when Max's son Joseph Stettheimer married Rosetta Walter (Florine Stettheimer's parents), relations between the Stettheimer and Seligman families were strained.

3. There is no direct evidence to support this assumption. Joseph might, however, have traveled under an assumed name. The name Stettheimer is not listed among nineteenth-century ocean-liner passengers who entered Australia from the south-

ern Adelaide port region, but this does not preclude his having entered the country through another port. There is no Stettheimer listed in the current Adelaide or greater Sydney telephone directories, and no comprehensive directory exists for their nineteenth-century arrivals. I am grateful to Dr. Kevin Fewster, Director of Australia's National Maritime Museum, for this information.

4. Author's interview with Joseph Solomon, New York, January 1991.

5. Another Content daughter, Rosa, married James Seligman and had eight children, including Florette, who, after marrying Benjamin Guggenheim, became the mother of the art collector Peggy Guggenheim. Rosa Content was a highbred, violent-tempered beauty whose parents made it clear that she was marrying beneath her station but agreed to the match because Seligman was wealthy. Birmingham, op. cit., pp. 68–69.

6. The Ives portraits remain in the New York collection of a grandniece of the Stettheimers who also owns a large pastel painting of Israel Walter and a photograph of the eight Walter children.

7. Walter served as president of the local synagogue and of the foremost Jewish charity, the Montefiore Benevolent. He retired in 1859 and died in New York on December 9, 1866. *Encyclopedia of American Biography* (1937), s.v. "Walter, Josephine."

8. Parker Tyler, *Florine Stettheimer: A Life in Art* (New York: Farrar, Straus, 1963). p. 171.

9. Author's telephone interview with Jean Steinhardt, Florine's niece, April 1991. Steinhardt said that her father, Walter Stettheimer, once mentioned that there had been another Stettheimer child who was born prematurely and died. To date I have not found any confirmation.

10. Augusta Walter married and lived in California; Florine Walter died at age eighteen. Mildred, the fifth daughter, married the banker Sylvan Weil and lived in Paris. Relatives remember Mildred as nice, but the family disliked her

husband, feeling that he was unkind to his wife. They therefore referred to Weil by the nickname "Interim," which in Latin means "meanwhile," indicating both the nature of his treatment of his wife and the hope that it would not continue. Sophie, who followed Mildred, was extremely intelligent; she was well read in French and German and could recite pages of Molière from memory. She married Julius Beer, a highly successful tobacco entrepreneur. Their eldest daughter, Carolina, married E. R. A. Seligman, a professor of economics at Columbia University, who invented the theory of installment buying. Author's interview with various family members, 1986–90.

11. In addition to her own practice, Josephine served as physician to the Clara de Hirsch Home and the Neustadter Home for Convalescents, was the consulting physician at the Montefiore Home, and was the attending physician at the New York Infirmary and Hospital for Women, to whose board she was appointed upon her retirement. When the United States entered World War I, Dr. Walter organized a unit of woman doctors, with the permission of the War Department, for service overseas, but the detachment was never sent. After her death, it was learned that she had been an anonymous contributor to more than fifty charities. Through her will she left substantial bequests to her three youngest Stettheimer nieces. The *Encyclopedia of American Biography* notes that as one of the pioneering women physicians of the United States, Josephine Walter "pursued her chosen occupation . . . with such notable success and devotion as to establish a clear claim to profess eminence in her half-century of practice and to render far more simple the task of others members of her sex who desired to follow her in medicine or surgery." A *New York Times* editorial of August 31, 1949, cited Dr. Walter's warm humanity and generosity of spirit and the fact that she took great satisfaction in treating generations of women.

12. The eighth Walter daughter, Adele, married

two Seligman first cousins, David and Henry Seligman, thereby further cementing the Walter association with the wealthy New York family. Over the years, this association provided Florine and her sisters access to the many Seligman retreats, including the family's lodge camp on Lower Saranac Lake. Harvey H. Kaiser, *Great Camps of the Adirondacks* (Boston: Godine, 1986), pp. 135–37. During the last quarter of the nineteenth century, a group of wealthy Eastern families, including the Seligmans, Loebs, Guggenheims, Baches, and Kahns, had purchased land and built large resort camps along Saranac Lake. Many were Jewish, and although tolerated as financiers of industrial expansion, they were not readily welcomed in many of the resorts established by Gentiles. An incident of discrimination at Saratoga's Grand Union Hotel in 1877 between owner Henry Hilton and Joseph Seligman evolved into the first publicized case of anti-Semitism in America. As a result, many Adirondack resorts became blatantly anti-Semitic, while others became exclusively German-Jewish. While vacationing in the Seligman's lodge in 1904, Florine painted a watercolor of a boat-house on Saranac Lake in her sketchbook. The family continued to spend time at Saranac Lake through the 1920s. Addie Walter-Seligman was known for her parties held in her houses in Elberon, Palm Beach, and East 56th Street in New York. She died during the depression in 1934. As a testament to her wealth and taste for only the most elegant of things, her dinner plates (not including cups, saucers or soup bowls) brought $2,660.92 at the auction held after her death. Birmingham, op. cit., p. 349. Little is known about Florine's next aunt, Nina, so called since she was the "ninth" Walter child. In 1862, only nine years before her granddaughter Florine was born, Henrietta finally gave birth to a son, William I. Walter, her tenth child. Author's interview with Mrs. John D. Gordan, March 1991. Like his sister Josephine, and later his niece Ettie Stettheimer, William attended Columbia University, graduating in 1881. After graduation he traveled west to California, where he took a

position in his sister Caroline Neustadter's family cotton company. He returned to New York after a few years and married Florence Bernheimer and went to work in his father-in-law's cotton business. William suffered from glaucoma, which he believed was the result of hitting his head against the ceiling of a low car. Later in his life, therefore, he was driven through the streets of New York in a custom-built Pierce-Arrow that was tall enough for a man to stand in and had blackened windows and an annually replenished Packard engine. William remained close to his three New York Stettheimer nieces throughout his life.

13. *CF*, p. 60.

14. According to a letter written by Ettie to Henry McBride on August 10, 1946 (Stettheimer Papers, Beinecke), Florine and Ettie were born in Rochester, New York. The Rochester family home is the background for Stettheimer's *Portrait of My Mother*, now in the collection of the Museum of Modern Art. Neither I nor the Stettheimer's lawyer, Joseph Solomon, have been able to find any records indicating where or how long the Stettheimers lived in Rochester or exactly where Florine and Ettie were born. According to Ettie's letter, Stella and Carrie were born in New York City. There are few extant records indicating when Stella was born, but she appears to have been somewhat older than the other children. Solomon has suggested that Stella was born in 1867 and Walter in 1869, but neither he nor their families, apparently, have any proof of exactly where or when the two were born. An obituary for Walter Stettheimer, published in the *New York Times* on October 16, 1954, lists Walter's birth date as 1873, but there are apparently no records confirming this. Walter died in Atherton, California, and was listed as a former president of Neustadter Brothers and later of W. W. Stettheimer & Company in San Francisco. From Florine's paintings, Stella appears more than four years older than her artist sister (see the painting *Cathedrals of Broadway*, in which white-haired Stella is accompanied by her grown son and the russet-

haired Florine), but perhaps that is because unlike her three younger sisters she did not dye her hair as she grew older.

15. There are existing birth certificates for the three youngest girls. At some later date, however, either Carrie or Ettie altered the records so that they both appear to have been born in the same year, even though there were at least five years between them in age. The three youngest Stettheimer girls were named after members of the Walter family. Caroline (or Carrie) was named after Rosetta's eldest sister, Caroline Neustadter; Florine after a Walter daughter who died at an early age; and Henrietta (or Ettie) after Rosetta's mother, Henrietta Content Walter.

16. "Florine Stettheimer," *The New Yorker*, June 1946, p. 27.

17. On a typed draft of the poem (Beinecke) Ettie wrote, "M. [Mother] did not read German," and she crossed out the word "Grimms" (line 18), which Florine had inserted over the word "us" in pen. This evidence of Ettie's editing of Florine's poems is an example of Ettie controlling Florine's posthumous image.

18. Some of Stettheimer's biographers have speculated that Rosetta's brother William provided financial support to the Stettheimers after Joseph left, but as William was born in 1862, it is unlikely that he had the resources for several decades.

19. *CF*, p. 73.

20. Stettheimer's sketchbooks and all of her early works (pre-1916) were given by Joseph Solomon to Columbia University after her death. They are often undated and unpaginated, and many were edited by Ettie along with the correspondence. It is therefore not possible to cite specific references. The fortune-telling cards are stored, along with the sketchbook and early oils, in Columbia's Rare Book and Manuscript Library. A number of the later oil paintings which were also given to Columbia are stored in the Art Properties collections of the university under the guidance of Sally Weiner.

21. *CF*, p. 71.

22. Florine's sister Ettie also felt Maggie's influence on religious and moral matters. At age seven she was informed that, whereas up to now Maggie had been responsible to God for Ettie's behavior, Ettie would henceforth be responsible for herself, and that whether or not she did what was right was, as far as God and Maggie were concerned, her own affair. Ettie remembered being thrilled that her nurse felt her to be so independently responsible at such an early age, but at the same time noted that she did not in the least believe in Maggie's God because it was not the same God as her Mother's God—and while both gods seemed remarkable inventions on the part of the two most significant adults in her life, "neither [God] had on any occasion any real effect on me." Ettie Stettheimer, *Philosophy* (New York: Longrams, Green, 1917), pp. 104–5.

23. *CF*, p. 74.

24. Dorothy Dayton, "Before Designing Stage Settings She Painted Composer's Portrait," *New York Sun*, March 24, 1934. There is no evidence or record of Ettie and Carrie's early schooling or of whether they were also permitted to concentrate and specialize in any one area of endeavor as quickly and thoroughly as Florine.

25. A diagonal line can be drawn from Florine's name on an elaborately tufted chair at the right of the picture, through von Prieser's lorgnette, to her face, and then through the classical bust to Florine's portrait. The composition is thereby balanced, with the artist and a symbol of her teacher on one side and her teacher and a corresponding symbol of the artist on the other. By portraying herself as a child, the artist implied the proper European "distance" between herself and her mentor.

26. Modius Eksteins, *Rites of Spring: The Great War and the Birth of the Modern Age* (New York: Anchor Books, 1990), pp. 74–78.

27. *CF*, p. 74.

28. The Feuchwanger name was later shortened to Wanger. Stella and her husband had three children: Walter, a film producer in Hollywood; Henry, who married and worked in real estate; and Beatrice, a dancer with the Follies Bergère at St. Paul de Vance.

29. Tyler, op. cit., p. 19. In California, Walter Stettheimer married Florence Neustadter, the grandniece of his aunt Caroline Neustadter's two husbands. Walter had a passion for Scottish terriers, and it was only when his wife Florence put her foot down—"Either babies or dogs," she said—that he gave up raising the animals. He and Florence traveled to Japan for their honeymoon. They had two daughters: Barbara, who was born in 1903 and married Julius Ochs Adler; and Jean, who was born in 1906 and married Paul Warburg and then Lawrence Steinhardt. Jean currently lives in California and remembers her father as a remote, unemotional, conservative man who was shocked by his sisters' avant-garde lifestyle, including their friendships with artists and homosexual men. Author's interview with Jean Steinhardt, 1990.

30. Nancy Woloch, *Women and the American Experience* (New York: Knopf, 1984), pp. 276–77. Barnard College was established in 1889 as an affiliate of Columbia after that school's trustees vigorously rejected the admission of women.

31. The author thanks Steven Watson for bringing this handwritten inscription on the flyleaf of his copy of Stettheimer's memorial volume to my attention.

32. *Philosophy* was published by Longrens, Green & Company in 1917. Ettie dedicated the novel to her mother, Rosetta.

33. *CF*, p. 75.

34. Erica E. Goode and Betsy Wagner, in the article "Intimate Friendships" in the July 5, 1993, issue of *U.S. News & World Report*, noted that "every era clings to the belief that the way it views the world reflects not the influence of culture and location but the way the world is. In the most inti-

mate area of life . . . of what sexuality means and how it is expressed, such convictions gain particular force. . . . In women, a desire for higher education or an interest in a professional career was [often mistakenly] seen as a mark of lesbian tendencies" (pp. 49–52).

35. Tyler, op. cit., p. 93.

36. That the artist preferred the notion of romantic love to the realities of sexual relations can be seen in a notation in her diary of January 1914. On hearing that a *vicomte* and a married woman (*madame*) are going to live together at 7 Villa Said in Paris, Stettheimer observed in her diary, "I do not find French ways of doing things it disgusts me—it's too prosaic for a romantic love!" The author is grateful to Dr. Joy Moser, an art educator, for pointing out the comparison between the figures in Stettheimer's mature works and the attenuated, stiff, sexless, doll-like figures that are characteristic of the drawings of pre-adolescent girls. A common comment I hear when showing Stettheimer's work to women is that she "paints like a virgin."

37. In England, a series of legislative acts materially improved women's legal status: the Married Woman's Property Act of 1882 and the Guardianship of Infants Act of 1886. The World's Columbian Exposition of 1893 in Chicago included a Woman's Building, which was designed by women, who also created all of its sculptural and painted decorations and made all the works on exhibition. Elaine Showalter, *Sexual Anarchy: Gender and Culture at the Fin de Siècle* (London: Penguin Books, pp. 6–7). During the fin-de-siècle years, new forms of fiction developed emphasizing female experience and subjectivity, with the heroine as the center of narrative consciousness. The feminist author Mary Wilkins Freeman wrote numerous articles urging women not to bury their creative self but to stay independent: "A young writer should follow the safe course of writing only about those subjects she knows thoroughly and concerning which she trusts her own convictions. Above all, she must write in her own way, with no

dependence upon the work of another for aid and suggestions. *She should make her own patterns and found her own school."* Quoted from "What Women Can Earn," in Celia Asher, ed., *Between Women* (Boston: Beacon, 1984), pp. 187–93. Women novelists, seeking to create fates for their characters other than marriage or death, experimented with alternative fictional forms such as short stories, fantasies, allegories, fragments, and dream narratives, all of which would find their way into Stettheimer's mature work.

38. Marius Ary-Leblond, "Les Peintres de la Femme Nouvelle," in *La Revue* 39 (November 1, 1901), pp. 275–85, quoted in Deborah Leah Silverman, "Nature, Nobility and Neurology: The Ideological Origins of 'Art Nouveau' in France, 1889–1900" (Ph.D. diss., Princeton University, 1983), p. 129.

39. Before the 1890s women were considered old by their mid-thirties. In that decade, however, magazine and newspaper articles increasingly ran stories about the exciting, independent lives of "bachelor" women. Ardent feminist leaders such as Elizabeth Cady Stanton, Susan B. Anthony, and Frances Willard helped create alternative models for perceiving older women, while actresses such as Lilian Russell, Sarah Bernhardt, and Lilly Langtry helped lower the cultural prohibitions against women's attempting to look younger. As a result, middle- and upper-class women, such as the Stettheimers, began to dye their hair and use makeup to camouflage their age. Lois Banner, *American Beauty* (New York: Knopf, 1983), pp. 222–23.

40.Silverman, op. cit., pp. 129–33.

41. *The New Woman and the Victorian Novel* (London: Macmillan, 1978), pp. 1–3. In 1916 the popular American magazine *Vanity Fair* ran a series of articles enumerating the problems with marriage and poking fun at men. In one, a feminist turns down a marriage proposal, saying, "We now know that husband and wife are what marriage makes them—a dull, uninteresting, spiritless cou-

ple, usually victims of monotony and routine, slaves to domesticity. . . . Marriage will have to yield to feminism in the end." In September 1916, Ettore Marrone included in his *Vanity Fair* article this statement: "The small circle of a man's arm does not constitute the orbit of the world. When that circle is irrevocably closed a woman should be as charming and graceful as she was at twenty, but in a *new way*. A man's whisper of love is not all the poetry and music of the universe."

42. Nineteenth-century feminists attributed the growing surplus of unmarried women to the fact that women's traditional domestic roles were outmoded, and that social policies which prevented women from receiving the training and education to be self-sufficient were futile and self-defeating. Showalter, op. cit., pp. 18–21. As Showalter noted, George Gissing, the author of the 1891 novel *The Odd Woman*, defined his title in a letter to a friend as "'Les Femmes Superflues'—the women who are *odd* in the sense that they do not make a match; as we say 'an odd glove.'"

43. *CF*, p. 4.

44. Box 10, folder 178, Stettheimer Papers, Beinecke. On December 4, 1908, Ettie attended a woman suffrage meeting at Carnegie Hall held by the Inter-Urban Woman's Suffrage Council. Mrs. Philip Snowden addressed the group on "The Woman's Suffrage Movement in England." Ettie also attended a Votes for Women "Mass Meeting" at Carnegie Hall on November 17, 1909, called by the National Women's Suffrage Association. The speakers included the Reverend Anna H. Shaw, Professor Frances Squire Potter, Mrs. Harriet Stanton Blatch, and Mr. George Foster Peabody, president of the Voters League for Woman's Suffrage. According to their archived files, either Ettie or Florine kept a copy of an "American Women's News Bulletin" issue which noted the organization of a "Who's Who Among Women of the Nation." This indicates that one or the other of the women was considering including herself in the volume. Many years later, in 1952, Ettie contacted Mrs. Frederick Overbury, a former class-

mate who had assembled a major collection of books, manuscripts, and letters by women authors, including a number of first editions. Ettie donated a great many books from her own collection to Overbury, including her *Memorial Volume* and other works, all by women authors.

45. Elizabeth Janeway, "Susanna Moore and Ettie Stettheimer," *New York Times*, June 17, 1951. Years later, in a letter written about her heroine, Ettie overtly acknowledged the conscious, political nature of her unmarried status: "You know that I am a great feminist, and that I believe men and women have totally divergent emotions, love-emotions. I believe Susanna to be entirely normal, and that many women approximate her in instinct and taste, although few have lives which permit them to express their preference in action." Letter from Ettie to Carl Van Vechten, dated June 17, year unknown, Stettheimer Papers, Beinecke.

46. Tyler, op. cit., p. 11. See also Banner, op. cit., pp. 190–91, 222–23. In the mid-nineteenth century, by age thirty-five women could easily be grandmothers and most donned caps under which they tucked their hair, symbolically renouncing their sexuality. By the 1890s magazines were full of articles critical of this attitude, pointing out that men in their forties and fifties were still able to be social and professional leaders. In Paris and New York the term "bachelor girls" was coined to describe unmarried women of various ages. It was considered complimentary, reflecting society's acknowledgment that single women, like men, could live irresponsible, pleasure-filled lives.

47. The Art Student's League was founded by disgruntled students from the National Academy of Design, which had just indicated that it would have to fire its only salaried teacher, Lemuel Wilmarth, due to increasing financial problems. The students met and elected Wilmarth president of their new organization, rented rooms on Fifth Avenue and Sixteenth Street, and managed all aspects of the administration of their new organization, from cleaning floors to keeping the books. After the Academy rehired Wilmarth, the League

found among artists returning from Europe a number of superb instructors, including William Merrit Chase, Frank Duveneck, and Kenyon Cox, many of whom had been taught in major European ateliers.

48. The first was offered at the Pennsylvania Academy of Fine Arts, which had a women's life-drawing class since the 1860s but fired professor Thomas Eakins when he revealed a nude male model before his women students. As a result, most women aspiring to be painters were restricted to the less highly regarded fields of portraiture, genre, landscape, or still-life painting. Even at the League, however, life classes remained separated by gender, with the men's life classes in the mornings and the women's in the afternoons (it was not until the late 1920s and early 1930s that men and women joined in one life class). Usually women drew and painted only from female models, but Florine, apparently, had access to some male models in her life classes. In 1909 she commented at an Italian production of D'Annunzio's *Fedra* that while Teresa Funagalli Franchini was a fascinating actress with a wonderful voice, Gabriellion D'Annunzio, who played Ippolito, was also fascinating "for reason of his lack of clothing. He reminded me of my life class days—not that he was quite without clothing but his build is such that students love to draw."

49. Women were not able to compete for the coveted Prix de Rome or numerous other honors by which young male artists made their reputations. Carol Duncan, "Happy Mothers and Other New Ideas in French Art," *Art Bulletin* 55 (December 1973), pp. 570–83. For most women artists, the only model of independence and achievement was a male one. A woman who wanted independence had to reject the traditional women's role and, in the process, was often forced to reject traditional women as well. It was extremely difficult for women like Stettheimer, who lacked a close personal relationship with a male figure, whether father or husband, to gain access to the training and knowledge necessary to function as an artist.

As Linda Nochlin astutely noted, "For a woman to opt for a career at all, much less for a career in art, has required a certain unconventionality. . . . And it is only by adopting, however covertly, the "masculine" attributes of single-mindedness, concentration, tenaciousness, and absorption in ideas and craftsmanship for their own sake, that women have succeeded . . . in the world of art." As a result, many exceptional women tended to identify with like-minded men rather than with other women, seeing themselves as "honorary men." Linda Nochlin, "Why Have There Been No Great Women Artists?" in *Art and Sexual Politics,* ed. Thomas B. Hess and Elizabeth Baker (New York: Macmillan, 1971), pp. 1–10.

50. For discussions on the formation and difference between the German and French opposition between "classical" and "romantic" values and notions of modernism, see Batchelor, op. cit., pp. 77–85, and Nancy Troy, *Modernism and the Decorative Arts in France* (New Haven: Yale University Press, 1991), pp. 3–5, 8–101.

51. Diary entry, July 24, 1910. In 1913 Stettheimer visited the Japanese Exhibition in Paris, savored works by Utamaro and Hokusai (although she found the Hiroshiges disappointing), and identified a print in her own collection as by an eighteenth-century artist named Kunisada Utagawa.

52. Kenyon Cox, *The Classic Point of View* (New York: Charles Scribner's Sons, 1911), pp. 3–5. Cox came from Ohio and studied art in Paris, working in the studios of the French academicians Carolus-Duran and Alexandre Cabanal before matriculating at the Ecole des Beaux Arts, where he studied with Léon Gerôme from 1878 until the fall of 1882. Cox was known as an excellent draughtsman, particularly of the human figure.

CHAPTER TWO: INFLUENCE GATHERING

1. These actions were precipitated by economic and political rather than aesthetic motives. The French government was troubled that France's birth rate was falling while Germany's was doubling. It saw this trend as a harbinger of future problems and determined that the best means of reversing it was for Frenchwomen to reaffirm their traditional roles as nurturers and keepers of the home. In 1892, at the First Exhibition of the Arts of Women, Georges Berger, president of the French Central Union, declared that women were "the directors and protectors of the decorative arts." Berger assigned women the task of moving the French economy back to economic ascendancy and thus toward national salvation. Silverman, op cit., pp. 385–90. For further discussion, see Nancy Troy, *Modernism and the Decorative Arts in France* (New Haven: Yale University Press, 1991), pp. 2–102.

2. The primacy of the rococo was confirmed in the *Revue des Arts Décoratifs* in 1882 by a new cover design in which the title of the journal was surrounded by rococo cartouches composed of shells, vines, ribbons, and trellises. These motifs were also interspersed throughout the magazine to emphasize the integrated, feminine qualities of the style.

3. Silverman, op. cit., pp. 22–39, 303–15. *La Grande Dame, Revue de l'Elegance et des Arts,* vol. 1, 1893, pp. 3, 20–21, quoted in Silverman, op. cit., p. 502.

4. Stettheimer Collections, Butler , scrapbook 1. In addition to numerous drawings of English furniture styles and sketches of various symbols, this sketchbook contains a list of sixteenth-to-eighteenth-century artists from France and Italy who interested Stettheimer. In certain cases, she noted the dates the different artists arrived in Florence and their main commissions, and occasionally she commented on the colors in their palettes. In her diaries she took extensive notes on the origins of the rococo style in France and wrote down the time span of the German rococo, listed papal tombs, and drew a floor plan of a gothic cathedral. Although she was undoubtedly aware of the increasingly hostile competition between the French and German (*munichois*) decorative-arts movements following the Salon d'Automne of

1912, she moved freely among disparate styles as they appealed to her.

5. The cover was designed by Jean-Louis Forain. See Silverman, op. cit., pp. 495–500.

6. Stettheimer drew and signed the cover illustration for the catalogue of the Art Collection of the Fair in Aid of the Educational Alliance and Hebrew Technical Institute, an organization that Carrie supported through volunteer work. The fair was held at Madison Square Garden in December 1895. Copies of the catalogue are in the New York Public Library and in the Educational Alliance files of Yivo Institute for Jewish Research in New York.

7. Stettheimer's interest in folding screens may have been sparked by a lecture titled "Grèce et Japon," given by Edmond Pottier, curator of ancient ceramics at the Louvre on the occasion of an exhibition of Japanese woodcuts in 1890. Pottier's lecture was transcribed in *Gazette des Beaux-Arts*, ser. 3, vol. 4, no. 2 (August 1890), pp. 105–32. Although there is no evidence she did so, Stettheimer might have attended the lecture or the exhibition or have read the article.

8. That Stella is not included on the screen may indicate that she was no longer living near the family. In his fanciful biography of Stettheimer, Parker Tyler (op. cit., pp. 165–66) claimed that the theme of the screen was resurrective, as he saw parallels between its motifs and those of Etruscan funerary urns. He therefore declared that the echoing of canopies and stands in the screen indicates that Stettheimer anticipated that her greatest fame would be posthumous. There is little to support this statement in the screen itself. Its fragile, winding, asymmetrical composition is very much in keeping with the French eighteenth-century rococo style, which was revived in the late nineteenth century. As in many rococo screens, Stettheimer created a sense of balance by placing a typically decorative urn at the bottom of each panel and a canopy form at the top. But she varied the details on each to reflect the

differing personalities of the Stettheimer siblings.

9. Walter Stettheimer's daughter, Mrs. Julius Ochs Adler, formerly owned the large screen and, according to Tyler (op. cit., p. 142), testified that the portrait looked nothing like him. However, comparison of a photograph of Walter and his image on the screen demonstrates that the likeness is very good.

10. In an interview late in her life, after both her sisters had passed away, Ettie stated that Carrie had always wished to be a stage designer. There is no evidence of this interest, beyond the dollhouse Carrie spent her life creating, and it is likely that this remark was another attempt by Ettie to posthumously control the stories and memories of her two sisters. Given the outcry when Florine did finally obtain some publicity as the designer of *Four Saints in Three Acts,* it is unlikely that the family would have welcomed two of its members practicing such a public profession. Whatever her inner longings might have been, Carrie undertook the management of the household and never actively pursued a profession.

11. According to museum conservators who have worked on Stettheimer's mature paintings, the artist used lead white on top of the sized canvases. Over that she added a calcium carbonate ground. Her paint layers inevitably included a layer of zinc or "china white" paint, on top of which she added oil colors. Over time, the upper layers of color have often "bled" into the china white underpaint, causing a loss of detail. According to notes in Stettheimer's diaries, she drew with charcoal or lead pencil on top of the white ground and then "stained in" the colors of her composition. Then she proceeded to add thick layers of color, often not waiting until they dried properly. On occasion, she painted with pen and ink to add details. Over time, the ink has often flaked and disappeared on many of the paintings.

12. Silverman, op. cit., pp. 143–58, 187–90. The prominent French neurologist Jean-Martin Charcot (with whom Florine's Aunt Jo appren-

ticed) was noted for his explorations of the visual dimension of thought processes, with emphasis on the role images play in suggestion, dreams, and hypnotism. In the 1890s Charcot fashioned his Parisian home as a space for the "exteriorization of dreams," and he spent his free time designing furniture and objets d'art for placement in his house. As was the case with Stettheimer's screens, Charcot aimed not for accurate historical location but for subjective transformation, stamping the objects in his collection with personal memory and the self-reflexive sense of his own personality.

13. Troy, op. cit., pp. 15–35. An interesting comparison can be made between Stettheimer and Bing. Both came from German-Jewish backgrounds and spent a great deal of time in Paris. Like Bing's early incarnation of his Art Nouveau gallery, Stettheimer did not feel compelled to remain bound or limited by national stylistic boundaries in designing her decorative schemes.

14. Marcel Proust, *Within a Budding Grove* (New York: Vintage, 1970), pp. 83, 178, 237.

15. According to a later diary entry, although Florine initiated this "flirtation" with Dr. Ricci, he ended up corresponding with Ettie. Unfortunately, Ettie's editing of the diaries prevents us from knowing either sister's reaction to this state of affairs.

16. The Stettheimers took advantage of the remarkable quality of available performances and performers. Between 1906 and 1910, in London, Munich, and New York, they saw such diverse talents as Ignac Paderewsky, Mary Garden, Kathryn Kidder, Wassily Safonoff, Douglas Fairbanks, Ruth St. Denis, Isadora Duncan, and Margaret Anglin, as well as Walter Damrosch conducting with Sergey Rachmaninoff as soloist, and Arturo Toscanini conducting with Enrico Caruso as soloist—to name only a few. The variety is very broad, ranging from the Ziegfield Follies to a performance of Goethe's *Iphigenia in Tauris*. But the most startling point is the high number of performances dealing with women's issues.

17. *CF*, p. 59.

18. Ibid., p. 46. Once again, it is unclear whether the subtle alterations between the printed version of the poem and the handwritten and typed versions in Beinecke are Florine's or Ettie's doing.

19. The author thanks Wanda Corn for her insight into the modernity of Stettheimer's poetry.

20. Nochlin, "Florine Stettheimer," op. cit., pp. 67–69.

21. *CF*, p. 79. Under the word "Meister" Florine wrote "In black swallow tail suit," but she crossed that line out and added the current stanza in blue ink.

22. Quoted by Henry McBride as being from a diary during the early Munich student days, but the record is undated.

23. Florine's attitude toward children is unclear. They are invisible in her diaries and, except for images of her siblings and herself, small children appear only as props in Stettheimer's paintings. In 1901 she wrote to her mother from Paris, where she and her her sister Carrie were enjoying themselves at a local wedding. Among the items sold at booths near the wedding party were dolls "in shapelessness of babies," which were presented to the bride with a wink by gentleman of the bridal party. "I bought a bebe also as a souvenir of the afternoon but had it wrapped up in brown paper to hide it from the French jubilee—but that was my mistake and I realized it when walking up the steps of the Park Royal station, I saw at the head two customs officers waiting for victims. Imagine me undoing the wrapping gently and the officers saying 'à, la, la mademoiselle!!'"

24. *CF*, p. 58.

25. This poem was handwritten by Florine in blue ink. Later Ettie annotated it with her own comments: "Can't place 'JS.'—sounds like Sides? Don't like this p[oem]." The poem could also refer to Gerald Sides, an art collector and later acquaintance of the Stettheimers. James Loeb grew up in

New York, studying Egyptology at Harvard University before joining the firm of Kuhn, Loeb & Company in Manhattan, at his father's insistence. He disliked banking and fell in love with a Gentile girl from a prominent New York family. The religious differences caused the families to prevent their marriage, and Loeb suffered a nervous breakdown. He went abroad to recover and consulted Freud, with whom he lived for a number of years. Eventually, with a generous settlement from his father, Loeb settled in Germany and built a large estate in Murnau, near Munich, which is where Stettheimer met him. He amassed a fine collection of ancient art and rare books. After many years he married Toni Hambuchen, his nurse and companion. He died, a virtual recluse, in 1933. Birmingham, op. cit., p. 253.

26. According to Ettie, the work was first a drawing intended as a bookplate and then a painting. She noted, "I admired [it] greatly in those days."

27. It is not clear whether she was referring to her sister or to the well-known painting of Medusa by Caravaggio, but she was clear in her opinion that Medusa should be bad-tempered: on May 22, 1909, she noted that she was beginning to truly admire her painting since she had seen so many good-natured Medusas in Italy. Marcel Duchamp later reproduced the painting in an issue of *View* magazine (series 5, no. 1).

28. Letter of August 23, 1948, Ettie Stettheimer, Beinecke.

29. Stettheimer loved the island of Capri, but other places often failed to live up to her expectations. When visiting Versailles she complained, "For years I have wanted to come to Versailles for a short time to live and sketch in the park. I am here but everything is so different from the way I want it to be . . . the park was full of hoi poloi who were camping out all over everything and a beast of a waiter served us a poor meal."

30. *CF*, p. 77.

31. The faun and its pose later resurfaced in several of Stettheimer's paintings and had private meaning for the artist.

32. *CF*, p. 78.

33. Ettie Stettheimer's introduction to *CF*.

34. Among Stettheimer's private papers at Columbia University are photographs of Michelangelo's *David*, a medieval knight in armor, and various marble and bronze Greek statues of nude men.

35. The Stettheimer diary entry is from January 1913. Among Stettheimer's papers at Columbia is a reproduction taken from a contemporary German newspaper of an Englishwoman, Mrs. John Lavern, posing in the costume of Spring from Botticelli's painting (fig. 36).

36. Lionello Venturi, *Sandro Botticelli* (Oxford: Oxford University Press, 1957), pp. 9–12.

37. The heavily damaged and unstretched portrait was discovered by the author in a box of works labeled "estate paintings, not by Florine Stettheimer" at Columbia University. I am very grateful to Sally Wiener and Larry Soucy of Columbia Art Properties for their patience and generous support throughout this project and for allowing me to explore the stacks and boxes of the Stettheimer bequest.

38. See particularly the head of Pallas in the painting *Pallas and the Centaur*, the detailed portraits in the background of the *Adoration of the Magi*, and various individual portraits.

39. The Botticelli painting hangs in the Uffizi Gallery in Florence and so was well known to Stettheimer.

40. See the Statue of Liberty in *New York* and the figure of George Washington in *Cathedrals of Wall Street*.

41. In the diary of that year she included reproductions of paintings by Daumier (*In the Theater*), Van Gogh (*Die Beiden Erdarbeiter, Still Life, Père Tanguy*), and Goya (*Still Life with Cut Melon*). Stettheimer Collections, Butler.

42. Stettheimer is referring to Manet's painting of

Nina de Callais, titled *Lady with Fans,* which was painted in 1873 and is in the collection of the Musée d'Orsay in Paris. The side of Mme. Callais's face is pulled upward by the force of her palm.

43. Stettheimer's friend, the writer Carl Van Vechten, later described his first reaction to the Moreau museum as "room after room of unicorns, Messalinas, muses, magi, Salomes, sphinxes, argonauts, centaurs, mystic flowers, chimerae, Semeles, hydras, Magdalens, griffins, Circes, ticpolongas and crusaders." Carl Van Vechten, *Peter Whiffle, His Life and Works* (New York: Knopf, 1922), p. 57.

44. David Batchelor, "'This Liberty and This Order': Art in France after the First World War," in *Realism, Rationalism, Surrealism: Art between the Wars* (New Haven: Yale University Press, 1993), pp. 3–4.

45. *CF,* p. 76. Another version of this poem was handwritten by the artist in brown ink. It differs in its choice of subjects for the paintings described in the poem so that "Primitive Saints, Renaissance Prophets, Even Gothic Madonnas" are used instead of cows and sheep, but the essential mood and attitude of the poem is the same.

46. Regnault was considered a romantic hero, having been killed in 1871 when, disregarding orders, he left his military unit to save his mother during the siege of Paris. The painting in question, titled *Salome,* was one of the few large-scale paintings by Regnault, who had originally sold the work to an art dealer for $1,000. The painting was subsequently purchased from the gallery by Marquise Carcano for $2,000. On May 30, 1912, Carcano put the *Salome* canvas, now officially assessed at $100,000, up for sale at auction, causing a huge outpouring of concern over the potential loss of a "national treasure." Baron Henri Rothschild and others tried to raise enough money to buy the painting for the Louvre, but their efforts failed. On the day of the sale, the New York art dealer Roland Knoedler successfully bid $96,000

for the painting, but he gave the French government two months to raise an equal amount and so keep the painting. This effort also failed, and there was great controversy in the media about the "American Peril to French Art."

47. When the painting was first shown in the Salon of 1870, the critic Camille Lemonnier made comparisons between its sitter and Parisian *courtisanes.* T. J. Clark, *The Painting of Modern Life* (Princeton: Princeton University Press, 1984), p. 115.

48. Quoted in Robert Craft, "Stravinsky's Russian Letters," *New York Review of Books,* February 21, 1974, p. 17; Edward Marsh, *Rupert Brooke* (Toronto, 1918), p. 75.

49. Diaghilev's ballets were designed with sets and costumes by premier Russian artists such as Leon Bakst, Alexandre Benois, and Nicolas Roerich, who used bright, provocative colors and lavish Georgian silk to create sets that were an integral part of the spectacle. Michel Fokine's choreography called for the new energy and physical abilities of young dancers such as Nijinsky, Pavlova, and Karsavina. The ballet themes were exotic, usually Russian or oriental; and the music, by such composers as Claude Debussy and Igor Stravinsky, was not, as in the past, a means to relate movement to sound but to express sound through movement. Eksteins, op. cit., pp. 29–45, and Richard Shead, *Ballets Russes* (Secaucus, N.J.: Wellfleet Press, 1989), pp. 31–33.

50. Shead, op. cit., pp. 56–57.

51. Eksteins, op. cit., pp. 27–29.

52. The only extant photographs of the production were taken by Baron de Meyer, who later became a leading member of the Stettheimers' most intimate circle of friends.

53. Jiri Mucha, *Alphonse Mucha: His Life and Art* (New York: Rizzoli, 1989), pp. 35–42.

54. *CF,* p. 77.

55. Eksteins, op. cit., p. 50.

56. T. J. Clark has pointed out that even in 1872 respectable classes came "in droves" to such Parisian street cafés as Les Ambassadeurs and mingled with the lower classes or at least sat and listened to the same songs and music. Clark, op. cit., p. 212. It is not unlikely that Stettheimer knew that Degas had located a series of pastels at Les Ambassadeurs, where he portrayed singers like Thérésa performing to a mixed crowd.

57. In the original draft, each character was intended to sing a song when entering to explain her or his role. In one set of notes for the ballet, Stettheimer included the following lyrics to be sung by Orpheus to Georgette: "Lovely one / where do you hail / charmed lyre / do not fail— Loverly one / you come so late / the wasted ages / I waited for fate / I and my lyre / wandering on earth / for the divine fire / to give you birth / and how do those who love you call you." The lyrics are rather naive and simplistic, as are the lyrics she was to devise when she designed her ballet on the Pocohantas theme twenty-five years later. Since ballet contains few sung lines, it is possible that this was more a means of conceptualizing the action than something she intended the characters to sing.

58. Mucha, op. cit., pp. 59–60. The minister of the interior, Dupuy, who ordered out the police, was probably overreacting to a series of anarchist bombings and a wave of assassination attempts. In addition, one of the organizers of the ball, Alphonse Mucha, chose to dress up as the would-be dictator of France, General Boulanger, complete with red paint dripping down his temple, signifying his suicide a few years earlier. Boulanger had been a very popular man who was Germanophobic and committed to recovering Strasbourg from the Germans. When Mucha as Boulanger rode through the procession in an open carriage, the street crowds grew riotous, falling in behind the carriage and singing seditious Boulangist songs.

59. Box 8, folder 142, Stettheimer Papers, Beinecke. Among others, she took notes on Allan

Manquand's *Greek Architecture*, Ernest Gardiner's *Greek Athletic Sports and Festivals*, Lanciani's *Destruction of Ancient Rome*, H. H. J. Greenidge's *Roman Public Life*, W. Warde Fowler's *Roman Festivals*, and Walter Lowrie's *Monuments of the Early Church*.

60. Orpheus was a favorite subject for a number of European symbolist painters and poets as well as for Friedrich Nietzsche, Sigmund Freud, and the Surrealists, who viewed his descent to Hades to retrieve Eurydice as a descent into his own unconscious. The text of Stettheimer's ballet bears some similarity to the myth. Orpheus, although accompanied by Euridyce, who ends up dancing with the Apache, himself dances suggestively with the temporarily transformed Georgette. As in the myth, her transformation disappears with the first rays of the sun, and she returns to her position in society with her father. Orpheus and the rest of the revelers then depart.

61. Unfortunately, no photographs by the Stettheimers survive, but Florine mentions taking photographs several times in her travels, and it is known that she used prints in making her portraits of friends in the 1920s. From 1895 to 1914, while traveling in Europe, she apparently amassed a respectable collection of *vues d'optiques*, and a list of the individual locations is handwritten on the back pages of her 1913 diary.

62. A listing of titles on the back of her 1913 diary gives an idea of the eclectic nature of Stettheimer's reading: Arnold Bennett, Leo Tolstoy, Julius Meier-Graefe, Arthur Schnitzler, August Strindberg, Edith Wharton, Robert Herrick, H. G. Wells, Otto Ernst, Jack London, Romain Rolland, Henry James, Thomas Hardy, Edmont Kelly (on twentieth-century socialism), Olive Schreiver (on women and labor), George Moore, Julia France, Winston Churchill, and Bret Harte, among others.

63. Tyler, op. cit., pp. 17–28.

64. Matthew Lorden, "Review of the Society of Independent Artists," in *The World Magazine*,

March 20, 1921. The article was accompanied by a reproduction of Stettheimer's painting *The Picnic at Bedford Hills*.

CHAPTER THREE: RETURN TO NEW YORK, 1914–1916

1. CF, p. 81.

2. When Bergson came to America to lecture at Columbia University in February 1913, the streets were clogged with would-be attendees, and one lady fainted in the crush at the lecture-room door. In the United States, Bergson's book *Creative Evolution* sold in two years half as many copies as it had sold in France in fifteen years. Copies of his theories were sold in popular New York department stores. May, op. cit., pp. 228–29.

3. Arlette Klaric, "Arthur G. Dove's Abstract Style of 1912: Dimensions of the Decorative and Bergsonian Realities," Ph.D. diss., University of Wisconsin, Madison, 1982.

4. Ibid., pp. 370–71.

5. This quotation was taken from the text of a lecture by Karl Ann Marling on roadside colossi delivered to the art-history department at Yale University on April 25, 1984. Dr. Marling did not refer specifically to the Stettheimer painting, but the description is particularly apt given the recent situation of Stettheimer's life.

6. *CF*, p. 79.

7. This was not an unusual move. As early as 1895 Siegfried Bing, who had been charged by the French director of the Beaux-Arts to visit America and review the state of the arts there, wrote, "Suddenly America, which only shortly before had experienced its first artistic stirrings, was to bear proof of singular powers of initiative and youthful vigor." Bing believed that the genius of Americans was their ability to look back through the history of art and reshape and transpose art from ancient civilizations into a native American idiom. He stated, "The most admirable qualities of the Americans were their capacity to adapt artistic forms from the past to new needs, to modern con-

ceptions." Quoted in Silverman, op. cit., pp. 442–46.

8. Although the number was never confirmed, the exhibition was said to have had an attendance of one hundred thousand in New York. Eventually more than 250,000 people paid to see the exhibition, and three hundred paintings were sold, including practically all of the thirty cubist paintings. Milton Brown, *American Painting from the Armory Show to the Depression* (Princeton, N.J.: Princeton University Press, 1955), p. 50. The exhibition also had a major impact on the New York art market: "In the five years following the Armory Show, thirty-four galleries and organizations mounted more than 250 shows of European and American modern art." Judith Zilcher, "The Armory Show and Its Aftermath," in the High Museum's *The Advent of Modernism* (Atlanta, 1986), p. 31. A special number of *Camera Work*, published in August 1912, included the publication of two articles by Gertrude Stein on Matisse and Picasso. In the editorial to the issue, Alfred Stieglitz himself described Post-Impressionism as a movement at odds with familiar traditions and forms of self-expression, and as involving analogies rather than accepted facts. National coverage of the event made the term *post-impressionism* a household word, following its coinage by the English art critic Roger Fry, who used it to refer to all painting done between 1886 and 1910. Reporters subsequently used the terms *post-impressionism, cubism,* and *futurism* interchangeably, creating a confusion that was never entirely remedied in the popular press.

9. Included in the exhibition were more than 120 works by Cézanne; and Gauguin, Van Gogh, and Matisse were each represented by small solo exhibitions within the larger show. Press coverage of the exhibition was unprecedented, including critics reviling the European modernists and making fun of their works. Among the artists who spoke against the exhibition was Stettheimer's former teacher, Kenyon Cox. At a meeting in Philadelphia, Cox denounced modernism as

"cheap notoriety" and "dangerous anarchistic thought," while William Merrit Chase, another Art Students' League teacher and well-respected artist, called Matisse a "charlatan and faker."

10. Stettheimer's only extant reference to cubism is in a poem under the heading "Nursery Rhythms" in *CF:*

> *Young Artist Rat*
> *In a garret sat*
> *Caught in a trap*
> *"I'm a modern chap*
> *For the funnel*
> *I took for a Tunnel*
> *And the dead fish*
> *It ought to smell delish*
> *I shall paint in cubes*
> *And call it—Prudes*
> *And add a rotten banana*
> *In my very best manner."*

11. The American art theoretician Arthur Wesley Dow's book *Composition* was published in 1899. Dow particularly encouraged decorative treatment in the fine arts and not simply in the design of utilitarian objects, a point of view suggested several decades earlier in France with the repositioning of the decorative arts. As a result of Dow's influential writing and teaching, a number of avant-garde artists turned to ornamental and decorative traditions such as oriental, tribal, and folk art rather than past Western painting and sculpture in the search for alternatives to academic illusionism.

12. Gil Perry, "Primitivism and the 'Modern,'" in *Primitivism, Cubism, Abstraction: The Early Twentieth Century* (New Haven: Yale University Press in association with The Open University, 1993), pp. 50–53. According to Perry, by 1906 the term *decorative* had become unstable and was used both to denote a work's modernity and, in a more pejorative sense, to signify the ornamentation of the applied arts. For a further discussion of the development of the concept of decorative landscape vis-à-vis the Fauve painters, see Robert Benjamin, "Fauves in the Landscape of Criticism:

Metaphor and Scandal at the Salon," in *The Fauve Landscape* (London: Royal Academy, 1991), p. 254. *Luxe, calme et volupté* was exhibited by Matisse at the Salon des Indépendents of 1905, which included a number of Fauvist works and small retrospective exhibitions of Seurat and Van Gogh.

13. Jack Flam, *Matisse: The Man and His Art* (Ithaca, N.Y.: Cornell University Press, 1986), pp. 119–20.

14. Ultimately these paintings probably refer back to Cézanne's well-known *Three Bathers* of 1870, in which three nude women gather in a grove. This painting was undoubtedly known to both Matisse and to Stettheimer, although there is no direct reference in her diaries or correspondence to either Cézanne nor Matisse's specific works.

15. A key figure in the dissemination of the work of Matisse was Leo Stein, an influential member of Parisian avant-garde circles between 1905 and 1913 and a close friend of the Stettheimers. Although it is not known when and where they became acquainted, by 1916 Stein was writing intimate and chiding letters to Ettie Stettheimer, and he was an occasional member of the Stettheimer's New York social evenings. In 1916 Stein wrote to Ettie at Lake Saranac and addressed her as "Consolatrice Carissima Mia." In 1917 he wrote her a number of letters at her 401 West End Avenue house, addressing her as "Chere Henrie" and "My dear Romantic Lady" and commenting on her newly published novel, *Philosophy.* Correspondence from the Stettheimer Papers, Beinecke.

16. In 1905 the Fauves held their first exhibition at the Société du Salon d'Automne, and retrospectives of Seurat and Van Gogh were staged at that year's Salon des Indépendants, with Matisse as chairman of the hanging committee. This was the same exhibition in which the Russian-born artist Wassily Kandinsky exhibited a series of woodcuts and linocut prints whose themes were derived from Russian folktales and fables.

17. Review of Knoedler's 1916 exhibition of paintings by Florine Stettheimer. *New York Evening Post*, October 21, 1916. Clipping from Stettheimer scrapbook, Columbia University, Stettheimer Archives.

18. Another possibly influential work in this genre is Cézanne's *Still life with Plaster Cupid*.

19. Although there is no evidence beyond the remarkable stylistic similarity tying the work of Dove with that of Stettheimer, Dove included his painting *The Lobster* in the Salon d'Automne in Paris of 1908 and again in an exhibition the next year in Stieglitz's gallery in New York.

20. Parker Tyler fancifully attributed the illusionism and lack of weightlessness in these floral still lifes to the fact that Stettheimer "is a woman and so secure in ignoring the laws of space." Parker Tyler, "Stettheimer, Leonid, Tanguy," *View* 7 (December 1946), pp. 186–89.

21. Henry McBride, *Florine Stettheimer* (New York: MOMA, 1946), p. 15. McBride continued to note that Stettheimer's flowers "were, as they were to Redon, merely points of departure—botanical but also unearthly. Like Redon they are imbued with the occult, reaching out of this world to the other—Florine's flowers have more actual freedom than Redon [whom McBride never heard her mention]." The painting in the illustration referred to herein remained in the Wanger family until the early 1980s, when it was sold to a private collector. Comparison with an early archival photograph of the painting demonstrates that Stettheimer substantially altered the background and vase of the painting—a practice she continued throughout these years, particularly with the flower paintings. Originally the vase was simple, having rounded edges and made of earthenware with a blue design. It rested on a flat wood table against a plain wall. In the current version the flowers remain the same, but the porcelain vase is not white and ends in a scalloped, almost lacy base. The table has been eliminated, and small partial curtains are now visible on both sides of the top of the painting.

22. This poem, which was handwritten by the artist in ink, was never published. It is amusing to speculate that the reference to attributes may refer to the work of her friend, Georgia O'Keeffe, whose flower paintings were marketed by Stieglitz and were often viewed by contemporary critics as having sexual overtones and as resembling genitals.

23. Also hanging was what Van Vechten refers to as "one of her paintings of a reclining maiden over the mantelpiece," which probably refers to a self-portrait based on Manet's *Olympia*. In 1946 Van Vechten wrote to Ettie asking her for her recollections in response to a number of questions for an article he was writing titled "The World of Florine Stettheimer." This information was culled from their correspondence and the article itself.

24. Carl Van Vechten, "The World of Florine Stettheimer," typewritten drafts 1–4, Stettheimer Papers, Beinecke. The finished article appeared in *Harper's Bazaar*, October 1946, p. 238.

25. This poem was never published; Ettie noted on the manuscript, "I don't like this one." It was written in August, while Stettheimer was at Monmouth Beach (probably in the late 1900s or early 1920s).

26. Letter to Van Vechten from Ettie Stettheimer, July 27, 1946. Ettie noted, "I think she painted them [flowers] as no one has before or since. And they never seem to get reproduced."

27. On a title page of a copy of the 1917 edition of Ettie's novel Philosophy: An Autobiographical Fragment, located in Beinecke, the photographer Edward Steichen crossed out the title and wrote in its place, "Flagellation, Being the wonderful tale of an apple and a hickory nut as told with much intelligence [?]ness and charm by the hickory nutte." On the next torn-out blank page he wrote, "'Get thee to a nunnery—we are arrant knaves, all; believe none of us: go thy ways to a nunnery.' Thaddeus." Emily James Putnam wrote to Ettie about her novel, "I laugh outright as I read it and my family ask for the cause; but I tell them they must read it for themselves and there is now a

waiting list. It pleases me as a feminist, for women don't often write like that; and it pleases me as an American, for Americans never do." Letter, March 16, 1917.

28. From the few black and white photographs of Stettheimer it is impossible to determine the exact color of her hair and whether or not she dyed it as she aged. In all of her self-portraits, however, she portrayed herself having red hair—varying from the bright orange of this painting to the dark auburn of later images. As Lois Banner has indicated, red hair was for centuries the emblem of deviance and evil and was popularly believed to mark a troublesome, passionate personality. The hair color came into vogue during the first decades of the twentieth century and was popular with everyone from musical-comedy performers to society women. It was alleged that some wealthy American women went all the way to Rome to obtain a particular shade of red that an Italian hairdresser had discovered. According to Banner (op. cit., pp. 176–77), the popularity of Titian-colored hair dates from the 1890s and symbolized the "new sensuality of the end-of-the-century era." Banner, op. cit., pp. 176–77. In the 1940s, Carl Van Vechten asked Ettie in a letter about a red wig he was told she occasionally wore to parties. Ettie replied, "As for the wig: it was an auburn Bobb & I got it for a special dress-up something & for some years wore it on an average of once a year at home chiefly if I thought some party promised to be dull and needed enlivening. Probably that is why you never saw it." Letter of August 9, 1946, Beinecke.

29. The subtle changes in this and other paintings from this period became apparent when comparing the works as they now exist with photographs of the paintings taken during Stettheimer's lifetime by Peter Juley & Sons, professional photographers, and by comparing contemporary descriptions of the works in the Knoedler exhibition with their current appearance.

30. Clark, op. cit., p. 79. Stettheimer might have been aware of the poem by Zacharie Astruc which

Manet placed under the painting of *Olympia* when it was displayed at the Salon, and she may have purposely chosen the composition and attitude of her sitter with the poem as well as Manet's painting in mind. Stettheimer's nude's facial expression illustrates Astruc's poem, in which "When weary of dreaming, Olympia wakes." Stettheimer was herself at a turning point in her work when completing this painting, and was in the process of "waking" a new, mature style of her own.

31. Quoted in Gill Saunders, *The Nude: A New Perspective* (London: Herbert Press, 1989), p. 21.

32. *CF*, p. 78.

33. John Berger, *Ways of Seeing* (London: Penguin, 1972), pp. 47–54.

34. In a pair of sketches Stettheimer painted for her large nude *Self-Portrait*, it is apparent that she experimented with placing the sitter's arms both behind her head, in a posture emulating Goya's work, and resting on one elbow, which is what she finally chose to paint (see fig. 71).

35. Carl Van Vechten, in his foreword to Parker Tyler's biography, offered a rare, if incorrect, description of the work: "No one who saw it can ever forget the huge Robert Henri period classical nude she always kept hanging on the most prominent wall of her studio. This nude, which informed observers how conventionally she had begun to paint, was dazzlingly at variance with the brilliant contemporary fantasies which, with the aide of a palette knife, she had imagined on canvas, fancies as evanescent as dew and as exquisite as the dawn" (p. xii). In fact, the painting does not resemble Robert Henri's style, nor is it particularly "conventional" in its palette or its handling of the subject matter. It does, however use the same pose as a contemporary work by Henri, *Portrait of Gertrude Vanderbilt Whitney*. Stettheimer's ironic humor leads me to speculate that this comparison was intended by her, although none of her friends noticed the resemblance between the facial features of the nude and several of her contemporary

self-portraits.

36. Simone de Beauvoir, *The Second Sex* (London: Penguin, 1972), p. 175.

37. Banner, op. cit., pp. 207–8.

38. *CF*, p. 60.

39. T. J. Clark (op. cit., p. 111) quotes Flaubert in his correspondence of 1870: "Everything was false, false army, false politics, false literature, false credit, and even false *courtisanes*."

40. When the first dollhouse was offered in the raffle at the bazaar, it was won by Rosetta Stettheimer, who redonated it; it eventually brought between five hundred and one thousand dollars. A neighborhood carpenter built the $49^{1}/_{2}$ x 35 x $27^{1}/_{2}$ inch frame for Carrie's second dollhouse, stylized as an imposing mansion, complete with numerous rooms furnished in various styles popular in the 1920s, from Louis XV to contemporary with touches of Oriental and Pennsylvania German influence. The details that Carrie included in the dollhouse attest to her twenty-five years' work on the structure, which at her death was still unfinished. The dollhouse even has a formal art gallery, in which friends "competed for the honor of being represented." Although several of the works of art were added by Ettie after Carrie's death, the gallery includes miniature original works by Stettheimer friends Marcel Duchamp, Gaston Lachaise, Archipenko, Carl Sprinchorn, Albert Gleizes, and Albert Sterner. When, after Carrie's death, Ettie donated the still-unfinished dollhouse to the Museum of the City of New York, she emphatically stated that neither she nor Florine had had anything to do with its creation and that Carrie never consulted either of them in making the work. Nonetheless, in a letter of August 5, 1946, she wrote that *she*, not Carrie, had asked the Zorachs for works for the dollhouse and that after a "fuss" with Zorach, his statue was taken out. She also stated that Archipenko, who had earlier presented Carrie with a small bronze for the gallery, made a lovely drawing for the dollhouse after Carrie's death, at Ettie's suggestion.

41. The Stettheimer sisters had spent much of their early life traveling and staying in France, and Florine was known to read books on art and philosophy in French, so it is probable that this arrangement with Duchamp (who had received so much attention for his entry in the 1913 Armory show) was one created by the sisters in order to monetarily assist an artist whose company they enjoyed.

42. In one of his letters, Gans asked Ettie her views on the war. She replied that although America was almost at war, "there is little sign in daily life except for the newspapers, recruiting stations, high price of living and good intentions to prepare practically." May 2, 1916, Stettheimer Papers, Beinecke.

43. Knoedler's began as a New York art gallery by receiving consignments from its French parent company, Goupil, Vibert, throughout the 1870s. In the 1880s the gallery exhibited Barbizon paintings and works by French academic painters such as Delacroix, Detaille, and Tissot. By the next decade it was showing work by prominent English and American artists, including a series of watercolors by Winslow Homer and works by John Singer Sargent, William Merritt Chase, Frederick Blum, Frederick Remington, and Ashton Knight. The first exhibition of works by a woman artist was in 1898 with a series of miniatures by Miss Gwendolyn Dunlevy Kelley, and henceforth they frequently exhibited portraits by women artists. Between 1912 and 1918 Knoedlers held approximately one hundred and seventy exhibitions, of which eighteen were devoted to works by women artists, the best known of whom were the Boston artists Cecilia Beaux, who was given an exhibition in 1917, and Marie Oakey Dewing, in 1914.

44. *New York Evening Post*, review, October 21, 1916.

45. Later she added "It never came off!" to this diary entry.

46. *American Art News*, October 21, 1916.

47. W. G. Bowdoin, "Miss Florine Stettheimer at

Knoedler's," *Evening World*, October 21, 1916.

48. *New York Times*, October 22, 1916.

49. Bolm's most famous roles were the Moor in *Petrushka* and Prince Ivan in *The Firebird*. He choreographed Rimsky-Korsakoff's *Sadko* for the Ballets Russes and rehearsed the troupe in Switzerland before their American tour. At one point in the tour an article of November 13, 1916, in *Musical America* noted, "At present Boston likes Bolm better than it likes Nijinsky . . . he is as Egyptian as Verdi's *Aida*; he burns with Puccini's passion." In 1917 Bolm left the Ballets Russes and set up his own company, which was a collection of individual artists performing their own work who included Roshanara, who performed East Indian dances, Ratan Devi singing Indian melodies, and others. Bolm went on to sign with Ziegfeld and stage dances for *Miss 1917* at the Century Theater with a cast including Irene Castle and with the nineteen-year-old George Gershwin as rehearsal pianist. In 1923 Bolm moved to Chicago and was made ballet master of the Chicago Civic Opera. In 1930 he moved to Los Angeles and worked as a choreographer for several months. In 1932 he became ballet master of the San Francisco Opera. Naima Prevots, *Dancing in the Sun: Hollywood Choreographers* (Ann Arbor: University of Michigan Press, 1987), pp. 154–72.

50. Tyler, op. cit., p. 26.

51. Georges Duthuit, "Le Fauvisme II," *Cahiers d'art* 4 (1929), pp. 260–61, quoted in Robert Goldwater, *Primitivism in Modern Art* (Cambridge: Harvard University Press, 1989), p. 98.

52. In *Morning*, Stettheimer originally painted her friend and curator, Marie Sterner, in the act of arranging an abundant bouquet of flowers. For some reason, Stettheimer later removed the figure of Sterner from the painting and replaced her with a gold-scalloped white curtain and two small butterflies. The revisions to *Morning* change its focus from the figure to the central bouquet. In another painting, labeled *Flowers #8* in the Knoedler show, a dark-haired woman wearing a headband was originally seated at the right of a composition including a white parrot and two vases filled with bright blossoms. The pose of the woman, with her head turned and her arms folded in front, flattened her body into a single shallow plane into which the artist also seemed to place the vases and parrot. Sometime following the painting's 1916 exhibition, Stettheimer revised it by eliminating the figure of the woman and painting a bowed curtain in her place. She made several other less noticeable changes, such as extending and darkening the circular pattern of the tablecloth and emphasizing the rounded base of the vase at the right. The edges of the table have been blurred so that it is no longer evident where the table ends and the walls begin. These changes augment the painting's depth and create a greater sense of ambiguity and spatial movement.

53. Diary entry, December 5, 1916.

54. Duchamp resigned from the board prior to the opening when the society's other directors rejected a mass-produced urinal, which had been submitted as a work of art by the Philadelphia artist Robert Mutt. It was not revealed until sometime later that Duchamp himself had submitted the urinal to the exhibition.

55. Ettie Stettheimer to Henri Gans, February 1917?, Beinecke.

56. Steve Watson has asserted that there may have been a romance between Duchamp and Ettie Stettheimer. See his book *Strange Bedfellows: The First American Avant-Garde in New York* (New York: Abbeville Press, 1991) and his May 1992 article on the Stettheimer sisters in *Art and Antiques* ("Three Sisters"). But in letters and in her diaries, Ettie, who was twelve years older than Duchamp, continually referred to him as though he were a child, "little Marcel," rather than a suitor. In one letter to her friend Gans she describes him as "a young French painter . . . futurist-cubist school, otherwise a charming and dear boy." Ettie was romantically involved with the sculptor Elie Nadelman for a time, but there is no evidence to

suggest that she and Duchamp were ever more than friends.

57. Van Vechten, "World of Florine Stettheimer," op. cit.

58. Thévenaz painted a life-sized oil of Florine around 1916, which was owned by Carl Van Vechten and now belongs to a private collector. Thévenaz was a personable young man, and Parker Tyler stated that women were susceptible to him and that he tended, however harmlessly, to take advantage of it. In her diary, Stettheimer noted Thévenaz's premature death from an infection: "All his charm and talent buried with his beautiful person." Tyler, op. cit., p. 90.

59. *CF*, p. 43.

60. Stettheimer used this pose several times for Bolm. (Note his positioning at the bottom of the painting *Music*.) It was also used to depict small dogs in the paintings *Easter* and *Picnic at Bedford Hills*. Ratan Devi was a singer of East Indian songs that were accompanied by the tambour. She was the wife of Dr. Amanda Coormaraswamy. Although the dancer Ruth St. Denis reproduced the atmosphere of Indian life and feeling in her work, only Devi presented an authentic "Nautch" on the New York stage, a combination of dance, gesture, song, and musical accompaniment. She wrote an article entitled "Oriental Dances in America" for the May 1917 issue of *Vanity Fair*, p. 61.

61. In the actual photograph of Duchamp, taken by Steichen at André Brook on June 22, 1917, the Frenchman stands with one arm against a brick wall, his head tilted up instead of down as in the painting. Steichen photograph of *Marcel Duchamp*, Philadelphia Museum of Art, reproduced in Anne d'Harnoncourt and Kristen McShine, *Marcel Duchamp* (Philadelphia Museum of Art, 1973), p. 220. The photograph, like Stettheimer's painting, shows Duchamp standing with a shaft of diffused sunlight outlining his characteristically classic profile and brushed-back hair.

62. Sometime in the 1960s the art dealer Kirk Askew, who was handling Stettheimer's estate, contacted Stettheimer's grandniece to ask assistance in identifying several of the figures in the painting. In a letter of December 2, 1963, she replied, "The information on Mr. Alfred Seligsberg comes from Mrs. Joe Bach of 50 East 79th Street, a very elderly lady who is a friend of my cousin, Mrs. Samuel Sicher. Mrs. Bach reported that Mr. Seligsberg was a lawyer, a very cultured gentleman and an usher at her wedding. His sister was Mrs. Hugo Seligman who must have been a connection of Florine's. Mrs. Bach thinks that Mr. Seligsberg was a partner of George Spiegelberg's father in his law firm." The relative (who wishes to remain anonymous) went on to identify Paul Chalfin as an influential figure in the art world whose most outstanding work was Viscaya, a mansion he designed for the late James Deering, near Miami, which is now a museum. The author thanks the Cleveland Museum of Art for providing a copy of this correspondence.

63. Goldwater, op. cit., p. 203.

64. Ibid., pp. 89–101. This affinity between Stettheimer's paintings of this period and those of the Fauvists is another instance of how she learned lessons from studying European artists' work.

65. Owen Jones, *The Grammar of Ornament* (London: Bernard Quaritch, 1868), pp. 15–16.

66. Wassily Kandinsky, "Ueber die Formfrage," *Der Blaue Reiter*, pp. 92–93, quoted in Goldwater, op. cit., p. 128. Macke quoted from the article "The Masks" in the same manifesto.

67. Sadakichi Hartmann, "The Exhibition of Children's Drawings," *Camera Work* 39 (July 1912), pp. 45–46. Note also Judith Zilczer's article "Primitivism and New York Dada."

68. Charles Baudelaire, *The Painter of Modern Life and Other Essays*, translated and edited by Jonathan Mayne (London: Phaidon, 1964), p. 8; quoted in Goldwater, op. cit., p. 213. As Margaret Gilman has noted, Baudelaire may have adopted this idea from the artist Eugène Delacroix.

69. Batchelor, op. cit., pp. 81–85, particularly the references to Henri Massis's "Defence of the West" of 1926. The work of Matisse, which greatly influenced Stettheimer's mature style, does not belong to the French academic tradition but instead is part of the concurrent explorations in pattern and decoration that also fall under the expanded definition of modernism as proposed by this book and by the work of Batchelor, Briony Fer, and Nancy Tory.

70. Islamic art was exhibited fairly regularly in Paris during the early twentieth century, when Stettheimer might well have visited them. In May and June 1903 an exhibition was held at the Musée des Arts Décoratifs (Pavilion de Marsan), and in 1907 an exhibition of Islamic tiles and miniatures was held at the same site. In October 1910 a large exhibition was held in Munich, which was also attended by Matisse. From June to October 1912 the Musée des Arts Décoratifs held an exhibition of Persian miniatures. Stettheimer could have attended any or all of these exhibitions. There is a marked resemblance between the composition and organization of *Sunday Afternoon in the Country*—with its high horizon line, verticality, and apparently random placing of the figures—and numerous Persian miniatures.

71. An undated painting, titled *Easter*, is a transitional work done by Stettheimer as she was beginning to incorporate formal and literal elements from Persian miniatures. *Easter* represents a childhood memory or fantasy. Two women, wearing turbaned headdresses and Persian tunics, sit on brightly colored rugs. A Caucasian woman dressed in blue holds an unidentified bundle against her seated body and keeps a watchful eye on the children in the foreground. A second brown-skinned woman holds a tiny, naked Caucasian baby (Ettie?) in her arms. A second dark-haired, naked infant sits at the edge of the bright yellow rug, scratching the stomach of a small, wiggling cat. This child may represent the artist, as Stettheimer often painted herself similarly playing with small animals. In the foreground, six children of varying sizes play along the edge of an irregularly formed stream that meanders toward the pink mountains and stylized sunset at the horizon line. They correspond in age and coloring to Stettheimer's elder siblings. All three are playing with toys that they control by long strings. The painting, with its bright, jewel-toned palette, varied lighting (ranging from bright, almost glowing sunshine to dark, flat shadows), has an exotic flavor. This is heightened by the ambiguity of the subject matter and the inclusion of Persian clothes, the dark-skinned woman, and young naked boys. The painting is not dated, but the handling of the composition and paint is still somewhat clumsy, suggesting that it was painted sometime between the Knoedler paintings and the more sophisticated works that followed.

72. According to Wendy Steiner, the most important conditions contributing to true narrative in painting are that the work present more than one temporal moment, that the subject be specific personages repeated within the composition, and that the setting be at least minimally realistic. These conditions are all met in Stettheimer's work. Wendy Steiner, *Pictures of Romance* (Chicago: University of Chicago Press, 1988), pp. 7–20.

73. Picabia and his wife, Gabrielle Buffet, first arrived in New York on January 20, 1913, and charmed both reporters and artists despite his poor knowledge of the English language. When he returned to Europe, he worked closely with Stieglitz, suggesting artists and works for his New York gallery. In August 1915 the Picabias returned to New York to escape from the war in Europe and were frequent members of the Walter and Louise Arensberg salon as well as occasional visitors to the Stettheimers.

74. Leo Stein was an insistent and incessant talker. His sister, Gertrude Stein, alluded to his increasing deafness and his intransigence in her essay "Two," in which she tracks the end of their brother-sister alliance: "She was changing. He was changing. They were not changing." She also portrayed her brother as characterized by denial

and an unmitigating sense of "oneness." It is perhaps the latter characterization that Stettheimer was mocking by splitting him in "two" in her *Fête* painting. Although Ettie and Leo Stein corresponded somewhat regularly, Ettie found that "although I enjoy his flashes of mental brilliancy, I don't follow him on the whole," and did not enjoy his constantly criticizing her. In 1919 she noted in her diary that she had gone out with Stein and found that "he was rather upsetting, we disagreed so and he turned red radical and spoke of education radically and condemned everything (me by implication and also explicitly on occasions). I don't think we'll ever be very good friends; I don't like criticism to that extent."

75. I am indebted to Francis M. Naumann for bringing these place cards to my attention. Only four of them still exist. Naumann published descriptions of the cards intended for Carl Van Vechten and Fania Marianoff in the exhibition catalogue *Marcel Duchamp* for the Galerie Ronny van de Velde, Antwerp, September 15–December 15, 1991, nos. 38 and 39.

76. *New York Sun*, April 28, 1918.

77. See letter from Ettie Stettheimer to Carl Van Vechten, August 2, 1946, Beinecke. Elizabeth Duncan ran a school in Europe where she trained young girls in the techniques of dance and movement used by her sister Isadora. When she came to the United States she established a similar school in Croton, New York, but when Isadora visited the country she claimed the "Isadorables" for her own troupe. Elizabeth began a dancing school again in Tarrytown on the Frank Vanderbilt estate. She purchased it with funds from wealthy patrons, including Mabel Dodge, and apparently conducted a number of love affairs while in residence there. During 1917–18, Stettheimer painted another work in which she experimented with the effects of artificial light against an opaque evening sky. The scene takes place on the water either along the Hudson River near Tarrytown or on Saranac Lake. The three Stettheimer sisters ride in separate canoes near a bonfire on the water. The figures in

the painting display an unusual role reversal. Although the composition includes three grown men, all but one of the figures rowing boats are women. The only man holding an oar is Stettheimer's relative, the economist Eustace R. A. Seligman. In the uppermost canoe, Duchamp sits petting a small pointy-eared dog while an elegant woman in red with gold jewelry (possibly the actress Fania Marianoff), dips her red oars into the fiery water. An unidentified woman (possibly Elizabeth Duncan) is rowed by another young, thin girl at the left. Meanwhile Carrie, with her usual erect posture, sits holding the sides of a canoe and lets another unidentified woman row her. In a one-person craft in the lower left corner, a man (possibly Van Vechten) sits hunched over a Victrola attempting to add musical accompaniment to the visual spectacle.

78. Ettie's account of the day reflects the difference in the sisters' personalities. "Got to Garrison, found nothing there but a ferry, crossed to West Point, found a jammed, very noisy, untidy hotel on the reservation grounds. . . . Everything 1820ish; also the females foregathered to companion the cadets. Hardly a modern person there. Stayed to see someone, reputed to be Baker, Secretary of War or Daniels, but looking like neither, reviewed three units of cadets . . . very interesting day. Went home over Tuxedo but saw nothing from it. Car and chauffeur very satisfactory."

79. Marcel Duchamp later suggested to Stettheimer's biographer that she liked the American flag because it has the red and white stripes of peppermint candy, but Tyler himself felt she was fond of the flag because it was "like the Stettheimer sisters themselves, tripartite, being red, white and blue. Tyler, op. cit., pp. 16–18.

80. This copy had been obtained recently by Clarence P. Towne and dedicated in 1915, as noted by Linda Nochlin, op. cit. (1980), p. 70.

81. "Portraits of Men in Service," *Brooklyn Eagle*, May 5, 1918.

82. Unfortunately, the painting has been missing

since the 1950s from the West Point Military Academy, to which it was donated by Ettie in 1945, the same year it was used as the cover illustration of the May issue of *Town and Country* magazine.

83. Letter from Ettie Stettheimer to Henri Gans, October 22, 1917, Stettheimer Papers, Beinecke.

CHAPTER FOUR: SOCIAL RELATIONS AT WAR'S END

1. Ettie, at age forty-nine, spent the year engrossed in flirtations. Throughout March she made reference in her diary to the man she nicknamed "Don Juan"—Eli Nadelman. According to the Stettheimers' lawyer, Ettie was in love with the sculptor, despite the fact that he was several years her junior. Nadelman and she often took long walks by themselves and discussed life and books. Marcel Duchamp later remarked to Parker Tyler that the romance might have been more serious on both sides than either imagined, that it was "somewhat like a movie plot except that nothing ever happened." The character of Paul Gratz in Ettie's fictionalized autobiography *Love Days* is based on Nadelman. Throughout the flirtation with Nadelman, Ettie also dated an Englishman named William Piercy, whom she called her "anti-dote."

2. Batchelor, op. cit., p. 4. See also Kenneth Silver, *Esprit de Corps* (New Haven: Yale University Press, 1991), pp. 164–66. Silver notes there was a "subtle but quite definite shift in the modern artist's relationship to past art. . . . We find again the more traditional notion of the past as something to be embraced (rather than negated or neglected) that was beginning to emerge in the midst of the war." According to her diary, Stettheimer visited Manet's painting in Paris on June 5, 1910, and found that, at least on this occasion, it "looked hard in a bright, cold light today."

3. As described by Hamilton Easter Field in 1919. In 1950 the Pennsylvania Academy of Art, to which Ettie had donated *Picnic at Bedford Hills* after Florine's death, reproduced the painting on the cover of their annual report, "as one of those

most important acquisitions for the year." Archives of American Art, roll 70. Letter from Joseph Fraser, Jr., to Ettie Stettheimer, February 16, 1951.

4. Michael Levey, *Rococo to Revolution* (New York: Thames and Hudson, 1985), pp. 58–62.

5. In 1916, Charles H. Caffin, in a review of Nadelman's sculpture, noted that the sculptor "is for the moment less concerned with anatomical averages and standards than with enhancing the expressiveness," a statement that equally well describes Stettheimer's painted figures.

6. Stettheimer included *Picnic* (no. 553) and *West Point* (no. 554) in the Third Annual Exhibition of the Society of Independent Artists in 1919.

7. Ettie continued to have a varied and full social life. On June 30, "little Duche" came and took tea with Ettie at the Beaux Arts Cafe. Duchamp prolonged the meal so that Ettie was forced to get down on her knees "for fun to get him to leave in time for me to dress for dinner," and then Nadelman and she dined at the Ritz roof. By early July, she was writing to Henri Gans, inquiring whether the Frenchman knew "any thin, dark, sinister, complicated, artificial and very brilliant captain of artillery to send to me?" None of her current romances, it seems, were very satisfactory.

8. The artist commemorated the event by inscribing the words "Mother, July 22 1918" on the birthday cake in the foreground, but she also signed and dated the painting "FS/1919" in the lower left foreground. The painting was included in the Arts Council of the City of New York's Exhibition of One Hundred Important Paintings by Living American Artists in 1929. In preparation for the exhibition, a number of art critics, museum directors, dealers, and collectors were asked to submit a list of twenty-five to fifty names of artists they considered "important." The ensuing list of 336 names was then sent to artists throughout the city. Recipients were asked to place a check next to one hundred of the names. Stettheimer was selected, as were Charles Demuth, Joseph Stella, Henry

O. Tanner, Maurice Sterne, Thomas Dewing, and Preston Dickinson. Stettheimer's *Heat* was illustrated in the exhibition catalogue (no. 88).

9. Carl Van Vechten, "The World of Florine Stettheimer," *Town and Country*, 1935, p. 56.

10. Undated, unpublished manuscript in Stettheimer Papers, Beinecke.

11. Ettie noted in her diary, "Whatever that expressed I don't know. He has no prospects nor friends down there. I told him to call on me if he got sick or penniless, but I don't believe he would. Poor little floating atom, a strange boy—But a dear." She later amended this entry by adding, "I believe he went with & was treated by Miss Katherine Dreyer [*sic*]!!" According to Francis Naumann, Duchamp sailed to Argentina on the SS *Crofton Hall* on August 13, 1918, accompanied by Jean Crotti's wife, Yvonne, with whom he had an affair. Before leaving, he invited the three Stettheimer sisters to join him for dinner. Only Ettie made it into the city, and then not for dinner. Instead, the two spent from Friday at one o'clock in the afternoon until 12:30 at night wandering together, except for a short interruption while Ettie had a private dinner with Stella. Ettie and Duchamp then traveled out to the Stettheimers' Bedford Hills house for a small party, which was partially rained out.

12. Carl Van Vechten, "The World of Florine Stettheimer," *Harper's Bazaar* 79 (October 1946), p. 238. Meals at the Stettheimers' were widely noted for the house specialties, such as feather soup, smelt stuffed with mushrooms, lobster in aspic mayonnaise, chicken chaud-froid, oyster salad (immortalized by Avery Hopwood when he introduced it to the Broadway stage in his play *The Gold Diggers*), and the "thousand and one other dishes" that graced the table. Dinners were served with heavy silverware, and the table was set with red damask, a centerpiece of Venetian lace or Italian antique lace altar cloths, and Worcester, Rockingham, or Crown Derby porcelain.

13. Paul Rosenfeld, "Florine Stettheimer," *Accent*

5, no. 2 (Winter 1945), pp. 99–102.

14. Henry McBride, "Artists in the Drawing Room," *Town and Country*, December 1946, p. 75.

15. Reminiscing in 1973 about her first meeting with Marcel Duchamp, Georgia O'Keeffe recalled one such "unveiling": "It was probably in the early twenties that I first saw Duchamp. Florine Stettheimer made very large paintings for the time, and when a painting was finished she had an afternoon party for twenty or twenty-five people who were particularly interested to see what she had been painting."

16. Tyler, op. cit., p. 5.

17. Van Vechten, op. cit., p. 354.

18. McBride, *Florine Stettheimer* (New York: MOMA, 1946), p. 10.

19. This painting has consistently been misdated to ca. 1915. This date is unlikely, because the integration of figures, color, and composition demostrate greater proficiency in the handling of this new style than Stettheimer would have had at this early date. Parker Tyler called the work one of Stettheimer's earliest conversation pieces and attributed his 1915 dating of it to the fact that neither Duchamp nor McBride is present. At the same time, he claims that all three Stettheimer sisters are depicted in the composition, but in fact Carrie is also absent. On the upper left side of a stretcher supporting the unlined canvas, "August 25, 1919" is written in pencil. This is a far more likely date, as Duchamp was by that time already in Argentina. In a 1992 telephone conversation with the author, Francis Naumann concurred that Leo Stein was not in New York before 1917, giving additional weight to a 1917–19 date for the painting.

20. Norman Bryson, *Looking at the Overlooked: Four Essays on Still Life Painting* (London: Reaktion Books, 1990).

21. The conversation piece is defined as a fusion of genre and portrait, in that the figures are identifiable as themselves and not as "types" or ficti-

tious characters. The action takes place not at a public function but within the privacy of a carefully articulated, specified, identifiable interior. Octavio Paz, *Conversation Pieces*, pp. 23–33.

22. This figure was identified by Donald Gallup in a conversation with the author in February 1991.

23. Michael Levey, op. cit., pp. 54–62. The figure at the right side of Watteau's *Fête Vénitienne* is a self-portrait by the artist, as is the case with the figure on the right edge of Stettheimer's painting.

24. Silver, op. cit., pp. 126–83.

25. Examination of this painting under ultra-violet light reveals that Stettheimer reworked and experimented a great deal with the outlines of the figures in the composition, gradually reducing the volume of each and making them less bulky. Based on the author's April 1990 viewing of the painting at Columbia University's Art Storage.

26. Lachaise and his wife were close friends of the Stettheimers. In 1931 the artist donated miniature drawings and a miniature sculpture of a nude woman to the art gallery in Carrie's dollhouse.

27. A few years after Florine's death, Ettie wrote to Carl Van Vechten, asking whether he had attended the family party at which she, Ettie, had (cleverly, she thought) put Leo Stein in a central seat, and he proceeded to launch into a self-analytic monologue. When someone disagreed or asked a question, Stein would turn his head and offer them his deaf ear, saying, "That question is irrelevant," before continuing to dominate the discussion. It is not known whether Florine had this particular incident in mind when she composed *Soirée*, but it is well suited to the reading of the composition as an ironic comment on the arbiters of culture. Stettheimer Papers, Beinecke.

28. Stettheimer signed the work with a vertical monogram "FS" and a date in the same manner as *Heat*, executed in the same year.

29. S. Jay Kaufman, "Round the Town," *The Globe*, March 20, 1920.

30. Not yet a regular member of the Stettheimers' social circle, McBride did not correctly identify Rosetta as the woman in black standing at the red balcony, her straight-backed and arm-braced pose echoed by a black, barrel-chested bulldog as she gazes out at an arriving houseboat.

31. James Gibbons Huneker, "Too Proud to Paint, Independent Idea, When Folk Cannot Draw or Wield Brush, They Develop an Ism or a Cult," *The World* (New York), March 20, 1920.

32. Tyler, who interviewed the Mexican artist as one of the sources for his Stettheimer biography, claims that Best-Maugard was the last major influence on her work and that she was probably attracted, because of her "essentially simple, though highly susceptible, mind" by Best-Maugard's plain way of attaching grandiose spiritual ideas to simple pictorial design. This notion is contradicted later in Tyler's biography when he describes an "explosive" occasion in which Stettheimer, in a tête-à-tête dinner with the artist Carl Sprinchorn, attacked the so-called "mystical" attributes of art (pp. 36–37). In fact, as her writings and works of art attest, Stettheimer might have been susceptible, but her mind was never "simple." A far more interesting approach is to note that because of his Latin American origins, Best-Maugard, like Stettheimer, did not see the concept of the decorative as a pejorative one not having a place in the modern world or modernist aesthetics. As a Latin American and as a woman, both artists were outside the "mainstream" of Western art and could exploit their marginality and difference in their work.

33. The location of Best-Maugard's painting of Ettie is unknown, but a reproduction exists in the Stettheimer archives of Columbia University, box 3. The author wishes to express sincere thanks to James Oles, who located the Best-Maugard portrait of Florine in a private collection in Mexico.

34. Tyler, op. cit., p. 133. This seems a bit of a stretch, as Beardsley's legs are tethered by rope, whereas Best-Maugard stands on top of the rope

and "controls" the line. An interesting comparison can be made with Stettheimer's use of the ribbon in her portrait of the Mexican artist and André Breton's description of the work of another Mexican artist, Frida Kahlo, as "a ribbon around a bomb." Quoted by Briony Fer, in "Surrealism, Myth and Psychoanalysis," in *Realism, Rationalism, Surrealism: Art Between the Wars*, ed. Briony Fer and David Batchelor (New Haven: Yale University Press, 1993), p. 243.

35. Above all, surrealism was a heterogeneous movement, marked by stylistic and conceptual disunity. Stettheimer's work, while based too closely on actual events, sites, and individuals within her everyday life to fall under most general definitions of surrealism, is much closer to André Breton's concepts than to those of Georges Bataille. Had he known Stettheimer's work, as he did Frida Kahlo's, Breton might have found in it the same sense of representing the "other," feminine side of humans. For further discussion of Breton's surrealism and Kahlo's work, see Dawn Ades, *Dada and Surrealism Reviewed* (London: Arts Council of Great Britain, 1978), and André Breton, *Surrealism and Painting,* translated by S. Watson Taylor (London: Macdonald, 1972).

36. For an interesting discussion of how dreams and notions of the feminine influenced surrealism, see Fer, op. cit., pp. 171–83, 231–47.

37. Silverman, op. cit., pp. 150–55. From Edmond de Goncourt, *La Maison d'un Artist* (1881; Paris: Charpentier, nouvelle edition, 1904), pp. 202–4.

38. According to Parker Tyler, on meeting new people, like the artist Carl Sprinchorn at the opening of his first one-person exhibition, Stettheimer drew their attention to the importance of the artist's working hand so that she would then be able to shake hands without concern that her painting hand would be damaged. Tyler, op. cit., pp. 86–87.

39. This inclination was due, in part, to her own body type and the slim unvoluptuousness of the female "flapper," which was fashionable at the time. For further examples of this, see her early nude self-portrait and compare the figures of Charles Demuth, Arnold Genthe, and Harlequin in *Love Flight* to the female contestants and swimmers in *Beauty Contest* and *Natatorium Undine*. The women's bodies, like Stettheimer's, tend to be slender and athletic. Stettheimer apparently reserved sensuous lines for her depictions and appreciations of men. This distinction was carried even further in the portrait of Duchamp.

40. *The Virgil Thomson Reader* (New York: Dutton, 1984), p. 18.

41. Carl Van Vechten, "Pastiches et Pictaches," *The Reviewer* 2, no. 4 (February 1922), p. 270.

42. Historically, the terms by which writers, historians, and artists have identified persons of African-American ethnic origin are highly charged and ultimately revealing more about the relative attitudes toward "otherness" held at that particular time than about how these terms were apprehended by African Americans themselves. This makes it particularly difficult to write about the subject without also using terms which may prove more revealing about ourselves as writers than about our subjects' attitudes toward "difference."

43. *CF*, p. 38. In the version published by Ettie, the word *ebony* was dropped.

44. Toni Morrison has referred to this tendency as an "American Africanism—a fabricated brew of darkness, otherness, alarm, and desire that was uniquely American." Morrison, *Playing in the Dark: Whiteness and the American Literary Imagination* (New York: Vintage, 1992), p. 38.

45. Quoted in Linda Nochlin, "Florine Stettheimer, Rococo Subversive," *Art in America*, September 1980, p. 72.

46. Ibid., pp. 70–73.

47. Toni Morrison, op. cit., pp. 10–15.

48. There is some confusion as to the dating of this work. According to a loose paper in the

Stettheimer archives at Columbia University, Carl Van Vechten believed the work to have been painted between 1925 and 1930, and not in 1920, as indicated in the poster of Caruso on the left side of the composition. The poster, he suggested, was an old one that had remained on the reviewing stand for several years. Van Vechten himself was at work on *Nigger Heaven* in 1924–26, and that obviously added to his belief in a later date. There are, however, a number of exhibition reviews that discuss the painting in 1921, indicating 1920 is the correct date.

49. Letter to McBride, August 18, 1932, Stettheimer Papers, Beinecke. It is rather difficult today to judge the tone and manner in which Stettheimer and her friends discussed African Americans. From the extant correspondence, one can infer that for Stettheimer and McBride, at least, African Americans were somewhat alien but nevertheless fascinating people, particularly aesthetically. In a letter to Florine of July 16, 1932, McBride describes one George, "a colored youth" who "rode up on a bicycle, in the state you artists call *the altogether,* and asked for work . . . the youth, who seemed quite unabashed by the scarcity of his attire (the Biblical loin-cloth!) was extraordinarily handsome; so much so that even my aged cousin Maria Pugh comments on it, and she unlike you has never been subjected to the Carl Van Vechten influence. So George . . . is outside now engaged in clearing away a tangled mess of poison-vine." In the letter, McBride goes on to describe how the village newspaper reported a murder in the area "of one colored man by another, and the nom-de-famille was the same as George's. I have just been asking George if the murderer was possibly a relation, and George, in a cold, disinterested voice has just replied, 'My brother.' That makes two of my friends involved in murder cases." Letter dated July 16, 1932. As usual, Stettheimer's interest in this bizarre incident was solely in reference to a possible visual image. Her only remark to McBride was to inquire, "What shade of brown is George?"

Stettheimer Papers, Beinecke.

50. "The colored maid" Stettheimer mentions is probably a reference to Mary Bell, whose remarkable drawings are stored in Beinecke. Bell worked as a cook for Isabelle Lachaise's sister, and according to Parker Tyler, Van Vechten sent several of Bell's chalk drawings to Stettheimer. She eventually returned them to him. Tyler, op. cit., p. 145. I have not found any traces of the poems by the Atlantic City poet. In the mid-1950s, Van Vechten received an honorary doctorate from Fisk, a black university in Tennessee. He subsequently donated his collection of black musical literature to Fisk as part of the Van Vechten collection and gave his art and art history books in Florine Stettheimer's name.

51. Bushnell Diamond, "Boredom Banished by the Modernists, *Philadelphia Inquirer,* April 17, 1921.

52. Hamilton Easter Field, "Review of Exhibitions Including Independents," *The Arts,* April 1921, p. 51. It is interesting to note that at some point the original frame designed by Stettheimer to accompany this painting must have been lost. The one shown in a photograph of Carl Van Vechten when he and Ettie donated *Asbury Park South* to Fisk University is a plain gilt frame that lacks "flounces."

53. Henry McBride, "Review of the Independents," *New York Herald,* March 6, 1921.

54. *CF,* p. 37.

55. Gaston Lachaise to Stettheimer, March 23, 1921, Stettheimer Papers, Beinecke.

56. Henry McBride, review, *New York Herald,* April 17, 1921. According to Florine's diary, she and Ettie "did not think well of Philadelphia—our sister love for it was not aroused—the only person I knew in that strange town was a waiter from the Beaux Arts. . . . I rang up Carles (Arthur B.) because I wanted to know how to get entree to the Barnes Collection."

57. In an April 9, 1922, *New York Herald* review of the "Modern Artists of America" show at the

Brummer Gallery, Henry McBride completely misinterpreted Stettheimer's painting: "Miss Florine Stettheimer's *Russian Bank* is somewhat of a mystery. The artist figures in the picture herself, entering 'the bank' through a trellised opening in a gay hedge. Whether it is the bank where on the wild thyme blows or merely a bank from which money may be obtained is not clear. Probably the latter, since Miss Stettheimer's Aunt Kate consults a clairvoyant in the foreground as to what the immediate future has in store." This misreading indicates that at this time McBride was not yet a close intimate of family.

58. McBride, Museum of Modern Art catalogue (1946), p. 13. Friends, including Duchamp, also referred to the Stettheimer sisters as the three sisters in Chekhov's *Cherry Orchard*. See postcard from Duchamp to the Stettheimers in correspondence files, Beinecke. At some point after she had the painting professionally photographed, Stettheimer added the figure of her sister Ettie, book in hand, at the base of a tall, attenuated tree at the right. It is not clear why Stettheimer left Ettie out of the original composition; whether by intention or oversight, evidently she later thought better of the exclusion.

59. One novelty followed another, from pogo sticks, crossword puzzles, yo-yos, and mah-jongg to potato crisps, which were introduced in 1928. Carolyn Hall, *The Twenties in Vogue* (New York: Octopus Books, 1983), pp. 14–16.

60. Eksteins, op. cit., pp. 257–59, and Hall, op. cit., pp. 14–16.

61. Van Vechten, "World of Florine Stettheimer," op. cit., p. 353.

62. David Lloyd, "Review of the Society of Independent Artists," *New York Evening Post*, March 13, 1922.

63. Ibid.

64. Stettheimer's conscious use of images from daily life was not particularly noted by contemporary reviewers but is apparent if one compares her works with *Vanity Fair* covers. In a 1932 review, Paul Rosenfeld vaguely alluded to this relationship between her work and popular culture: "The idea of grandiose documentary caricatures of the land of the free found expression in Miss Stettheimer's art some while before it was popularized by the *American Mercury*." Paul Rosenfeld, "The World of Florine Stettheimer," *The Nation* 134 (May 4, 1932), p. 524. In the 1950s and 1960s, after her death, her influence can be seen in the illustrations of Constantin Alajalov and the work of pop artists from Andy Warhol and Holis Sigler to William Wegman, Richard Green, and Robert Kurshner, all of whom cite her work an influence.

CHAPTER FIVE: FRIENDS AND FAMILY: PORTRAITURE

1. Klaric, op. cit., n. 35.

2. Wendy Steiner, *Exact Resemblance to Exact Resemblance: The Literary Portraits of Gertrude Stein* (New Haven: Yale University Press, 1978), pp. 2–5.

3. Alfred Stieglitz, *Camera Work* (August 1912), pp. 29–30, 225.

4. Jan Thompson, "Picabia and His Influence on American Art," *Art Journal* 39 (Fall 1979), p. 14.

5. Features of Demuth's "portraits," although executed more than ten years later, bear close resemblance to Stettheimer's *Portrait of Avery Hopwood* in the use of large contextual letters and the connotations of a poster or advertisement for a personality; Stettheimer's painting, however, also contains a physical likeness of the sitter.

6. Demuth, unpublished manuscript, Beinecke.

7. There is no evidence that Stettheimer met Gertrude Stein at any time during her earlier years in Paris. Although the two women were virtually the same age and were raised in educated, well-to-do Jewish American families, the difference in their personalities and lifestyles precluded any friendship between them. In a letter to Ettie of

August 22, 1921, Stettheimer thanked her sister for an art book by Roger Fry, whom she described sarcastically as "a simple soul—and I think not from choice," and continued, "There is a reproduction of Gertrude Stein's portrait by Picasso in the book—it is interesting but she doesn't look fat, comfortable nor humorous—and no Homeric laugh could ever come from the lips he painted." Neither Stettheimer nor Stein had much use for women friends and colleagues. Each tended to surround herself with men, both heterosexual and homosexual. In addition, Stettheimer was not a "joiner" and never participated as actively in group conversations and discussions as Stein and her intimates.

8. Robert Martin, ed., *The Writer's Craft: Hopwood Lectures, 1965–81* (Ann Arbor: University of Michigan Press, 1982), pp. 1–5.

9. *Fair and Warmer* proved to be Hopwood's undoing. Despite writing melodramas, musicals, and thrillers, the early success of the farce stereotyped the writer in critics' and audiences' eyes, and his reputation dwindled. He spent his final days, in 1928, in Paris with friends Gertrude Stein and Alice Toklas, who noted a sense of impending doom about the playwright, who claimed that an unnamed friend was pursuing him and would kill him. Shortly after this, the women received a postcard from Hopwood on the same day that they learned he had been killed in a drowning accident in the Mediterranean. On her tour of the United States in 1934, Gertrude Stein visited the University of Michigan, from which Hopwood was graduated in 1905. While there she was shown the Hopwood Room, which under the terms of Hopwood's will had been established to commemorate the playwright, as had an endowment for fellowships for young writers. Stein mentioned to Mr. Cowden, responsible for the room, that he should contact Carl Van Vechten, as she believed that a close friend of his had painted an excellent portrait of Hopwood. In reply to Cowden's inquiry, Van Vechten wrote, "There is but one portrait of Avery, but this is not only an excellent portrait,

but also an important work of art by one of the most important of contemporary painters—Miss Florine Stettheimer. . . . I have talked with Miss Stettheimer about the portrait. She was an intimate friend of Avery's and is interested in the project. She suggests that for the present she loan it to you." Although Cowden wrote to Stettheimer and repeatedly to Van Vechten in the hope of receiving the portrait, Stettheimer never replied, although Van Vechten did send Cowden a photograph of the painting. Five years later, in 1941, Cowden again approached Van Vechten for advice on obtaining the work. Van Vechten, in an irritable mood, noted that "Miss Florine Stettheimer . . . like all painters . . . is temperamental. In any case, she first assured me that she would give the picture to Michigan. Later she changed her mind and said she didn't see why she should. . . . I'll do what I can, which is precisely nothing unless she asks my advice, as I already begged her to send you the painting and she refused. Let me know what happens." Finally, in July 1944, Van Vechten wrote to tell Cowden that Stettheimer had died and that her sister Ettie was willing to donate the painting to Michigan's Hopwood room. The painting was finally hung at the university in 1945.

10. The following poem, written in 1928, may have been prompted by Hopwood's death:

A friend died
he left an empty world to me
it is so big
and so desolate
I want to get rid of it
to whom could I give it
I shall stay in my studio
I may forget it.

This poem was never printed, but a typed version is among the Stettheimer Papers at Beinecke. If in fact the poem does refer to Hopwood's death, it might explain Stettheimer's reluctance to part with his portrait.

11. The use of background block letters to indicate the sitter's name and professional references

is very much in keeping with art-nouveau posters and with Charles Demuth's portraits of 1923–29. Many of Demuth's sitters were also part of Stettheimer's circle. When the painting of Hopwood was completed, Carl Van Vechten asked to see it. To accommodate him, on December 17, 1916, Stettheimer held her first private unveiling, inviting friends, including Marcel Duchamp, the Van Vechtens, Marie Sterner, and the Marquis de Buenavista to come to see the portrait and have tea in her studio.

12. The works that appear to be the closest in concept and chronology to Stettheimer's portraits are paintings by Malevich, such as *An Englishman in Moscow* (1913–14), now in the Stedelijk Museum in Amsterdam, and an unusual portrait by the Mexican artist Frida Kahlo, *Portrait of Miguel N. Lira* (1927). Concurrent with Stettheimer and the Modernists, a number of painters working in the art-deco style painted portraits. See Edward Lucie-Smith, *Art Deco Painting* (New York: C. N. Potter, 1990). The main emphasis, however, on the art-deco portraits by artists such as Stettheimer's friend Paul Thévenaz was on the style of their execution rather than any exploration of notions of "identity."

13. The painting was included in the exhibition at the Art Gallery of the Women's World Fair held in Chicago, April 18–25, 1925. It was in the collection of Carl Van Vechten and was later donated to Beinecke.

14. Carl Van Vechten, *Peter Whiffle, His Life and Works* (New York: Knopf, 1921), pp. 49, 177.

15. Ibid., p. 206.

16. *CF*, p. 53. The references are to Peter Whiffle, Edna Kenton—to whom, with his cat Feathers, Van Vechten dedicated *Tiger in the House*—and Mabel Dodge.

17. "My experience with drugs," wrote Van Vechten, "is that I have experienced very little with very few of them . . . because I had only taken heroin and cocaine or something like that a couple of times. My experience was that when you took this drug you felt as if you knew everything and could write anything. Again it gives you enormous power of feeling that you are all and understand all things." He eventually discontinued drug use, however, believing that in fact it impaired his writing.

18. Van Vechten, notes for a never-completed essay on Stettheimer, undated, Beinecke.

19. Stettheimer opened a 1932 letter to Van Vechten "Dear Snakecharmer." She noted that the previous Friday evening Van Vechten had declared that he liked each of the Stettheimer sisters "the same amount" and felt no favoritism toward any one. She included Rosetta's recollection of visiting the Van Vechtens' apartment, "Separate rooms, said she"—an ironic reference to the Van Vechten–Marianoff marriage and Van Vechten's homosexuality.

20. McBride, MOMA catalogue, op. cit., p. 13. To further demonstrate the care with which Stettheimer seeded her compositions with facts and images from the contemporary lives of her sisters, the second edition (1927) of *Peter Whiffle* contains a photograph of the Café d'Harnoncourt taken by Van Vechten (p. 16). By 1925, David Belasco had directed 355 plays. He was particularly known for his special lighting effects, declaring in 1919, "Lights are to drama what music is to the lyrics of a song. The greatest part of my success in the theater I attribute to my feeling for colors, translated into effects of light." His attention to sets and lighting led to the term "Belasco atmosphere." In 1907 Belasco moved into the new Stuyvesant Theater and had built one of the largest lighting systems in the country so that light could be used to symbolize the mood of the play, to interpret its meaning, and to strengthen its emotional appeal. This notion of the importance of lighting for mood was adopted by Stettheimer in 1934, when she designed the stage sets and costumes for the opera *Four Saints in Three Acts.*

21. Penelope Redd to Florine Stettheimer, May 5, 1922, Beinecke.

22. Review, March 1923, journal unknown, pasted into Stettheimer's scrapbook in the Stettheimer archives, Butler. Stettheimer's work was often compared by contemporary critics to that of Marie Laurencin, whose sloe-eyed females were largely self-portraits and who was seen as having an essentially "feminine" quality in her painting style. Laurencin debuted at the Salon des Indépendents in 1902 and went on to work in printing and lithography. There is no information on Stettheimer's attitude toward Laurencin's work.

23. Review, March 4, 1923, journal unknown, pasted into Stettheimer's scrapbook in the Stettheimer archives, Butler.

24. McBride, MOMA, op. cit.

25. Marsden Hartley, *Creative Art* 9 (July 1931), pp. 21–23.

26. Carl Van Vechten, unpublished notes, Beinecke.

27. At Steichen's urging, Frank Crowninshield, editor of *Vanity Fair*, wrote a series of letters over the next six years urging Stettheimer to consider sending photographs of her portraits in order to make "an amusing feature" for his magazine. Unfortunately, Crowninshield rarely spelled Stettheimer's first name correctly when addressing her, an act of negligence that would not have endeared him to the artist. The photographic event never materialized.

28. McBride to Robert McAdam, Archives of American Art, Smithsonian Institution, Washington, D.C.

29. Carlotte Devree, "Profile, Henry McBride . . . Dean of Art Critics," *Art in America* (October 1955), p. 42. I disagree with Steven Watson, who in his 1991 exhibition at the National Portrait Gallery claimed that Stettheimer made McBride appear as though he were much younger than his actual age of fifty-four. McBride was a tall, lean, very dapper man in his fifties, and contemporary photographs reveal that Stettheimer convincingly captured the character and physiognomy of

McBride in 1922. It is true that Stettheimer did not emphasize a sitter's age and physical characteristics. In a memorial article McBride wrote on Stettheimer in 1945 he noted that in her portrait of Carl Van Vechten she "preferred to take an ageless view of the author and portrayed him as a guileless youth. She rejected age in all her friends, for that matter, and in the portraits turned us into the essences of what we were. The 'too, too solid flesh' meant nothing to her. She weighed the spirit." In fact, Stettheimer's portrayal of Van Vechten caught his age accurately, but she played with his varying weight. Henry McBride, "Florine Stettheimer: A Reminiscence," *View* ser. 5, no. 3 (October 1945), p. 13.

30. McBride to Florine Stettheimer, June 14, 1922, Stettheimer Papers, Beinecke. For additional letters see also Archives of American Art, McBride correspondence, microfiche roll NMcB 5, fr. 675.

31. In a letter to his friend McAdam of February 15, 1932, McBride described a party at Juliana Force's in which the guests watched a film of McBride and others playing tennis. McBride lamented, "I was such a fat figure in it that I almost died of shame and what made matters worse is that everybody said it was wonderfully like me. I was shown playing tennis and I don't think I ought to play tennis anymore if I look like that. . . . I think after this I will be permanently camera-shy." Archives of American Art, New York.

32. McBride, *New York Sun*, March 13, 1926.

33. McBride's fondness for Homer was well known. At some time, Stettheimer painted another portrait of McBride, this time over a postcard reproduction of a

Homer watercolor depicting a view from Nassau toward Hog Island. On the surface of the card she painted McBride clutching the trunk of a coconut palm with both arms and looking up toward two small figures who stand in the leafy palm fronds waving American flags (fig. 72).

34. Louis Bernheimer to Ettie Stettheimer, July 1922, Stettheimer Papers, Beinecke.

35. Florine Stettheimer to Bernheimer, postcard, August 7, 1922, Beinecke.

36. McBride, MOMA, op. cit., p. 43.

37. In 1939, Ettie wrote a letter to Fania Marinoff, apologizing for not realizing that Christmas "is an important & great or holy day for you. . . . I make no excuses for not having guessed it, for you have always stressed your Jewish feeling very vociferously & I myself have a very *unpleasant* conscience about celebrating Xmas at all, which I only do—after reducing the celebration to its smallest dimension—because our family, brought up in Germany, got the Xmas habit."

38. Ben Ray Redman, "A Gifted Writer," *The New Yorker*, 1955.

39. In 1923, cellophane was introduced as a dress material at the Parisian Opera Ball when Duchesse de Gramont came dressed in a cellophane gown designed by Vionet and Cheruit, as reported by *Vogue* magazine. Hall, *Vogue in the 20s*, op. cit.

40. Tyler, op. cit., p. 86.

41. Silverman, op. cit., pp. 495–500.

42. Ibid., p. 632. Linda Nochlin has suggested that another prototype for the imagery in this self-portrait might be William Blake's illustration for his *Song of Los*, where the figure reclines weightlessly on a flower. The image was included in Laurence Binyon's *Drawings and Engravings of William Blake*, which was published in 1922, a year before Stettheimer's self-portrait was completed. Although the artist was a voracious reader of art books and was undoubtedly familiar with Blake's work, it is uncertain whether the red form on which Stettheimer has placed herself in the portrait is in fact a flower or is simply a red-fringed material support used in the same manner as the red chaise in the portrait of Ettie. An interesting extension to Nochlin's observation is the possibility that Blake's hand-painted etching provided prototypical features for both Stettheimer works. Blake set his oversized lilies against a starry sky, just as Stettheimer did in her portrait of Ettie. Another amusing comparison can be made between Stettheimer's painting and the cover of a 1930 popular comic book in which a boy is drawn into the large red mouth of a huge Venus flytrap. The colors and composition of the illustration are surprisingly similar to Stettheimer's self-portrait, although it was created seven years later.

43. Sidra Stich, *Anxious Visions: Surrealist Art* (New York: Abbeville Press, 1990), p. 11. In this exhibition catalogue, Stich offers a substantial revisionist notion of surrealism. See also Mary Ann Caws, Rudolf Kuenzli, and Gwen Raaberg, *Surrealism and Women* (Cambridge: MIT Press, 1991).

44. Notions conflating women with children (the naive *femme-enfant*), flowers, and visible manifestations of emotional states dominated the thinking of Breton and others. Often women in early surrealist journals were imaged as children, their eyes wide open and "hypnotically glazed," indicating their openness to emotions and the stream of autonomic, unconscious stimuli. The early surrealists celebrated the French psychiatrist Charcot's research into hysteria in women by publishing photographs of women in a state of ecstasy and defining hysteria not as a pathological phenomenon but as a poetic precept, the supreme means of expression, and one which was exclusively available to women. For Breton, woman "completes the male vision by absorbing into herself those qualities that man recognizes as important but does not wish to possess himself." Whitney Chadwick, *Women Artists and the Surrealist Movement* (New York: Thames and Hudson, 1991), pp. 13–42.

45. Carl Van Vechten, preface to Tyler, op. cit., p. xiii.

46. Tyler, op. cit., p. 41. This was apparently a popular notion. The 1915 July cover of *Vanity Fair* includes an illustration of male and female "insects" who hold hands and flirt.

47. *CF*, p. 20. Stettheimer preferred to call them "flutterby's," as she noted in a poem: "Miss Butterfly, signed a sigh, 'My name does me belie,' . . . For I love the air, and to flutter, and I do not care, for Butter."

48. *CF*, p. 43.

49. Norman F. Cantor, *Twentieth Century Culture: Modernism to Deconstruction* (New York: Peter Lang, 1988), p. 43; see also Silverman, op. cit., pp. 150–60.

50. Kate Chopin, *The Awakening and Selected Stories* (New York: Penguin, 1976), pp. 51, 68, 124.

51. See Carolyn G. Heilbrun's use of Erik Erikson's predominantly male model for human development. Heilbrun, *Writing a Woman's Life* (New York: Ballantine Books, 1988), p. 49.

52. *CF*, p. 42.

53. *CF*, p. 53.

54. Most of Stettheimer's male sitters were married—Van Vechten, de Meyer, Hergesheimer, Bouché, Duchamp (after his portrait was painted)—and were heterosexual or bisexual. A large number of her male friends, however, including McBride, Demuth, Thomson, and Tchelitchew were openly homosexual. Their homosexuality offered a certain comfort for the Stettheimer sisters: they did not have to bother with wives, who did not interest them, and with their gay friends the women were able to play favorites and flirt playfully without repercussions. There is no indication that homosexuality elicited any form of concern or curiosity on the part of the Stettheimers. Homosexuality, both male and female, flourished during the 1920s in New York and abroad. As A. J. P. Taylor observed in his volume of the *Oxford History of England*, "At the *fin de siècle* it [homosexuality] had been consciously wicked. Now it was neither innocent nor wicked. It was merely, for a brief period, normal." Quoted by Bevis Hillier, *The World of Art Deco* (New York: Dutton, 1971), p. 38. See also Terence Greenidge, *Degenerate Oxford?* (London: Chapman and Hall, 1930), pp. 89–114.

55. Carl Van Vechten, "How I Remember Joseph Hergesheimer," in *Yale University Library Gazette*, pp. 87–93. Undated clipping in Stettheimer Papers, Beinecke.

56. James J. Martine, *American Novelists, 1910–1945*, vol. 9 of *Dictionary of Literary Biography* (Detroit: Gale Research, 1988), pp. 123–30.

57. Stettheimer Papers, 1925, Beinecke.

58. Also included in the exhibition were works by Max Weber, Jules Pascin, Eugene Speicher, William Glackens, John Covert, Louis Eilshemius, Charles Duncan, Joseph Stella, Robert Chandler, and George Bellows, among others. Andrew Dasburg exhibited one painting and eight carved paddles from New Guinea and New Britain, indicating the eclectic nature of the selections.

59. Nitrates are located in the Peter Juley Photography Archive, Smithsonian Institution, Washington, D.C.

60. John Savage, "Baron de Meyer: His Influence on American Taste in the Different Branches of Art," *Vanity Fair*, November 1920, p. 75.

61. At some time during 1923, Stettheimer also painted a portrait of Louis Bouché, a painter and the director of the Wanamaker Gallery. The portrait is very simple compositionally, perhaps because she was not as close to, or knowledgeable about, the sitter. In her depiction, Bouché's arm clutches a lace curtain and holds it against his chest. Caught in the act of exhaling smoke from his Cupid's mouth, the heavy-lidded sitter is the epitome of languor and sophisticated disinterest. During the 1920s Victorian lace was very much in vogue, and a number of artists, including Bouché,

used lace in their paintings. McBride, reviewing an exhibition in which the portrait was included two years later, observed that "Miss Stettheimer's portrait of Mr. Bouché is one of a series of portraits that already enjoys much fame. The technic is both free and new and seems to be evolved from the theme itself. . . . Mr. Bouché, as all New York knows, attaches a Freudian significance to the use of Nottingham lace as decoration and in many of his studies of the low and upper-low life uses it. In Miss Stettheimer's portrait, the bread he cast upon the waters returns to him, and he is surrounded by the despised Nottingham lace, most cleverly arranged and painted." In the painting's turquoise background, Stettheimer carved rosette decorations by using a palette knife and incising the paint with the back of her brush. A cascade of roses weaves down from a vase across Bouché's lap and terminates in a small fish bearing a ribbon with the sitter's and the artist's name. These elements relate directly to a known painting by Bouché titled *Fish and Roses to My Darling*.

62. Man Ray proposed the name Société Anonyme, the French phrase for "incorporated." New York State added the redundant "Inc." when the papers of incorporation were submitted, making the name the perfect Dada gesture, as Robert Herbert has noted, and an "automatic" invention. Robert L. Herbert, introduction to *The Société Anonyme and the Dreier Bequest at Yale University* (New Haven: Yale University Press, 1984), p. 3.

63. Fer, op. cit., pp. 183–84.

64. Henry McBride, "Florine Stettheimer: A Reminiscence," *View*, ser. 5, no. 3 (October 1945), pp. 13–14.

65. Interview with Virgil Thomson in New York City, October 1983.

66. Robert Crunden, *American Salons* (New York: Oxford University Press, 1993), p. 432.

67. Tyler, op. cit., p. 41. Duchamp first came into contact with the "fourth dimension" through his brothers, who were members of the Puteaux group and followers of theosophy. In 1912, Gaston de Pawlowski, whom Duchamp read, defined the fourth dimension as the "necessary symbol of the unknown without which the known could not exist." Duchamp used these ideas in forming his *Large Glass*, and he came to think of the fourth-dimensional continuum "as essentially the mirror of a three-dimensional one." Crunden, op. cit., pp. 430–31.

68. The fact that the window is partially open prefigures another work Duchamp made in Paris in 1927, known as *Door: 11 rue Larrey*. Duchamp designed a door to be positioned in such a way as to close the entrance either to the bedroom or to the bathroom, but not to both at the same time, a play on the French adage "Il faut que le porte soit ouverte or fermée," indicating that Duchamp may have discussed the idea with Stettheimer before 1927.

69. I am very grateful to Francis Naumann for bringing this work to my attention and locating it in the permanent collection of the Springfield (Mass.) Museum in Art, where it had resided anonymously for a number of years. Francis suggested the dating 1922–23 on the basis of Duchamp's closely cropped hair and his being in New York during those years. See F. Naumann, *New York Dada* (New York: Abrams, 1994), p. 236.

70. Stettheimer apparently kept the drawing, and in 1952 Ettie gave it to Virgil Thomson, who asked Duchamp to sign it. He did, inscribing it "Chère Florine à Virgil/Marcel Duchamp/1952/(done around 1925)." Since Duchamp was not in New York in 1925, the drawing was probably executed in either 1923 or 1926. Joseph Solomon wanted to have it and so approached Duchamp, asking him if he couldn't make another copy. Duchamp, who had long since abandoned drawing "retinal" work, refused. Solomon then approached Thomson, who at first said he wanted a thousand dollars for the piece but then backed off and kept it. The drawing remained in his collection until it was sold at auction to a private art dealer, Timothy Baum, in 1990. May 1991 interview with Joseph Solomon,

New York City.

71. The author thanks Romy Golan for observing the word play this title generates: *duché* means "duchy" or "aristocracy," and *douche* means shower or bath and was the name of Duchamp's infamous urinal; the word also connotes a succession of good and bad news, cold and hot water. *Donner une douche,* "to give someone a shower," is to cool someone off, tone down their excitement. All these meanings resonate with Duchamp's persona.

72. *CF,* p. 55.

73. In 1925, Jane Heap wrote to Ettie asking her to buy shares in Duchamp's stock company, created as part of his Monte Carlo "system." On March 27, Duchamp sent Ettie a bond by registered mail indicating that she had contributed to the enterprise. After this, however, there is little evident communication between Ettie and Duchamp. Francis Naumann, *The Mary and William Sisler Collection* (New York: Museum of Modern Art, 1984), pp. 200–203. There might have been a falling out between them or simply jealousy at his marriage and his growing allegiance to Katherine Dreier.

74. In October 1923, Carrie and Ettie, who were always closer to each other than to their artistic sister, rented a small apartment to work on their own projects. Ettie planned her next book and Carrie continued to work on her elaborate dollhouse whenever she had time free from household and social duties such as designing the elaborate menus, overseeing the servants, and ordering the food shopping. After her death, Ettie donated Carrie's still unfinished dollhouse to the Museum of the City of New York. In the brochure (June 12, 1947) accompanying the work, she noted that although Carrie was extremely successful and competent in her role as housekeeper, she "had no liking whatever for the job—she enjoyed reading, learning and conversation all of which took time and kept her from the dollhouse." Instead, Ettie suggested the dollhouse was really a substitute for the vocation for which Carrie was eminently suit-

ed—stage design. There is no evidence to support this supposition, but it is interesting that Ettie would stress Carrie's interest in an area in which Florine had received her widest public reception. The dollhouse remained unfinished at Carrie's death and offers an interesting metaphor for the sisters' preference for anticipation over reality. In 1931 Carrie wrote to Gaston Lachaise, thanking him for the drawing she was including in the gallery of her dollhouse, which already contained a miniature Lachaise sculpture. In a reference to dolls that might eventually inhabit the house, Carrie wrote, "I am now hoping they will never be born, so that I can keep them forever in custody, and enjoy them myself, while awaiting their arrival." April 11, 1931, Stettheimer Papers, Beinecke. The irony of this statement is that after the dollhouse was donated by Ettie to the Museum of the City of New York, the museum's director, John Noble, took it upon himself to create dolls of the Stettheimers and their friends and inserted them into the dollhouse for public viewing. This angered many of the Stettheimer relatives and produced an unfortunate misapprehension on the part of many writers and the public that Carrie herself designed the dolls. Given her earlier statement, it is not clear that she would have welcomed this addition to her life's work.

75. Carrie did not always dress so conservatively, however. In a letter to Ettie dated December 9, 1922, Florine described Carrie's attire as "white satin slippers, white turban and her new blue metal dress." According to Joe Solomon, after the funeral, which was presided over by Samuel Berliner, Jr., Ettie gave Carrie's clothes to Isabelle Lachaise, a longtime friend of the sisters, whose sculptor husband had recently died, leaving his wife in dire financial straits.

76. Interview with Barbara Katzander, May 1991, New York City. The author wishes to express her thanks to Katherine Moore of the Katonah Museum of Art for making this introduction.

77. The main difference between this image and

the earlier rendition of the scene is the addition of a man, possibly Walter Stettheimer, at the right and a uniformed maid bearing a tray at the left.

78. See Wendy Steiner, *Pictures of Romance* (Chicago: University of Chicago Press, 1988), p. 19.

79. Stettheimer executed several tiny watercolor sketches for the painting of Carrie and her dollhouse. In the sketches, a family is grouped in front of an accurate rendition of Carrie's model. Both watercolors feature a brown-haired young man with blue eyes and a red-haired, blue-eyed woman with two small blue-eyed children. Since Florine and Ettie Stettheimer both had brown eyes, it is probable that this is an imaginary family and not another recollection from the artist's childhood.

CHAPTER SIX: AMUSEMENTS IN THE 1920S

1. Ettie complained to Kenyon that she was misquoted and that he completely misunderstood and misfelt the book. Kenyon replied diplomatically: "Personally I should like you to know that I very much enjoyed your book. . . . But I cannot believe that you expected any woman to take it with entire seriousness. . . . You have done a remarkable thing in recording so exactly that very duality in woman's nature." From Florence, Leo Stein wrote a long, critical analysis of Ettie's book, noting that until he realized that it was written from a woman's point of view it seemed "curiously unreal." Chastising Ettie that not every male is so insensitive or futile as depicted in her novel, Stein suggested that "a little more veracity and a little less romance would have made a much better work." Ettie Stettheimer to Bernice Kenyon, January 20, 1924; Kenyon to E. Stettheimer, January 29, 1924; Leo Stein to E. Stettheimer, n.d. Stettheimer Papers, Beinecke.

2. *CF*, p. 49.

3. Van Vechten, introduction to Tyler, op. cit., pp. xii–xiii.

4. In March, Stettheimer resigned from the Modern Artists of America and refused Yasuo Kuniyoshi's many requests to reconsider. Kuniyoshi sent Stettheimer a handwritten letter: "Perhaps I am not [the] person to make you feel towards the society more friendly, yet I want to write to you because I don't want to lose you from this society for I like your work so much and the society feels the same." She also refused to include a work in their forthcoming portrait exhibition, stating "I have decided not to show any more portraits for the present as I am keeping them for my own show." The suggested exhibition never materialized.

5. Penelope Redd, "Paintings from International Selection for Tour," *Pittsburgh Sunday Post*, May 11, 1924.

6. Beauty contests had been held on midways of carnivals since the 1890s, but it was difficult at first to get middle- and upper-class women to enter as contestants. To change this, the entrepreneur and entertainer P. T. Barnum launched a campaign appealing to America's patriotism and nationalism by claiming that such contests would prove that American women were the most beautiful in the world. By 1907 newspapers and magazines began to use beauty contests as promotional devices, and in 1921 Clara Bow won a *Photoplay* magazine photographic contest, further widening the acceptance of such events. Lois W. Banner, *American Beauty* (New York: Knopf, 1983), pp. 248–50.

7. Banner, op. cit., pp. 248–69.

8. In addition to writing poetry, Sandburg had several vocations, including reporter. Surprisingly, this figure is not identified or mentioned in any descriptions, contemporary or modern, of the painting. The rendition of Sandburg's features, however, is so accurate that the identification is certain. It is known that he attended at least one of Stettheimer's studio parties, but the nature of his relationship with Stettheimer—indeed, whether they were ever more than passing acquaintances—is unclear.

9. As Linda Nochlin has noted, Miguel Covarrubias also made a number of caricatured impressions of Harlem night life, which offer stylistic parallels for Stettheimer's depictions of black figures in this painting and in her earlier *Asbury Park South*. Nochlin, *Art in America,* op. cit., p. 77.

10. Stettheimer to Van Vechten, September 23, 1925. Stettheimer Papers, Beinecke.

11. McBride, MOMA, op. cit., p. 39. According to Ettie, the portrait takes place at the Stettheimer house in Rochester, N.Y., where she and Florine were born.

12. Tyler, op. cit., p. 120.

13. There is conflicting information in the diaries and correspondence concerning when the move took place. In June 1926, Alfred Stieglitz wrote to the Stettheimers at the Alwyn Court address, but Florine Stettheimer's diary indicates that they moved in June 1927. It is possible that they moved into Alwyn Court in 1926 and gave up their residence on West End Avenue and over the next year moved their remaining belongings to Fifty-eighth Street.

14. Carl Van Vechten, foreword to Tyler, op. cit., p. xii.

15. In the first version, the evening sky above an American flag is illuminated by bursts of red, white, and blue firecrackers. In the second version, the artist painted a flower bouquet on a straw fan that is inscribed with the title, date, and her first name. Small flies and mosquitoes alight on the fan, and two small American flags are crossed at its base, encircled by a string of unlit firecrackers. In addition to reflecting Stettheimer's love of holidays, the paintings may have been inspired by a contemporaneous letter written by McBride from Demuth's home in Lancaster, Pennsylvania, in which he described listening to the church congregation sing "America," which was "charming at a distance of sixty feet . . . [with the] incessant bombardment of Fourth of July explosives both day and night. I had no idea the interior of the country was so patriotic."

16. Sue Davidson Lowe, *Stieglitz* (New York: Farrar Straus Giroux, 1983), pp. 278–82.

17. Stettheimer Papers, Beinecke.

18. There is an ironic, but probably accidental, parallel between this statement and one written in 1870 by the critic Camille Lemonnier describing Regnault's painting *Salomé,* which Stettheimer commented on in her diary of 1912. Lemonnier noted, "I am looking for Woman. . . . I find his figure to be *a* Salome, it does not matter to me if she is not *the* Salome." Quoted in Clark, op. cit., p. 115.

19. Frederick R. Karl, *Modern and Modernism: The Sovereignty of the Artist* (New York: Macmillan, 1985), p. 307.

20. Cook invested the women's money in mortgage and participation certificates. Although for a time these were rendered almost worthless, on Cook's advice the Stettheimers held on, and they eventually received a return of almost one hundred cents on the dollar. Cook passed the Stettheimer account on to his young associate, Joseph Solomon, who became very close to the three women. Following Solomon's advice, after the depression they invested their savings in equity, particularly preferred stocks. Solomon remembers the stir caused by the startling image of three sisters, each wearing a highly idiosyncratic long, loose garment, coming to the rather staid legal offices for conferences.

21. In a 1930 letter (Stettheimer Papers, Beinecke), Stieglitz obliquely noted, "As for myself I'm at peace—& that in spite of Wall Street & several jolts I received," and in 1931 McBride wrote to his friend Robert McAdam, "People are scared to death here over the financial situation and they say the whole world is going to smash. I've just got a new suit at Brooks. I thought if the world did smash I'd better be prepared with adequate garments" (Archives of American Art, Smithsonian Institution).

22. John McMullin, "Bright Lights and New York

Nights," *Vogue*, July 1, 1923, pp. 27–30.

23. Erika L. Doss, "Images of American Women in the 1930s: Reginald Marsh and Paramount Pictures," *Woman's Art Journal* 4, no. 2 (Fall 1983).

24. The first review also referred to the exhibition of the painting in the American Society of Painters, Sculptors and Gravers, held at the Whitney in 1932, but the clipping title, "Attractions in Other Galleries," is cut out and left undated and unascribed in the Stettheimer archives at Butler. Paul Rosenfeld, "The World of Florine Stettheimer," *The Nation* 34 (May 4, 1932), pp. 522–23.

25. Edward Alden Jewell, "Whitney Museum Show of American Society of Painters, Sculptors and Gravers," *New York Times*, February 14, 1932.

26. One of the most noted aspects of Frederick Ashton's choreography for *Four Saints in Three Acts*, produced in 1934, were the resonances between the figural groupings and compositions from well-known Old Master paintings. Stark Young, in his review of the opera for *Theater Arts Monthly*, noted that Ashton had created "visual moments . . . that replicate . . . pictorial borrowings from various well known paintings." Young compared the figural groupings in *Four Saints* to Giotto's work in Santa Croce, while he found in another scene that "Goya is the key," and in yet another he saw references to "El Greco's late baroque exoticism." In his review Young goes on to note that "they are not specific *tableau vivants*, but his [Ashton's] derivations were alive . . . his pictorial borrowings were elusive and one's pleasure in them lay not in recognition . . . but in the freshness of their precision, their fluency of imitation and the light vitality of their departure. It was not so much a case of imitation as of the contagious life in the art tradition." This interpretation serves equally well in describing Stettheimer's numerous "borrowings" from the history of art. Although the comparison with Giotto is not necessary to interpret or enjoy *Cathedrals of Broadway*,

it is likely that Stettheimer consciously used Trecento art as a model for the painting, just as she had previously paid homage to Matisse, Manet, and Botticelli in other works in order to place her work in a continuum of art history. Stark Young, "Reading Lesson," *Theater Arts Monthly*, May 1945.

27. In the sketch, a blonde woman on a balcony, with her male lover or husband standing behind her, rests her head in her hands and looks out over a fantasy landscape. In the foreground, a figure (Narcissus?) gazes at its reflection in a shallow pool. In the middle ground, a man with arms outstretched walks on the sand, and another rides away on a white charger. A third lays on a raft in the water.

28. This was originally handwritten in purple ink by Stettheimer on a loose piece of paper. Stettheimer Papers, Beinecke. *CF*, p. 44.

29. This identification is not certain, as none of the figures in *Love Flight* was identified by the artist or by Ettie. But a comparison of the man's features in this work and the small portrait of Demuth in Stettheimer's painting of two years later, *Cathedrals of Fifth Avenue*, makes the identification appear likely. The same comparison is available for the figures of Genthe in both paintings.

30. Georgia O'Keeffe to Florine Stettheimer, October 7, 1929, Beinecke.

31. Handwritten poem in Stettheimer Papers, Beinecke.

32. On August 10, 1931, Hartley wrote to Stettheimer at the Gould estate asking her to send him information and any books she could find about the poet Gerald Manley Hopkins. She apparently sent him a book on Hopkins's life, noting with surprise that Hartley had not known Hopkins's work before. He replied, "I would hate to be so informed in that dull sense—as some I have known. I fell in love with Hopkins at once, not only his face—but because he was a sure, fine person." According to their correspondence and

Joe Solomon, the Stettheimer sisters helped several other artists financially as well, including the sculptor Alexander Archipenko.

33. In an article in the May 1992 issue of *Art and Antiques* on the three Stettheimers, Steve Watson continues the fallacious notion that Stettheimer refused to exhibit her works, stating that she "demanded that her paintings never leave the womblike atmosphere of her room." In fact, she regularly exhibited her paintings in numerous public forums, although she was reluctant to sell them.

34. An unpleasant situation arose in 1938 when Stettheimer accused one of the frame makers she worked with of plagiarizing her frame and furniture designs and making a reputation for himself based on her aesthetic. In reply, the indignant man denied that he had done so, claiming that although he was familiar with her frames before he designed his line of moldings, he had always been "charmed by valentines and architecture" and did not realize that she "set such store by" her frames, which he admitted were "an individual painter's effort to accommodate paintings, practically unique." Although he appreciated her past goodness to him, "Billy" claimed he had been working on similar designs for a number of years, and that they were his "bread and butter." He felt that her charges against him warranted his sending copies of his reply to several of their mutual friends. "Billy" to Florine Stettheimer, November 12, 1938, Stettheimer Papers, Beinecke.

35. Stettheimer was by no means the only artist to borrow architectural motifs from gothic architecture and medieval painting. In 1933, for example, Professor Eugene Savage painted a mural that was installed over the main desk of Yale University's Sterling Memorial Library. The composition includes a portal schematic of a gothic cathedral and the figure of laurel-crowned Alma Mater under the arch. In her hands, she holds the sphere of learning and an open book inscribed with the seal of the university. Savage claimed that the painting symbolized "the inspiration that directs the University's spiritual and intellectual efforts." *Yale University Library Gazette* 5, no. 4 (April 1931) and 7, no. 3 (January 1933).

36. Nochlin, *Art in America*, op. cit., p. 73.

37. The completely self-absorbed Susanna Moore, heroine of Ettie's largely autobiographical novel *Love Days*, lies in bed and has nightmares of weddings. She is sickened by her first proposal from a man and finds herself equally distressed at the imminent marriage of her best friend. "In regard to marriage for herself Susanna's mind was lazy, rejecting. She almost never thought of it otherwise than abstractly. When— rarely—. . . she did try to picture herself as married, the picture was an uninspired, meager, dreary academic thing, one that died in the process of composition. . . . Marriage was to her, in fact, about as alluring a prospect, and as real a one, as might be to a fifteen year old boy with the world before him the proposal to settle down in a house just-like-everyone's, conduct it, and rear in it a family of his own creation." *Love Days*, in Henrie Waste (pseud.), *Memorial Volume*, pp. 23–35.

38. Eksteins, op. cit., pp. 266–70.

39. Hilda Rebay to Florine Stettheimer, May 4, 1932, Beinecke.

40. The year 1931 ended with the death of Stettheimer's eldest sibling, Stella Wanger. Because of Rosetta's fragile condition, news of her daughter's death was withheld. The ever-vigilant Carrie wrote discreet cards to family friends stating that the three remaining sisters were "composed as we have to be under the circumstances."

41. Ettie Stettheimer to Carl Van Vechten, August 2, 1946, Beinecke.

42. Apparently, Paul Rosenfeld took Ettie to task for her reaction, and she wrote to Stieglitz that "I should feel upset about your having received a report from anyone but myself, did I not realize . . . it is not because my feelings are mine but because you think they may be typical of a class of Georgia's female followers. . . . The way I

differ from the other women admirers, or some of them, is that, knowing Georgia, I hold her in great affection as a person. . . . I harbor the same sentiments for yourself. . . . I'm going to follow your invitation to see your Exhibition & behave as tho' nothing were changed between us." Individual reactions to such exhibitions did not prevent the Stettheimer sisters from actively providing financial support to Stieglitz's gallery. On March 30, 1932, Dorothy Norman wrote to "My dear Miss Stettheimer" to thank the sisters for their financial support for An American Place.

43. McBride to Stettheimer, August 20, 1932, Beinecke.

44. Henry McBride, "$20,000 Purchase Fund Leads to Gay & Vivacious Display," *New York Sun*, November 26, 1932. McBride, in a letter to his friend Robert McAdam on May 10, 1931 (Archives of American Art), described a parade on Fifth Avenue of which several elements are present in both of Stettheimer's earliest *Cathedral* paintings: "I saw Cardinal Hays and two attending priests sitting out in state on the Cathedral steps in the full blaze of the sun which was hot. . . . In a moment along came Jimmy [Walker], looking very swell. . . . The police cheered and Jimmy doffed his topper . . . seeing Cardinal Hays, Jimmy left the ranks and darted over to him, making a profound obeisance . . . somehow it looked cute and affecting. . . . Jimmy certainly knows the right thing to do." This again reinforces how aware Stettheimer was of the events taking place around her and how she borrowed from various sources to create her painted impressions.

CHAPTER SEVEN: *FOUR SAINTS IN THREE ACTS*

1. Samuel Chotzinoff, "Four Saints in Three Acts," *Town and Country*, March 1, 1934, p. 20, with photographs by Harry Bull. According to Thomson, Stein gave him the complete text at the end of July. By November he had taken a studio on the quai Voltaire and began composing the score. *Virgil Thomson Reader*, op. cit., pp. 61–62.

2. *Virgil Thomson Reader*, op. cit., pp. 54–55.

3. Henry McBride, "Florine Stettheimer: A Reminiscence," *View*, series 5, no. 3 (October 1945), p. 14.

4. *CF*, p. 56. The first word in the last line of the poem was published by Ettie as "Et," but in the version written in Florine's hand it appears closer to "St.," which is in keeping with the theme of the opera.

5. Dorothy Dayton, "Before Designing Stage Settings She Painted Composer's Portrait," *New York Sun*, March 24, 1934.

6. In the unpublished Stettheimer correspondence at Beinecke, there are two handwritten versions of this poem, which are substantially the same except for the reversal of the words "it was" and "it waved." Stettheimer's play on Stein's gender roles and sexual preferences in the short poem indicates her amusement at Stein's expense. Others often joined in: Henry McBride, in an article on Stettheimer after her death, described how Van Vechten was not too pleased when Thomson made fun of Stein in a song that he sang at one of the Stettheimers' social evenings. Henry McBride, "Artists in the Drawing Room," *Town and Country*, December 1946, pp. 75ff.

7. Stettheimer from Virgil Thomson dated May 31, 1933, Beinecke. The American subject matter discussed here was undoubtedly the genesis of the Pocahontas ballet on which Thomson and Stettheimer intended to collaborate (see chapter 8).

8. In 1932, Thomson continued to give private recitals of the score of *Four Saints* in the homes of various friends. The flavor of the social scene comes through in a December 27, 1932, letter (Beinecke) from McBride to a friend, when he describes going to the Dudensing's for Christmas dinner, "passing up the more brilliant Stettheimer dinner because the Dudensings asked me first, thereby setting a high example that even you would find difficult to match." He was given a bottle of Floris perfume by Juliana Force, which he

subsequently gave to Carrie Stettheimer. "After the Dudensing dinner I went on over to the Stettheimers' where Virgil Thomson was to sing some of his opera. . . . It was to die, of course, especially as Virgil had a cold and all his top notes cracked. He has had a row with Gertrude and he sang also a satirical song entitled "La Mystère de la rue de Fleurs," which was also to die. He says the Stein-Thomson opera really is to be given next year."

9. None of Stettheimer's original models for the opera survives, but she had the maquettes photographed by Peter Juley, who also photographed her paintings and studio. The dolls and stage props remain in various forms of disrepair in Butler, where they are lightly covered with paper in three cardboard boxes, the first of which includes scraps of material, cellophane, and crushed gold sequins placed in a French wooden packing trunk. One of the stage settings has been re-created using original dolls constructed by Stettheimer (Butler). The scene is from Act I. The background is light-blue crinkled cellophane, in front of which are placed the two-pyramid chorus of saints on both sides of a tall crystal beaded edifice. Saint Theresa sits on a white chair with crystal beads. She is wearing a red velvet dress edged with beige lace, crystal buttons down the front, a lace mantilla under a large red satin flat hat with gold trim and red satin gloves. On either side of her are two palms of roped silver-white wire trunks and threaded cellophane fronds; chained to each with beading are the two yellow yarn-haired lions. In front of this grouping are three black dancing girls with silver thread skirts and bust wraps and tinsel anklets. On the left an unidentified saint in pink satin skirt, white lace top, and pink neckpiece and hat stands near Saint Settlement, who wears white gloves, white gauze mantilla, and a white satin full train skirt with paper circular underskirt visible. Also in the front left are three "minor" saints, one dressed in bright red satin with elaborate old lace overcollar, one in a pink satin underdress with lace collar, and the third in orange satin with a lace collar. Each of the

three saints has a matching color bow at her neck. In front, at left, is the Compère, in black satin pants with a cape of black satin with salmon silk reverse material and white gloves. Next to him sits the second Saint Theresa, in the same costume as in back, but her frontal dress buttons are brass, not crystal. She sits on the same kind of beaded white chair. In front, facing the audience with one arm up, is another minor saint, wearing a salmon satin cape and headdress and white underdress. At the right is Saint Ignatius, in a green satin robe and hat. Next to him is the Commère, in a red sequined dress with sequined train, wearing red lipstick and with big, made-up eyes. While faithfully copying the photographs of Stettheimer's models of this scene, the contemporary model is too large and modern in style to replicate the mood and atmosphere of the original conception.

10. Dayton, op. cit.

11. Stettheimer dressed the figure of Saint Ignatius in a pale green cassock and sewed tiny burgundy sequins on the black lace dress and train of the Commère, who also wears a black lace mantilla, black velvet gloves, and white beaded bracelets. Other figures include three angels, complete with yellow foil halos and gold foil wings and dressed in pink cellophane overdresses, variously designed with silver and gold foil trim and beaded tassels; four male priests in off-white linen; two clergymen, one in white satin with a white satin cape, the other with a vertical sash; three sailors, one in turquoise linen pants, two in blue velvet pants, neck scarves, and berets; three blonde figures in white gauze skirts, full white lace collars to the waist, necklaces with gold vertical beading; three exotic female dancers, one in an orange turban tied with gold foil, one in gold material with matching turban and neck band, one in pink and white gauze with a long necklace of gold beading.

12. When the production of *Four Saints* moved to New York City for a short run after Hartford, union rules prevented Stettheimer from being listed in the official program as stage and costume designer. Kate Lawson, the production's stage manager,

was listed instead, a fact that Ettie found disgrace-
ful. According to Parker Tyler, Houseman's hiring
of Kate Lawson to help execute the sets and cos-
tumes angered Stettheimer and made her quite
bitter. This reaction was compounded when Kate
Lawson's name was used instead of Stettheimer's
in conjunction with an Imperial Wallpapers adver-
tisement in the March 7, 1936, issue of the *New
Yorker*. Stettheimer complained to the editor of the
"Talk of the Town" section, Geoffrey Hellman, but
although he apologized, he pointed out that the
advertising agency provided him with the text ver-
batim and that the release was signed by Lawson.
He suggested that Stettheimer take up the matter
directly with Lawson. After Stettheimer's death,
Hellman wrote a letter of condolence to Ettie, call-
ing the artist "a rare and charming and talented
person. . . . I also loved her paintings and I often
wished, journalistically, that she had allowed me
to write about her in the *New Yorker*." This state-
ment is somewhat hypocritical, as correspondence
indicates that the only time the *New Yorker*
attempted to interview Stettheimer, Hellman did
not do so himself but sent another reporter, who
annoyed the artist because he knew nothing about
music or art.

13. Text from program from Chicago performance
of *Four Saints*, 1934.

14. McBride, review of *Four Saints*, *New York Sun*,
February 10, 1934.

15. John Houseman, *Run-through* (New York:
Curtis Books, 1972).

16. Tyler, op. cit., pp. 65–66.

17. Gilbert Seldes, "Delight in the Theater,"
Modern Music 11, no. 3 (March/April 1934).

18. Houseman, op. cit..

19. McBride, MOMA, op. cit., p. 34.

20. Edith Isaacs, "Theater Magic: Broadway in
Review," *Theater Arts Monthly*, April 1934, p.
246.

21. February 24, 1934, "The Stage in Review."

22. Claggett Wilson to Florine Stettheimer, April
12, 1934, Stettheimer Papers, Beinecke.

23. As reported by Lucius Beebee, "This New
York," *Saint Louis Dispatch*, March 4, 1934.

24. According to Joe Solomon, Ettie never spoke
about her sister's participation in *Four Saints*.
When Virgil Thomson conducted a concert version
of the score in New York in 1952, Ettie "felt terri-
ble" that the Saturday matinee was attended by
"only a handful of people." Apparently Ettie was
far more comfortable attributing recognition for
Four Saints to Thomson than to her sister. I am
grateful to Steve Watson for allowing me to listen
to the tapes of his interview with Thomson.

25. Although some have inferred from this state-
ment that the conversation at the Stettheimers'
parties was a good deal more staid and avoided
such issues, my reading is just the opposite.
Stettheimer's written aside, "sounds antiquated,"
suggests that she is laughing at the separation of
topics according to gender. A discussion of child-
birth would not have interested the artist, nor
would being sequestered with only the women
guests.

26. Postcard from the Stettheimers and McBride to
Charles Demuth, August 8, 1934, Archives of
American Art, New York, microfilm roll 2385.

27. According to the Chicago program for the per-
formance, Moses had chanced to be invited to a
rehearsal of the opera several years earlier at
Harlem's Saint Phillip's Church, where most of the
all-black cast had been recruited. He and his wife
were "so enchanted . . . by the strange beauty of
the opera" that they stayed through the entire
afternoon and evening. Moses was a businessman,
and he provided the financing for such other pro-
ductions as *Grand Hotel* and *The Warrior's
Husband*, which first brought the actress Kath-
arine Hepburn to the attention of the public. A
German friend of the Stettheimers' saw the
Chicago production and wrote to Ettie, "No one
has been so conspicuous by her absence as Miss

Florine" (Niemand hat je mehr geglänzt durch ihre Abwesenheit wie Miss Florine).

28. Stettheimer Papers, 1935, Beinecke.

CHAPTER EIGHT: INDEPENDENCE
AND FAME

1. Tyler, op. cit., p. 153. Tyler's statement that the painting contains the largest figures Stettheimer ever painted is not true if one compares it with her paintings from around 1916.

2. July 11, 1944, Beinecke.

3. Ettie Stettheimer, *Philosophy* (New York: Longmans, Green, 1917), p. 460.

4. "I don't mind your loving my sisters—but the *en bloc* system has never appealed to me." Florine Stettheimer to Henry McBride, June 27, 1932, Beinecke.

5. *CF*, p. 47.

6. Rosenfeld, *Accent*, op. cit., p. 101.

7. Stettheimer's notes indicate that she located an illustration of Captain Smith in a 1918 reproduction in volume 2 of a Richmond, Virginia, general history book. She also read *True Travel Adventures & Observations in Europe, Asia, Africa and America*, by John Randolph, and an article in *Harper's New Monthly Magazine* (no. 136, November 1860) on Captain Smith. While in Atlantic City she took notes for the *Pocahontas* ballet on Blemheim Hotel stationary. Stettheimer and Thomson ultimately took a number of liberties with the narrative. As conceived, their ballet opens with Smith training his men and celebrating his trip at the English royal court. By scene 5, he meets the Native Americans and Pocahontas, who immediately puts in a claim for him, which he refuses. In the next scene Smith is about to be killed by the warriors until Pocahontas again claims him. Her father donates Smith to her because she begs him, singing:

> *Your majesty—I'm a king's daughter*
> *Pa governs great forests and water*
> *Strangers come to take away our land*

> *John Smith came with his little band*
> *Our men were about to beat him to death*
> *when I rushed forward and to Pa saith*
> *"Give him to me and we will unite and*
> * live in a state of bliss*
> *A United State of American bliss."*

In scene 12, Smith reenters with a beautiful young man, John Rolfe, and presents him to Pocahontas as his replacement: "Darling I am much too old / Here's a sailor young & bold / In his Majesty's marine / Won't you be his lovely queen." A grand wedding march provides the ballet's finale. Stettheimer wrote numerous versions of this "poem." In one, it is Rebecca/Pocahontas who is "young & bold," and sometimes the artist stretched the rhythm to a humorous degree: "In my stead / Here's a sailor / Who I vouch / Will never / Fail you." It is not clear whether she intended Thomson to incorporate these short poems in the ballet or whether, like her earlier *Orpheus* ballet, they were simply written to assist her in conceiving the sets and costumes. The sophistication of her poems published in *Crystal Flowers* leads me to prefer the latter interpretation, as the ballet-related poems are trite and poorly written. There is no clear evidence either way, however.

8. A small box in Butler contains twenty-two puppets for the Pocahontas ballet. The figures include John Smith in elaborate quilted pants, silver boots, red velvet tunic, and silver thread cape, with blonde hair; a blonde woman in white gauze dress; two red-headed Scottish dancers doing a jig in gauze and silver kilts; a blonde figure with gold material shirt, kilt, and gold beaded belt holding two red feathers; three Indian maidens in red and orange gauze skirts and hats; four Indian braves with long black braids and orange cellophane skirts; two Indian maidens in yellow and white cellophane skirts and hats with long braids (faces of braves more masculine and stern); three Indians in orange tasseled full costume in dance poses; Pocahontas in wedding dress of gold foil headdress, gold beaded necklace training down the

chest and curled around the arms and legs, gold brocade skirt and long streamers of gold foil; another figure of Smith with a silver collar, red shirt, and black kilt; a disintegrated figure of an Indian woman in a red shawl and transparent pants with black beads along the edge; a blonde woman in white gauze wedding gown; and a broken red-headed figure in a kilt.

9. Stettheimer had already met Walter Arensberg in New York and found him "very pleasant," but this was the first time she met his wife, whom she described as "also very admirable and sympathetic."

10. *CF*, p. 41.

11. Interview with Joseph Solomon, 1991.

12. Isabelle Lachaise to R. S. James, September 27, 1945, Beinecke.

13. Stettheimer to McBride, postcard, October 16, 1935, Beinecke. Originally Stettheimer used the word "invite" before "serpents," but she crossed it out and substituted "welcome."

14. The artist's resignation was caused by the society's recent adoption of a resolution that their membership not submit paintings to museum or gallery exhibitions unless a rental fee be paid by the borrowing institution. A major controversy resulted with the Worcester Museum and others aggressively refusing to pay a rental fee. As a result of their determined stand on the issue, the society incurred the loss of a number of artist members besides Stettheimer, including Charles Burchfield, Guy Pene duBois, John Sloan, Eugene Speicher, and William Glackens.

15. *CF*, p. 41.

16. The Wawbeek Inn was built in 1891 on Upper Saranac Lake's southwest shore. It was rebuilt after a fire in 1915 but completely and irreparably burned down in 1980.

17. In 1937, the Whitney began holding exhibitions of contemporary art annually instead of biennially. One hundred and fifteen artists were invited to submit works, but Stettheimer was not among them, despite the fact that she had been invited to show in every previous biennial exhibition.

18. Nochlin, *Art In America*, op. cit., pp. 75–77, 83. My analysis of this painting is based on Nochlin's analysis in her seminal article on the artist.

19. The fair was constructed over three years on 1,216 acres of land in Flushing Meadow Park in Queens. For a nominal fee, the public entering the fair could walk the equivalent of sixty miles of two-lane highways and visit over three hundred newly constructed buildings. The fair was designed around seven focal zones: government, community interests, food, production and distribution, transportation, communications, medicine and health, science and education, and amusements. The government zone, a "city" consisting of specially designed pavilions from different nations, centered on the large, stately Federal Building. Representing the United States, the building hosted many entertainment extravaganzas, and it stood at the far end of Constitution Mall between the figure of Washington and the fair's official symbol, the modernistic Trylon and Perisphere.

20. Conger Goodyear was chairman of the fair's Governing Committee, on which he served with Juliana Force and Holger Cahill. Of the artists on the Artists' Committee, only William Zorach was a close friend of Stettheimer.

21. Stettheimer designed her uncompleted painting around two women spectators looking out from a gaily striped balcony at an amalgam of the fair grounds and Manhattan's city streets. A copy of the marble George Washington bust sitting in her studio's "patriotic niche" balances on the edge of the balcony, with a stylized American eagle seal below. On either side of the painting, the two partially seen women balance their arms on soft pillows in order to watch the proceedings below. Both women's arms are circled with elaborate bracelets. One holds back a cellophane curtain with one

hand and waves an American flag with the other. The second woman, only partially visible, holds a pair of opera glasses in one hand. They look down on a huge open space lined with small pine trees and fronted by the Federal Building from the government section of the World's Fair. In the background, a number of tall skyscrapers from New York's skyline are visible, including a fanciful version of the RCA Building mounted with a huge star for which Stettheimer made several sketches. For stylistic and iconographic reasons, I would also date another unfinished work by Stettheimer, *Christmas*, now in the Collection of the Yale University Art Gallery, to the end of the 1930s. During this period the artist was intrigued with the city's architecture, and now that she lived alone, she tended to venture out and explore the city on her own more frequently than ever before. The background architectural renderings, the inclusion of Indian headdresses on two of the ice skaters, and the compositional resemblance to her unfinished painting of George Washington (described above) suggest this dating.

22. Stettheimer was by no means the only one obsessed with images of Washington. The first president's picture was often reproduced, and his life was the subject of articles in popular magazines throughout the period between the world wars. In 1919, *Vanity Fair* ran an article describing a newly found diary of Washington covering the period 1782–83, when he was in France. Gilbert Stuart's image of Washington graced the cover of the magazine in March 1932, with superimposed images of gangsters.

23. The selectors for New York State were Gifford Beal, Charles Burchfield, Stuart David, Philip Evergood, Jonas Lie, Hermon Moore, Henry Schnakenberg, Eugene Speicher, and Max Weber—none of them members of Stettheimer's circle, although Marsden Hartley did serve on the selection committee for Maine. It is interesting to note there were no women on the selection committee for New York—Isabel Bishop, Katherine Schmidt, and Gwendolyn Bennett were among the

alternates, along with Gladys Wiles, none of whom could match Stettheimer's professional record or reputation. The overall theme of the exhibition was regionalism, and there was a concerted effort to overcome the recent "drift of art talent from all parts of the country towards the already overcrowded art centers" and to prove, through the works in the exhibition, that "many of these towns have outstripped New York, especially in their more direct response to the inspiration of the country." Therefore, "that full representation of every aspect of contemporary American art is to be found in the exhibition is a fact of such great importance that it cannot be stressed enough." Exhibition catalogue, *American Art Today* (New York: Apollo Books, 1938–39).

24. Quoted in *Cahiers d'Art* (Paris: Zervos, 1931), p. 197; Eksteins, op. cit., p. 268.

25. Stettheimer apparently was related to Natalie Clifford Barney and her sister, Mrs. Dreyfus, through their Pike/Content ancestors. Barney was born in Dayton, Ohio, the daughter of the painter Alice Pike Barney. In May 1939, Stettheimer took Barney and Dreyfus to her uncle William Walter's house to show them the pair of Content portraits. Barney's Parisian literary circle included Marcel Proust, André Gide, and Gabriele D'Annunzio, among others.

26. Ettie, in a letter to Stieglitz and O'Keeffe, noted that Duchamp had also reappeared on the scene and "is as charming as before. More so to my taste, because older & more ripe, even tho' less sappy. But dried figs are nicer than fresh ones unless they're eaten off the tree. I think the fig part is an amusing comparison & could be developed if I had the energy. But I have less than ever. I may be turning into dried ginger myself."

27. According to Parker Tyler, Stettheimer was so deeply impressed with Tchelitchew's work that she admonished a critic friend for not demonstrating more respect for the work. Tchelitchew had a dream in which Stettheimer appeared wearing a half-silver, half-gold dress, introduced herself, and

declared, "I will be your friend to my last days." A few days later, he was taken to Stettheimer's studio and met the artist. Apparently one of her paintings, *Sun*, so closely resembled his dream that following Stettheimer's death, Ettie and Carrie gave it to him. Stettheimer respected Tchelitchew sufficiently that, according to her friends, "he is the only one she ever 'talked shop' with." Tyler, op. cit., pp. 100–101.

28. Raphael's work was part of a cycle of frescos referring to the domains of learning: theology, philosophy, law, and the arts. At either side of the composition (in a like manner to the frontal figures in Stettheimer's work), grisaille statues of Apollo and Minerva act as counterpoints to the painting's main characters. Raphael intimated the relationships among the figures through their gestures and placement vis-à-vis adjacent figures. Plato is shown raising his hand to heaven, the realm where earthly forms retain their ideal embodiment, while Aristotle points downward to the earth as his source for observation and reality. Diogenes is represented as an old man, with his body splayed across several stairs. At the lower left, Pythagoras sketches his system of proportion with chalk on a slate. At the right, Euclid and Ptolemy contemplate a celestial globe while their followers look on. Michelangelo sits by himself, brooding, in the foreground, slightly right of center. Among the contemporary personalities portrayed in the painting, Raphael (like Stettheimer in her painting) included a self-portrait at the lower right, glancing directly out at the viewer.

29. Because of the Depression and the public's perception of the museum as being a mere treasure house of the past, the Metropolitan's attendance fell throughout the 1930s, as did membership. City appropriations fell from $501,495 in 1930 to $369,592 in 1939, even though the museum's operating costs continued to rise. William Zorach, in a letter to the *New York Times*, castigated the museum's policy on American sculpture, and the painter Stuart Davies charged in 1940 that the Metropolitan "suppresses modern and abstract

art . . . as effectively as would a totalitarian regime." Calvin Tomkins, *Merchants and Masterpieces* (New York: Dutton, 1973), pp. 265, 300.

30. Avis Berman, *Rebels on Eighth Street: Juliana Force and the Whitney Museum of American Art* (New York: Athenaeum, 1990), p. 421.

31. Alice Goldfarb Marquis, *Alfred H. Barr, Jr.: Missionary for the Modern* (Chicago: Contemporary Books, 1989), p. 172.

32. By 1929, the women had amassed the largest collection of works by living American artists, and they offered it to the Metropolitan along with an endowment to build a new wing to house it. Edward Robinson, then director of the Metropolitan, refused the offer. Because of his lack of foresight, Force and Whitney established their own museum of modern American art in 1930 and opened the galleries to the public on West Eighth Street in 1931.

33. Berman, op. cit., p. 455.

34. Muriel Draper, "Robert Locher: His Art and Craft," *Creative Art* 9, no. 1, p. 53. This is the same issue which featured Marsden Hartley's flowery article on Stettheimer. The Stettheimer Papers at Beinecke contain a number of letters and hand-drawn Christmas cards from Robert and Beatrice Locher to the Stettheimers.

35. *CF*, p. 26.

36. Hilton Kramer, "Florine Stettheimer's Distinctive Vision of Society," *New York Times*, March 16, 1980, pp. 33, 42.

37. Nochlin, *Art in America*, op. cit., p. 72.

38. In a letter to her sisters of March 29, 1934, Stettheimer noted that Harry Wehle had invited her to dine at his home and meet a man from the museum. Her only written comment was "no!"

39. Tyler mentions that such an exhibition actually took place at the Metropolitan, with a "cocktail dress" included as one of the primary exhibits. Tyler, op. cit., p. 74.

40. Identified by Jerry Selz as *Acrobat* (1939) at left and *Seated Woman* (1938) at right. Virgil Thomson claimed that Stettheimer said about the clashing patterns in a Picasso painting, "What could you use them for, but a sport's suit?" Tyler, op. cit., p. 145, and Eleanor Heartney, "Florine Stettheimer, Saints, Esthetes and Hustlers," *Art News* 90, no. 5 (May 1991), pp. 95–96.

41. Marquis, op. cit., p. 181. The work was one of the final acquisitions of collector John Quinn, who since the Armory Show of 1913 had formed the most extensive privately owned collection of modern art. When Quinn died in 1924, his collection was sold at auction in Paris and the painting was purchased by the dealer Henry Bing, who sold it to a private Swiss collector, Madame E. Ruckstuhl-Siewart. Barr persuaded the owner to send the painting to the Modern in New York for safekeeping and eventually persuaded Mrs. Guggenheim to purchase it for the museum.

42. Monroe Wheeler, *Twentieth Century Portraits* (New York: Museum of Modern Art, 1942), p. 24. John Baur, in his exhibition "Revolution and Tradition in Modern American Art," also held at the Modern in 1951, was no more able to categorize Stettheimer's work. *Family Portrait No. 2* was included in the exhibition. Baur, however, discussed the work not in any of the chapters dealing with revolution of subject or form but under the traditional art types. He associated it specifically with the so-called Primitives, writing that some artists have consciously imitated the quaint mannerisms of the Sunday painter (naif) "like Florine Stettheimer, [who has consciously copied] the naive drawings of children, to create an art which is gay and fanciful but highly mannered." If anything, Baur should have placed Stettheimer's work in his subsequent chapter on "Romantic Visionaries," along with Dove, Eilshemius, Davies, and Pittman.

43. The date of this hospitalization offers an example of the inaccuracies promoted by Parker Tyler, who in his biography of Stettheimer mistakenly states that the date of her entry into the hospital was the beginning of 1941. According to statements to the author by Joe Solomon, it was the summer of 1942. In fact, her diary demonstrates that she was again in the hospital from January to March 1943, and at the Dorset from then until she returned to her studio in July.

44. When Stettheimer died, Solomon had difficulty probating the will. He had to prove that both of her parents were deceased, but her father's whereabouts for the last forty to fifty years were unknown.

45. Solomon handled the funeral arrangements, including a private service in the sisters' apartment at the Dorset, officiated by Algernon Black, the spiritual leader of the Ethical Culture Society. Solomon also witnessed Stettheimer's cremation on May 11, 1944, at the Plaincliff Cemetery in Hartsdale, New York. Sometime after this, Ettie directed the lawyer to "hold the ashes" at the Universal Chapel until she decided their eventual disposition. Ettie had displayed no such indecisiveness in arranging for her other sister, Carrie. At Ettie's direction, Carrie was interred in the Walter family plot in Salem Fields, Brooklyn, alongside her aunt Josephine and her mother, Rosetta.

46. Following Ettie's death, Solomon, as the trustee of her estate, worked with the advise of Kirk Askew and Carl Van Vechten to distribute thirty-seven of Stettheimer's major works to "top museums, colleges and universities across the country." He tried to get a number of institutions to take Stettheimer's oeuvre as a unit but had no success. At the time, Columbia University was planning to build a new museum on its campus, including a wing to contain the Sackler Collection, which they were anticipating being given. Solomon made an agreement with the President of Columbia that the remaining Stettheimer paintings (less those given to the Metropolitan Museum of Art and the Museum of Modern Art) be given to Columbia, which in turn would create a permanent room for their display. To facilitate this, Solomon also donated $130,000 from Ettie's estate, as pro-

vided for in her will (the original amount was $75,000, but Solomon increased the principal by investing it in stock in IBM), as maintenance for the works. But the university scrapped plans for a new museum and instead expanded its Avery Library building to include a small room for the exhibition and observation of the donated Stettheimer works. When construction of the library was completed, they held a small reception for the Stettheimer paintings and published a catalogue.

47. The entire catalogue for the Stettheimer exhibition was reprinted under the title *Three American Romantic Painters* by the Museum of Modern Art in 1969. McBride's essay and all the photographs were reproduced in the large hardbound volume along with Barr's 1930 catalogue and essay on Charles Burchfield and Andrew Carnduff Ritchie's catalogue on Franklin C. Watkins.

48. McBride, MOMA, op. cit.

49. Stephen Bourgeois to Ettie Stettheimer, April 12, 1950.

CHAPTER NINE: EPILOGUE

1. Glenway Wescott to Ettie Stettheimer, November 23, 1946, Beinecke.

2. Ettie Stettheimer, preface to *CF*.

3. Tyler, op. cit., p. 87.

4. Rosenfeld, *The Nation*, op. cit.

5. Ettie Stettheimer, April 8, 1952, Beinecke.

6. Ettie Stettheimer, preface to *CF*.

7. *New York Times*, April 20, 1947.

8. John Elderfield, *Henri Matisse: A Retrospective*, exhib. cat. (New York: Museum of Modern Art, Harry Abrams, 1992), p. 34.

9. Carl Van Vechten, "World of Florine Stettheimer," op. cit., p. 356.

10. James Rosenberg to William Milliken, n.d., Beinecke.

INDEX

The initials "FS" in the index refer to Florine Stettheimer. Page numbers in boldface refer to reproductions of artworks and photographs.

DATE DUE

			Printed in USA

HIGHSMITH #45230